THE SOCIAL HISTORY
OF ART

Renaissance, Mannerism, Baroque

VOLUME TWO

THE SOCIAL HISTORY
OF ART

Renaissance, Mannerism
and Baroque

ARNOLD HAUSER

VOLUME II


ROUTLEDGE

LONDON

First published in two volumes 1951
Reprinted 1952
This edition
Published in four volumes 1962
by Routledge & Kegan Paul plc
Reprinted four times
Reprinted 1989, 1992 by
Routledge
11 New Fetter Lane, London EC4P 4EE
Text printed in Great Britain
by Hartnolls Limited
Bodmin, Cornwall, England
A member of the Martins Printing Group
Plates printed in Great Britain
by Headley Bros. Ltd., Ashford, Kent

Translated in collaboration
with the Author by
Stanley Godman

ISBN 0 415 04579 7

CONTENTS

1. THE CONCEPT OF THE RENAISSANCE *page* 1
 *The liberal-individualistic and the aesthetic-
 sensualistic concept of the Renaissance, page 3;
 National and ethnographic criteria, page 6;
 The uniformity of the representation as a formal
 principle, page 8; The continuity between the
 Middle Ages and the Renaissance, page 10; The
 rationalism of the Renaissance, page 12*

2. THE DEMAND FOR MIDDLE-CLASS AND COURTLY
 ART IN THE QUATTROCENTO *page* 13
 *The class struggles in Italy at the end of the
 Middle Ages, page 13; The struggle for the
 guilds, page 15; The rule of the Medici, page
 18; From the heroic age of capitalism to the age
 of the rentier, page 19; Giotto and the Trecento,
 page 21; The romantic-chivalric art of the North
 Italian courts, page 25; The middle-class natur-
 alism of the Florentine Quattrocento, page 27;
 The change of style around the middle of the
 century, page 29; The guilds as the trustees of
 public artistic activity, page 32; From the founder
 to the collector, page 34; The patronage of the
 Medici, page 37; Lorenzo and Bertoldo, page 39;
 The courtly culture of the Renaissance, page 40;
 The stratification of the art public, page 42;
 The cultural élite, page 44*

3. THE SOCIAL STATUS OF THE RENAISSANCE ARTIST *page* 46
 *Art and craftsmanship, page 46; The art market,
 page 50; The emancipation of the artist from the*

CONTENTS

guild, page 53; *The legend of the artist, page* 57;
The Renaissance concept of genius, page 61; *The
autonomy of art, page* 65; *Scientific tendencies
in art, page* 67; *Specialization and versatility,
page* 70; *Dilettantism and virtuosity, page* 71;
The humanists, page 72

4. THE CLASSICISM OF THE CINQUECENTO *page* 75
Rome as a cultural centre, page 76; *Ecclesiastical
and secular patronage, page* 78; *The 'maniera
grande', page* 79; *Classicism and naturalism,
page* 80; *The uniformity in the development of
the Renaissance, page* 81; *The artistic formalism
and formulism of the moral concepts, page* 82;
Kalokagathia, page 84; *The perfect courtier as
the ideal personality, page* 86

5. THE CONCEPT OF MANNERISM *page* 88
Manneristic and mannered, page 88; *The re-
lation of mannerism to the classicism of the
Renaissance, page* 90; *The discovery of man-
nerism by the present age, page* 91; *Spiritualism
and naturalism, form and formlessness, page* 92;
The dissolution of space, page 93; *Mannerism
and baroque, page* 94

6. THE AGE OF POLITICAL REALISM *page* 96
The subjugation of Italy, page 97; *The economic
predominance of the oceanic nations, page* 99;
The beginnings of modern capitalism, page 100;
Social unrest and the Reformation, page 101; *The
Catholic reform movement in Italy, page* 103;
Michelangelo, page 104; *The idea of political
realism, page* 107; *Machiavelli, page* 108; *The
Tridentinum and art, page* 110; *The Reforma-
tion and art, page* 113; *The Counter Reformation
and mannerism, page* 114; *The art theories of
mannerism, page* 116; *The idea of the Academy,
page* 118; *The problem of lay criticism, page*

121; *Florentine mannerism, page* 122; *The problem of space, page* 123; *The courtly character of mannerism, page* 124; *Tintoretto, page* 125; *Greco, page* 127; *Bruegel, page* 128

7. THE SECOND DEFEAT OF CHIVALRY *page* 131
Romantic chivalry and the rationalism of the century, page 131; *Disillusioned Spain, page* 132; *Cervantes, page* 133; *Elizabethan England, page* 137; *Shakespeare's political outlook, page* 138; *Writers and patrons, page* 144; *Shakespeare's public, page* 146; *The preconditions of Shakespearian form, page* 150; *Shakespeare and the 'domestic drama', page* 153; *Shakespeare's naturalism, page* 154; *Shakespeare's mannerism, page* 157

8. THE CONCEPT OF THE BAROQUE *page* 158
The ramification of the baroque, page 158; *The impressionism and the revaluation of the baroque, page* 160; *Woelfflin's basic concepts, page* 161; *The cosmic outlook on life, page* 166

9. THE BAROQUE OF THE CATHOLIC COURTS *page* 168
The origins of modern ecclesiastical art, page 168; *Baroque Rome, page* 171; *The absolute monarchy and French society, page* 173; *French court art, page* 175; *The academies and the royal manufactory, page* 179; *Academicism, page* 182; *Official and unofficial art, page* 184; *The nobility and the bourgeoisie in their relationship to classicism, page* 186; *The beginnings of modern psychology, page* 187; *The salons, page* 188

10. THE BAROQUE OF THE PROTESTANT BOURGEOISIE *page* 191
Flanders and Holland, page 191; *Middle-class culture in Holland, page* 196; *Dutch fine art trade, page* 201; *The economic situation of the Dutch painters, page* 202; *Rubens and Rembrandt, page* 203

CONTENTS

NOTES *page* 209

INDEX *page* 220

ILLUSTRATIONS

Ceiling Painting. Rome, S. Domitilla Catacomb.
Photo Alinari PLATE I. 1
Christ with the Apostles. Rome, Sta Pudenziana.
Photo Anderson 2
Empress Theodora with Attendants. Ravenna,
S. Vitale. Photo Anderson II. 1
Emperor Justinian and Bishop Maximian. Ravenna,
S. Vitale. Photo Alinari 2
Christ with Angels. Ravenna, S. Apollinare Nuovo.
Photo Anderson 3
Cruciform page from St. Chad's Gospels. Lich-
field, Cathedral Library. Photo Victoria and
Albert Museum III. 1
The Arrest of Christ. From the Book of Kells.
Dublin, Trinity College. Photo Trinity College
Library 2
Evangelist. From the Codex aureus. British
Museum. Photo Brit. Museum IV. 1
Drawing from the *Utrecht Psalter*. British
Museum. Photo Brit. Museum 2
The Last Judgement. Autun, St.-Lazare. Photo
Arch. Photogr. d'Art et d'Hist. V. 1
St. Peter. Moissac, Saint-Pierre. Photo Hurault 2
Scene from the Bayeux Tapestry. Bayeux, Museum,
Photo Arch. Photogr. d'Art et d'Hist. 3
Rider. Bamberg, Cathedral. Photo Marburg, Kun-
stinstitut VI. 1
Ekkehart and Uta. Naumburg, Cathedral. Photo
Marburg, Kunstinstitut 2
Head. Chartres, Cathedral: Royal Door. Photo
Arch. Photogr. d'Art et d'Hist. VII. 1
John the Baptist. Chartres, Cathedral: North Porch.
Photo Arch. Photogr. d'Art et d'Hist. 2
Head. Rheims, Cathedral: Central West Door.
Photo Hurault 3
JAN VAN EYCK: *The Just Judges*. Ghent, St. Bavon VIII. 1

ix

ILLUSTRATIONS

PAUL DE LIMBOURG: *February*. Chantilly, Musée
Condé. Photo Bulloz PLATE VIII. 2

ROBERT CAMPIN: *Virgin and Child*. London,
National Gallery. Photo National Gallery IX. 1

GIOTTO: *Meeting of St. Joachim and St. Anne*.
Padua, Cappella dell' Arena. Photo Anderson 2

AMBROGIO LORENZETTI: *The Good Government*.
Siena, Palazzo Pubblico. Photo Anderson X. 1

NARDO DI CIONE: Detail from the *Paradise*.
Florence, S. Maria Novella. Photo Brogi 2

MASACCIO: *The Tribute Money*. Florence, Carmine.
Photo Anderson XI. 1

MASACCIO: *St. Peter Baptising*. Florence, Carmine.
Photo Anderson 2

DONATELLO: *Judith and Holofernes*. Florence.
Photo Alinari 3

GENTILE DA FABRIANO: *The Adoration of the Magi*.
Florence, Uffizi. Photo Anderson XII. 1

FRA ANGELICO: *Annunciation*. Florence, S. Marco.
Photo Anderson 2

PIERO DELLA FRANCESCA: *The Queen of Sheba
before Solomon*. Arezzo, S. Francesco. Photo
Anderson XIII. 1

DOMENICO GHIRLANDAJO: *The Birth of John*. Florence, S. Maria Novella. Photo Anderson 2

BOTTICELLI: *Annunciation*. Florence, Uffizi. Photo
Anderson XIV. 1

DESIDERIO DA SETTIGNANO: *Female Bust*. Paris,
Louvre. Photo Arch. Photogr. d'Art et d'Hist. 2

MANTEGNA: *Ludovico II with Family*. Mantua,
Pal. Ducale. Photo Anderson XV. 1

FRANCESCO COSSA: *The Triumph of Venus*. Ferrara, Pal. Schifanoja. Photo Anderson 2

BERTOLDO: *Bellerophon and Pegasus*. Vienna,
Kunsthist. Museum. Photo The Arts Council of
Great Britain XVI. 1

NERI DI BICCI: *Annunciation*. Florence, Uffizi.
Photo Alinari 2

LEONARDO: *The Last Supper*. Milan, S. M. delle
Grazie. Photo Anderson XVII. 1

RAPHAEL: *The Disputa*. Rome, Vatican. Photo
Anderson 2

MICHELANGELO: *David*. Florence, Acc. di Belle Arti.
Photo Anderson XVIII. 1

ILLUSTRATIONS

TITIAN: *Charles V*. Madrid, Prado. Photo Anderson PLATE XVIII. 2

TITIAN: *Shepherd and Nymph*. Vienna, Kunsthist. Museum. Photo Rijksmuseum Amsterdam 3

MICHELANGELO: *The Last Judgement*. Rome, Sistine Chapel. Photo Anderson XIX. 1

MICHELANGELO: *The Conversion of St. Paul*. Rome, Vatican. Photo Anderson 2

MICHELANGELO: *Pietà Rondanini*. Rome, Pal. Rondanini. Photo Anderson 3

PONTORMO: *Joseph in Egypt*. London, National Gallery. Photo National Gallery XX. 1

BRONZINO: *Eleonora of Toledo with her Son*. Florence, Uffizi. Photo Anderson 2

PARMIGIANINO: *Madonna del collo lungo*. Florence, Pal. Pitti. Photo Anderson 3

TINTORETTO: *The Last Supper*. Venice, S. Giorgio Maggiore. Photo Anderson XXI

TINTORETTO: *Moses bringing forth Water from the Rock*. Venice, Scuola di San Rocco. Photo Anderson XXII. 1

TINTORETTO: *St. Mary Aegyptiaca*. Venice, Scuola di San Rocco. Photo Anderson 2

GRECO: *The Burial of the Count of Orgaz*. Toledo, S. Tomé. Photo Anderson XXIII. 1

GRECO: *The Visitation*. Washington, Dumbarton Oaks Coll. Photo The Fogg Museum of Art 2

BRUEGEL: *Autumn*. Vienna, Kunsthistorisches Museum. Photo Braun XXIV. 1

BRUEGEL: *A Country Wedding*. Vienna, Kunsthist. Museum. Photo Braun 2

CARAVAGGIO: *The Crucifixion of St. Peter*. Rome, S. M. del Popolo. Photo Anderson XXV. 1

LODOVICO CARRACCI: *Madonna with Saints*. Bologna, Pinacoteca. Photo Anderson 2

PIETRO DA CORTONA: *Ceiling painting*. Rome, Pal. Barberini. Photo Anderson XXVI. 1

VIGNOLA: *Il Gesù*. Rome. Photo Anderson 2

LORENZO BERNINI: *Ludovica Albertoni*. Rome, S. Francesco a Ripa. Photo Alinari XXVII. 1

LORENZO BERNINI: *Francesco I of Este*. Modena, Gall. Estense. Photo Alinari 2

LE BRUN: *The 'Salon de la guerre'*. Versailles. Photo Arch. Photogr. d'Art et d'Hist. XXVIII. 1

xi

ILLUSTRATIONS

LE BRUN: *Louis XIV Visits the Gobelin Manufacture.* Versailles. Photo Arch. Photogr. d'Art et d'Hist. — PLATE XXVIII. 2

POUSSIN: *Et in Arcadia Ego.* Paris, Louvre. Photo Arch. Photogr. d'Art et d'Hist. — XXIX. 1

LOUIS LE NAIN: *Peasant Meal.* Paris, Louvre. Photo Arch. Photogr. d'Art et d'Hist. — 2

HYACINTHE RIGAUD: *Louis XIV.* Paris, Louvre. Photo Giraudon — 3

RUBENS: *The Rape of the Daughters of Leucippus.* Munich, Alte Pinakothek. Photo National Gallery, London — XXX. 1

RUBENS: *The Adoration of the Magi.* Sketch: London, Wallace Collection. Photo Wallace Collection. Altar-piece: Antwerp, Museum. Photo Braun — XXXI. 1/2

REMBRANDT: *The Sacrifice of Manoah.* Dresden, Gemaeldegalerie. Photo Alinari — XXXII. 1

REMBRANDT: *Self Portrait.* London, National Gallery. Photo National Gallery — 2

REMBRANDT: *The Return of the Prodigal Son.* Leningrad, Hermitage. Photo Braun — XXXIII.

FRANS HALS: *The Civic Guard of Archers of St. George.* Haarlem, Frans Hals Museum. Photo Braun — XXXIV. 1

VERMEER VAN DELFT: *The Allegory of Painting.* Vienna, Kunsthist. Museum. Photo The Arts Council of Great Britain — 2

HOBBEMA: *The Avenue.* London, National Gallery. Photo National Gallery — XXXV. 1

ALBERT CUYP: *River Scene with Cattle.* London, National Gallery. Photo National Gallery — 2

PIETER DE HOOCH: *Courtyard of a Dutch House.* London, National Gallery, Photo National Gallery — XXXVI. 1

METSU: *Music Lesson.* London, National Gallery. Photo National Gallery — 2

ADRIAEN VAN DER WERFF: *The Repose in Egypt.* London, National Gallery. Photo National Gallery — 3

xii

RENAISSANCE, MANNERISM, BAROQUE

1. THE CONCEPT OF THE RENAISSANCE

How arbitrary the usual distinction between the Middle Ages and the modern age is and how fluid the concept of the 'Renaissance' is best shown by the difficulty there is in assigning such personalities as Petrarch and Boccaccio, Gentile da Fabriano and Pisanello, Jean Fouquet and Jan van Eyck, to one or other of these categories. If one likes, one can even consider Dante and Giotto as belonging to the Renaissance and Shakespeare and Molière to the Middle Ages. In any case, the idea that the real turning-point does not occur until the eighteenth century and that the modern age really begins with the enlightenment, with the idea of progress and with industrialization, is not to be lightly dismissed.[1] But it will probably be best to place the crucial dividing-line between the first and second half of the Middle Ages, that is to say, at the end of the twelfth century, when money economy comes to life again, the new towns arise and the modern middle class first acquires its distinctive characteristics— it would be quite wrong to place it in the fifteenth century, in which, it is true, a number of things come to fruition but as good as nothing absolutely new begins. Our naturalistic and scientific conception of the world is certainly in essentials a creation of the Renaissance, but it was medieval nominalism that first inspired the new direction of thought in which this conception of the world has its origin. The interest in the individual object, the search for natural law, the sense of fidelity to nature in art and literature—these things do not by any means begin only with the Renaissance. The naturalism of the fifteenth century is merely the continuation of the naturalism of the Gothic period

1

in which the individual conception of individual things already begins to be clearly manifest. And if those who sing the praises of the Renaissance profess to see in all the spontaneous, progressive and personalist tendencies of the Middle Ages a heralding or a proto-form of the Renaissance, if for Burckhardt even the songs of the wandering scholars are proto-Renaissance and Walter Pater sees an expression of the Renaissance spirit in such an absolutely medieval creation as the chante-fable 'Aucassin and Nicolette', then this conception only sheds light on the same state of affairs, the same continuity between the Middle Ages and the Renaissance, from the opposite angle.

In his description of the Renaissance, Burckhardt laid the greatest stress on the naturalism of the period, and represented the turning to empirical reality, 'the discovery of the world and of man', as the most fundamental factor in the 'rebirth'. In so doing, he, like most of his successors, failed to see that in the art of the Renaissance not naturalism in itself but merely the scientific, methodical, totalitarian character of naturalism was new, and that not the observation and analysis of reality, but merely the conscious deliberation and consistency with which the criteria of reality were registered and analysed were in advance of medieval conceptions—that the remarkable thing about the Renaissance was, to put it briefly, not the fact that the artist became an observer of nature, but that the work of art became a 'study of nature'. The naturalism of the Gothic period began when pictures and sculpture ceased being exclusively symbols, and began to acquire purpose and value as mere reproductions of the things of this world, apart from their connection with transcendental reality. The sculptures of Chartres and Rheims, obvious as their supernatural relationships are, differ from the art of the Romanesque period by reason of their immanent purpose, which is separable from their metaphysical significance. On the other hand, the real change brought about by the Renaissance is that metaphysical symbolism loses its strength and the artist's aim is limited more and more definitely and consciously to the representation of the empirical world. The more society and economic life emancipate themselves from the fetters of ecclesiastical dogma the more freely does art turn to the consideration of

immediate reality; but naturalism is no more a new creation of the Renaissance than the acquisitive economy.

The Renaissance discovery of nature was an invention of nineteenth-century liberalism which played off the Renaissance delight in nature against the Middle Ages, in order to strike a blow at the romantic philosophy of history. For when Burckhardt says that the 'discovery of the world and of man' was an achievement of the Renaissance, this thesis is, at the same time, an attack on romantic reaction and an attempt to ward off the propaganda designed to spread the romantic view of medieval culture. The doctrine of the spontaneous naturalism of the Renaissance comes from the same source as the theory that the fight against the spirit of authority and hierarchy, the ideal of freedom of thought and freedom of conscience, the emancipation of the individual and the principle of democracy, are achievements of the fifteenth century. In all this the light of the modern age is contrasted with the darkness of the Middle Ages.

The connection between the concept of the Renaissance and the ideology of liberalism is even more striking in the work of Michelet, who coined the slogan of the 'découverte du monde et de l'homme',[2] than in that of Burckhardt. Even the way he chooses his heroes, and brings together Rabelais, Montaigne, Shakespeare and Cervantes with Columbus, Copernicus, Luther and Calvin,[3] his characterization of Brunelleschi, for instance, as the destroyer of the Gothic and his conception of the Renaissance in general as the beginning of a development which finally secures the victory for the idea of freedom and reason, shows that the main interest in his analysis is to establish the genealogy of liberalism. He is concerned with the same struggle against clericalism and intellectual authoritarianism which made the enlightened philosophers of the eighteenth century conscious of their opposition to the Middle Ages and of their affinity with the Renaissance. For both Bayle (*Dict. hist. et crit.*, IV) as well as Voltaire (*Essai sur les moeurs et l'esprit des nations*, chap. 121) the irreligious character of the Renaissance was a foregone conclusion, and the Renaissance has remained encumbered with this feature until our own day, although it was in reality merely anti-clerical, anti-scholastic and anti-ascetic, but in no sense sceptical. The ideas about salva-

tion, the other world, redemption and original sin, which filled the whole spiritual life of medieval man, became, it is true, merely 'secondary ideas',[4] but there can be no question of an absence of all religious feeling in the Renaissance. For if, as Ernst Walser remarks, 'one tries to inquire into the life and thought of the leading personalities of the Quattrocento, a Coluccio Salutati, Poggio Bracciolini, Leonardo Bruni, Lorenzo Valla, Lorenzo Magnifico or Luigi Pulci, inductively, then the result will always be that, strangely enough, the established characteristics of scepticism are absolutely inapplicable to them. . . .'[5] The Renaissance was not even so hostile to authority as the enlightenment and liberalism asserted. Clerics were attacked, but the Church as an institution was spared, and as its authority diminished it was replaced by that of classical antiquity.

The radicalism of the eighteenth-century rationalist conception of the Renaissance was markedly intensified by the spirit of the fight for freedom in the middle of the last century.[6] The struggle against reaction renewed the memory of the Italian republics of the Renaissance and suggested the idea of connecting the splendour of their culture with the emancipation of their citizens.[7] In France it was anti-Napoleonic, in Italy anti-clerical journalism which helped to give final point to and spread the liberal conception of the Renaissance,[8] and both middle-class liberal, as well as socialistic historians have adhered to this conception. Even today, the Renaissance is still celebrated in both camps as Reason's great war of liberation and as the triumph of individualism,[9] whereas in reality the idea of 'free research' was not an achievement of the Renaissance,[10] nor was the idea of personality absolutely foreign to the Middle Ages; the individualism of the Renaissance was new only as a conscious programme, as a weapon and a war-cry, not as a phenomenon in itself.

In his definition of the Renaissance, Burckhardt combines the idea of individualism with that of sensualism, the idea of the self-determination of the personality with the emphasis on the protest against medieval asceticism, the glorification of nature with the proclamation of the gospel of the joy of life and the 'emancipation of the flesh'. Out of this association of ideas there arises,

partly under the influence of Heine's romantic immoralism and as an anticipation of Nietzsche's a-moral hero-worship,[11] the well-known picture of the Renaissance as an era of unscrupulous brutes and epicures—a picture the libertine features of which are, perhaps, not directly related to the liberal conception of the Renaissance, but which would be inconceivable without the liberal trend and individualistic approach of the nineteenth century. The discomfort with the world of middle-class morality and the revolt against it produced the exuberant paganism which tried to find a substitute for pleasures beyond its grasp by depicting the excesses of the Renaissance. In this picture, the condottiere with his demonic lust for pleasure and unbridled will to power was the stock figure of the irresistible sinner, who committed, as a proxy, all the monstrosities conjured up in the middle-class day-dreams of the happy life. It has been asked, justifiably, whether this infamous brute, as described in the histories of Renaissance morals, ever existed at all in reality, and whether this 'wicked tyrant' was ever anything more than the result of memories derived from the classical reading of the humanists.[12]

The sensualistic conception of the Renaissance is based more on the psychology of the nineteenth century than on that of the Renaissance itself. The aestheticism of the romantic movement was far more than a cult of the artist and of art; it led to a revaluation of all the great questions of life according to aesthetic standards. All reality became the substratum of an artistic experience and life itself a work of art, in which every element was merely a stimulus of the senses. This aesthetic philosophy characterized the alleged sinners, tyrants and villains of the Renaissance as great picturesque figures—the fitting protagonists for the colourful background of the age. The generation which, drunk with beauty and longing for disguise, wanted to die 'with vine-leaves in the hair' was only too ready to exalt a historical epoch which clothed itself in gold and purple, which turned life into a gorgeous feast, and in which, as this generation desired to believe, even the simple folk delighted enthusiastically in the most exquisite works of art. The historical reality was, of course, no more in accordance with this aesthete's dream than

5

with the picture of the superman in tyrant's form. The Renaissance was hard and business-like, matter-of-fact and unromantic; in this respect, too, it was not so very different from the late Middle Ages.

The characteristics of the individualistic-liberal and of the sensualistic conception of the Renaissance apply only in part to the actual Renaissance, and almost as much as they apply to it, they also apply to the late Middle Ages. The frontier here seems to be more geographical and national than purely historical. In the problematical cases—as for instance in that of Pisanello or the van Eycks—as a rule, one will assign southern phenomena to the Renaissance and northern phenomena to the Middle Ages. The spacious representations of Italian art, with their freely moving figures and the spatial unity of their settings, seem to be Renaissance in character, whilst the impression made by the confined spaces of Old Netherlandish painting, with its timid, somewhat awkward figures, its laboriously assembled accessories and its delicate miniature technique, is wholly medieval. But even if one is prepared to grant a certain relevance here to the constant factors of evolution, particularly the racial and national character of the groups which make the decisive contribution to the culture of the age, one should not forget that in so far as one accepts the validity of such factors one thereby abdicates as a historian, and one should strive to postpone the moment of such resignation as far as possible. For usually it turns out that the allegedly constant factors in evolution are merely the outcome of stages in the historical development or the premature substitute for hitherto unexplored but thoroughly explorable historical conditions. At any rate, the individual character of races and nations has a different significance in the different epochs of history. In the Middle Ages it has hardly any importance at all; in that age the great collective of Christendom has an incomparably higher degree of reality than the separate national individualities. But at the end of the Middle Ages the place of the universal Western feudal system and of international chivalry, of the universal Church and its uniform culture, is taken by the nationally and civically patriotic middle class with its economic and social forms subject to local conditions, by the narrowly confined spheres of

interest of the towns and countrysides, by the particularism of the territorial principalities and the variety of national languages. The national and racial elements now come more strongly into the foreground of the picture as differentiating factors, and the Renaissance appears to be the particular form in which the Italian national spirit emancipates itself from universal European culture.

The most striking feature of the art of the Quattrocento is, in contrast both to that of the Middle Ages and that of Northern Europe, the extraordinary freedom and effortlessness of expression, the grace and elegance, the statuesque weight and the great, impetuous line of its forms. Everything here is bright and serene, rhythmical and melodious. The stiff and measured solemnity of medieval art disappears and gives place to a vivid, clear, well-articulated formal idiom, beside which even the contemporary Franco-Burgundian art seems to have 'a mood of fundamental gloom, a barbaric splendour, and bizarre and overladen forms'.[13] With its lively feeling for important and simple relationships, for limitation and order, for monumental forms and firm structures, the Quattrocento anticipates, in spite of occasional harshnesses and an often unchecked playfulness, the stylistic principles of the high Renaissance. And it is precisely the immanence of the 'classical' element in this pre-classical art, which distinguishes the style of the early Italian Renaissance most incisively from late medieval art and the contemporary art of Northern Europe. The 'ideal style', which connects Giotto with Raphael, dominates the art of Masaccio and Donatello, Andrea del Castagno and Piero della Francesca, Signorelli and Perugino; probably not a single Italian artist of the early Renaissance entirely escapes its influence. The basic element in this conception of art is the principle of uniformity and the power of the total effect, or at least the tendency towards uniformity and the striving, despite all the fullness of detail and colour, to make a total impression. Seen beside the artistic creations of the later Middle Ages, a work of the Renaissance always seems to be an unbroken and perfect whole, and, however rich its content, fundamentally simple and homogeneous.

The basic form of Gothic art is juxtaposition. Whether the

individual work is made up of several comparatively independent parts or is not analysable into such parts, whether it is a pictorial or a plastic, an epic or a dramatic representation, it is always the principle of expansion and not of concentration, of co-ordination and not of subordination, of the open sequence and not of the closed geometric form, by which it is dominated. The beholder is, as it were, led through the stages and stations of a journey, and the picture of reality which it reveals is like a panoramic survey, not a one-sided, unified representation, dominated by a single point of view. In painting it is the 'continuous' method which is favoured; the drama strives to make the episodes as complete as possible and prefers, instead of the concentration of the action in a few decisive situations, frequent changes of scene, of the characters and the motifs. The important thing in Gothic art is not the subjective viewpoint, not the creative, formative will expressed in the mastering of the material, but the thematic material itself, of which both artists and public can never see enough. Gothic art leads the onlooker from one detail to another and causes him, as has been well said, to 'unravel' the successive parts of the work one after the other; the art of the Renaissance, on the other hand, does not allow him to linger on any detail, to separate any single element from the whole composition, but forces him rather to grasp all the parts at one and the same time.[14] Just like central perspective in painting, the spatially and temporally concentrated scene in the drama makes it possible to realize this simultaneity of vision. The change that takes place in the conception of space, and therefore in the whole conception of art, is perhaps expressed most strikingly in the fact that the stage scenery based on separate unconnected settings is suddenly felt to be incompatible with artistic illusion.[15] The Middle Ages, which thought of space as something synthetic and analysable, not only allowed the different scenes of a drama to be set up alongside one another, but allowed the actors to remain on the stage even when they were not taking part in the action. For just as the audience simply did not take any notice of the scenery in front of which no acting was taking place, so they took no notice either of the actors who were not engaged in the scene being played. To the Renaissance, such divided attention seems

impossible to justify. The change of outlook is probably expressed most clearly by Scaliger, who finds it quite ludicrous that the 'characters never leave the stage, and those who are silent are regarded as not present'.[16] For the new conception of art, the work forms an indivisible unity; the spectator wants to be able to take in the whole range of the stage with a single glance, just as he grasps the whole space of a painting organized on the principles of central perspective, with a single glance.[17] But the development from a successive to a simultaneous conception of art implies, at the same time, a lessened appreciation of those silently accepted 'rules of the game' on which, in the final analysis, every artistic illusion is based. For, if the Renaissance regards it as nonsensical 'to behave on the stage as if one could not hear what one person is saying about another',[18] although the persons in question are standing next to each other, this can perhaps be described as a symptom of a more highly developed naturalistic approach, but it also no doubt implies a certain atrophy of the power of imagination. However that may be, the art of the Renaissance owes the impression of totality, that is to say, the appearance of a genuine, self-dependent, autonomous world, and with that its greater truth as compared with the Middle Ages, above all, to this uniformity of the artistic presentation. For the genuineness of the description of reality, its trustworthiness and power to convince, is here, as so often, dependent on the inner logic of the approach, on the mutual conformity of the elements of the work, to a greater extent than on the conformity of these elements with the external reality.

With the principles of unity which inspire its art, Italy anticipates the classicism of the Renaissance, just as it anticipates the capitalistic development of the West with its economic rationalism. For the early Renaissance is an essentially Italian movement, as opposed to the High Renaissance and mannerism, which are universal European movements. The new artistic culture first appears on the scene in Italy, because this country also has a lead over the West in economic and social matters, because the revival of economic life starts here, the financial and transport facilities of the crusades are organized from here,[19] free competition first develops here, in opposition to the guild ideal of the Middle Ages,

and the first European banking system arises here,[20] because the emancipation of the urban middle class takes place here earlier than in the rest of Europe, because from the very outset feudalism and chivalry are less developed here than in the North and the rural aristocracy not only have town residences very early on, but adapt themselves absolutely to the urban financial aristocracy, and no doubt also because the tradition of classical antiquity was never entirely lost in this country where classical remains are to be seen everywhere. It is well known what importance has been attributed precisely to this last factor in the theories on the origins of the Renaissance. What could have been simpler than to trace back the beginnings of this new style to one uniform, direct, external influence? But it was forgotten that an outside historical influence is never the ultimate reason for an intellectual revolution, for such an influence can only become effective if the preconditions for its reception are already in existence; what has to be explained is, in fact, why such an influence becomes of importance at a particular time, it cannot in itself explain the topical importance of the phenomena by which it is accompanied. If, therefore, from a certain point in time classical antiquity began to have a different influence from that which it had previously, the first question that must be asked is, why this change really took place, why a different attitude was taken all at once to the same thing; but this question is hardly to be answered any more easily or in stricter terms than the original question, namely why and wherein the Renaissance differed from the Middle Ages. The re-assimilation of classical antiquity was merely a symptom; it had social presuppositions, like the rejection of classical antiquity at the beginning of the Christian era. But we must not overrate the symptomatic importance of this re-assimilation. It is true that the protagonists of the Renaissance themselves had the epochal consciousness of a rebirth and a sense of the revitalizing spirit of classical antiquity—but the Trecento had already had this feeling.[21] Now instead of, therefore, claiming Dante and Petrarch for the Renaissance, we shall do better to investigate, as the opponents of the classical theory have done, the medieval origins of the idea of rebirth, working out the continuity between the Middle Ages and the Renaissance.

The best-known protagonists of the theory of the medieval origins of the Renaissance represent the Franciscan movement as the decisive influence, establish a connection between the lyrical sensibility, the feeling for nature and the individualism of Dante and Giotto in particular, then of the later masters as well, and the subjectivism and inwardness of the new religious spirit. They deny that the 'discovery' of the antiquity in the fifteenth century caused a break in a development for which the way had already been prepared.[22] Reference has also been made to the connection between the Renaissance and the Christian culture of the Middle Ages and the directness of the transition from the Middle Ages to modern times from quite different presuppositions. Konrad Burdach describes the so-called fundamental streak of paganism in the Renaissance as a fairy-tale,[23] and Carl Neumann not only maintains that the Renaissance is based 'on the enormous powers created by Christian education', that the individualism and realism of the fifteenth century were 'the last word to be spoken by medieval man in his full maturity', but also that the imitation of classical art and literature, which had already led to the stagnation of culture in Byzantium, was also more of a hindrance than a help in the Renaissance.[24] Louis Courajod goes so far, indeed, as to deny all inner connection between the Renaissance and classical antiquity, and represents the Renaissance as the spontaneous revival of Franco-Flemish Gothic art.[25] But even these scholars, who are aware of the direct continuation of the Middle Ages in the Renaissance, do not recognize that the relationship between the two epochs is grounded in the continuity of their economic and social development, that the Franciscan spirit, emphasized by Thode, the medieval individualism, emphasized by Neumann, and the naturalism, emphasized by Courajod, have their origin in that social dynamism which changes the face of Western Europe at the end of the medieval period of natural economy.

The Renaissance deepens the influence of this medieval development with its striving towards the capitalistic economic and social system only in so far as it confirms the rationalism which now dominates the whole intellectual and material life of the time. The principles of unity which now become authorita-

tive in art, the unification of space and the unified standards of proportions, the restriction of the artistic representation to one single theme and the concentration of the composition into one immediately intelligible form, are also in accordance with this new rationalism. They express the same dislike for the incalculable and the uncontrollable as the economy of the same period with its emphasis on planning, expediency and calculability; they are creations of the same spirit which makes its way in the organization of labour, in trading methods, the credit system and double-entry book-keeping, in methods of government, in diplomacy and warfare.[26] The whole development of art becomes part of the total process of rationalization. The irrational ceases to make any deeper impression. The things that are now felt as 'beautiful' are the logical conformity of the individual parts of a whole, the arithmetically definable harmony of the relationships and the calculable rhythm of a composition, the exclusion of discords in the relation of the figures to the space they occupy and in the mutual relationships of the various parts of the space itself. And just as central perspective is space seen from a mathematical standpoint, and right proportions are only equivalent to the systematic organization of the individual forms in a picture, so in the course of time all criteria of artistic quality are subjected to rational scrutiny and all the laws of art are rationalized. This rationalism does not remain by any means restricted to Italian art; but in the North it assumes more trivial characteristics than in Italy, it becomes more obvious, more naïve. A typical example of this new conception of art outside Italy is the London Madonna by Robert Campin, in the background of which the upper edge of a fire-screen also serves to form the Virgin's halo. The painter uses a formal coincidence to bring an irrational and unreal element of the picture into conformity with everyday experience, and although he is perhaps just as firmly convinced of the supernatural reality of the halo as he is of the natural reality of the fire-screen, the mere fact that he thinks he can increase the attraction of his work by the naturalistic motivation of this phenomenon is the sign of a new, although not unheralded epoch.

2. THE DEMAND FOR MIDDLE-CLASS AND COURTLY ART IN THE QUATTROCENTO

The art public of the Renaissance consists of the urban middle class and the court society of the residences. The trends of taste represented by these two circles have many points of contact despite their different origins. On the one hand, the courtly elements of the Gothic style have an after-effect in middle-class art and with the revival of the chivalric ways of life, which had never entirely lost their powers of attraction on the lower classes, the middle class adopts new forms of art governed by the taste of the courts; on the other hand, court society, too, finds it impossible to keep aloof from the realism and rationalism of the middle class and it participates in the formation of a conception of the world and of art, which has its origin in urban life. At the end of the Quattrocento the urban middle-class and the chivalric-romantic directions in art are so intermingled that even such a thoroughly middle-class art as the Florentine assumes a more or less courtly character. But this phenomenon is merely in keeping with the general trend and simply marks the way leading from urban democracy to princely absolutism.

As early as the eleventh century small maritime republics like Venice, Amalfi, Pisa and Genoa arise, independent of the feudal lords of the surrounding territories. In the following centuries further free communities are constituted—amongst others, Milan, Lucca, Florence and Verona, still forming socially somewhat undifferentiated commonwealths, based on the equal rights of their trading citizens. Soon, however, the conflict breaks out between these communities and the rich barons in their neighbourhood and ends for the moment with the victory of the middle class. The country aristocracy moves into the towns and tries to adapt itself to the economic and social structure of the urban population. But almost at the same time another conflict begins which is waged much more ruthlessly and is not settled so soon. It is the twofold class struggle between the upper and the lower middle class, on the one hand, and between the proletariat and the middle class as a whole, on the other. The urban population, which was still united in the struggle against the common

enemy, the nobility, splits up, now the enemy seems to be van-
quished, into different parties and engages in the most bitter
strife. At the end of the twelfth century the primitive demo-
cracies became military autocracies. We do not exactly know
what the cause of this development was, and cannot say definitely
whether it was the feuds of fractions of the aristocracy raging
furiously against each other or the struggles within the middle
class, or perhaps both these phenomena together, which made
necessary the appointment of the *podestà*, as an authority stand-
ing above the contending parties; at any rate, a period of party
warfare was followed everywhere sooner or later by despotisms.
The despots themselves were either members of local dynasties,
such as the Este in Ferrara, imperial governors, such as the Vis-
conti in Milan, condottieri, such as Francesco Sforza, the successor
of the Visconti, nepots like the Riario in Forlì and the Farnese in
Parma, or distinguished citizens like the Medici in Florence, the
Bentovogli in Bologna and the Baglioni in Perugia. As early as
the thirteenth century despotic government became hereditary
in many places; in other places, especially in Florence and Venice,
the old republican constitution was preserved at least in form,
but the old freedom declined everywhere along with the institu-
tion of the *signoria*. The free civic community became an anti-
quated political form.[27] The townspeople had become unaccus-
tomed to military service owing to their absorption in economic
affairs and had left warfare to military entrepreneurs and pro-
fessional soldiers, to the condottieri and their hirelings. The
signori are everywhere the direct or indirect commanders of the
troops.[28]

The development of the situation in Florence is typical of
all the Italian cities in which, for the present, no dynastic solu-
tion is found and where, to begin with, no court life develops.
It is not as if a capitalistic economy appeared here any earlier
than in many other cities, but the separate stages of capitalistic
development are more distinct here and the motives behind the
class struggles which accompany this development more evident
than elsewhere.[29] It is the process by which the upper middle
class seizes power over the state through the medium of the
guilds and the way it exploits this power to increase its economic

superiority which can be followed more exactly in Florence than in other communities with a similar structure. After the death of Frederick II and with the Guelphs to protect them, the guilds come to power in the community and snatch the reins of government from the *podestà*. The *primo popolo* is formed—'the first consciously illegal and revolutionary political association'[30]—and elects its *capitan*. Formally, he is subordinate to the *podestà*, but in actual fact he is the most influential official in the state; he has not only the whole militia at his disposal, he not only has the final word in all difficult questions of taxation, but he also exercises 'a kind of tribunitial right to assist and inspect' in all cases where a charge of violence is brought against a member of the nobility.[31] With that the power of the military families is broken and the feudal aristocracy forced out of the government of the republic. It is the first decisive victory of the middle class in modern history, an event which reminds one of the victory of Greek democracy over the tyrannies. The nobility succeeds in seizing power again after about ten years, but the bourgeoisie only needs now to swim with the tide of events, for this carries it above the stormy waves again and again. At the end of the sixties there already begins the first alliance between the financial and the hereditary aristocracy, and that prepares the way for the rule of that plutocratic upper class which remains in control during the later history of Florence.

Around the year 1200 the upper middle class is already in full possession of the power which it exercises in essentials through the agency of the guild Priors. The latter control the whole political and administrative machine and since they are, formally at any rate, representatives of the guilds, Florence can be described as a guild city.[32] In the meantime the economic corporations had become 'political guilds'. All positive civic rights are now based on membership of the legally recognized corporations. Anyone who does not belong to a professional organization is not a fully qualified citizen. The magnates are excluded from the office of the guild Priors unless they take up a civic profession or trade or at least become formal members of a guild. That does not mean, however, that all full citizens have equal rights; the rule of the guilds is based on the dictatorship of the capitalistic

middle class united in the seven greater guilds. We do not know how the different ranks arose among the guilds. When the documentation of Florentine economic history begins, the differentiation is already a *fait accompli*.[33] Economic conflicts do not break out here, as in most German cities, between the guilds, on the one side, and the unorganized urban patriciate, on the other, but between the various groups within the guilds themselves.[34] In Florence the patriciate has the advantage over the North from the very beginning in that it is just as rigidly organized as the lower sections of the urban population. Its guilds, in which the wholesale trade, big industry and banking are united, develop into real employers' associations, pooling their resources. But the preponderance of these guilds enables the upper bourgeoisie to use the whole machinery of guild organization to keep down the lower classes, and above all to reduce wages.

The fourteenth century is full of the class struggles between the middle class which controls the guilds and the workers who had been forced out of them. The wage-earning class was hit worst of all by the prohibition of any coalition to protect their interests and by the qualification of any kind of strike movement as a revolutionary act. The worker is here the subject of a class state and finds himself completely deprived of all civil rights. In this state capital rules more ruthlessly and less troubled by moral scruples than ever before or after in the history of Western Europe.[35] The situation was all the more hopeless in that there was no awareness of the fact that a class struggle was in progress, no understanding of the proletariat as a social class, and the propertyless wage-earners being described as the 'poor' 'which are always with us in any case'. The economic boom, which is partly due to this suppression of the working class, reaches its climax in the years 1328–38; then the bankruptcy of the Bardi and Peruzzi follows and leads to a serious financial crisis and general stagnation. The oligarchy suffers an apparently irreparable loss of prestige and has to submit first to the despotism of the 'Duke of Athens', then to a popular, essentially petty bourgeois government—the first of its kind in Florence. The writers and poets side again, as once in Athens, with the old ruling class—Boccaccio and Villani are examples—and speak in the most contemptuous tones

of the ruling shopkeepers and craftsmen. The forty years which now follow, and which extend to the crushing of the *ciompi* revolt, form the only really democratic period in the history of Florence —a short intermezzo between two long epochs of plutocracy. Of course, even in this period it is only the will of the middle class that gains authority—the broad masses of the working class are still forced to have recourse to strikes and revolts. The *ciompi* revolt of 1378 is the only one of these revolutionary movements of which we have more exact knowledge, and it is also, in any case, the most important one. Now for the first time the basic conditions of economic democracy are realized. The common people drive away the guild Priors, create three new guilds representing the petty bourgeoisie and the working class, and set up a popular government which proceeds first of all to redistribute the burden of taxation. The revolt, which is fundamentally a rising of the fourth estate and which strives to establish a dictatorship of the proletariat,[36] is suppressed only two months after its start by the moderate elements in alliance with the upper bourgeoisie, but it secures active participation in the government for the lower classes of the population for another three years. The history of this period does not merely prove that the interests of the proletariat were incompatible with those of the bourgeoisie, but shows what a serious error it was on the part of the working class to want to accomplish the revolutionary change in methods of production in the framework of the already out-of-date guild organization.[37] The wholesale trade and big industry recognized much more quickly that the guilds had become an institution obstructing progress and tried to rid themselves of them. Subsequently more and more purely cultural and less and less political tasks were assigned to them, until they finally fell completely victim to free competition.

After the suppression of the people's government the position was the same as before the *ciompi* revolt. The 'popolo grasso' was in power again, the only difference being that its power was exercised no longer by the whole class, but only by a few rich families, and it was no longer in serious danger of being challenged. Wherever a subversive movement crops up in the following century endangering the upper class even in the slightest

degree, it is immediately suppressed without any trouble.[38] After the comparatively short reign of the Alberti, Capponi, Uzzano, Albizzi and their followers, the Medici take over the reins of power. From now onwards there is even less justification for speaking of a democracy than before, when, it is true, only a part even of the middle class had been in possession of positive political rights and economic privileges, but the rule of this class had been conducted, at least within its own ranks, with a certain justice and, on the whole, unobjectionable methods. Under the Medici even this already very limited democracy is undermined from within and bereft of its whole purpose. Now, if the interests of the ruling class are at stake, the constitution is no longer altered, but simply abused, the ballot-boxes are falsified, the officials bribed or intimidated, the guild Priors pushed about hither and thither like mere puppets. What is called 'democracy' here is the unofficial dictatorship of the chiefs of a family firm, who proclaim themselves simple citizens and hide behind the impersonal forms of a bogus republic. In the year 1433 Cosimo, oppressed by his rivals, has to go into exile—an event well known in Florentine history; but after his return in the following year he exercises his power again completely unimpeded. He allows himself to be elected to the position of Gonfaloniere for two months, after having already previously filled this office on two occasions; his whole period of office, therefore, covers six months. He rules behind the scenes, through his stooges, and controls the city without any particular official title and dignity, without authority, by purely illegal methods. Consequently, as early as the fifteenth century, the oligarchy is followed in Florence by a disguised principate from which the real principality later develops quite smoothly.[39] The fact that, in their struggle against their rivals, the Medici unite with the petty bourgeoisie does not bring about any fundamental change in the position of this class. However patriarchal the forms in which it clothes itself, the rule of the Medici is in essence still more partisan and arbitrary than the government of the whole oligarchy. The state still represents merely private interests; the 'democracy' of Cosimo consists only in the fact that he lets others rule for him and uses fresh young talent whenever possible.[40]

Despite the fact that calm and stability were merely forced on the majority of the population, from the beginning of the fifteenth century a new period of economic prosperity began for Florence, which was not interrupted during Cosimo's lifetime by any crisis worth speaking of. There were occasional stoppages of work here and there, but they were insignificant and of short duration. Florence attains the summit of its economic potential. Sixteen thousand pieces of cloth reach Venice from Florence every year; the Florentine export merchants also use the port of conquered Pisa for this purpose, and from 1421, the port of Livorno which had been acquired for 100,000 florins. It is understandable that Florence was elated with victory and that the ruling class, which profited from the various acquisitions, wanted, like the middle class in Athens of old, to show its power and riches. From 1425 Ghiberti works on the splendid East portal of the Baptistry; in the year in which the port of Livorno is acquired, Brunelleschi is commissioned to carry out his project of building a dome over the Cathedral. The idea is to make Florence a second Athens. The Florentine merchants become insolent and presumptuous, they want to make themselves independent of foreign countries, and set up an autarchy, that is, increase home consumption in accordance with rising production.[41]

The original structure of capitalism had undergone some fundamental changes in Italy in the course of the thirteenth and fourteenth centuries. In the place of the primitive striving after profit, the idea of expediency, calculation and planning came to the fore, and the rationalism which was a more or less dominant feature of profit economy from the very outset now became absolute. The enterprising spirit of the pioneers lost its romantic, adventurous, piratical character and the conqueror became an organizer and an accountant, a carefully calculating merchant, managing his business with prudent circumspection. It was not the principle of expediency in itself that was new in the economic life of the Renaissance, nor the mere readiness to give up traditional methods of production as soon as a better and more appropriate method was discovered, but the consistency with which tradition was sacrificed to rationality and the ruthlessness with which all the resources of economic life were put to practical

19

use and turned into an item in the ledger. This absolute rationalization first made possible the solution of the problems which arose from the increase in goods traffic. The raising of the output demanded a more intensive exploitation of the available labour, a progressive division of labour and the gradual mechanization of labour methods, by which is to be understood not merely the introduction of machines, but also the depersonalization of human work, the valuation of the worker purely in terms of the output achieved. Nothing expresses the economic philosophy of this new age more trenchantly than precisely this materialist approach, which estimates a man according to his achievement and the output according to its value in money—the wage—which, in other words, turns the worker into a mere link in a complicated system of investments and financial yields, of risks of profit and loss, of assets and liabilities. But the rationalism of the age is expressed, above all, in the fact that the essentially artisan quality of the earlier urban economy now becomes more or less thoroughly commercialized. And this commercialization does not consist merely in the fact that the manual element in the activity of the business man gradually recedes and the calculating and speculative element gets the upper hand,[42] but also in the recognition of the principle that the business man need not necessarily create new goods to create new values. The outstanding characteristic of the new economic philosophy is the understanding which it reveals for the fictive, changeable nature of the market price, its dependence on circumstances of the moment, its appreciation of the fact that the value of a commodity is by no means constant, but perpetually fluctuating, and that its standards depend not on the good or bad will of the merchant, but on objective economic circumstances. As the concept of the 'just price' and the scruples concerning interest show, in the Middle Ages value was regarded as a substantial quality, inherent in the commodity and fixed once and for all; it was not until economic activity was commercialized that the real criteria, the relativity and the morally indifferent character of value were discovered.

The capitalistic spirit of the Renaissance consists in the profit-motive and the so-called 'middle-class virtues', acquisitiveness and industry, frugality and respectability.[43] But even this new

morality is only another expression of the universal process of rationalization. It is characteristic of the bourgeois that even when he is apparently concerned merely with his prestige, he follows the principles of rational utility, that by respectability he understands business solidity and a sound reputation and that in his language fidelity means solvency. Not until the second half of the Quattrocento do the principles of rational conduct yield to the ideal of the *rentier*. It is only then that the life of the bourgeoisie assumes seigniorial features. The development takes place in three stages. In the 'heroic age of capitalism' the business man appears, above all, in the guise of the ruthless conqueror, the self-dependent daring adventurer who has outgrown the relative security of medieval economy. The middle class still fights with real weapons in its hands against the hostile aristocracy, the rival urban communities and the inhospitable seaports. When these conflicts come to a partial standstill, and the safer organization of goods traffic allows and demands a more systematic and more intensive development of production, the romantic features gradually disappear from the character of the bourgeois; he subjects his whole existence to a logical and methodical plan. But as soon as he feels economically secure, the discipline of his middle-class morality is slackened and he succumbs with growing satisfaction to the ideals of leisure and the beautiful life. He tends towards an irrational way of life precisely at the same time as the now financially-minded princes are beginning to adapt themselves to the business principles of the solid, trustworthy and solvent merchant.[44] The circles of court and middle-class society thus meet half-way. The princes become more and more progressive and prove themselves just as advanced in their cultural efforts as the newly-rich middle class; the middle class, on the other hand, becomes more and more conservative and favours an art in which a return is made to the courtly-chivalric, Gothic-spiritualistic ideals of the Middle Ages, or, rather, these ideals, which had never entirely disappeared from middle-class art, now come back into prominence again.

Giotto is the first master of naturalism in Italy. The old writers, Villani, Boccaccio and even Vasari, emphasize, and not without good reason, the irresistible impression made on his

contemporaries by his fidelity to nature, and it is not for nothing that they contrast his style with the stiffness and artificiality of the Byzantine art, which was still widespread when he appeared on the scene. We have become accustomed to compare the clarity and simplicity, the logic and precision of his style with the later, more trifling kind of naturalism, and we, thereby, overlook what tremendous progress his art had meant in the direct representation of things, how much he was able to make clear and to relate pictorially that up till then it had been impossible in painting. Thus, for us, he has come to stand for the great principles of classical form, based on severe and lofty rules, whereas he was really the master of a simple, sober, straightforward middle-class art, the classical quality of which sprang from the ordering and synthesizing of experience, from the rationalization and simplification of reality, not from an idealism abstracted from reality. He was made out to be inspired by classical formalism, whereas he himself wanted to be nothing but a good story-teller, expressing himself concisely and precisely, whose rigorous formalism is to be taken as striving for dramatic effect, not as anti-naturalistic aloofness. His conception of art is rooted in a still comparatively unpretentious middle-class world, although it is a world already firmly grounded on capitalistic foundations. His activity falls into the period of economic prosperity between the formation of the political guilds and the bankruptcy of the Bardi and Peruzzi, into that first great period of middle-class culture, in which the finest buildings of medieval Florence, the churches of S. Maria Novella and S. Croce, the Palazzo Vecchio and the Cathedral with the Campanile, were created. Giotto's art is austere and objective, like the character of those who commissioned his works, men who wished to be prosperous and to exercise authority, but who attached not too much importance to outward show and lavish expenditure. After him, the style of Florentine art became more and more natural, in our modern sense of the word, that is to say, more and more scientific, but no artist of the Renaissance ever made a more honest effort than he to be as simple, direct and true as possible in the description of reality.

The whole Trecento is dominated by this naturalistic style of Giotto's. It is true that here and there there are still traces of earlier

styles, of failures to escape from the stereotyped forms of the pre-Giotto tradition; there are retarding, even reactionary tendencies, which hold fast to the hieratic style of the early Middle Ages, but naturalism is now predominant. The progressive style of Giotto undergoes its first significant transformation in Siena, and from here it penetrates to the North and the West chiefly through the mediation of Simone Martini and his frescoes in the papal palace in Avignon.[44a] For a time, Siena takes the lead in the development, whilst Florence has to take a back seat. Giotto dies in the year 1337; the financial crisis which results from the great insolvencies begins in 1339; the barren period of the despotic rule of the Duke of Athens covers the years 1342–3; in 1346 a serious insurrection takes place; 1348 is the year of the great plague, which rages more terribly in Florence than elsewhere; the years between the plague and the *ciompi* revolt are full of unrest, tumults and insurrections: it is a sterile period for the plastic arts. In Siena, where the influence of the lower middle class is stronger and both social and religious traditions are more deeply rooted, intellectual development proceeds less disturbed by crises and catastrophes, and religious feeling is able to clothe itself in more up-to-date and more developable forms, precisely because it is still a thoroughly live feeling. The most important progress in advance of Giotto is made by the Sienese artist Ambrogio Lorenzetti, the creator of the naturalistic landscape and the illusionistic town-panorama. In contrast to Giotto's treatment of space, which is unified and continuous, but in which the depth never extends beyond that of stage scenery, he creates in his picture of Siena a view which, not only for its breadth of space but also for the natural connection of the parts into a spatial whole, surpasses all previous efforts of this kind. The picture of Siena is so life-like that one can still recognize which part of the city the painter used as his main theme, and imagine oneself moving about in the alleys which wind in and out alongside the palaces of the *nobili* and the houses of the middle class, the workshops and business houses, and up the hills.

In Florence the situation first develops not only more slowly but also less uniformly than in Siena.[45] It is true that it keeps mainly to naturalistic paths but by no means always in the direc-

tion of the Lorenzetti type of milieu painting. Taddeo Gaddi, Bernardo Daddi, Spinello Aretino, are simple story-tellers like Lorenzetti himself; with the empirical tendency of their art, they are in line with the tradition of Giotto and strive, above all, to achieve the illusion of spatial depth. But there is another important trend in Florence alongside of this direction, namely that of Andrea Orcagna, Nardo di Cione and their pupils, which follows not the intimacy and spontaneity of the art of Lorenzetti, but the solemn hieratic style of the Middle Ages, its rigid symmetry, its principles of sequence and accumulation. The thesis that all this is merely evidence of an anti-naturalistic reaction[46] has, however, rightly been disputed, and attention has been drawn to the fact that naturalism in painting is by no means limited to the illusion of spatial depth and the dissolution of geometrically bound forms, but that those 'tactile values' which Berenson praises precisely in connection with Orcagna are just as much the achievement of naturalism.[47] With the plastic volume and statuesque weight which he gives to his figures, Orcagna represents, historically, just as progressive a direction as Lorenzetti or Taddeo Gaddi with their deepening and extension of the space occupied by the representation. How unfounded the hypothesis is that what we are dealing with here is a deliberately archaistic tendency, based on the influence of the Dominicans, is best shown by the frescoes in the Spanish chapel of the monastery of S. Maria Novella, which, although they are dedicated to the glorification of the Dominican order, are among the most progressive artistic creations of the age.

In the fifteenth century Siena forfeits its leading place in the history of art. Florence, now at the height of its economic power, comes back into the foreground again. The position which it holds does not perhaps directly explain the existence and the character of its great masters, but it does explain the uninterrupted flow of commissions and the competitive atmosphere from which the Florentine masters emerged. Florence is now, in addition to Venice, which, however, has its own by no means typical development, the only place in Italy where any important progressive activity is taking place in the world of art, more or less independent of the Western European, late medieval court style.

In middle-class Florence there is, to start with, only a limited understanding for the chivalric art imported from France and adopted by the courts in North Italy. This region stands closer to the West geographically and has, to some extent, direct contact with French-speaking territory. As early as the second half of the thirteenth century, the French novels of chivalry circulate here and are not merely translated and imitated in the native tongue, as in the other countries of Europe, but are also further developed in the original language. Epic poems are composed in French, just as lyrical poems are written in the language of the troubadours.[48] It is true that the great trading cities of Central Italy are by no means cut off from the North and West, and their merchants, who maintain commercial relations with France and Flanders, transmit the elements of chivalric culture to Tuscany, but no one here is interested in an indigenous epic of chivalry or in painting in the grand, romantic, courtly-chivalric style. At the princely courts in the Po valley, in Milan, Verona, Padua, Ravenna and in many other smaller towns, where the dynasties and despots conduct their courts in strict accordance with the French model, the French novels of chivalry are not only read with undiminished enthusiasm, not only copied and imitated, but also illustrated in the style of the originals.[49] And the painting activity of these courts is by no means restricted to the production of illuminated manuscripts, but extends to mural decoration consisting of representations of ideas derived from the novels of chivalry and themes from court life, of battles and tournaments, hunting-scenes and cavalcades, scenes of play and dancing, tales from mythology, the Bible and history, portraits of heroes of antiquity and the present, allegories of the cardinal virtues, of the free arts and, above all, of love in all its possible forms and variations. Usually, these paintings keep to the style of tapestry, the genre to which they probably owe their whole origin. They try, like their models, to arouse a dazzling, festive impression chiefly through the splendour of the costumes and the ceremonial behaviour of the society portrayed. The figures are represented in conventional poses, but are comparatively well observed and drawn with a certain facility, which is the more understandable as this painting is in fact rooted in the same Gothic naturalism

from which the middle-class art of the late Middle Ages is also derived. One need only think of Pisanello to appreciate what the naturalism of the Renaissance owes to these mural paintings with their verdure-like backgrounds, their freshly observed and well-painted plants and animals. The earliest surviving remains of this decorative painting in Italy probably date from no further back than the beginning of the fifteenth century, but the older examples from the fourteenth century will hardly have been essentially different. What is extant is in Piedmont and in Lombardy, and the most important examples are in the castle La Manta in Saluzzo and in the Palazzo Borromeo in Milan. But we know from contemporary accounts, that many other princely seats in North Italy also possessed rich and fastidious mural decorations, especially the castle of Cangrande in Verona and the castle of the Carrara in Padua.[50]

In contrast to the art of the courts, that of the city republics had an essentially ecclesiastical character in the Trecento. Not until the fifteenth century does its spirit and its style change; only then does it assume a secular character in accordance with the new private demands for art and the universal rationalization of the age. Not only new secular genres appear, however, such as narrative painting and the portrait, but specifically religious pictures also become full of secular motifs. Even so middle-class art still preserves more points of contact with the Church and religion than the art of the courts, and the middle class remains, at least in this respect, more conservative than the court society of the princely residences. But from the middle of the century courtly-chivalric characteristics also become apparent in urban middle-class, particularly Florentine, art. Spread abroad by the minstrels, the novels of chivalry penetrate to the lower levels of society, and in their popular form even reach the Tuscan cities; in so doing, however, they lose their original idealistic character and become mere light reading.[51] It is above all this literature which arouses the interest of the indigenous painters in romantic subjects, but the direct influence of artists like Gentile da Fabriano and Domenico Veneziano, who diffuse the courtly artistic tastes of their northern Italian homeland in Florence, must also be taken into account. Finally, the middle-class élite which has

become rich and powerful begins to adopt the manners of court society and to see in the themes of romantic chivalry not merely something exotic but also something worth emulating.

At the beginning of the Quattrocento, however, there is relatively little evidence of this new turning towards the courtly style in art. The masters of the first generation of the century, especially Masaccio and Donatello, stand nearer to the austere art of Giotto, with its concentrated spatial form and statuesque figure drawing, than to the precious style of the courts and to the dainty and often playful forms of Trecento painting. After the shocks of the great financial crisis, the plague and the *ciompi* revolt, this generation has to start almost from the beginning again. In its manners as well as in its taste, the middle class now shows itself more simple, more sober, more puritanical than before. An objective, realistic, unromantic attitude to life now predominates again in Florence, with a new, fresh, robust natural-ism, against which the courtly-aristocratic conception of art can only make its way gradually, in the measure that the middle class becomes consolidated again. The art of Masaccio and of the young Donatello is the art of a society still fighting for its life, albeit thoroughly optimistic and confident of victory, the art of a new heroic period in the development of capitalism, of a new epoch of conquest. The confident, although not always absolutely secure, feeling of power that is expressed in the political decisions of these years is also expressed in the imposing realism of the art. The complacent sentimentality, the playful exuberance of the forms, the calligraphic lineal style of Trecento painting disappears. The figures again become more physical, more massive, more in repose; they stand more firmly on their legs, move about in space more freely and more naturally. They express power, energy, dignity and gravity, are more compact than over-delicate, more coarse than elegant. The feeling of this art is fundamentally un-Gothic, that is to say, unmetaphysical and unsymbolical, un-romantic and unceremonial. That is, at any rate, the predomi-nant, if not also the exclusive tendency of the new art. The artistic culture of the Quattrocento is already so complicated, and so many different hereditary and educational levels of society participate in it, that it is impossible to form any completely uniform and

universally valid conception of its nature. Beside the 'Renaissance-like', classically statuesque style of Masaccio and Donatello, the Gothically spiritualistic and ornamental tradition is still thoroughly alive, not only in the art of Fra Angelico and Lorenzo Monaco, but also in the works of such progressive artists as Andrea del Castagno and Paolo Uccello. In an economically so differentiated and culturally complex society as that of the Renaissance, a stylistic tendency does not disappear from one day to the next, even if the class for which its products were originally intended loses its political and economic power and is replaced as an upholder of culture by another class or changes its own intellectual outlook. The medieval-spiritualistic style may already have seemed out of date and unattractive to the majority of the middle class, but it was still most in accord with the religious feelings of a very considerable minority. Different classes of society and different artists dependent on these classes, different generations of art-consumers and art-producers, young and old, harbingers and stragglers, live side by side in every more highly developed culture; but in such a comparatively old culture as the Renaissance the separate tendencies hardly any longer find absolutely clear expression in any one cultural group, unaffected by the others. The antagonism between the various aims cannot be explained merely by the contiguity of the different generations, the 'simultaneity of different ages';[52] conflicts often exist within one and the same generation: Donatello and Fra Angelico, Masaccio and Domenico Veneziano were born within a few years of each other, yet Piero della Francesca is separated by half a generation from Masaccio, with whom he has the greatest affinity. The antagonisms are even present within the mind of the individual artists. In an artist like Fra Angelico ecclesiastical and secular, Gothic and Renaissance elements are fused as indissolubly as rationalism and romanticism, the middle-class and the court element are in Castagno, Uccello, Pesellino and Gozzoli. The frontier dividing the stragglers of the Gothic period from the precursors of the middle-class romanticism, that is in many respects related to the Gothic, is absolutely fluid.

Naturalism, which constituted the basic artistic tendency of the whole century, repeatedly changes its direction according to

social developments. The monumental naturalism of Masaccio, with its anti-Gothic simplicity and its emphasis on the clarification of spatial relationships and proportions, the richness of genre traits in the art of Gozzoli and the psychological sensibility of Botticelli represent three different stages in the historical development of the middle class as it rises from frugal circumstances to the level of a real money aristocracy. A motif taken from the direct observation of life, like the 'freezing man' in Masaccio's 'Baptism of St. Peter' in the Brancacci chapel, is still a rarity at the beginning of the Quattrocento, but quite normal towards the middle of the century. The delight in the individual instance, in the characteristic and trivial, now comes into the foreground for the first time. The idea now arises of a world-picture made up of the 'petits faits vrais', such as was previously unknown in the history of art. The subjects of the new naturalistic art are episodes from everyday middle-class life, street scenes and interiors, lying-in rooms and betrothals, the Birth of Mary and the Visitation as social scenes, Hieronymus in the milieu of a middle-class home and the life of the saints in the bustle of busy towns. It would be wrong to assume, however, that the artists were trying to say: 'the saints are also only human beings', and that the fondness for themes of middle-class life was a token of class-conscious modesty; on the contrary, they took a self-satisfied pride in revealing all the details of this everyday life. But the members of the rich middle class, who now come forward as persons interested in art, do not desire to seem more than they are, thoroughly aware though they are of their own importance. Not until the second half of the century do the first signs of a change appear. Piero della Francesca already betrays a certain taste for solemn attitudes and a fondness for ceremonial form. It must be remembered, of course, that he worked a good deal for princely patrons and stood under the direct influence of court conventions. But in Florence art remains on the whole unconventional and informal until the end of the century, although here, too, it becomes more and more ornamented and precious, striving increasingly after elegance and delicacy. At any rate, the public of Antonio del Pollajuolo and Andrea del Verrocchio, Botticelli and Ghirlandajo has no longer anything in common with that puritanically-

minded middle class for which Masaccio and the young Donatello worked.

The antagonism between Cosimo and Lorenzo Medici, the difference in the principles according to which they exercise their power and organize their private life, is typical of the whole distance which separates their generations from one another. Just as after the reign of Cosimo the form of government was transformed from that of an apparently democratic republic into that of an absolute principality, and just as the 'first citizen' with his followers had become a prince with his household, so also there developed out of the once so plain and industrious middle class a class of *rentiers*, who despise work and money-earning, who only want to enjoy the wealth inherited from their fathers and devote their lives to leisure. Cosimo was still entirely a business man; it is true that he loved art and philosophy, had beautiful houses and villas built for himself, surrounded himself with artists and scholars and could make a lavish show in public when the occasion demanded, but the bank and the office were the real centre of his life. Lorenzo no longer takes any interest in the business of his grandfather and great-grandfathers, he neglects it and allows it to decline; he is only interested in state business, in his connections with the European dynasties, his court household, his rôle as intellectual leader, his Neoplatonic philosophers and his art academy, his experiments in poetry and his patronage of the arts. Externally everything continues to take place in middle-class patriarchal forms. Lorenzo does not allow his person and his house to form the object of a cult; the portraits of members of the family still serve, as do those of other distinguished citizens of the city, purely private purposes, and are not intended for the public, as are the statues of the Grand Dukes a hundred years later.[53]

The late Quattrocento has been described as the culture of a 'second generation', a generation of spoilt sons and rich heirs, and the contrast to the first half of the century considered so outstanding that one could speak of a deliberately reactionary movement, of an intentional 'restoration of the Gothic' and of a 'counter-Renaissance'.[54] As opposed to this conception, it has rightly been pointed out that the tendency which is here described as a return to the Gothic forms a permanent undercurrent of

the early Renaissance, and does not begin to appear only in the second half of this period.[55] But evident as is the continuance of medieval traditions and the grappling of the middle-class mind with the ideas of the Gothic, it is no less obvious that an anti-Gothic, unromantic and uncourtly outlook is predominant in the bourgeoisie until the middle of the century, and that spiritualism, conventionalism and conservatism do not gain the upper hand till the age of Lorenzo. One must not, however, imagine the development to have been such that the dynamic and dialectical structure of the middle-class mind was changed suddenly and absolutely into a state of immobility. The predominance of conservative, spiritualistic, courtly and chivalric tendencies in the second half of the Quattrocento is no less contested than that of progressive, liberal and realistic tendencies in the first half of the century. Just as there had been, in early times, alongside the progressive circles of society also such as had a retarding influence on new developments, so now alongside the conservative groups progressive elements make their mark everywhere.

The withdrawal of the sated strata of society from active economic life and the advance into the vacant positions of new elements, who had hitherto had no part in the risks and chances of a profit economy, or, in other words, the advancement of the destitute strata of society into well-to-do and of the well-to-do into aristocratic positions, is typical of the constant rhythm of capitalistic development.[56] The upholders of culture, who were still progressively-minded yesterday, feel and think conservatively today, but before they can completely transform cultural life to suit their new outlook, a new dynamically-minded stratum comes into possession of the instruments of culture—a group which a generation ago still stood outside the sphere of culture, and which a generation later will itself have a retarding influence on the development, in order to make room in its turn for a new progressive group. In the second half of the Quattrocento the conservative elements set the fashion in Florence, but the shifting of social influence from one class to another by no means comes to a standstill; there are still considerable dynamic forces at work, which prevent the stagnation of art into a condition of courtly preciosity, conventionalism and 'artiness'. Despite the tendency

to mannered subtleties and an often empty elegance, new natural-
istic efforts make themselves felt. However many courtly char-
acteristics the art of the period takes on, and however formalistic
and affectedly artistic it becomes, it never cuts itself off com-
pletely from the possibility of revising and expanding its out-
look. It remains an art delighting in reality and open to new
experience—the medium of expression of a somewhat finicky and
fastidious society, but one by no means averse to the reception
of new impulses. This mixture of naturalism and convention,
rationalism and romanticism produces at the same time both the
middle-class respectability of Ghirlandajo and the aristocratic
delicacy of Desiderio, the robust realism of Verrocchio and the
poetic dreaminess of Piero di Cosimo, the gay charm of Pesellino
and the effeminate melancholy of Botticelli. The sociological pre-
suppositions of the change of style which occurs about the middle
of the century are to be sought partly in the shrinking of the
public interested in art. The rule of the Medici inflicted consider-
able injury on economic life by the pressure of taxation and
forced many business men to leave Florence and transfer their
businesses to other cities.[57] Symptoms of industrial decline, the
emigration of workers and the falling-off in production are
noticeable even in Cosimo's lifetime.[58] Wealth is concentrated
in fewer hands. The private interest in art, which spreads to ever
widening circles in the first half of the century, shows a tendency
to become confined to narrower circles. Commissions are given
mainly by the Medici and a few other families; as a consequence,
artistic production takes on a more exclusive, more fastidious
character.

In the course of the last two centuries the commissions for the
building of churches and for ecclesiastical works of art in the free
Italian cities had been given mostly not by the ecclesiastical
authorities themselves but by their secular agents and attorneys,
that is to say, on the one hand, the communes, the great guilds
and spiritual fraternities, and, on the other, the private patrons,
the rich and distinguished families.[59] Communal building and
artistic activity reached its zenith in the fourteenth century, in
the first flowering of urban economy; middle-class ambition was
still expressing itself in collective forms—it was only later that it

assumed more personal characteristics. The Italian communes spent their money on this artistic activity just as the Greek city states had done before them. And not only Florence and Siena, also the small communes, such as Pisa and Lucca, were anxious to play their part and exhausted themselves by an excess of patronage. In most cases the individual rulers who came to power continued the artistic activities of the communes and outdid them in the expenditure of their resources. By flattering the vanity of the townspeople and presenting them with works of art for which the recipients themselves usually had to pay in the end, they provided the best advertisement for themselves and their government. This was the case, for example, in the erecting of Milan Cathedral, whilst the costs of the building of the Certosa of Pavia were met from the privy purse of the Visconti and the Sforza.[60]

The artistic activities of the guilds were not limited in Italy, as in other lands, to the building and decoration of their own oratories and guildhalls, but extended to direct participation in artistic undertakings, especially the great church buildings of the city communes. Such tasks were the concern of the guilds from the very beginning in Italy and they grew in extent as the political and economic influence of the corporations declined. But the guilds were in most cases merely the experts and supervisory organs of the communes, just as these, too, were often merely the stewards of private foundations. The corporations must on no account be regarded as the patrons nor even as the spiritual originators of all the artistic enterprises directed by them; often they merely took care of the money made available for the buildings, and supplemented it at best with loans or freewill contributions from members of the guilds.[61] To supervise the undertakings with which they were entrusted, they formed building commissions from their own ranks, consisting of four to twelve members (*operai*) according to the size of the undertaking. These commissions organized competitions, commissioned the individual artists, gave an opinion on their plans, supervised the execution of the work, supplied the materials and liquidated the wages. If the criticism of the artistic and technical work required special knowledge, they called in specialists to advise them.[62] With such

resources, the Arte della Lana directed the building of the Cathe-
dral and the Campanile in Florence, the Calimala directed the
work on the Baptistry and the church of S. Miniato and the Arte
della Seta the building of the Foundling-hospital. What usually
happened in the competitions is best shown by the history of the
bronze doors of the Baptistry. In 1401 the Calimala organized
an open competition for the making of the doors. Of those who
competed for the commission, six artists were chosen for the
short list, amongst others Brunelleschi, Ghiberti and Jacopo della
Quercia. They were given a year to produce a bronze relief, the
subject of which must have been exactly described, to judge from
the thematic similarity of the works which have been preserved.
The production costs and the livelihood of the artists during the
test were covered by the Calimala. A tribunal appointed by the
guild and consisting of thirty-four well-known artists passed
the final verdict on the specimens submitted.

The artistic commissions given by the middle class consisted,
to begin with, mainly in gifts for churches and monasteries; not
until towards the middle of the century were orders placed in
greater numbers for secular works and works intended for private
purposes. From then on, the homes of rich middle-class citizens
as well as the castles and palaces of the princes and the *nobili* are
adorned with pictures and sculptures. Naturally, considerations of
prestige, the desire to shine and to set up a memorial to oneself,
play just as great, if not an even greater part in all this artistic
activity than the satisfaction of purely aesthetic needs. It is a
well-known fact that these interests were indeed by no means
absent in the endowments of ecclesiastical art. But conditions had
changed to the extent that the most distinguished families, the
Strozzi, the Quaratesi, the Rucellai, are much more keenly occu-
pied with their palaces than with their family chapels. Gio-
vanni Rucellai is perhaps the best representative of the new type
of secularly-minded patron.[63] He comes from a patrician family
which had made its money in the wool industry and he belongs
to the generation devoted to the enjoyment of life which begins
to withdraw from business during the regime of Lorenzo Medici.
'I have now', he writes in his autobiographical notes, one of the
famous 'Zibaldoni' of the time, 'done nothing for fifty years but

earn and spend money, and it has become clear to me that spending money gives more pleasure than earning it.' Of his ecclesiastical foundations he says that they have given and still give him the greatest satisfaction, for they redound to the glory of God as well as to the glory of the city and his own memory. But Giovanni Rucellai is no longer merely a founder and builder, but also a collector; he owns works by Castagno, Uccello, Domenico Veneziano, Antonio Pollajuolo, Verrocchio, Desiderio da Settignano and others. The development of the art connoisseur from founder to collector can best be followed, incidentally, by considering the Medici. Cosimo is still above all the builder of the churches of S. Marco, S. Croce, S. Lorenzo and of the Badia of Fiesole; his son Piero is already a systematic collector; and Lorenzo is exclusively a collector.

The collector and the artist working independently of the customer are historically correlative; in the course of the Renaissance they appear simultaneously and side by side. The change does not, however, occur all at once, it represents a long process. The art of the early Renaissance still bears an on the whole workmanlike character, varying according to the nature of the commission, so that the starting point of production is to be found mostly not in the creative urge, the subjective self-expression and spontaneous inspiration of the artist, but in the task set by the customer. The market is, therefore, not yet determined by the supply but by the demand.[64] Every product still has its exactly definable utilitarian purpose and concrete connection with practical life. An order is placed for an altar-piece in a chapel well known to the artist, for a devotional picture in a definite room, for the portrait of a member of the family on a certain wall; every piece of sculpture is planned from the outset for one special place, and every piece of furniture of any importance designed for a definite interior. In our days of artistic freedom it has become an unproven dogma that there was inevitably something beneficial and helpful in the outward constraint to which the artist had to submit in earlier ages, but to which he was also in a position to submit. The results seem to justify this belief, but the artists affected thought differently on the matter; they tried to emancipate themselves from these restraints upon their freedom

as soon as conditions in the art market allowed. This occurred when the place of the mere consumer of art was taken by the amateur, the connoisseur and the collector, and is, by that modern type of consumer who no longer orders what he needs but buys what is offered. His appearance on the market meant the end of the period in which art was conditioned exclusively by the consumer and the buyer, and it created new and previously unheard-of opportunities for the free and independent artist.

The Quattrocento is the first epoch since the classical age from which a considerable selection of secular works of art has come down to us, including not merely numerous examples of the already well-known genres, such as mural paintings and easel pictures of a secular content, tapestries, embroideries, goldsmiths' work and armour, but also many works of a quite new kind, above all creations of the new upper middle-class domiciliary culture which, in contrast to the old imposing court style, are based on comfort and intimacy: richly decorated wainscoting, painted and carved chests (*cassoni*), elaborately worked bedsteads, devotional pictures for the home in dainty round frames (*tondi*), figurally decorated plates given as presents to ladies in confinement (*dischi di parto*), besides other kinds of majolica and many other products of applied art. All this output is characterized by an almost complete homogeneity of art and craft, of fine art and mere decoration; a change takes place only after the autonomy of purposeless and useless art has been recognized and confronted with the mechanical nature of mere craftwork. Not until then does the personal union of the artist and the craftsman cease, and the painter begin to create his pictures from a viewpoint different from that which inspired the painting of chests and wall panelling, flags and saddle-cloths, plates and jugs. But then he also begins to break away from the patron's wishes and to concentrate more on the production of art as a saleable commodity. From the artist's angle, that is the presupposition behind the emergence of the amateur, the connoisseur and the collector. From the consumer's angle, the presupposition is the formalistic, non-utilitarian conception of art—a form, however primitive, of 'l'art pour l'art'. An immediate concomitant of the arrival of the collector, and a phenomenon which results from the impersonal

relationship between the buyer and the artist and his work, is the fine art trade. In the Quattrocento, in which there are only isolated cases of systematic collecting, the trading with works of art, independent of their producers, is almost unknown; it does not arise until the following century with the beginnings of a regular demand for monuments of the past and the buying up of works by famous masters of the present.[65] The first fine art dealer whom we know by name is the Florentine Giov. Batt. della Palla, who comes on the scene at the beginning of the sixteenth century. In his native city he orders and acquires *objets d'art* for the French king and already buys from private owners, not merely from artists. Soon cases also occur in which a merchant orders pictures with a view to speculation, hoping to sell them again at a profit.[66]

The wealthy and distinguished citizens of the city republics wanted to make sure of their posthumous fame, although they had to exercise a certain degree of restraint in their way of life, out of consideration for their fellow-citizens. Ecclesiastical endowments were the most suitable method by which to secure eternal fame without challenging public criticism. This is a partial explanation of the incongruity between ecclesiastical and secular art even in the first half of the Quattrocento. Piety was by no means any longer the most important motive behind the endowments of Church art. Castello Quaratesi wanted to provide the church of S. Croce with a façade, but as he was refused permission to put his coat of arms on it, he gave up the whole project.[67] Even the Medici considered it advisable to give an ecclesiastical tinge to their patronage of the arts. At any rate, Cosimo tried rather to hide than display his private expenditure on art. The Pazzi, Brancacci, Bardi, Sassetti, Tornabuoni, Strozzi, Rucellai immortalized their names by the building and decorating of chapels. They used the best artists of the time for this purpose. The Cappella dei Pazzi was built by Brunelleschi, the chapels of the Brancacci, Sassetti, Tornabuoni, Strozzi decorated by painters like Masaccio, Baldovinetti, Ghirlandajo and Filippino Lippi. It is very doubtful whether the Medici were the most unselfish and intelligent of these friends of art. Of the two great Medici, Cosimo seems to have the more solid and balanced taste. Or was it merely

his age that was more balanced? He employed Donatello, Brunelleschi, Ghiberti, Michelozzo, Fra Angelico, Luca della Robbia, Benozzo Gozzoli, Fra Filippo Lippi. Donatello, the greatest of them all, certainly had a more enthusiastic friend and patron in Roberto Martelli. Otherwise why would he have repeatedly left Florence if Cosimo had appreciated his true worth? 'Cosimo was a great friend of Donatello and of all painters and sculptors'—we read in the memoirs of Vespasiano Bisticci, it is true. But, he goes on, 'as it seemed to him, that there was little work available for the latter and as he was sorry that Donatello should remain inactive, he entrusted him with the pulpits and doors of the sacristy in San Lorenzo'.[68] But why, in this golden age of the arts, should an artist like Donatello be in danger of unemployment? Why should Donatello be given a commission only as a special favour?

It is just as difficult or even more difficult properly to assess Lorenzo's understanding of art. The high standard and the variety of the talents in his entourage has always been placed to his personal credit, and the intense feeling for life which the poets, philosophers and artists promoted by him express has been characterized as radiating from his personality. Since Voltaire, his age has been reckoned with the age of Pericles, the principate of Augustus and the Grand Siècle as one of the happy periods in human history. He himself was a poet and philosopher, an art collector and the founder of the first academy of art in the world. The part played in his life by Neoplatonism and the debt owed to him personally by this movement is well known. The details of his friendly relationships with the artists of his time are familiar. It is well known that Verrocchio restored antiques for him, that Giuliano da Sangallo built the Villa da Cajano and the sacristy of S. Lorenzo for him, that Antonio Pollajuolo was much employed by him and that Botticelli and Filippino Lippi were close friends of his. But think of all the names that are missing from this list! Lorenzo not only did without the services of Benedetto da Majano, the creator of the Palazzo Strozzi, and of Perugino, who spent many years in Florence during his rule, but also those of Leonardo, the greatest artist since Donatello, who apparently left Florence owing to lack of recognition and had to move to Milan.

Perhaps the fact that he had absolutely nothing to do with the Neoplatonic movement[69] explains why Lorenzo took no interest in him. Neoplatonism, like Platonic idealism itself, was the expression of a purely contemplative attitude to the world and, like every philosophy that falls back on pure ideas as the only authoritative principles, it implied a renunciation of the things of 'common reality'. It left the fate of this reality to the actual holders of power; for the true philosopher strives, as Ficino thought, only to die to temporal reality and to live in the timeless world of ideas.[70] It is obvious that this philosophy appealed inevitably to a man like Lorenzo, who had destroyed the last vestiges of democracy and disapproved of every kind of political activism.[71] In any case, the Platonic doctrine, which it is so easy to dilute and to translate into purely poetical terms, will have been in accordance with his taste.

Nothing is more typical of Lorenzo's patronage than his relation to Bertoldo. This elegant but relatively unimportant sculptor was the most closely associated with him of all the artists of the time. Bertoldo lived with him, sat daily at his table, accompanied him on his travels, was his confidant, his artistic adviser and the director of his academy. He had humour and a sense of tact and always maintained a respectful distance from his master despite the intimacy of the relationship; he was a man of fine culture and possessed the gift of entering intelligently into the artistic ideas and desires of his patron; he was a man of high personal worth and was, nevertheless, prepared to subordinate himself absolutely; he was, in a word, the ideal court artist.[72] It must have been a source of great pleasure to Lorenzo to be able to help Bertoldo at his work as he 'devised complicated and strange, occasionally also quite banal allegories and classical myths',[73] and to see the realization of his humanistic scholarship, his mythological dreams and poetic phantasies. Bertoldo's style, his restriction to the material of noble, supple yet enduring bronze and the form of dainty and elegant compositions with small figures, was most in accordance with Lorenzo's conception of art in any case. His fondness for the minor arts is unmistakable. Very few of the great creations of Florentine sculpture were in his possession;[74] gems and cameos, of which he possessed some

five to six thousand, formed the nucleus of his collection.[75] This genre was part of the classical inheritance, and was favoured by him as such. The fact that it cultivated a classical technique and classical subject-matter was indeed not the least recommendation of Bertoldo's art. The whole of Lorenzo's activity as patron and collector was nothing but the hobby of a grand seigneur; and just as his collection bore in many respects the marks of a prince's cabinet of curios, so his taste in general, his fondness for the dainty and the expensive, the trifling and the artistic, had many points of contact with the petty regent's penchant for the rococo.

In the Quattrocento, besides Florence, which remains the most important artistic centre in Italy until the end of the century, other important centres for the cultivation of the arts develop, above all at the courts of Ferrara, Mantua and Urbino. They follow the pattern of the northern Italian courts of the fourteenth century; to them they owe their chivalric-romantic ideals and the tradition of their strictly formal, non-middle-class mode of life. But the new middle-class spirit, with its rationalism aiming at efficient production and emancipating itself from tradition, does not leave the life of the courts unaffected. It is true that the old novels of chivalry are still read, but a new, more aloof, half-ironical attitude to them has been found. Not only Luigi Pulci in middle-class Florence, but also Bojardo in courtly Ferrara, treats the chivalric themes in a new semi-serious tone of detachment. The mural paintings in the castles and palaces still preserve the atmosphere which is familiar enough from the preceding century, and themes of classical mythology and history, allegories of the virtues and the arts, personalities of the ruling family and scenes from the life of the court continue to be favoured as themes for artistic representation, but the old novels are hardly used at all as source-books.[76] Painting is not a suitable medium for the ironic treatment of any subject. We possess instructive example of court art of the Quattrocento in two important places: the mural paintings of Francesco Cossa in the Palazzo Schifanoja in Ferrara and the frescoes by Mantegna in Mantua. In Ferrara the connection with late Gothic French art, in Mantua with the Italian naturalism of the time, is stronger; but in both cases the difference from the middle-class art of the same period is more thematic

than formal. Cossa is not fundamentally different from Pesellino, and Mantegna describes life at the court of Ludovico Gonzaga with almost as direct a naturalism as, to quote one example, Ghirlandajo the life of the patricians of Florence. The differences between the artistic taste of the two circles were mutually adjusted to a very large extent.

The social function of court life is to enlist the support and adherence of the public for the ruling house. The Renaissance princes want to delude not only the people, they also want to make an impression on the nobility and bind it to the court.[77] But they are not dependent on either its services or its company; they can use anyone, of whatever descent, provided he is useful.[78] Consequently, the Italian courts of the Renaissance differ from the medieval courts in their very constitution; they accept into their circle upstart adventurers and merchants who have made money, plebeian humanists and ill-bred artists—entirely as if they had all the traditional social qualifications. In contrast to the exclusive moral community of court chivalry, a comparatively free, fundamentally intellectual type of *salon* life develops at these courts which is, on the one hand, the continuation of the aesthetic social culture of middle-class circles, such as described in the *Decamerone* and in the *Paradiso degli Alberti*, and represent, on the other, the preparatory stage in the development of those literary *salons* which play such an important part in the intellectual life of Europe in the seventeenth and eighteenth centuries. Although women participate in literary social life from the very beginning, they are not the centre of the courtly *salons* of the Renaissance; and later on, in the age of the middle-class *salon*, they become the centre in quite a different sense than in the age of chivalry. Incidentally, the cultural importance of women is only another expression of the rationalism of the Renaissance. They are regarded as the intellectual equals of men, but not as their superiors. 'Everything that men can understand, can also be understood by women', to quote from the *Cortegiano*; but the gallantry which Castiglione demands of the courtier has no longer much in common with the woman-worship of the knights. The Renaissance is a masculine age; women like Lucrezia Borgia, who kept court in Nepi, or even Isabella d'Este, who was the

centre of the court in Ferrara and Mantua, and who not only had a stimulating influence on the poets of her entourage but also seems to have been a connoisseur of the plastic arts, are exceptions. Nearly everywhere the leading patrons and friends of art are men.

The court life of medieval chivalry created a new system of morality, new ideals of heroism and humanity. The Italian courts of the Renaissance do not aim so high; their contribution to social culture is limited to that conception of refinement which, further developed by Spanish influences, reaches France in the sixteenth century, there becoming the basis of court culture and the pattern for the whole of Europe. As far as artistic matters are concerned, the courts of the Quattrocento created hardly anything new. The art which owes its origin to the princes of this period is neither better nor worse in quality than the art which the urban middle classes initiate. The choice of artist probably depends more often on local conditions than on the personal taste and tendency of the patron, but it is worth mentioning that Sigismondo Malatesta, one of the most cruel despots of the Renaissance, employs the greatest painter of the age, Piero della Francesca, and that Mantegna, the most important painter of the following generation, works not for the great Lorenzo Medici but for the petty prince Ludovico Gonzaga. That does not by any means imply that these princes were in the nature of infallible connoisseurs. They possessed just as many second- and third-rate things as did the middle-class lovers of art. On closer examination, the thesis of a universal appreciation of art in the Renaissance proves to be as untenable a legend as that of the uniformly high level of its artistic output. Balanced standards of taste were not achieved even in the upper classes of society, let alone in the lower. Nothing is more typical of the predominant artistic taste of the time than the fact that Pinturicchio, the elegant, but rather superficial painter of decoration, was the busiest artist of his time. But is it even permissible to speak at all of a universal interest in art, in the way in which the usual accounts of the Renaissance do? Did both 'high and low' really take an equal share in matters of art? Was it really 'the whole city' which was enthusiastic about the plan for a Cathedral dome in Florence? Was the preparation of a

work of art really 'an event for the whole population of the city'? Of what classes did this 'whole' population consist? Did it include the starving workers? Hardly very likely. Did it include the petty bourgeoisie? Perhaps. But, in any case, the interest of the broader masses in the concerns of art will have been more religious and parochial than purely artistic. One must not forget that at that time public affairs still took place very largely in the streets. But a carnival procession, a state reception, a funeral, certainly aroused no less interest than the publicly exhibited cartoon of Leonardo, which, as we are told, the public crowded to see for two days long. Most of them will have had no inkling of the qualitative difference between the art of Leonardo and that of his contemporaries, even though the gulf between quality and popularity was certainly not so wide as it is today. The gulf was only just appearing; it could still be bridged on occasion—the artistically valuable was not yet the exclusive possession of the initiated. There is no doubt that the artists of the Renaissance enjoyed a certain measure of popularity; the great number of stories and anecdotes about artists that were in circulation is evidence of that. This popularity was bestowed, however, not on the artists as such, but, above all, on the publicly employed personalities, who took part in competitions, exhibited their works, preoccupied the commissions of the guilds and attracted attention merely by the uncommon features of their profession.

In spite of the relatively big demand for art which existed in cities like Florence and Siena at the time of the Renaissance, it is not possible to speak of a popular art in the sense that one can speak of the popular poetry of the religious hymns, of the 'rappresentazioni sacre' and of the popular ballads into which the novels of chivalry degenerated. Peasant art certainly did exist, as did also a widespread production by bunglers, intended for popular consumption, but real works of art were, despite their comparative cheapness, beyond the means of the great majority of the population. It has been ascertained that towards the end of the 1470's, 84 workshops for wood-carving and tarsia-work, 54 for decorative work in marble and stone, 44 gold- and silver-smith workshops, were operating in Florence;[79] we have no records of the numbers of painters and sculptors in employment at the same

time, but the guild register of the painters in Florence between 1409 and 1499 shows 41 names.[80] A comparison of these figures with the number of craftsmen employed in other trades—the fact, for example, that there were at one and the same time 84 wood-carvers and 70 butchers in Florence[81]—is sufficient to give an idea of the contemporary expenditure on art. On the other hand, the identifiable artists account for only a third or even only a fourth of the masters whose names are entered in the guild registers.[82] Of the 52 painters who had a workshop of their own in Siena in 1428, we know only nine.[83] Most of them will probably not have been individually recognizable personalities in any case, and will, like Neri di Bicci, have concentrated on mass production. The business affairs of these undertakings, of which we have exact information in the records of Neri di Bicci,[84] prove that the feeling for quality of the public interested in art was not anything like so reliable as it is usually credited to have been. The majority of the public bought inferior goods of only average quality. To judge by what is said about the Renaissance in the text-books, one might imagine that it was good form to possess works of art, and that it was the general rule to find such works at least in the homes of the well-to-do middle class. But to all appearance that was by no means the case. Giov. Batt. Armenini, an art critic of the second half of the sixteenth century, remarks that he knows many good homes in which there was no sign of a picture of passable quality.[85]

The Renaissance was not a civilization of small shopkeepers and artisans, nor of a well-to-do, half-educated middle class, but rather the jealously guarded possession of a highbrow and Latinized élite. This consisted mainly of those classes of society which were associated with the humanistic and Neoplatonic movement —a uniform and, on the whole, like-minded intelligentsia, such as, for example, the clergy, taken as a totality, had never been. The important works of art were intended for this circle. The broader masses either had no knowledge at all of them or appreciated them inadequately and from a non-artistic point of view, finding their own aesthetic pleasure in inferior products. This was the origin of that unbridgeable gulf between an educated minority and an uneducated majority which had never been

known before to this extent and which was to be such a decisive factor in the whole future development of art. The civilization of the Middle Ages was not that of a standardized community either and the upholders of culture in classical times were even fully aware of their distance from the masses, but in neither of these periods was it the intention, with the exception of occasional small groups, deliberately to create the culture of an exclusive élite, to which the majority were debarred from having access. This is the fundamental change which occurs in the Renaissance. The language of the ecclesiastical culture of the Middle Ages was Latin, because the Church was still organically related to the civilization of late Roman times; but the humanists wrote Latin, because they wanted to break with the popular tendencies of the Middle Ages and the different national languages in which they were expressed, and to create a cultural monopoly for themselves, as a kind of new priestly caste. The artists place themselves under the protection and spiritual guardianship of this group. In other words, they emancipate themselves from the Church and the guilds, only to become dependent on the goodwill of a group which claims for itself the authority of both the Church and the guilds. For the humanistic literati are now not only considered to be the absolute authority on all iconographic questions of historical or mythological relevance, but they also begin to specialize in questions of a formal and technical nature. In the end, the artists submit themselves to their judgement in matters in which previously only tradition and guild regulations had been authoritative guides, and in which no layman was allowed to have a say at all. The price of their independence of the Church and the guilds, the price which they have to pay for their social ascent, for success and fame, is partly the acknowledgement of the humanist as the supreme judge in matters of art. The humanists are, of course, by no means all qualified critics and connoisseurs, but amongst their number are the first laymen with some idea of the criteria of true quality in art and who are capable of judging works of art on purely aesthetic grounds. They, as the section of the public which is really capable of forming a judgement, are the beginning of the art public in our modern sense of the term.[86]

3. THE SOCIAL STATUS OF THE RENAISSANCE ARTIST

The increased demands for works of art in the Renaissance leads to the ascent of the artist from the level of the petty bourgeois artisan to that of the free intellectual worker, a class which had previously never had any roots but which now began to develop into an economically secure and socially consolidated, even though by no means uniform group. The artists of the early Quattrocento are still entirely small folk; they are regarded as higher-grade craftsmen and their social origins and education do not make them any different from the petty bourgeois elements of the guilds. Andrea del Castagno is a peasant's son, Paolo Uccello the son of a barber, Filippo Lippi the son of a butcher, the Pollajuoli the sons of a poulterer. They are named after the occupation of their father, their birthplace or their master, and they are treated as familiarly as domestics. They are subject to the rules of the guild, and it is by no means their talent which entitles them to practise as professional artists, but the course of instruction completed according to guild regulations. Their education is based on the same principles as that of the ordinary craftsmen; they are trained not in schools, but in workshops, and the instruction is practical, not theoretical. After having acquired the rudiments of reading, writing and arithmetic, they are apprenticed to a master while still children and they usually spend many years with him. We know that even Perugino, Andrea del Sarto and Fra Bartolommeo were apprenticed for eight to ten years. Most of the artists of the Renaissance, including Brunelleschi, Donatello, Ghiberti, Uccello, Antonio Pollajuolo, Verrocchio, Ghirlandajo, Botticelli and Francia, started in the goldsmith's workshop, which has rightly been called the art school of the century. Many sculptors begin work with stonemasons and ornamental carvers just as their medieval predecessors had done. Even when he is received into the Luke Guild, Donatello is still described as a 'goldsmith and stonemason', and what he himself thinks about the relation between art and craft is best shown by the fact that he plans one of his last and most important works, the group of Judith and Holofernes, as a decoration for the fountain in the courtyard of the Palazzo Riccardi. But the leading

artists' shops of the early Renaissance introduce, despite their still fundamentally artisan-like organization, more individual teaching methods. That applies, above all, to the workshop of Verrocchio, Pollajuolo and Ghirlandajo in Florence, of Francesco Squarcione in Padua and Giovanni Bellini in Venice, of which the leaders are just as important and famous as teachers as they are as artists. Apprentices no longer enter the first workshop that they come across, but go to a particular master, by whom they are received in greater numbers the more famous and sought after he is as an artist. For these boys are, if not always the best, at least the cheapest source of labour; and that is probably the main reason for the more intensive art education which is to be observed from now on, not the masters' ambition to be considered good teachers.

The course of instruction begins, still following the medieval tradition, with all kinds of odd jobs, such as the preparation of colours, repairing brushes and the priming of the pictures; it then extends to transferring the individual compositions from the cartoon to the panel, the execution of the various parts of garments and the less important parts of the body, and finishes with the completion of whole works from mere sketches and instructions. Thus the apprentice develops into the more or less independent assistant, who must be differentiated, however, from the pupil. For not all the assistants of a master are his own pupils, and not all pupils remain with their teacher as assistants. The assistant is often on the same level as the master, but also often merely an impersonal tool in the hands of the workshop-owner. As a consequence of the various combinations of these possibilities and the frequent co-operation of the master, the assistants and the pupils, there arises not only a mixture of styles which is difficult to analyse, but sometimes even an actual balancing of the individual differences, a communal form, on which, above all, the tradition of craftsmanship has a decisive influence. The circumstance which is familiar—whether it is truth or fiction—from artists' biographies of the Renaissance, that the master gives up painting because one of his pupils has outstripped him (Cimabue-Giotto, Verrocchio-Leonardo, Francia-Raphael), must either represent a later stage of development in which the workshop community

was already in process of dissolution, or, as for example in the case of Verrocchio and Leonardo, there must be a more realistic explanation than is given in the anecdotes about these artists. Verrocchio probably stops painting and restricts himself to the execution of plastic works, after he has convinced himself that he can safely entrust the painting commissions to an assistant like Leonardo.[87]

The artist's studio of the early Renaissance is still dominated by the communal spirit of the masons' lodge and the guild workshop; the work of art is not yet the expression of an independent personality, emphasizing his individuality and excluding himself from all extraneous influences. The claim independently to shape the whole work from the first stroke to the last and the inability to co-operate with pupils and assistants are first noticeable in Michelangelo, who, in this respect too, is the first modern artist. Until the end of the fifteenth century the artistic labour process still takes place entirely in collective forms.[88] In order to cope with extensive undertakings, above all, great works of sculpture, factory-like organizations are started with many assistants and handymen. Thus in Ghiberti's studio up to twenty assistants are employed during the work on the Baptistry doors, which are among the greatest tasks to be commissioned in the Quattrocento. Of the painters, Ghirlandajo and Pinturicchio maintain a whole staff of assistants while they are working on their great frescoes. Ghirlandajo's workshop, in which above all his brothers and brother-in-law are engaged as permanent collaborators, is, along with the studios of the Pollajuoli and the della Robbia, one of the great family businesses of the century. There also exist owners of studios who are more business men than artists, and who usually accept commissions only in order to have them carried out by a suitable painter. Evangelista da Predis in Milan seems to have been one of these. For a time, he also employed Leonardo. Apart from these business-like forms of collective labour, we encounter in the Quattrocento the partnership of two usually still young artists, running a common workshop, because they cannot afford the expense of an independent undertaking. Thus, for example, Donatello and Michelozzo, Fra Bartolommeo and Albertinelli, Andrea del Sarto and Franciabigio, work together. Everywhere

we still find superpersonal forms of organization preventing the atomization of artistic work. The tendency to intellectual amalgamation makes itself felt both in the horizontal and in the vertical direction. The representative personalities of the age form long uninterrupted successions of names which, as, for example, in the case of the master-pupil sequence: Fra Angelico—Benozzo Gozzoli—Cosimo Rosselli—Piero di Cosimo—Andrea del Sarto—Pontormo—Bronzino, make the main development seem to be that of an absolutely continuous tradition.

The spirit of craftsmanship which dominates the Quattrocento is expressed, above all, in the fact that the artists' studios often take on minor orders of a purely technical nature. From the records of Neri di Bicci we learn what a vast amount of handicraft goods is produced in one busy painter's workshop; apart from pictures, armorial bearings, flags, shop signs, tarsia-works, painted wood-carvings, patterns for carpet weavers and embroiderers, decorative objects for festive occasions and many other things are turned out. Even after he has become a distinguished painter and sculptor, Antonio Pollajuolo runs a goldsmith's workshop and in his studio, apart from sculpture and goldsmith work, cartoons for tapestries and sketches for engravings are drafted. Even at the height of his career, Verrocchio takes on the most varied terracotta work and wood-carving. For his patron Martelli, Donatello makes not only the well-known coat of arms but also a silver mirror. Luca della Robbia manufactures majolica tiles for churches and private houses, Botticelli draws patterns for embroideries and Squarcione is the owner of an embroidery workshop. Of course, one must discriminate both according to the stage of historical development and the standing of the individual artists and not run away with the idea that Ghirlandajo and Botticelli painted shop signs for the baker or the butcher round the corner; such orders will no longer have been executed in their workshop at all. On the other hand, the painting of guild flags, wedding chests and bridal plates was not felt to be a degrading occupation for the artist. Botticelli, Filippino Lippi, Piero di Cosimo, are active as painters of *cassoni* right into the period of the Cinquecento. A fundamental change in the generally accepted criteria of artistic work does not begin to make itself felt until the

period of Michelangelo. Vasari no longer considers the acceptance of mere handicraft work compatible with the self-respect of an artist. This stage also signifies the end of the dependence of artists on the guilds. The outcome of the proceedings of the Genoese painters' guild against the painter Giovanni Battista Poggi, who was to be prevented from practising his art in Genoa, because he had not undergone the prescribed seven-years course of instruction there, is of symptomatic importance. The year 1590, in which this case took place and which brought the fundamental decision that the guild statutes were not binding on artists who did not keep an open shop, brings to a close a development of nearly two hundred years.[89]

The artists of the early Renaissance are also economically on an equal footing with the petty bourgeois tradesman. Their situation is in general not brilliant, but neither is it exactly precarious. No artist is as yet in a position to live like a lord, but, on the other hand, there exists nothing that one could call an artistic proletariat. It is true that in their income-tax declarations the painters are constantly complaining about their difficult financial circumstances, but such documents can certainly not be considered the most trustworthy of historical sources. Masaccio asserts that he cannot even pay his apprentice, and we know for a fact that he died poor and in debt.[90] According to Vasari, Filippo Lippi could not buy himself a pair of stockings, and in his old age, Paolo Uccello complains that he owns nothing, cannot work any longer and has a sick wife. Those artists were still best off who were in the service of a court or a patron. For example, Fra Angelico received fifteen ducats a month at the curia, at a time when on 300 a year one could live in grand style in Florence, where the cost of living was anyhow somewhat lower.[91] It is characteristic that prices remained in general on a medium level and that even the well-known masters were not much better paid than the average artist and the higher-grade craftsman. Personalities like Donatello probably received somewhat higher fees, but 'fancy prices' were still non-existent.[92] Gentile da Fabriano received 150 florins for his 'Adoration of the Magi', Benozzo Gozzoli 60 for an altar-piece, Filippo Lippi 40 for a Madonna, but Botticelli already received 75 for his.[93] Ghiberti drew a fixed salary of 200

florins a year while he was working on the doors of the Baptistry, whereas the Chancellor of the Signoria received 600 florins out of which he was also obliged to pay four clerks. In the same period, a good copyist of manuscripts received 50 florins in addition to full board. Artists were, accordingly, not exactly badly paid, even though not anything like so well as the famous literati and university teachers, who often received 500 to 2000 florins per annum.[94] The whole art market still moved within comparatively narrow limits; the artists had to demand interim payments during the work and even the employer could often pay for the materials only by instalments.[95] The princes also had to fight against shortage of ready money, and Leonardo complains repeatedly to his patron Ludovico Moro about not having received his fee.[96] The handicraft character of artistic work was expressed not least in the fact that the artists were in receipt of a regular wage from their employers. In the case of larger-scale artistic undertakings, all cash expenditure, that is to say, both the cost of the materials, the wages and often even the board and lodging of the assistants and apprentices, was borne by the employer, and the master himself was paid according to the time spent on the work. Wage-work remained the general rule in painting until the end of the fifteenth century; only later was this method of compensation limited to purely artisan jobs, such as restorations and copying.[97]

As the artistic profession breaks away from pure craftsmanship, all the conditions set down in work contracts are gradually altered. In a contract with Ghirlandajo, dated 1485, the price of the colours to be used is still particularized; but according to a contract with Filippino Lippi, dated 1487, the artist already has to bear the cost of the materials, and a similar agreement is made with Michelangelo in 1498. It is, of course, impossible to draw an absolute dividing-line here, but the change occurs, at any rate, towards the end of the century, and is again connected most conspicuously with the person of Michelangelo. In the Quattrocento it was still the general custom to require the artist to provide a guarantor to stand surety for the observance of the contract; with Michelangelo this guarantee becomes a mere formality. Thus, in one case, the writer of the contract himself acts as a guarantor

for both sides.[98] The other obligations binding on the artist are defined more and more loosely and vaguely in the contracts. In a contract of the year 1524, Sebastiano del Piombo is left free to choose any subject he likes for a painting, on the sole condition that it shall not be the picture of a saint; and in 1531, the same collector orders a work from Michelangelo and it is left entirely to the artist to decide whether it shall be a painting or a piece of sculpture.

From the very beginning, artists were better placed in Renaissance Italy than in other countries, not so much as a result of the more highly developed forms of urban life—the bourgeois milieu in itself offered them no better opportunities than the ordinary craftsmen—but because the Italian princes and despots were better able to use and appreciate their gifts than foreign rulers. The fact that the Italian artists were less dependent on the guilds, which was the basis of their favoured position, is above all the result of their being frequently employed at the courts. In the North the master is tied to one city, but in Italy the artist often moves from court to court, from city to city, and this nomadic life already leads to a certain relaxation of guild regulations, which are based on local conditions and are only workable within local limits. As the princes attached importance to attracting to their courts not only highly skilled masters in general, but also particular artists who were often foreign to the locality, the latter had to be freed from the restrictions of guild statutes. They could not be forced to take local craft regulations into consideration in the execution of their commissions, to apply for a labour permit from the local guild authority and to ask how many assistants and apprentices they were allowed to employ. After they had finished their work for one employer, they went with their assistants into the employment and protection of another and again enjoyed the same exceptional rights. These travelling court painters were beyond the reach of the guilds from the very outset. But the privileges which artists enjoyed at the courts could not remain without effect on the way they were treated in the towns, particularly as the same masters were often employed in both places and the towns had to keep pace with the competition of the courts if they wanted to attract the best artists.

I

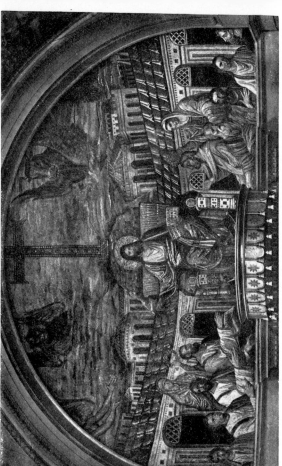

1. CEILING PAINTING in the S. Domitilla Catacomb in Rome. 2nd century.—The early Christian catacomb paintings preserve essential characteristics of late Roman impressionism, but show at the same time the signs of an often clumsy dilettantism.

2. CHRIST WITH THE APOSTLES. Mosaic in the Apse of Sta. Pudenziana, Rome. End of the 4th century.—Christ here appears, as it were, as a Roman consul in the company of high-ranking senators. In the age immediately following the Edict of Toleration, art again approaches the classical ideal of beauty.

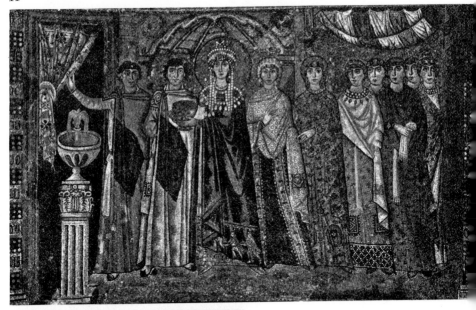

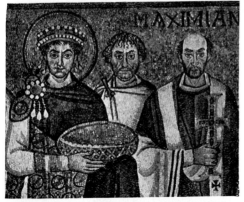

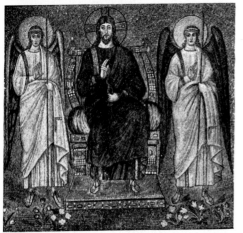

1. EMPRESS THEODORA WITH ATTENDANTS. *Mosaic in S. Vitale, Ravenna. 6th century.—The work represents a purely ceremonial scene; the religious act has turned into a court ceremony.*

2. EMPEROR JUSTINIAN AND BISHOP MAXIMIAN. *Detail from the companion-picture to the Theodora mosaic.—The individual characterization of the main figures, in keeping with the tradition of Roman portrait art, is in remarkable contrast to the stereotyped quality of the Byzantine style.*

3. CHRIST WITH ANGELS. *Detail from the mosaics in the Nave of S. Apollinare Nuovo in Ravenna. 6th century.—In these mosaics Christ is depicted as a king, Mary as a Queen, the company of angels, martyrs and apostles as a court society behaving in accordance with the strictest etiquette.*

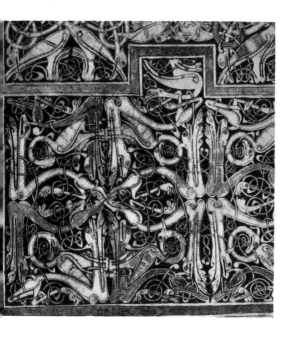

1. CRUCIFORM PAGE OF THE ST. CHAD'S GOSPELS (*Detail*). *Lichfield, Cathedral Library. Early 8th century.*—The miniature painting of the Irish monks is, with its purely ornamental conception of art, a typical product of the age of migrations.

. THE ARREST OF CHRIST. *From the Book of Kells. Dublin, Trinity College. 7th century.*—In this art even the human body becomes a mere ornament.

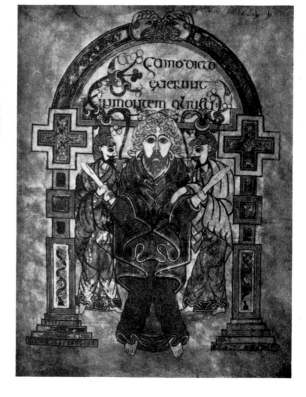

IV

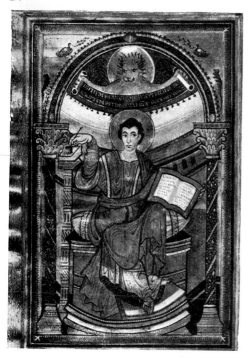

1. EVANGELIST. *From the Codex aureus. (Harley 2788). London, British Museum. About 800.—Example of the sumptuous courtly style with its whole-page richly coloured miniatures, which represent partly dedicatory pictures, partly evangelists.*

2. *Pen drawing from the* UTRECHT PSALTER. *London, British Museum. About 1000.—The drawing comes from the earliest of the three extant copies of the original which was produced in the diocese of Rheims at the beginning of the 9th century. The work represents the artistically most important example of the manuscripts done in the sketchy impressionistic style, in sharp contrast to the pompous imperial gospel books and obviously intended for a less fastidious public.*

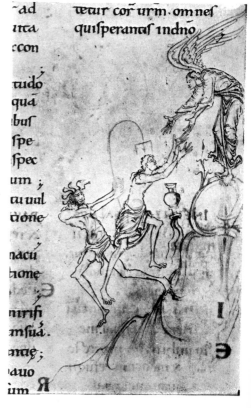

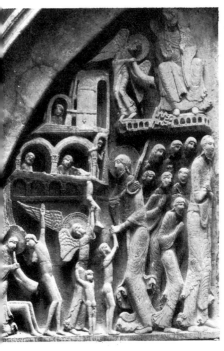

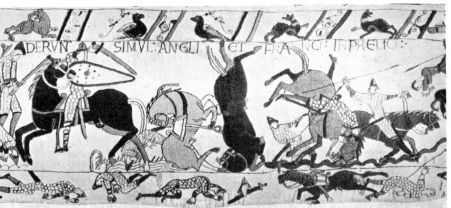

1. THE LAST JUDGEMENT (*Detail*). *Tympanum of the Portal of the Cathedral of St. Lazare in Autun. Second quarter of the 12th century.—The typical artistic expression of the ascetic outlook predominant since the Cluniac movement and the apocalyptic atmosphere which the Church is intent on spreading abroad.*

2. ST. PETER. *Relief from the Portal of Saint-Pierre in Moissac. First third of the 12th century.—Example of the expressionism of the late Romanesque 'baroque'.*

3. *Part of the* BAYEUX TAPESTRY. *Bayeux Museum. Late 11th century.— The most important monument of the secular art of the early Middle Ages. Contrary to the legend, this is, obviously, in no sense the work of a dilettante.*

1. RIDER *in the East Choir Bamberg Cathedral. 13th century. The 'Bamberg Rider', proud, refin intellectually and physically hig cultured, is the perfect embodiment the aristocratic ideal of the Got period.*

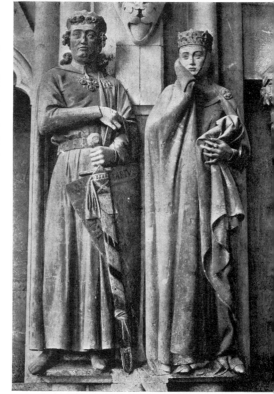

2. EKKEHART AND UTA. *Portraits of Founders in Naumburg Cathedral. Second half of the 13th century.— The Founders of Naumburg Cathedral are the most impressive representatives in the plastic arts of the nobility which, guided by common ideals in medieval Europe, forms the social milieu and the public of the courtly-chivalric poetry.*

1. HEAD of a column figure of the Royal Door of the Cathedral of Chartres. Middle of the 12th century. —One of the earliest examples of the individualizing representation of the human form in the Middle Ages.

2. JOHN THE BAPTIST. Porch of the Northern Transept of Chartres Cathedral. First quarter of the 13th century. —The sculptures of the North Porch of the Cathedral of Chartres are the first perfect examples of the synthesis of spiritualism and naturalism in Gothic art.

3. HEAD of an unidentified personality of the central West Door of Rheims Cathedral. Second quarter of the 13th century.—The technical skill of the masters of the Gothic already assumes here the characteristics of a playful virtuosity with a tendency to the stereotyped.

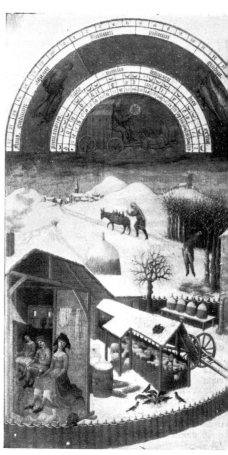

2. PAUL DE LIMBOURG: FEBRUARY. *Miniatfrom the Calendar of the 'Très Riches Heudu Duc de Berri'. Chantilly, Musée ConAbout 1416.—The naturalistic picture manners of bourgeois painting has its origin this luxurious form of courtly art.*

1. JAN VAN EYCK: THE JUST JUDGES. *Part of the Holy Lamb. Ghent, St. Bavon. Completed in 1432.—One of the numerous 'travel landscapes' typical of the dynamic outlook of the late Middle Ages.*

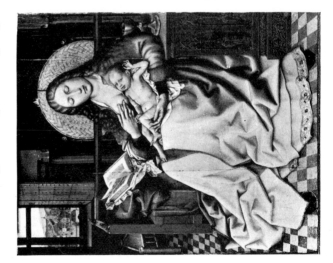

1. ROBERT CAMPIN: VIRGIN AND CHILD WITH A FIRESCREEN. London, National Gallery. First half of the 15th century.—
The use of the firescreen, which forms the halo round the head of the Virgin, is characteristic of the rationalization of artistic symbolism which takes place at the end of the Middle Ages.

2. GIOTTO: MEETING OF ST. JOACHIM AND ST. ANNE AT JERUSALEM. Fresco in the Cappella dell'Arena in Padua. About 1305.—Giotto is the first and greatest master of the bourgeois classicism that brings into perfect balance the naturalistic and formalistic elements of the representation. With him the clarity and precision of the form are, above all, the means of a story-teller who strives to express himself as concisely as possible and with the greatest dramatic intensity.

X

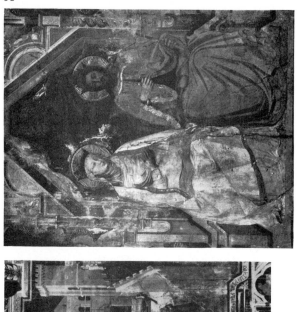

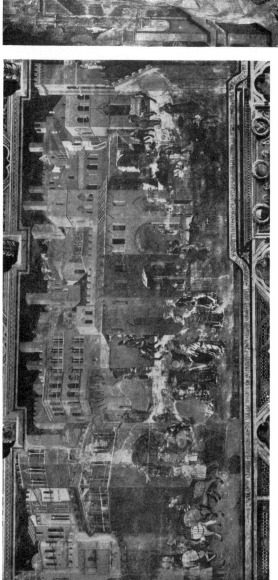

1. AMBROGIO LORENZETTI: THE GOOD GOVERNMENT. *Fresco in the Palazzo Pubblico of Siena. 1335–40.—Ambrogio Lorenzetti, the creator of the illusionistic town-panorama, takes, with the greater freedom of his spatial arrangement, the first important step in the* **artistic** *development leading beyond Giotto's style.*

2. NARDO DI CIONE: *Detail from the 'Paradise'. Fresco in S. Maria Novella in Florence. The 'fifties of the Trecento. The art of Nardo di Cione and Andrea Orcagna signifies, with the rigid planimetric organization of their compositions, the continuation of the solemn, hieratic style of the Middle Ages, but, at the same time, with the greater certainty in the reproduction of plastic forms, it marks an important stage in the progress of naturalism.*

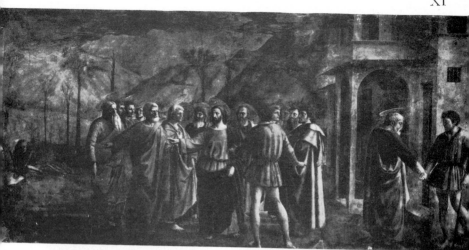

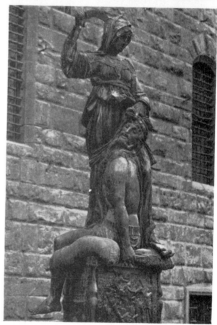

1. MASACCIO: THE TRIBUTE MONEY. *Fresco in the Brancacci Chapel of the Chiesa del Carmine in Florence. 1425–27.—The works of Masaccio are amongst the most representative artistic creations of the first generation of the Quattrocento in Florence. With their robust realism and healthy rationalism, they express the outlook of the bourgeoisie in its hard but confident struggle for power.*

2. MASACCIO: ST. PETER BAPTIZING. *Florence, Chiesa del Carmine. 1425–27.—The 'freezing man' at the right-hand edge of the picture is a classical example of the naturalism of the early Quattrocento.*

3. DONATELLO: JUDITH AND HOLOFERNES. *Bronze group in the Piazza della Signoria in Florence. 1455–57.—Characteristic of the relation between art and craft in the early Renaissance is the fact that Donatello plans this important work as a decoration for a fountain in a courtyard.*

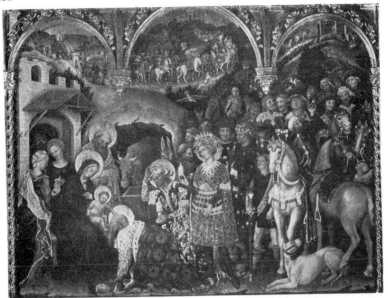

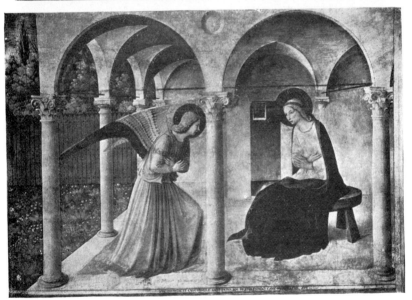

1. GENTILE DA FABRIANO: THE ADORATION OF THE MAGI. *Florence, Uffizi.*
1423.—The influence of the chivalrous-romantic spirit of the North Italian
courts makes itself felt in Florence as early as the beginning of the 15th century.
No work is more characteristic of this trend than Gentile's 'Adoration' which
stands, with its sumptuous and festive character, in the sharpest possible contrast
to the bourgeois art of the period.

2. FRA ANGELICO: ANNUNCIATION. *Florence, Museo di S. Marco. About*
1440.—The combination of the ecclesiastical and the secular, the medieval and
the modern elements in the painting of Fra Angelico is typical of the mixture of
styles in the first half of the Quattrocento.

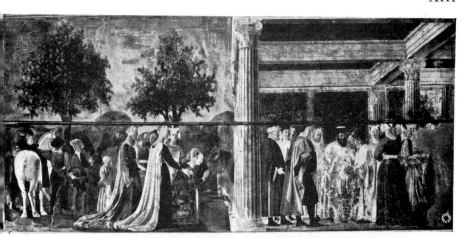

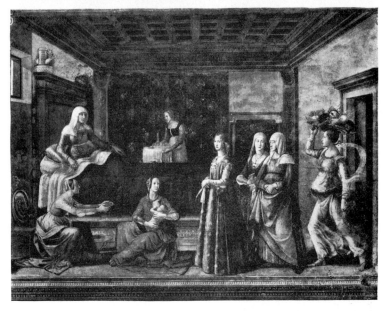

1. PIERO DELLA FRANCESCA: THE QUEEN OF SHEBA BEFORE SOLOMON. *From the fresco cycle 'The Legend of the Holy Cross' in the Choir of S. Francesco in Arezzo. About 1460.—Piero's art is guided fundamentally by naturalistic and rationalistic principles, but the courtly touch in the solemn and monumental style of the master, who was for long in the service of a court, is unmistakable.*

2. DOMENICO GHIRLANDAIO: THE BIRTH OF JOHN. *Fresco in the Choir of S. Maria Novella in Florence. Completed in 1490.—Towards the end of the century, art in Florence takes on an upper middle-class, patrician character. On the whole it remains unconventional and preserves its earlier liberalism, but the generation to which its public belongs, the third of the century, represents an age group of wealthy heirs which attaches more importance to elegance and genteel appearance than to solidity and intellectual independence.*

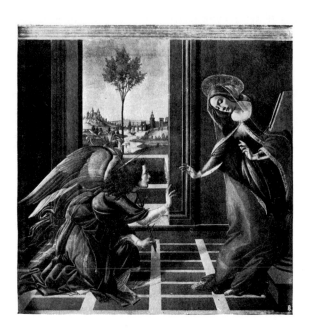

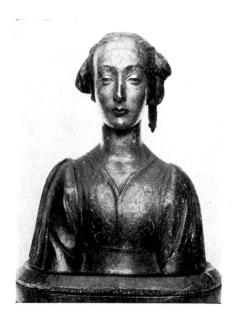

1. BOTTICELLI: ANNUNCIATION.
Florence, Uffizi. About 1490.—
*Botticelli is the main representative
of the aristocratizing tendency in
Florentine painting. He is the chief
master of that neo-romantic trend
which deflects the solid realism of
bourgeois art unto the precious and
the mannered.*

2. DESIDERIO DA SETTIGNANO:
FEMALE BUST. *Paris, Louvre.
After the middle of the century.*—
*The type of the elegant upper middle-
class portrait with strong emphasis on
the delicate and sensitive features of
the model.*

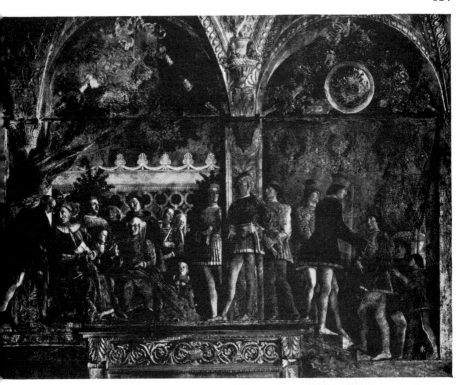

. MANTEGNA : MARCHESE
UDOVICO II WITH FAMILY. *Fresco*
the Palazzo Ducale in Mantua.
474.—Mantegna is one of the most
nportant mediators between the
ourgeois and the courtly art of the
uattrocento. He describes life at the
ourt of Ludovico Gonzaga with the
ame directness as, for example,
hirlandaio the life of the Florentine
atricians.

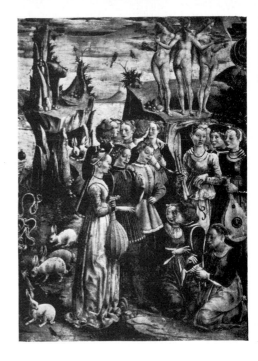

. FRANCESCO COSSA : THE TRIUMPH
F VENUS (*Detail*). *Fresco in the*
alazzo Schifanoia in Ferrara. 1470.
—The classical example of the
nightly-romantic art cultivated at
he North Italian courts of the
Quattrocento.

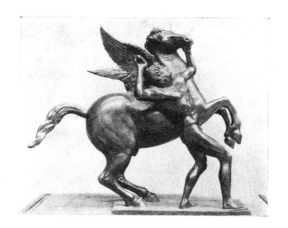

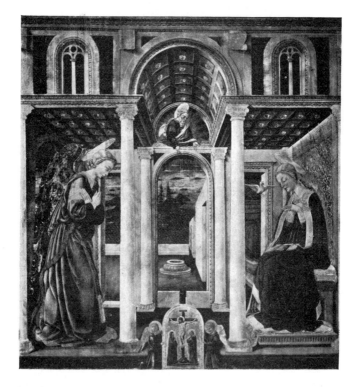

1. BERTOLDO: BELLEROPHON AND PEGASUS. *Vienna, Kunsthistorisches Museum. Towards the end of the century.—An important example of the artistic trend promoted by Lorenzo.*

2. NERI DI BICCI: ANNUNCIATION. *Florence, Uffizi. 1458.—A typical product of the busy workshop working for the broader strata of the middle class.*

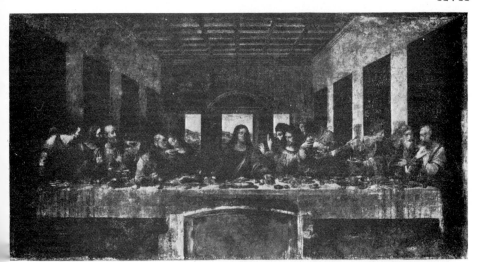

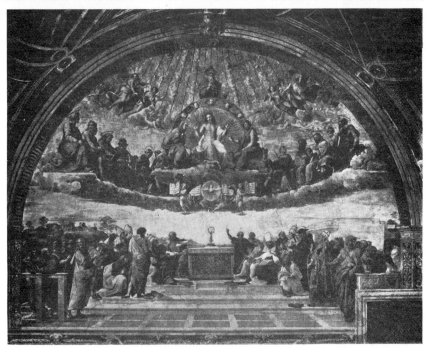

1. LEONARDO: THE LAST SUPPER. *Fresco in the Refectory of the Monastery of S. Maria delle Grazie in Milan. 1495–98.—The first perfect example of that strict form, confined to the essential and the necessary, which represents the artistic analogy to the aristocratic ideal of self-control.*

2. RAPHAEL: THE DISPUTA. *Fresco in the Stanza della Segnatura. Rome, Vatican. 1509–11.—Here the principle of normativity holds unlimited sway, and even those elements of spontaneity and directness are lacking which are still present in Leonardo.*

3. TITIAN: SHEPHERD AND NYMPH. *Vienna, Kunsthistorisches Museum. About 1570.*

2. TITIAN: EMPEROR CHARLES V ON HORSEBACK. *Madrid, Prado. 1548.*—*Here the grand heroic form already assumes the characteristics of a ceremonial style which one can hardly imagine in connection with Michelangelo.*

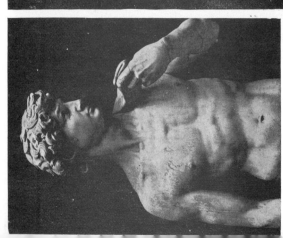

1. MICHELANGELO: DAVID *(Detail). Florence, Accademia di Belle Arti. 1501–4.*—*Just as an increasingly less heroic treatment of the male figure is to be observed in the course of development from Polycletus to Lysippus, the opposite tendency can be seen in the development leading from Donatello to Michelangelo: the ideal of human personality becomes increasingly less bourgeois and approaches the ideal of aristocratic kalokagathia.*

XIX

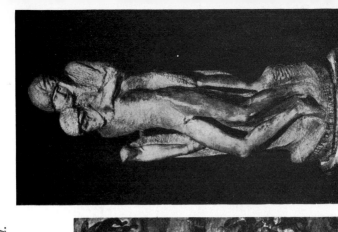

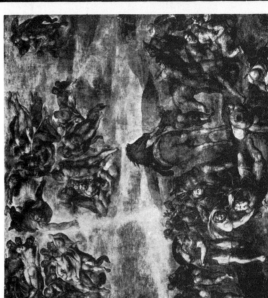

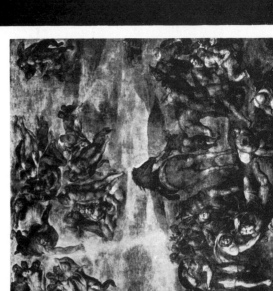

1. MICHELANGELO: THE LAST JUDGEMENT (Detail). *Rome, Sistine Chapel. 1534–41.—With Michelangelo, the main representative of the Renaissance, the dissolution of the classical feeling for harmony already begins. His 'Last Judgement' is no longer a monument of beauty, power and youth, but a picture of bewilderment and despair.*

2. MICHELANGELO: THE CONVERSION OF ST. PAUL. *Cappella Paolina. Rome, Vatican. 1542–49.—The frescoes of the Cappella Paolina mark the next phase in Michelangelo's development. The unreal and irrational character of his pictorial vision is intensified.*

3. MICHELANGELO: PIETÀ RONDANINI. *Rome, Palazzo Rondanini. 1556–64.—The body has lost its autonomy. The work can hardly any longer be called an artistic structure; it is an ecstatic confession—formless, unorganized, unarticulated.*

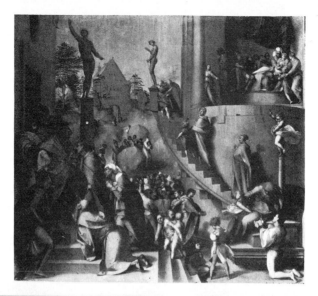

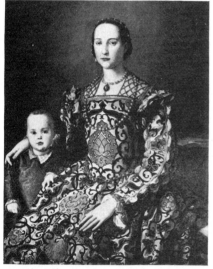

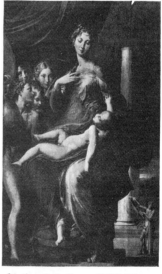

1. PONTORMO: JOSEPH IN EGYPT. *London, National Gallery. 1518-19.—* *We are here confronted with a disintegration of space similar to that in the* *last works of Michelangelo. Real figures move in an unreal, arbitrarily* *constructed framework.*

2. BRONZINO: ELEONORA OF TOLEDO WITH HER SON. *Florence, Uffizi.* *About 1555.—Bronzino is, above all as a portraitist, one of the founders of* *courtly manerism.*

3. PARMIGIANINO: MADONNA DEL COLLO LUNGO. *Florence, Palazzo Pitti.* *Begun in 1532, left incomplete.—The heterogeneousness of the pictorial* *elements becomes a highly skilled game, a secretive mannerism, the under-* *standing of which is confined to an extremely narrow circle.*

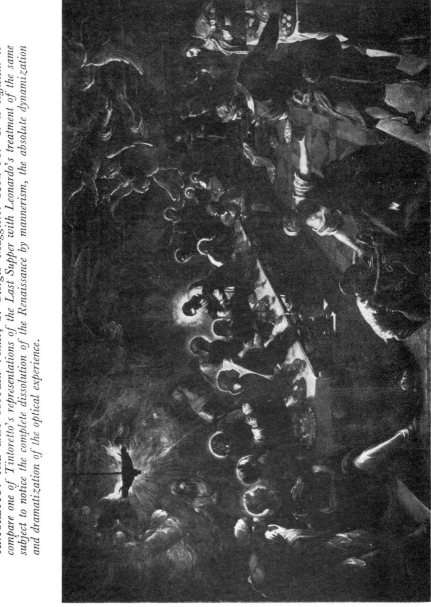

TINTORETTO: THE LAST SUPPER. *Venice, S. Giorgio Maggiore. 1592–94.—It is sufficient to compare one of Tintoretto's representations of the Last Supper with Leonardo's treatment of the same subject to notice the complete dissolution of the Renaissance by mannerism, the absolute dynamization and dramatization of the optical experience.*

1. **TINTORETTO: MOSES BRINGING FORTH WATER FROM THE ROCK.** *Venice, Scuola di San Rocco. 1577.— The representations of biblical stories take on a visionary and phantastic character in Tintoretto. They often represent cosmic happenings, primeval dramas in which God himself becomes a heavenly body in motion.*

2. **TINTORETTO: ST. MARY AEGYPTIACA.** *Venice, Scuola di San Rocco. 1583-87.— Here the scenery of the biblical motif is transformed into a mythological landscape in which the human figure almost disappears and the background dominates the stage.*

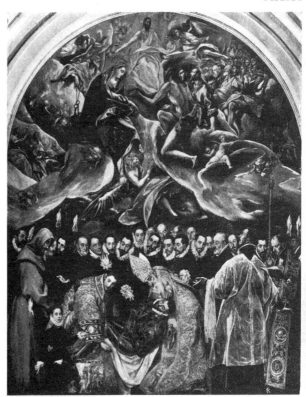

GRECO: THE BURIAL OF THE COUNT OF ORGAZ. *Toledo, San Tomé. 1586.—The work represents a ceremonial scene in the correct courtly taste, but it is, at the same time, the representation of a spiritual drama of the deepest, tenderest and most mysterious nature.*

2. GRECO: THE VISITATION. *Washington, Dumbarton Oaks Collection. 1604–14.—Greco is the artist who, in his last works, comes nearest to the dematerialization of reality achieved by Michelangelo. The 'Visitation' and the 'Wedding of Mary' take the place of the 'Pietà Rondanini' in his development. The figures are dissolved in the light and become airy, ethereal shadows in an abstract, unreal, indefinable space.*

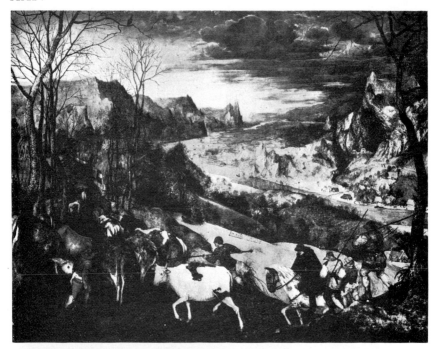

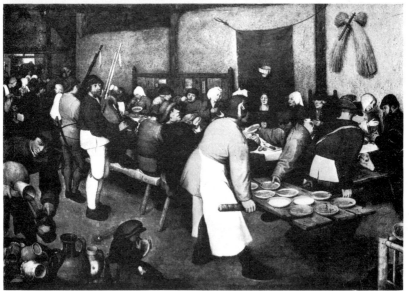

1. BRUEGEL: AUTUMN. *Vienna, Kunsthistorisches Museum. 1565.—An outlook on the world reminiscent of Tintoretto's cosmic conception predominates in Bruegel's landscapes.*

2. BRUEGEL: A COUNTRY WEDDING. *Vienna, Kunsthistorisches Museum. About 1565.—This work, with its dynamic treatment of space, is also reminiscent of Tintoretto, in whose representations of the Last Supper a similar disposition is to be found.*

XXV

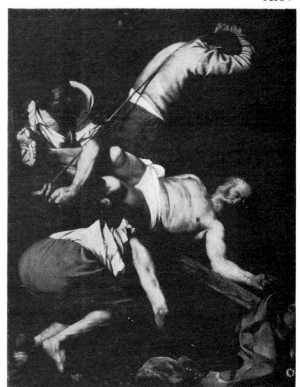

CARAVAGGIO: THE
CRUCIFIXION OF ST. PETER.
Rome, S. Maria del Popolo.
About 1600.—Caravaggio's
naturalism was by no means
always in accordance with the
taste of his ecclesiastical patrons
who missed the grandeur of
conception and objected to the
'vulgarity' in his treatment of
biblical subjects.

2. LODOVICO CARRACCI:
MADONNA WITH SAINTS. *Bologna,
Pinacoteca.—Of all the artists of
their time the Carracci were the
most successful in fulfilling satisfac-
torily the tasks set them by the
Catholic Church. The types of
devotional picture created by them
became the patterns of modern
ecclesiastical art.*

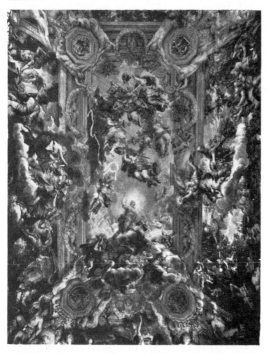

1. PIETRO DA CORTONA: CEILING PAINTING *in the Palazzo Barberini in Rome. 1633–37.— Pietro da Cortona is the leading master of high baroque ·mural painting. The pompous decorative style of the later Italian and French interiors is unthinkable without his frescoes.*

2. VIGNOLA: IL GESÙ. *Rome. 1568–84.—The prototype of the Roman baroque church.*

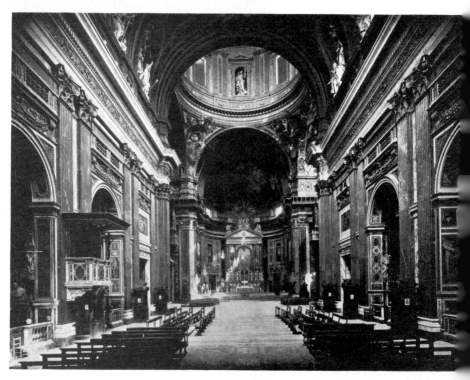

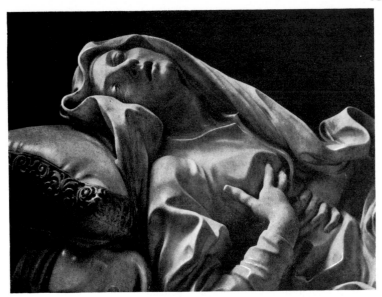

1. LORENZO BERNINI: THE
BLESSED LUDOVICA
ALBERTONI (*Detail*). *Rome, S.
Francesco a Ripa. 1674–76.—
Bernini creates the formal
language in sculpture of the
somewhat theatrical emotional-
ism of baroque religiosity.*

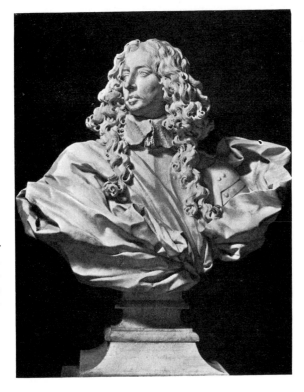

2. LORENZO BERNINI:
FRANCESCO I OF ESTE.
*Modena, Galleria Estense.
1650.—Bernini is, at the same
time, the leading master of
baroque portrait sculpture, the
rhetorical forms of which have
so much in common with the
language of religious emotional-
ism.*

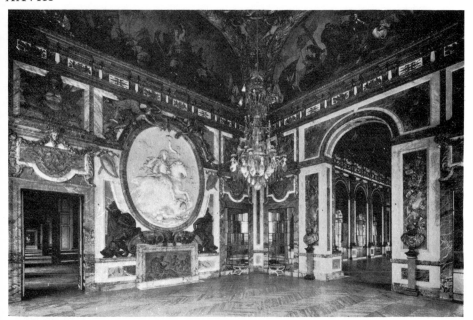

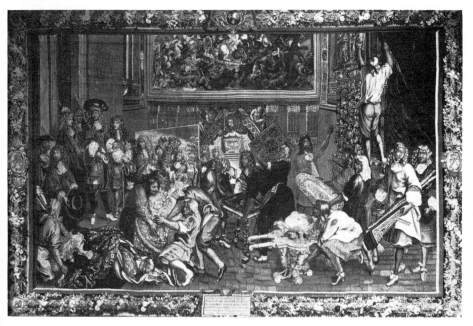

1. LE BRUN: THE 'SALON DE LA GUERRE' *in the Château de Versailles. 1686.—The 'art of Versailles' is the epitome of baroque court art.*

2. LE BRUN: LOUIS XIV VISITS THE GOBELIN MANUFACTURE. *Tapestry in the Château de Versailles. About 1667.—This tapestry gives a rough idea of the variety of things produced in the Royal Manufactory.*

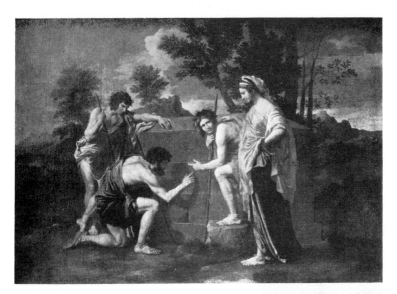

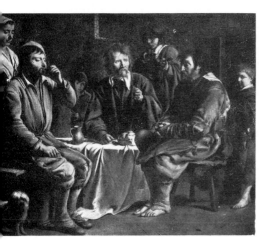

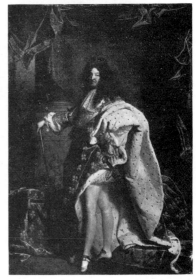

1. POUSSIN: ET IN ARCADIA EGO. *Paris, Louvre. 1638–39.—Poussin is the most important forerunner of Watteau as the painter of pastoral motifs, but he still represents a mythologically classicizing and strictly rationalistic conception of the subject.*

2. LOUIS LE NAIN: PEASANT MEAL. *Paris, Louvre. 1642.—The works of Louis Le Nain are amongst the most important creations of the French naturalism in the 17th century.*

3. HYACINTHE RIGAUD: THE PORTRAIT OF LOUIS XIV. *Paris, Louvre. 1701.— This portrait was the highest paid picture of its time; the artist received* **40,000** *francs for it.*

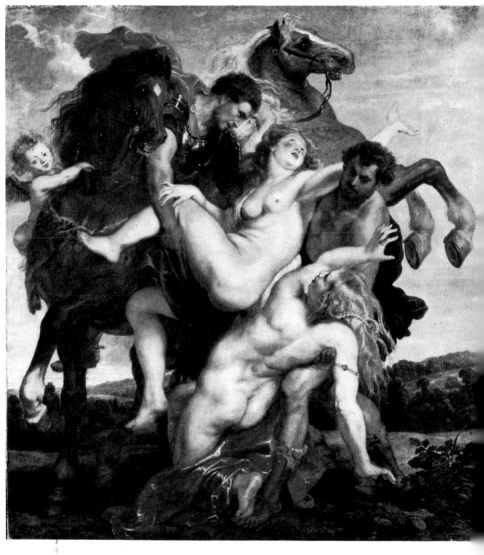

RUBENS: THE RAPE OF THE DAUGHTERS OF LEUCIPPUS. *Munich, Pinakothek. About 1618.—From no artist does one gain a more perfect conception of the ideals of the court baroque than from Rubens; none embodies the idea of grandiose form, of imposing external appearance, of the great theatrical gesture more impressively than he.*

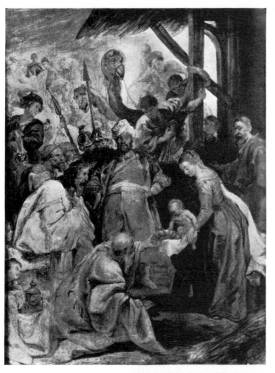

RUBENS: THE ADORATION OF THE MAGI. *Sketch of 1623–24. London, Wallace Collection.— Altar-piece of 1624. Antwerp, Museum.—Here we have the best illustration of the method of production normal in Rubens' workshop; we see how a great commission is carried out on the basis of the master's sketch.*

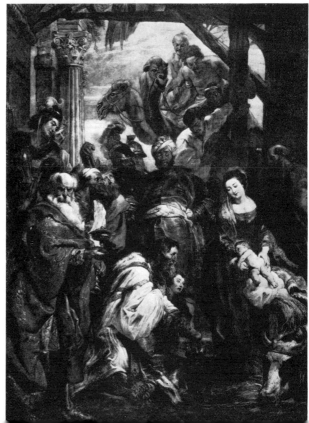

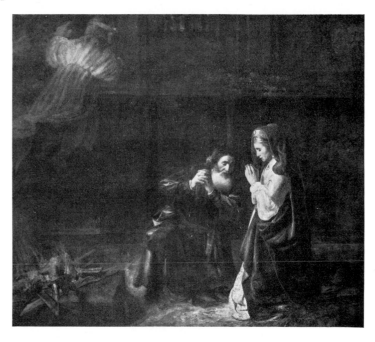

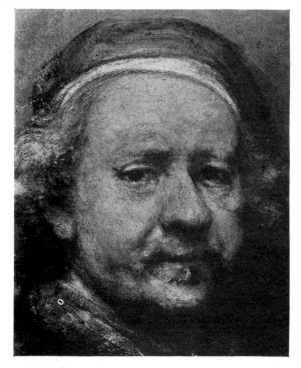

1. REMBRANDT: THE SACRIFICE OF MANOAH. *Dresden, Gemaeldegalerie. 1641.—Rembrandt, the bourgeois artist par excellence, spiritualizes what in Rubens was a more or less external, albeit extremely effective attitude.*

2. REMBRANDT: SELF PORTRAIT (*Detail*). *London, National Gallery. About 1660. —It was only in a bourgeois period of art, such as the Dutch 17th century, that the subjective conception of painting was possible which produced the flood of self portraits of Rembrandt.*

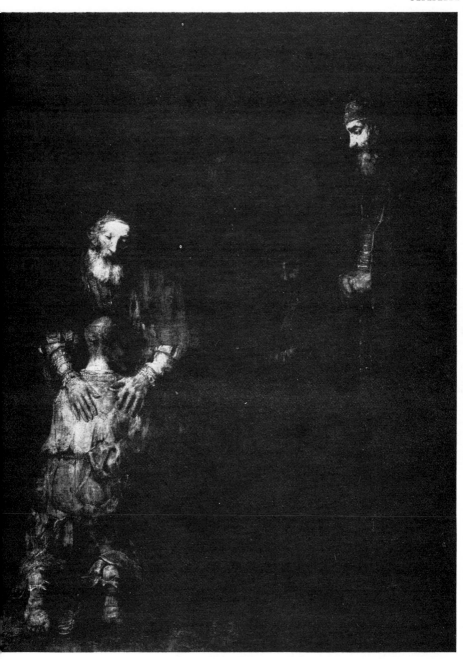

REMBRANDT: THE RETURN OF THE PRODIGAL SON. *Leningrad, Hermitage. Late work.—Rembrandt's last works dematerialize reality in a similar way to those of Michelangelo and Greco. The late style of the three masters has many characteristics in common, mediating between mannerism and the baroque.*

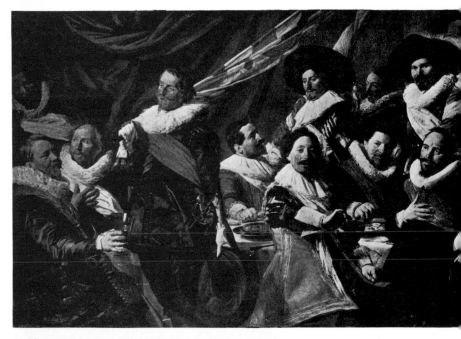

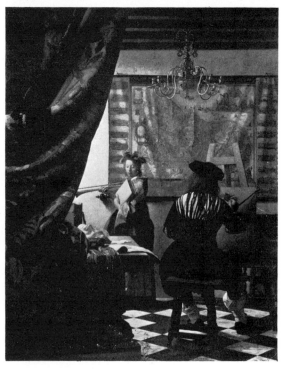

1. FRANS HALS: THE CIVIC GUARD OF ARCHERS OF ST. GEORGE. *Haarlem, Frans Hals Museum. 1627.—Frans Hals marks the summit of the Dutch group portrait in which the bourgeois class-consciousness of his contemporaries finds the strongest expression.*

2. VERMEER VAN DELFT: THE ALLEGORY OF PAINTING. *Vienna, Kunsthistorisches Museum. About 1665.—The Dutch discover the pictorial charm of the bourgeois interiors and develop therefrom an art of atmospherical effects of which Vermeer is the greatest master.*

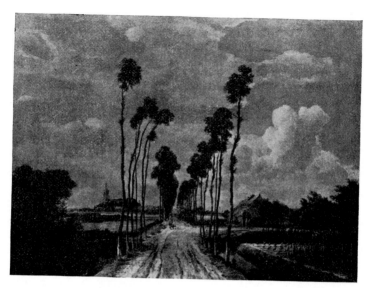

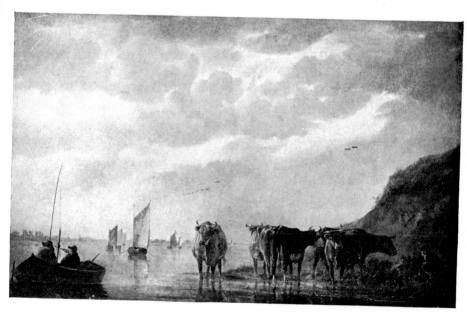

1. HOBBEMA: THE AVENUE. *London, National Gallery. Between 1663 and 1669.—The intimate relationship between the Dutch and the urban and rural property within whose framework the episodes of their life take place, leads to a new experience of space.*

2. ALBERT CUYP: RIVER SCENE WITH CATTLE. *London, National Gallery. Between 1655 and 1670.—The Dutch anticipate a good deal of the naturalism of the 19th century; they are the real masters of the painters of Barbizon.*

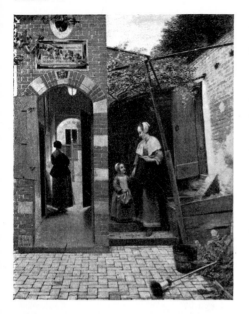

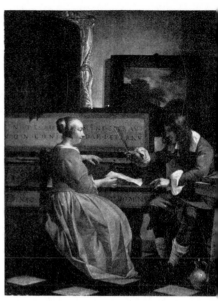

1. PIETER DE HOOCH: COURTYARD OF A DUTCH HOUSE. *London, National Gallery. 1658.—Pieter Hooch is the painter of the middle sections of the well-to-do bourgeoisie.*

2. METSU: MUSIC LESSON. *London, National Gallery. After 1655.— Metsu obviously works for a more refined and wealthy circle than Pieter de Hooch.*

3. ADRIAN VAN DER WERFF: THE REPOSE IN EGYPT. *London, National Gallery.—The works of van der Werff are the best examples of the change in taste which takes place in Holland with the advancing influence af the academic and aristocratic conception of art.*

The emancipation of the artists from the guilds is, therefore, not the result of their own heightened self-respect and the acknowledgement of their claim to be considered on an equal footing with the poets and scholars, but results from the fact that their services are needed and have to be competed for. Their self-respect is merely the expression of their market-value.

The social ascent of the artists is expressed first of all in the fees they receive. In the last quarter of the fifteenth century relatively high prices begin to be paid in Florence for fresco paintings. In 1485, Giovanni Tornabuoni agrees to pay Ghirlandajo a fee of 1,100 florins for painting the family chapel in S. Maria Novella. For his frescoes in S. Maria sopra Minerva in Rome, Filippino Lippi receives 2,000 gold ducats, which corresponds approximately to the same sum in florins. And Michelangelo receives 3,000 ducats for the paintings on the ceiling of the Sistine Chapel.[99] Towards the end of the century several artists are already doing well financially; Filippino Lippi even amasses a considerable fortune. Perugino owns houses, Benedetto da Majano an estate. Leonardo draws an annual salary of 2,000 ducats in Milan and in France he receives 35,000 francs per annum.[100] The celebrated masters of the Cinquecento, especially Raphael and Titian, enjoy a considerable income and lead a lordly life. Michelangelo's way of life is outwardly modest, it is true, but his income, too, is high, and when he refuses to accept payment for his work in S. Peter's, he is already a wealthy man. In addition to the increasing demand for works of art and the general rising of prices, the fact that round the turn of the century the papal curia comes more into prominence on the art market, and becomes a more serious rival to the Florentine public interested in art, must have had the biggest influence on the ascending scale of artists' fees. A whole series of artists now move from Florence to magnanimous Rome. Naturally, those left behind profit from the high offers of the papal court—that is to say, only the more distinguished artists really profit, those whom an effort is made to keep back. The prices paid to the others lag considerably behind the fees paid in the best market, and now, for the first time, there begin to be real differences in the payments made to artists.[101]

The emancipation of the painters and sculptors from the

fetters of the guilds and their ascent from the level of the artisan to that of the poet and scholar has been attributed to their alliance with the humanists; the humanists' support for them, on the other hand, has been explained by the fact that the literary and artistic monuments of antiquity formed an indivisible unity in the eyes of these enthusiasts, and that they were convinced that the poets and artists of classical antiquity were held in equal regard.[102] In fact, they would have considered it unthinkable that the creators of the works which they regarded with a common reverence because of their common origin should have been judged differently by their contemporaries. And they made their own age—and the whole of posterity right into the nineteenth century—believe that the artist, who had never been anything more than a mere mechanic in the eyes of antiquity, shared the honours of divine favour with the poet. There is no question that the humanists were very useful to the artists of the Renaissance in their efforts to achieve emancipation; the humanists confirmed them in the position they had won for themselves thanks to the favourable market, and they gave them the weapons with which to assert their claims against the guilds, and partly also against the resistance of the conservative, artistically inferior and, therefore, vulnerable elements in their own ranks. But the protection of the literati was by no means the reason for the social ascent of the artist; it was rather itself merely a symptom of the development which followed from the fact that—as a consequence of the rise of new seigniories and principalities, on the one hand, and the growth and enriching of the towns, on the other—the disproportion between supply and demand on the art market became ever smaller and began to achieve a perfect balance. It is a well-known fact that the whole guild movement had its origin in the attempt to prevent such a disproportion in the interest of the producers; the guild authorities only connived at the infringement of their statutes when shortage of work no longer seemed a menace. The artists owed their independence not to the goodwill of the humanists, but to the fact that this danger became increasingly insignificant. They also desired the friendship of the humanists, not in order to break the resistance of the guilds, but to justify the economic position they had already won for them-

selves in the eyes of the humanistically-minded upper class and in order to enlist the scientific advisers, whose help they needed in their fashioning of marketable mythological and historical subjects. For the artists the humanists were the guarantors of their intellectual status, and the humanists themselves recognized the value of art as a means of propaganda for the ideas on which their own intellectual supremacy was based. It was this mutual relationship which first gave rise to that conception of the unity of the arts which we take for granted, but which was unknown before the Renaissance. Plato is not the only one to make a fundamental distinction between the visual arts and poetry; even in the later years of classical antiquity and the Middle Ages, it occurred to no one to assume that there was any closer relationship between art and poetry than there was between science and poetry or between philosophy and art.

Medieval literature on art was limited to recipe books. No hard-and-fast line of any kind was drawn between art and craft in these practical manuals. Even Cennino Cennini's treatise on painting was still dominated by the ideas of the guilds and based on the guild conception of excellence in craftsmanship; he exhorted the artists to be industrious, obedient and persevering, and saw in the 'imitation' of the paragons the most certain way to mastery. All this was on the old medieval-traditionalist lines. The replacing of the imitation of the masters by the study of nature is first accomplished theoretically by Leonardo da Vinci, but he was merely expressing the victory of naturalism and rationalism over tradition which had been won long since in practice. His theory of art, which is based on the study of nature, shows that in the interim the relationship between master and pupil has completely changed. The emancipation of art from the spirit of pure craftsmanship had to begin with the alteration of the old system of apprenticeship and the abolition of the teaching monopoly of the guilds. As long as the right to practise as a professional artist was conditional on apprenticeship under a guild master, neither the influence of the guilds nor the supremacy of the craft tradition could be broken.[103] The education of the rising generation in art had to be transferred from the workshop to the school, and practical had to yield partly to theoretical instruction, in

order to remove the obstacles which the old system put in the way of young talent. Of course, the new system gradually created new ties and new obstacles. The process begins by the authority of the masters being replaced by the ideal of nature, and ends with the finished body of doctrine represented by academic instruction, in which the place of the old discredited models is taken by new, just as strictly limited, but from now on scientifically based ideals. Incidentally, the scientific method of art education begins in the workshops themselves. Already in the early Quattrocento apprentices are made familiar with the rudiments of geometry, perspective and anatomy in addition to the practical instruction, and introduced to drawing from life and from puppets. The masters organize courses in their workshops and this institution gives rise, on the one hand, to the private academies with their combination of practical and theoretical instruction,[104] and, on the other, to the public academies in which the old workshop community and craft tradition are abolished and replaced by a purely intellectual teacher-pupil relationship. Workshop instruction and the private academies maintain themselves through the whole Cinquecento, but they gradually lose their influence on the formation of style.

The scientific conception of art, which forms the basis of instruction in the academies, begins with Leon Battista Alberti. He is the first to express the idea that mathematics is the common ground of art and the sciences, as both the theory of proportions and of perspective are mathematical disciplines. He is also the first to give clear expression to that union of the experimental technician and the observing artist which had already been achieved in practice by Masaccio and Uccello.[105] Both try to comprehend the world empirically and to derive rational laws from this experience of the world; both endeavour to know and to control nature; both are distinguished from the purely contemplative, scholastically confined university teacher by reason of their creative activity—a *poiein*. But if the technician and the natural scientist now has a claim to be considered an intellectual on the basis of his mathematical knowledge, the artist, who is often identical with the technician and the scientist, may also well expect to be distinguished from the craftsman and to have the

medium in which he expresses himself regarded as one of the 'free arts'.

Leonardo does not add any new basic ideas to Alberti's statements, in which art is raised to the stature of a science and the artist placed on a level with the humanist; he merely stresses and increases the claims of his predecessor. Painting, he maintains, is, on the one hand, a kind of exact natural science; on the other, it is superior to the sciences, for these are 'imitable', that is, impersonal, whereas art is tied to the individual and his inborn abilities.[106] Leonardo, therefore, justifies the claim of painting to be considered one of the 'free arts' not only on the basis of the artist's mathematical knowledge but also on account of his talent, which, according to Leonardo, is equal to that of the poetic genius. He renews the dictum attributed to Simonides, which refers to painting as a 'silent poetry' and poetry as a 'speaking painting', and he thereby opens that long controversy about the order of precedence in the arts to which Lessing was later to contribute. Leonardo thinks that if the muteness of painting is regarded as a defect, then one might just as well speak of the blindness of poetry.[107] An artist in closer touch with the humanists would never have had the presumption to make such a heretical assertion.

A higher assessment of the value of painting, rising above the medieval workmanlike point of view, is to be noted even in the early forerunners of humanism. Dante erects an imperishable monument to the masters Cimabue and Giotto (*Purg.* XI, 94/96), and compares them with poets like Guido Guinicelli and Guido Cavalcanti. In his sonnets, Petrarch praises the painter Simone Martini, and in his eulogy of Florence, Filippo Villani also mentions several artists among the famous men of the city. The *novelle* of the Italian Renaissance, above all those of Boccaccio and Sacchetti, contain a wealth of anecdotes about artists. And although art itself plays the smallest part in these stories, it is characteristic that the artists as such seem to be interesting enough to the story-tellers to warrant their being lifted out of the anonymous existence of the ordinary craftsman and treated as individual personalities. The first half of the Quattrocento already sees the beginnings of the artist's biography, which is such

a typical product of the Italian Renaissance. Brunelleschi is the first artist to have his life written by a contemporary; such a distinction had previously been confined to princes, heroes and saints. Ghiberti writes the first autobiography which we possess by an artist. In honour of Brunelleschi the commune has a sepulchral monument erected in the Cathedral, and Lorenzo desires the remains of Filippo Lippi to be brought home from Spoleto and to be buried with full honours. He is told in reply, however, that it is regretted, but Spoleto is much poorer in great men than Florence and his wish cannot, therefore, be fulfilled. All this is the expression of an unmistakable shift of attention from the works to the personality of the artist. Men begin to be conscious of creative power in the modern sense and there are increasing signs of the rising self-respect of the artist. We possess signatures of nearly all the important painters of the Quattro-cento, and Filarete actually expresses a wish that all artists should sign their works. But even more characteristic than this custom is the fact that most of these painters also leave behind self-portraits, although they are not always self-contained pictures. The artists portray themselves and sometimes their family as well as bystanders beside the founders and patrons, the Madonna and her saints. Thus on a fresco in the church of S. Maria Novella, Ghirlandajo depicts his own relations opposite the founder and his wife, and the city of Perugia even commissions Perugino to put his self-portrait beside his frescoes in the Cambio. Gentile da Fabriano receives the patrician toga from the republic of Venice; the city of Bologna elects Francesco Francia to the office of Gon-faloniere; Florence bestows on Michelozzo the exalted title of Member of the Council.[108]

One of the most significant tokens of the new self-conscious-ness of artists and of their changed attitude to their own work is the fact that they begin to emancipate themselves from direct commissions, and, on the one hand, no longer carry out their orders with the old conscientiousness, and, on the other, often undertake artistic tasks of their own accord without any outside commission. Filippo Lippi is already known not always to have kept to the continuous and uniform rate which was the general rule in craft work and to have left certain commissions on one

side for a time, in order to apply himself to others on the spur of the moment. After his time, we come across this rhapsodic method of working more and more frequently,[109] and in Perugino we already meet a spoilt 'star' who treat his employers quite badly; neither in the Palazzo Vecchio nor in the Ducal Palace in Venice does he carry out the work he has taken on and he makes Orvieto wait so long for the promised painting of the Chapel of the Madonna in the Cathedral that the commune finally entrusts Signorelli with the execution of the work. The gradual ascent of the artist is mirrored most clearly of all in the career of Leonardo, who is, no doubt, esteemed in Florence but still not particularly busy there, who then becomes the pampered court painter of Ludovico Moro, and Cesare Borgias's first military engineer, whilst he ends his life as the favourite and intimate friend of the French king. The fundamental change occurs at the beginning of the Cinquecento. From then onwards the famous masters are no longer the protégés of patrons, but great lords themselves. According to Vasari, Raphael leads the life of a grand seigneur, not that of a painter; he resides in his own palace in Rome, associates with princes and cardinals as equals; Baldassare Castiglione and Agostino Chigi are his friends, a niece of Cardinal Bibbiena is his bride. And Titian climbs even higher up the social ladder. His reputation as the most sought-after master of his time, his way of life, his rank, his titles, raise him into the highest circles of society. Emperor Charles V appoints him a Count of the Lateran Palace and a member of the Imperial Court, makes him a Knight of the Golden Spur and bestows on him a whole series of privileges together with a hereditary nobility. Rulers make a great effort, often without success, to have their portraits painted by him; he has, as Aretino mentions, a princely income; every time he is painted by him, the Emperor gives him costly presents; his daughter Laviniá receives a magnificent dowry; Henry III pays the aged master a personal visit, and when he falls a victim to the plague in 1576, he is buried in the church of the Frari with the greatest honours the Republic can offer, in spite of the strict prohibition, otherwise always observed without exception, against burying a victim of the plague in a church. Michelangelo, finally, rises to absolutely unprecedented heights. His supremacy is so

obvious that he can afford wholly to forgo all public honours, titles and distinctions. He scorns the friendship of princes and popes; he can dare to be their opponent. He is neither a count, nor a state councillor, nor a papal superintendent, but he is called the 'Divine'. He does not wish to be described as a painter or sculptor in letters addressed to him: he says he is simply Michelangelo Buonarroti, no more and no less; he desires to have young noblemen as his pupils, and, in his case, this must not be ascribed simply to snobbery; he maintains that he paints 'col cervello' and not 'colla mano', and would like best of all to conjure forth the figures from the marble block by the mere magic of his vision. This is more than the artist's inborn pride, more than the consciousness of being superior to the craftsman, the mere mechanic, the philistine; it is really evidence of a fear of coming into contact with ordinary reality. He is the first example of the modern, lonely, demonically impelled artist—the first to be completely possessed by his idea and for whom nothing exists but his idea—who feels a deep sense of responsibility towards his gifts and sees a higher and superhuman power in his own artistic genius. A degree of sovereignty is attained here, in the light of which all earlier conceptions of artistic freedom fade into nothingness. Now, for the first time, the full emancipation of the artist is achieved; now, for the first time, he becomes the genius such as we have known him to be since the Renaissance. The final change is now accomplished: it is no longer his art, but the man himself who is the object of veneration and who becomes a vogue. The world, whose glory it was his task to proclaim, now proclaims his glory; the cult of which he was the instrument is now applied to him; the state of divine favour is now transferred from his patrons and protectors to himself. At all times there had really existed a certain reciprocity of praise between the hero and the artist who proclaimed his glory, between the patron and the artist;[110] the greater the fame of the panegyrist, the greater was the value of the glory which he proclaimed. But now the relationship is so sublimated that the patron is exalted by the very act of exalting the artist and praises the artist instead of being praised by him. Charles V stoops to recover the brush which Titian drops, and thinks that nothing is more natural than that a master like Titian

should be waited on by an emperor. The legend of the artist is complete. There is doubtless still an element of coquetry about it: the artist is allowed to swim in the light, so that the patron can shine in the reflection. But will the reciprocity of appreciation and praise, the mutual valuation and rewarding of services, the mutual protection of the other's interest, ever wholly cease? At the most, it will only become more veiled.

The fundamentally new element in the Renaissance conception of art is the discovery of the concept of genius, and the idea that the work of art is the creation of an autocratic personality, that this personality transcends tradition, theory and rules, even the work itself, is richer and deeper than the work and impossible to express adequately within any objective form. This idea remained foreign to the Middle Ages, which recognized no independent value in intellectual originality and spontaneity, recommended the imitation of the masters and considered plagiarism permissible, and which was, at the most, superficially touched but in no sense dominated by the idea of intellectual competition. The idea of genius as a gift of God, as an inborn and uniquely individual creative force, the doctrine of the personal and exceptional law which the genius is not only permitted to but must follow, the justification of the individuality and wilfulness of the artist of genius—this whole trend of thought first arises in Renaissance society, which, owing to its dynamic nature and permeation with the idea of competition, offers the individual better opportunities than the authoritarian culture of the Middle Ages, and which, owing to the increased need for publicity felt by the holders of power, creates a greater demand in the art market than the supply had had to meet in the past. But just as the modern idea of competition reaches back deep into the Middle Ages, so the medieval idea of art as determined by objective, superpersonal factors continues to have an after-effect for a long time and the subjectivist conception of artistic activity makes only very slow progress even after the end of the Middle Ages. The individualistic conception of the Renaissance, therefore, requires correction in two directions. Burckhardt's thesis is not, however, to be dismissed out of hand, for if strong personalities already existed in the Middle Ages,[111] yet to think and act

individually is one thing and to be conscious of one's individuality, to affirm and deliberately to intensify it, is another. One cannot speak of individualism in the modern sense of the term until a reflexive individual consciousness takes the place of a mere individual reaction. The self-recollection of individuality does not begin until the Renaissance, but the Renaissance does not itself begin with the self-recollecting individuality. The expression of personality in art had been sought after and appreciated long before anyone had realized that art was based no longer on an objective What but on a subjective How. Long after it had become a self-confession, people still continued to talk about the objective truth in art, although it was precisely the self-expressionism in art which enabled it to win through to general recognition. The power of personality, the intellectual energy and spontaneity of the individual, is the great experience of the Renaissance; genius as the embodiment of this energy and spontaneity becomes the ideal, in which it finds the supreme expression of the nature of the human mind and its power over reality.

The development of the concept of genius begins with the idea of intellectual property. In the Middle Ages both this conception and the desire for originality are lacking; both are directly interrelated. As long as art is nothing but the representation of the Divine and the artist only the medium through which the eternal, supernatural order of things is made visible, there can be no question of autonomy in art nor of the artist actually owning his work. The obvious suggestion is to connect the idea of intellectual property with the beginnings of capitalism, but to do so would only be misleading. The idea of intellectual productivity and intellectual property follows from the disintegration of Christian culture. As soon as religion ceases to control and unite within itself all the spheres of spiritual life, the idea of the autonomy of the various forms of intellectual expression appears, and an art which bears its meaning and purpose within itself becomes conceivable. In spite of all attempts to base the whole of culture, including art, on religion, no later age has ever succeeded in restoring the cultural unity of the Middle Ages and depriving art of its autonomy. Even when it is placed in the service of extra-artistic purposes, art now remains enjoyable and

significant in itself. But if one ceases to regard the separate intellectual moulds as so many different forms of one and the same truth, then the idea also occurs of making their individuality and originality the criterion of their value. The Trecento is still completely under the spell of *one* master—Giotto—and of his tradition; but in the Quattrocento individualistic efforts begin to make their mark in all directions. Originality becomes a weapon in the competitive struggle. The social process now seizes on an instrument which it has not itself produced, but which it adapts to its purposes and of which it heightens the effectiveness. As long as the opportunities on the art market remain favourable for the artist, the cultivation of individuality does not develop into a mania for originality—this does not happen until the age of mannerism, when new conditions on the art market create painful economic disturbances for the artist. But the ideal of the 'original genius' itself does not appear until the eighteenth century, when, in the transition from private patronage to the free, unprotected market, artists have to wage a sterner fight for their material existence than ever before.

The most important step in the development of the concept of the genius is from the idea óf actual achievement to that of the mere capacity to achieve, from the work to the person of the artist, from the appreciation of full success to that of mere intention and idea. This step could only have been taken by an age which had come to regard a personal style as interesting and instructive in itself. The fact that the Quattrocento already contained certain preconditions of this attitude is shown by a passage in Filarete's treatise, where the forms of a work of art are compared to the pen-strokes of a manuscript, which immediately betray the hand of the writer.[112] The appreciation of and growing fondness for drawings, rough drafts, sketches, the *bozzetto*, for the unfinished work generally, is a further step in the same direction. The origin of the taste for the fragment is likewise to be found in the subjectivist conception of art based on the idea of the genius; the philosophy of art developed by a study of classical torsi merely intensified it. For the Renaissance, the drawing and the sketch became momentous not merely as artistic forms, but also as documents and records of the creative process

in art; they were recognized to be a particular form of expression on their own, distinct from the finished work; they were valued because they revealed the process of artistic invention at its starting point, where it was almost completely merged with the subjectivity of the artist. Vasari mentions that Uccello left behind so many drawings that they filled whole chests. From the Middle Ages, on the contrary, hardly any drawings have come down to us. Apart from the fact that the medieval artist certainly did not ascribe the same importance to his momentary brainwaves as did later masters, and probably did not consider it worth while to record every fleeting idea, the reason for the rarity of extant medieval drawings may well be the fact that drawing only became widespread when usable and reasonably priced stocks of paper became available[113] and that only a comparatively small proportion of the drawings actually done have survived. Old age is certainly not the only reason for their disappearance; it is obvious that less importance was attached to their preservation than later, and the whole difference between the art philosophy of the Middle Ages with its matter-of-fact, objective ways of thought and that of the subjectivistic Renaissance is cogently expressed in the medieval lack of interest in drawings. For the Middle Ages the value of the work of art was purely objective, whereas the Renaissance also attributed a personal value to it. The drawing became the direct formula of artistic creation, for it gave the most striking expression possible to the fragmentary, uncompleted and uncompletable element which adheres, in the final analysis, to every work of art. The raising of the mere capacity for achievement above the achievement itself, this fundamental feature of the concept of the genius, means that genius is regarded as not wholly realizable, and this explains why the incomplete drawing is considered a typical form of art.

It was only one step from the inability of the genius to communicate himself fully, to the misunderstood genius and to the appeal to posterity against the verdict of the contemporary world. The Renaissance never made this step. Not because it had more understanding of art than later ages against whose judgement unsuccessful artists have appealed, but because the artist's struggle

for existence was still expressed in relatively harmless forms. Nevertheless, the concept of the genius already acquires certain dialectical characteristics; it already allows us a glimpse of the defensive machinery which the artist was to set in motion later on against the philistine to whom art is a closed book, on the one hand, and against the bunglers and dilettanti, on the other. Against the first named he was to shelter behind the mask of the eccentric, and against the latter he was to emphasize the inborn quality of his talent and the fact that art cannot be acquired by learning. Francisco de Hollanda already remarks in his *Conversations on Painting* (1548) that every important personality has something peculiar about him, and the idea that the genuine artist must be born was not even completely new at that time. The theory of the inspired quality of the genius, of the super-personal and irrational nature of his performance, shows that it is an intellectual aristocracy which is in process of constitution here, an aristocracy which prefers to forego personal merit, *virtù*, in the sense in which the early Renaissance used the term, in order to define itself the more sharply against others.

The autonomy of art gives expression in an objective form—from the standpoint of the work—to the same idea which the concept of the genius expresses in a subjective form—from the standpoint of the artist. The idea that cultural forms are independent of external laws is the counterpart of the idea of the spontaneity of the mind. On the other hand, the autonomy of art signifies for the Renaissance merely independence of the Church and of the metaphysics propounded by the Church, it does not imply an absolute and universal autonomy. Art emancipates itself from ecclesiastical dogmas, but remains closely connected with the scientific philosophy of the age, just as the artist breaks away from the clergy but enters all the more intimately into relationship with the humanists and their followers. But art is far from becoming a servant of science in the sense in which it was the 'servant of theology' in the Middle Ages. It is and remains rather a sphere in which it is possible, in seclusion from the rest of the world, to organize one's intellectual life and indulge in intellectual pleasures of a quite peculiar kind. As one moves about in this world of art, one is separated both from the transcendent

world of faith and from the world of practical affairs. Art can be made to serve the purposes of faith and be given problems to solve which are also the concern of science, but whatever extra-artistic functions it fulfils, it can always be considered as if it were itself its own object. This is the new point of view which the Middle Ages was not yet able and prepared to make its own. It does not mean, however, that before the Renaissance there was no feeling for and no enjoyment of the formal quality of a work of art, only such feeling and enjoyment was still unconscious and the work of art was judged, as soon as the transition had been made from a purely emotional to a conscious reaction, according to the intellectual content and symbolical value of the representation. The medieval interest in art was confined to the subject-matter, and it was not only in contemporary Christian art that the attention was concentrated on the meaning of the contents of the work, for even classical art was judged purely according to its spiritual content.[114] The change in the Renaissance attitude to classical art and literature is to be ascribed not to the discovery of new works and new authors, but to the transference of interest from the material content to the formal elements of the representation, whether it was a question of newly discovered or already familiar monuments, made no difference.[115] It is typical of the new attitude that the public now adopted the artistic approach of the artists themselves, and judged art not from the standpoint of life and religion but from that of art itself. Medieval art aimed at interpreting life and elevating man, Renaissance art at enriching life and delighting man. To the empirical and the transcendental sphere of life to which the medieval world was restricted, it added a new province, in which both the secular and metaphysical prototypes of existence acquired a new and hitherto undreamt-of meaning of their own.

The idea of an autonomous, non-utilitarian art, enjoyable in itself, was already familiar to the classical age; after being forgotten in the Middle Ages, it was simply rediscovered by the Renaissance. But it had never occurred to anyone before the Renaissance that a life devoted to the enjoyment of art might represent a higher and nobler form of existence. Plotinus and the Neoplatonists had ascribed a higher purpose to art, but had,

at the same time, deprived it of its autonomy and made it a mere vehicle of intelligible knowledge. The idea of an art preserving the autonomy of its aesthetic nature and becoming an educational force despite its independence of the rest of the intellectual world, in fact merely as a result of its sovereign beauty, an idea already foreshadowed by Petrarch,[116] is just as unmedieval as it is unclassical. The whole aestheticism of the Renaissance is unmedieval and unclassical, for even though the application to life itself of the standpoint and standards of art was not wholly foreign to classical antiquity, yet it would be impossible to find a parallel in any other age to the episode reported from the Renaissance of a believer refusing to kiss a crucifix handed to him on his death-bed because it was ugly and asking for a more beautiful one.[117]

The Renaissance conception of aesthetic autonomy is not a purist idea; the artist strives to emancipate himself from the fetters of scholastic thinking, but he is not particularly eager to stand on his own feet and it does not occur to him to make the independence of art a question of principle. On the contrary, he stresses the scientific nature of his intellectual activity. Not until the Cinquecento are the bonds uniting science and art into one homogeneous organ of knowledge loosened; not until then does the idea of the autonomy of art begin to imply that art is also independent of the world of science and learning. There are periods when art is turned in the direction of science, just as there are periods when science is turned in the direction of art. In the early Renaissance the truth of art is made dependent on scientific criteria, whilst in the later Renaissance and in the baroque scientific thinking is in many cases shaped in accordance with artistic principles. The perspective in painting of the Quattrocento is a scientific conception, whereas the Universum of Kepler and Galileo is a fundamentally aesthetic vision. Dilthey is right when he speaks of the 'artistic imagination' in the scientific research of the Renaissance,[118] but one could speak with equal justification of the 'scientific imagination' in the artistic creation of the early Renaissance.

The prestige of the scholar and the scientist in the Quattrocento was not attained again until the nineteenth century. In

both epochs all efforts were concentrated on promoting the expansion of industry and trade by new ways and means, by new scientific methods and technical inventions. This partly explains the primacy of science and the reputation of the scientist in both the fifteenth and the nineteenth centuries. What Adolf Hildebrand and Bernard Berenson understand by 'form' in the plastic arts[119] is, like Alberti's and Piero della Francesca's concept of perspective, more a theoretical than an aesthetic conception. Both categories are signposts in the world of sense experience, means towards the elucidation of spatial relationships, instruments of optical knowledge. The aesthetic philosophy of the nineteenth century can no more hide the theoretical character of its foundations than can the Renaissance the predominantly scientific nature of its interest in the external world. In the spatial values of Hildebrand, the geometrism of Cézanne, the physiological interests of the impressionists, the psychological interests of the whole of modern novel and drama, wherever we turn, we perceive a striving to find one's way about in the world of empirical reality, to explain the world as presented to us by nature, to multiply, to introduce order into and to work up into a rational system the data of sense experience. For the nineteenth century, art is an instrument of knowledge of the external world, a form of living experience, and of the analysis and interpretation of man. But this naturalism directed towards objective knowledge has its origin precisely in the fifteenth century; it was then that art underwent its first course of scientific training, and even today it is still living to some extent on the capital invested at that time. Mathematics and geometry, optics and mechanics, the theory of light and colour, anatomy and physiology were its tools, and the nature of space, the structure of the human body, movement and proportion, studies of drapery and experiments with colours were the problems with which it was concerned. That, for all its scholarliness, the fidelity to nature of the Quattrocento was merely a fiction is best seen from that means of expression, which may be regarded as the most concise epitome of Renaissance art: the central perspective used in the reproduction of space. Perspective was in itself no invention of the Renaissance.[120] Even classical antiquity was familiar with fore-

shortening and reduced the size of individual objects according to their distance from the spectator; but it was not acquainted with the representation of space based on uniform perspective and directed to one optical point, neither was it able or eager to represent the different objects and the space-intervals between them continuatively. The space in its pictorial representations was a compositum made up of disparate parts, not a uniform continuum—in the words of Panovsky, it was an 'aggregate space', not a 'systematic space'. Only since the Renaissance has painting been based on the assumption that the space in which things exist is an infinite, continuous and homogeneous element, and that we usually see things uniformly, that is to say, with a single and motionless eye.[121] But what we actually perceive is a limited, discontinuous and heterogeneously compacted space. Our impression of space is distorted and blurred at the edges in reality, its content is divided into more or less independent groups and pieces, and, since our physiologically conditioned field of vision is spheroid, we see, to some extent, curves instead of straight lines. The picture of space based on planimetric perspective such as Renaissance art presents us with, characterized by the equal clarity and the consistent shaping of all parts, the common vanishing point of the parallels and the uniform module of distance measurement, the picture which L. B. Alberti defined as the transverse section of the optical pyramid, is a daring abstraction. Central perspective produces a mathematically accurate but psycho-physiologically impossible representation of space. This completely rationalized conception could appear to be the adequate reproduction of the actual optical impression only to such a thoroughly scientific period as the centuries between the Renaissance and the end of the nineteenth century. Uniformity and consistency were in fact the highest criteria of truth during the whole of this period. It is only in recent times that we have again become aware of the fact that we see reality not in the form of a consistently organized and unified space, but rather in scattered groups from different visual centres, and that, as our eye moves from one group to another, we add together the total panorama of a more extensive complex from partial views of the whole, just as Lorenzetti did in his great mural paintings in

Siena. At any rate, the discontinuous representation of space in these frescoes makes a more convincing impression today than the pictures drawn according to the rules of central perspective by the masters of the Quattrocento.[122]

The versatility of talent, and especially the union of art and science in one person, has been felt to be particularly characteristic of the Renaissance. But the fact that artists were masters of several different techniques, that Giotto, Orcagna, Brunelleschi, Benedetto da Majano, Leonardo da Vinci, were architects, sculptors and painters, Pisanello, Antonio Pollajuolo, Verrocchio, sculptors, painters, goldsmiths and medallists, that, in spite of advancing specialization, Raphael was still both a painter and an architect, and Michelangelo a sculptor, painter and architect at the same time, is connected more with the craft-like character of the visual arts than with the Renaissance ideal of versatility. Encyclopaedic learning and practical versatility are in fact medieval ideals; the Quattrocento takes them over along with the tradition of craftsmanship and abandons them to the same extent as it abandons the spirit of craftsmanship. In the later Renaissance we more and more seldom meet artists practising different kinds of art at the same time. But with the victory of the humanistic conception of culture, the idea of the *uomo universale*, an intellectual tendency opposed to specialization, comes to the fore again and leads to the cult of a type of versatility which is more akin to the dilettante than the craftsman. At the end of the Quattrocento both tendencies vie with each other. On the one side, the universalism of the humanistic ideal, suited to meet the requirements of the upper classes, reigns supreme. Under its influence the artist tries to supplement his manual skill with knowledge of an intellectual and cultural kind. On the other side, the principle of the division of labour and specialization is triumphant and gradually attains supreme power even in the field of art. Cardano already points out that to be occupied with several different things at the same time undermines the reputation of a cultured man. As opposed to the tendency to specialize, reference must be made above all to the remarkable fact that of the leading architects of the High Renaissance only Antonio da Sangallo had prepared himself for the career; Bramante was originally

a painter, Raphael and Peruzzi continued to combine painting with architecture, and Michelangelo is and remains above all a sculptor. The fact that the architectural profession was taken up comparatively so late in life and that many of the masters received a predominantly theoretical training for it shows, on the one hand, how quickly practical education had been superseded by intellectual and academic education, and, on the other, how architecture becomes to some extent the pastime of an amateur. At all times the grand seigneur has in fact been fond of acting not merely as a patron but also as a dilettante architect.

Ghiberti needed several decades to complete the doors of the Baptistry and Luca della Robbia also spent nearly ten years on his Cantoria for the Cathedral in Florence. On the other hand, Ghirlandajo's method of working is already characterized by the *fa presto* technique of the genius, and Vasari sees a direct token of genuine artistic talent in ease and speed of production.[123] Both elements, dilettantism and virtuosity, contradictory as they are in themselves, are united in the humanist, who has been rightly described as the 'virtuoso of the intellectual life', but one might describe him equally well as the unspoilt and eternally youthful dilettante. Both elements are contained in the ideal of personality which the humanists are concerned to realize; but in their paradoxical union there is expressed the problematical nature of the intellectual life led by the humanists with its roots in the concept of the literary profession itself, of which they are the first representatives—the concept of a professional class which claims to be perfectly independent but is in fact tied in many ways. The Italian writers of the fourteenth century still came very largely from the higher classes of society; they were members of the urban aristocracy or the sons of well-to-do bourgeois. Cavalcanti and Cino da Pistoja were of noble extraction, Petrarch was a notary's son, Brunetto Latini was himself a notary, Villani and Sacchetti were prosperous merchants, Boccaccio and Sercambi the sons of rich merchants. These writers had hardly anything in common with the medieval minstrels.[124] But the humanists belong neither to a class-determined, nor to a culturally and professionally uniform social category, they include clerics and laymen, rich and poor, high officials and minor notaries, merchants

and schoolmasters, lawyers and scholars.[125] The representatives of the lower classes come, however, to form an ever-increasing proportion of their total numbers. The most famous, most influential of all of them is the son of a shoemaker. They are all town-born and bred—this is, at any rate, one characteristic which they share; many of them are the children of poor parents, some of them child prodigies, who, intended for a promising and highly attractive career, find themselves in unusual circumstances from the very start. Exaggerated ambitions aroused early in life, years of exacting study, often involving economic hardship, of struggle in tutorial and secretarial work, the search for position and fame, friendships with the great, jealousy-ridden animosities, cheap successes and undeserved failures, overwhelming honours and admiration, on the one hand, and vagabondage on the other—all these experiences could not fail to have an influence and inflict great moral injury on them. The social conditions of the age offered opportunities to a man of letters and threatened him with dangers which were apt to poison the spirit of a gifted young man from the outset.

The precondition of the rise of humanism as a, theoretically, free literary profession was the existence of a comparatively broad propertied class, able to provide a ready-made literary public. It is true that from the very beginning the most important centres of the humanist movement were the courts and state chancelleries, but most of its supporters were well-to-do merchants and other elements who had acquired money and influence through the rise of capitalism. The works of medieval literature were still intended only for a very limited circle, consisting usually of people already well known to the writers; the humanists are the first authors to address themselves to a broader and to some extent unknown public. Something in the nature of a free literary market and a public opinion conditioned and influenced by literature has only existed since their time. Their speeches and pamphlets are the first forms of modern journalism; their letters, which circulated amongst a relatively wide public, were the newspapers of their day.[126] Arentino is the 'first journalist' and, at the same time, the first blackmailing journalist. The freedom to which he owes his existence first became possible in an age in which the

writer was no longer absolutely dependent on a single patron or a strictly limited circle of patrons, but had so many potential customers for his products that he no longer needed to be on good terms with all of them. But, after all, it was only a comparatively small educated class on whom the humanists could rely for their public, and, compared with the modern man of letters, they still led a parasitical life, unless they had private means and were, therefore, independent from the very start. They were usually dependent on the favour of the courts and the patronage of influential citizens, whom they normally served as secretaries or private tutors. They drew salaries from the state, pensions and benefices instead of the old board and lodging and donations— their rather costly maintenance was regarded by the new élite as one of the inevitable expenses in the upkeep of an elegant household. Instead of a court singer or fool, a private historian or professional panegyrist, the gentleman of private means now kept a humanist in the house, but the services he performed, though the forms it took were somewhat sublimated, were in fact very much the same. On the other hand, more was expected of him than the mere performance of these services. For, just as the upper bourgeoisie had formerly allied itself with the hereditary aristocracy, it now wanted to enter into relationship with the intellectual aristocracy. Through the first great alliance it acquired a share in the privileges of noble birth, through the second it was to become intellectually ennobled.

Labouring under the misapprehension that they were intellectually free, the humanists were bound to feel their dependence on the ruling class humiliating. Patronage, that age-old and unproblematical institution, which was one of the things a poet of the Middle Ages took for granted, became a problem and a danger for the humanists. The relationship of the intelligentsia to property and wealth assumed increasingly complicated forms. To begin with, the humanists shared the stoical view of the wandering scholars and mendicant friars and regarded wealth in itself as valueless. As long as they were merely students, teachers and literati, they did not feel themselves called upon to change this opinion, but when they came into closer touch with the propertied class, an insoluble conflict arose between their former

views and their new way of life.[127] It did not occur at all to the Greek sophist, the Roman rhetor, or the medieval cleric to move outside his fundamentally contemplative position in life, which engaged him in nothing more practical than educational work, and to compete with the ruling classes. The humanists are the first intellectuals to claim the privileges of property and rank, and intellectual arrogance, likewise a hitherto unknown phenomenon, is the psychological weapon of self-defence with which they react against their lack of success. The humanists are first encouraged and promoted in their ambitious strivings by the upper classes but are nevertheless finally held down. From the very outset, there is mutual suspicion between the arrogant cultured class, fighting against all external ties, and the matter-of-fact, fundamentally unintellectual business class.[128] For just as the dangers of the Sophistic way of thinking had been felt acutely in the age of Plato, so now, too, the upper class is, for all its sympathy for the humanist movement, full of unconcealable suspicion against the humanists, who do in fact constitute a destructive element on account of their rootlessness.

The latent conflict between the intellectual and the economic upper class is nowhere openly engaged as yet, least of all by the artists, who, with their less developed social consciousness, react more slowly than their humanistic masters. But the problem, even if it is unadmitted and unexpressed, is present all the time and in all places, and the whole intelligentsia, both literary and artistic, is threatened by the danger of developing either into an uprooted, 'unbourgeois' and envious class of bohemians or into a conservative, passive, cringing class of academics. The humanists escape from this alternative into their ivory tower, and finally succumb to both the dangers which they had intended to avoid. They are followed in this by the whole modern aesthetic movement, which, like them, becomes uprooted and passive at the same time, serving the interests of conservatism without being able to adapt itself to the order which it supports. By independence the humanist understands the lack of ties; his social disinterestedness is really an alienation from society; and his escape from the present is irresponsibility. He abstains from all political activity, in order not to tie himself down, but by his passivity he

only confirms the holders of power. This is the real 'trahison des clercs', the betrayal of intellectual values by the intelligentsia, not the politicization of the spirit, for which it has been blamed in recent times.[129] The humanist loses touch with reality, he becomes a romantic who calls his estrangement from the world aloofness, his social indifference intellectual freedom, his bohemian way of thinking moral sovereignty. 'The meaning of life for him is'—as an expert on the Renaissance has put it—'to write a choice prose style, to shape exquisite stanzas, to translate from Greek into Latin. . . . What is essential to his mind is not that the Gauls should have been conquered, but that commentaries have been written about their having been conquered . . . the beauty of the deed yields to the beauty of the style. . . .'[130] The artists of the Renaissance are by no means so alienated from their contemporaries as the humanists, but their intellectual existence is already undermined, and they no longer succeed in finding the adjustment which enabled them to adapt themselves to the structure of medieval society. They stand at the cross-roads between activism and aestheticism. Or have they already made their choice? At any rate, they have lost the connection between artistic forms and extra-artistic purposes, a simply and absolutely unproblematical reality taken for granted by the Middle Ages.

The humanists are, however, not merely non-political aesthetes, idle speechifyers and romantic escapists, but also enthusiastic world-reformers, fanatical pioneers of progress and, above all, tireless pedagogues, rejoicing in the future. The painters and sculptors of the Renaissance owe them not only their abstract aestheticism, but also the idea of the artist as an intellectual hero and the conception of art as the educator of humanity. They were the first to make art an ingredient of intellectual and moral culture.

4. THE CLASSICISM OF THE CINQUECENTO

When Raphael came to Florence in 1504, Lorenzo had been dead for over ten years, his successor had been banished and the Gonfaloniere Pietro Soderini had introduced a bourgeois regime in the Republic again. But the change in the direction of a

courtly representative, strictly formal artistic style had already been prepared for, the guiding principles of the new conventional taste had been laid down and generally recognized—the whole development merely had to proceed along the same road, without any new stimulus from outside. Raphael had only to continue in the direction already traced out in the works of Perugino and Leonardo, and, as a creative artist, he could do nothing else but follow this intrinsically conservative tendency, conservative because tending towards a timeless and abstract canon of form, but nevertheless progressive in the stylistic situation of the time. Incidentally, there was also no lack of external stimuli to cause him to keep to the direction, even though the impetus no longer emanated from Florence. But outside Florence there were families with dynastic claims and courtly manners at the helm all over Italy, and a regular court was formed, above all, around the person of the Pope in Rome, in which the same social ideals prevailed as in the other courts where art and culture were used to contribute to the outward brilliance of life.

In disintegrated Italy, the Pontifical State had seized the reins of political power. The Popes felt that they were the heirs of the Caesars and they also partly succeeded in exploiting for their own power-political ends the fantastic expectations of a renewal of the old glory of the Roman Empire which were burgeoning in every corner of the land. It is true that their political endeavours remained unfulfilled, but Rome became the centre of Western civilization and attained an intellectual influence which became still deeper during the Counter Reformation and remained active until far into the baroque period. Since the return of the Popes from Avignon, the city had been not only a diplomatic meeting place, with ambassadors and chargés d'affaires from every corner of the Christian world, but also an important money market where what must have then seemed exorbitant sums flowed in and were spent. As a financial power the curia surpassed all the princes, tyrants, bankers and merchants of North Italy; it could afford a more sumptuous expenditure on culture than all of them and it took over the lead in the field of art hitherto held by Florence. When the Popes returned from France, Rome lay almost in ruins after the barbaric invasions and the destruction

caused by the century-long feuds of the Roman patrician families. The Romans were poor, and even the ecclesiastical dignitaries were unable to amass sufficient wealth to finance a revival of art which would have allowed Rome to compete with Florence. During the Quattrocento the papal residence had no Roman artists at its disposal; the Popes were dependent on outside forces. They called the most famous masters of the age to Rome, including Masaccio, Gentile de Fabriano, Donatello, Fra Angelico, Benozzo Gozzoli, Melozzo da Forlì, Pinturicchio and Mantegna, but after carrying out their commissions, they all left the city, without leaving behind the slightest trace apart from their works. Even under Sixtus IV (1471–84), who, by the commissions he gave for the decoration of his chapel, made Rome a centre of artistic production for a time, no school or tendency came into existence with a local Roman character. Such a tendency is not discernible until the papacy of Julius II (1503–13), after Bramante, Michelangelo and, finally, Raphael had settled in Rome and placed their gifts at the service of the Pope. That is the earliest beginning of that unique period of artistic activity of which the result is the monumental Rome, which we now see before us, not only as the greatest but also as the sole authoritative memorial of the High Renaissance, and which could have arisen at that time only under the conditions prevailing in the papal residence.

As opposed to the predominantly secular-minded art of the Quattrocento, we are now confronted with the beginnings of a new ecclesiastical art, in which, however, the emphasis is laid not on spiritual and supramundane values, but on solemnity, majesty, might and glory. The inwardness and other-worldliness of Christian feeling yields to an aloof coldness and the expression of physical as well as intellectual superiority. With every church, chapel, altar-piece and baptismal font, the Popes' chief intention seems to have been to immortalize themselves, thinking more of their own glory than of the glory of God. Court life in Rome reaches its zenith under Leo X (1513–21). The papal curia is like the court of an emperor; the cardinals' houses are reminiscent of small secular courts, and those of the other spiritual gentlemen of aristocratic households which try to outbid each other in splendour. Most of these princes and dignitaries of the Church

are interested in art from the outset; they employ artists to immortalize their names either by the endowment of ecclesiastical art, or by the erection and embellishment of their palaces. The rich bankers of the city, with Agostino Chigi, the friend and patron of Raphael, at their head, try to vie with them as patrons of the arts; they increase the importance of Rome as an art market, but add no new note of their own to it.

In contrast to the, generally speaking, uniform ruling class in the other Italian cities, above all in Florence, the upper class in Rome is made up of three sharply defined groups.[131] The most important consists of the papal household, with the Pope's relations, the higher ranks of the clergy, the Italian and foreign diplomats and the other innumerable personalities who have a share in the pontifical splendours. The members of this group are, on the whole, the most ambitious and moneyed supporters of art. A second group includes the great bankers and rich merchants, for whom economic conditions were the most propitious imaginable in the extravagant Rome of the time, now the centre of the world-embracing financial administration of the papacy. The banker Altoviti is one of the most generous supporters of art of the whole period, and, with the exception of Michelangelo, Raphael's enemy, all the most famous artists of the time work for Agostino Chigi; apart from Raphael, he employs Sodoma, Baldassare Peruzzi, Sebastiano del Piombo, Giulio Romano, Francesco Penni, Giovanni da Udine, as well as many other masters. The third group consists of the members of the old and already impoverished Roman families, who take almost no part in artistic life, and who only keep their names in the public eye at all by marrying their sons and daughters to the children of rich citizens, thereby bringing about a similar, though less comprehensive fusion of the classes, as had already taken place, in earlier times, in Florence and other cities, as a result of the participation of the old nobility in the business activities of the middle class.

At the beginning of the reign of Julius II it is possible to identify eight to ten painters resident in Rome, but only twenty-five years later as many as a hundred and twenty-four painters belonged to the Fraternity of St. Luke, of whom most were ordinary craftsmen, however, who, attracted by the require-

ments of the papal court and the rich bourgeoisie, flocked to Rome from all parts of Italy.[132] Now, however great the share which the prelates and bankers take in the production of art, in their capacity as employers, it is extremely characteristic of the art of the High Renaissance that Michelangelo worked almost exclusively, and Raphael also for the most part, for the Vatican. That fact is of decisive importance in the development of the style of this period. Only here, in the service of the Pope,'could that *maniera grande* be developed compared with which the artistic trends of the other local schools are all more or less provincial in character. Nowhere else do we find this lofty, exclusive style, which is so deeply impregnated with the elements of culture and learning and so completely restricted to the solution of sublimated formal· problems. The art of the early Renaissance could still at least be misunderstood by the broad masses; even the poor and the uneducated could find some points of contact with it, although these were on the periphery of its real aesthetic influence; but the masses have no contact at all with the new art. What possible meaning could Raphael's 'School of Athens' and Michelangelo's Sybils have had for them, even if they had ever been able tó see these works?

But it was precisely in such works that the classical art of the Renaissance was realized, this art that we are in the habit of praising for the universality of its appeal, and yet, in reality, it was addressed to a smaller public than any preceding it. At any rate, its public influence was more ·limited than that of Greek classicism, with which it did, however, have this in common, that, despite its tendency to stylization, it implied not merely no surrender, but, on the contrary, an intensification and consummation, of the naturalistic achievements of the previous period. Just as the statues of the Parthenon are shaped 'more correctly', more in accordance with normal experience, than the tympana of the Temple of Zeus in Olympia, for example, so the individual objects in the works of Raphael and Michelangelo are treated more naturally, more freely, more as a matter of course, than in those of the masters of the Quattrocento. In the whole of Italian painting before Leonardo there is no human figure which, compared with the figures of Raphael, Fra Bartolommeo, Andrea

del Sarto, Titian and Michelangelo, has not something clumsy, stiff, constricted about it. However rich they are in accurately observed details, the figures of the early Renaissance never stand quite firmly and securely on their feet, their movements are always somewhat cramped and forced, their limbs creak and wobble at the joints, their relationship to the space around them is often contradictory, the way they are modelled is obtrusive and the way they are illuminated artificial. The naturalistic efforts of the fifteenth century do not come to fruition until the sixteenth. The stylistic unity of the Renaissance is expressed, however, not merely in the fact that the naturalism of the fifteenth century is continued and consummated in the Cinquecento, but also in the fact that the process of stylization which leads to the classical art of the High Renaissance begins in the middle of the Quattrocento. One of the most important concepts of classicism, the definition of beauty as the harmony of all the parts, is already formulated by Alberti. He thinks that the work of art is so constituted that it is impossible to take anything away from it or to add anything to it, without impairing the beauty of the whole.[133] This idea, which Alberti had found in Vitruvius and which really has its source in Aristotle,[134] remains one of the fundamental propositions of the classical theory of art. But how can this comparative uniformity in the art philosophy of the Renaissance—with the beginnings of classicism in the Quattrocento and the continuance of naturalism in the Cinquecento—be reconciled with the social changes in the same period? The High Renaissance preserves the sense of fidelity to nature, maintains and even tightens up the empirical criteria of artistic truth, obviously because, like the classical period of the Greeks, it represents, for all its conservatism, a still fundamentally dynamic age, in which the process of rising in the social scale is not yet complete, and in which it is still impossible for any definite and final conventions and traditions to develop. Yet the attempt to bring the levelling process to an end and to prevent any further rises up the social ladder had been in full swing since the arrival of the middle class and its intermingling with the nobility; the beginnings of the classicistic conception of art in the Quattrocento are in accordance with this tendency.

The fact that the change from naturalism to classicism does not take place abruptly, but is prepared so long beforehand, can easily lead to a misunderstanding of the whole process of the stylistic transformation which now takes place. For, if one concentrates one's attention on the portents of the coming change and proceeds from transitional phenomena such as the art of Leonardo and Perugino, one will get the impression that the change goes on without a single break and with an almost logical inevitability, and that the art of the High Renaissance is nothing but the mere synthesis of the achievements of the Quattrocento. In a word, one will be easily persuaded to conclude that the development of the styles was endogamous. The change from classical to Christian art, or from Romanesque to Gothic, introduces so much that is fundamentally new that the more recent style can hardly be explained in terms of immanence, that is to say, as the mere dialectical antithesis or synthesis of the older style, and requires an explanation based on other than purely artistic and stylistic motives. In the case of the transition from the Quattrocento to the Cinquecento the situation is different, however. Here the change of style takes place almost without a break, in exact accordance with the social development, which is itself continuous. But it does not, therefore, take place automatically, that is, as a logical function with completely known coefficients. If social conditions, at the end of the fifteenth century, had developed differently, owing to some circumstance difficult for us to imagine —if, for example, a fundamental economic, political, or religious change had occurred instead of the consolidation of the conservative tendency for which the way had already been prepared— then, in accordance with such a change, art too would have developed in a different direction, and the resulting style would have represented a different 'logical' consequence of the early Renaissance from that consummated in the classical style. For, if one is going to apply the principle of logic to historical developments at all, one should at least admit that a set of historical circumstances may have several divergent results.

Raphael's Arazzi have been called the Parthenon sculptures of modern art; the analogy may be allowed to stand, provided one does not forget the vast difference between ancient and modern

classicism, despite all their similarity. Compared with Greek art, modern classical art is lacking in warmth and immediacy; it has a derived, retrospective and, even in the Renaissance, a more or less classicistic character. It is the reflection of a society which, filled with reminiscences of Roman heroism and medieval chivalry, tries to appear to be something which it is not, by following an artificially produced social and moral code, and which stylizes the whole pattern of its life in accordance with this fictitious scheme. Classical art describes this society as it wants to see itself and as it wants to be seen. There is hardly a feature in this art which would not, on closer examination, prove to be anything more than the translation into artistic terms of the aristocratic, conservative ideals cherished by this society striving for permanence and continuity. The whole artistic formalism of the Cinquecento merely corresponds to the formalized system of moral conceptions and decorum which the upper class of the period imposes on itself. Just as the aristocracy and the aristocratically-minded circles of society subject life to the rule of a formal code, in order to preserve it from the anarchy of the emotions, so they also submit the expression of the emotions in art to the censorship of definite, abstract and impersonal forms. For this society, self-control, the suppression of the passions, the subduing of spontaneity, of inspiration and ecstasy, are the highest commandment. The display of the feelings, the tears and grimaces of pain, swooning, wailing and wringing of the hands, in brief, all that bourgeois emotionalism of which some remains from the late Gothic survived in the Quattrocento, disappears from the art of the High Renaissance. Christ is no longer a suffering martyr, but once again the heavenly King above all human weakness. Mary looks at her dead son with no tears, no gestures; indeed she suppresses any kind of plebeian gentleness even towards the Christ child. Moderation in all things is the watchword of the age. The rules of discipline and order in the conduct of daily life find their closest analogy in the principles of economy and conciseness which art imposes upon itself. L. B. Alberti had already anticipated this idea of artistic economy. 'Whoever strives after dignity in his work', he thinks, 'will limit himself to a small number of figures; for just as princes enhance their majesty by the shortness

of their speeches, so a sparing use of figures increases the value of a work of art'.[135] Mere co-ordination of the formal composition is now replaced everywhere by the principle of concentration and subordination. But one must not imagine the functioning of social causality to be such that the authority which holds sway over the individual in social life becomes, in the field of art, the rule of the total plan governing all the separate parts of a composition, and that, therefore, the democracy of the elements of art is now transformed, as it were, into the sovereignty of the basic idea of the composition. The simple equation of the principle of authority in social life and the idea of subordination in art would be a mere equivocation. But a society based on the idea of authority and submission will, naturally, favour the expression and manifestation of discipline and order in art, and the conquest of rather than the surrender to reality.

Such a society will want to invest the work of art with regularity and necessity. It will want art to prove that there are universally valid, unshakable, inviolable standards and principles, that the world is ruled by an absolute and immutable purpose, and that man—though not every individual man—is the custodian of this purpose. Art forms will have to be authoritative to agree with the ideas of this society, and must make a definitive and consummate impression comparable to that which the authoritarian order of the age desires to make. The ruling class will look to art, above all, as the symbol of the calm and stability which it aspires to attain in life. For, if the High Renaissance develops artistic composition in the form of the symmetry and correspondence of the separate parts, and forces reality into the pattern of a triangle or circle, then that does not imply merely the solution of a formal problem, but also the expression of a stable outlook on life and of the desire to perpetuate the state of affairs which corresponds to this outlook. It places the norm above personal freedom in art and considers the pursuit of the norm here, as in life itself, to be the most certain way to perfection. The main ingredient in this perfection is the totality of outlook, which is attained only by the complete integration of the parts in a whole, never by the mere process of addition. The Quattrocento represented the world as in a state of never-ending flux, as an

uncontrollable, never completable process of growth; the individual person felt himself small and powerless in this world and surrendered himself to it willingly and thankfully. The Cinquecento experiences the world as a totality with definite boundaries; the world is as much as, but no more than man can grasp; and every perfect work of art expresses in its own way the whole of the reality that man can comprehend.

The art of the High Renaissance is absolutely secular in its outlook; even in the representations of religious subjects, it attains its ideal style not by contrasting natural with supernatural reality, but by creating a distance between the objects of natural reality itself—a distance which in the world of visual experience creates differences of value similar to those that exist between the élite and the masses in human society. Its harmony is the utopian ideal of a world from which all conflict is excluded, and moreover, not as a result of the rule of a democratic but of an autocratic principle. Its creations represent an enhanced, ennobled reality exempt from transitoriness and banality. Its most important stylistic principle is the restriction of the representation to the bare essentials. But what are these 'essentials'? They are the lasting, unchanging incorruptible things whose value lies, above all, in their remoteness from mere actuality and chance. On the other hand, the concrete and the direct, the accidental and the individual, in a word, those things which the art of the Quattrocento considered the most interesting and substantial elements in reality, are regarded by this art as inessentials. The élite of the High Renaissance creates the fiction of a timelessly valid, 'eternally human' art, because it wants to think of its own influence and position as timeless, imperishable and immutable. In reality, of course, its art is just as time-conditioned, just as limited and transitory, with its own standards of value and criteria of beauty, as the art of any other period. For even the idea of timelessness is the product of a particular time, and the validity of absolutism just as relative as that of relativism.

The most time-bound and most strictly sociological of all the factors of High Renaissance art is the ideal of kalokagathia. The dependence of its concept of beauty on the aristocratic ideal of personality is nowhere so strikingly expressed as in this element.

It is not the fact that physical beauty comes into its own in the Cinquecento that is new and a special mark of its aristocratic outlook—in contrast to the spiritualism of the Middle Ages, the fifteenth century had already had a loving eye for the attractions of the body—but what is new is that physical beauty and power become the valid expression of intellectual beauty and significance. The Middle Ages felt there was an irreconcilable conflict between the life of the unsensual spirit and the unspiritual body; the conflict was stressed more at some times than at others, but it was always present somewhere in men's thoughts. The medieval incompatibility of the spiritual and the physical loses its significance in the age of the Quattrocento; spiritual and intellectual significance is still not bound up unconditionally with physical beauty, but the two are no longer mutually exclusive. The tension which still exists here between spiritual and physical qualities disappears completely in the art of the High Renaissance. According to the presuppositions of this art, it would seem inconceivable, for example, that the apostles should be represented as ordinary peasants and commonplace artisans, as they were so often and with such relish in the fifteenth century. For this new art, the prophets, apostles, martyrs and saints are ideal personalities, free and great, powerful and dignified, grave and solemn—a heroic race in the full bloom of ripe, sensuous beauty. In Leonardo's work we still find everyday types alongside of these noble figures, but gradually nothing comes to appear worthy of artistic representation that is not grand and sublime. The water-carrier in the Raphaelesque 'Fire in the Borgo' belongs to the same race as Michelangelo's Madonnas and Sybils—a race gigantic, energetically active, self-confident and assured in all its movements. The grandeur of these figures is so overwhelming that, in spite of the old dislike of the aristocratic classes for the representation of the nude, they are allowed to appear unclothed; they thereby lose nothing of their sublimity. In the noble formation of their limbs, in the elegant harmony of their gestures, in the grave dignity of their bearing the same distinction is expressed as in the costumes that they otherwise wear, which are heavy, with deep folds, rustling as they move, and always tastefully reticent and fastidiously choice.

The ideal of personality which Castiglione represents in his 'Cortegiano' as thoroughly attainable, as having, in fact, already been attained, is taken as the model here and only heightened by that extra degree which every classical art adds to the size of its model. The courtly ideal contains, in essentials, all the predominant features of the High Renaissance representation of man in art. What Castiglione demands of the perfect man of the world is, first of all, versatility, the uniform development of physical and spiritual capacities, skill both in the use of weapons and in the art of refined social intercourse, experience in the arts of poetry and music, familiarity with painting and the sciences. It is obvious that the determining factor in Castiglione's thought is the aristocratic aversion from every kind of specialization and professional activity. In their kalokagathia, the heroic figures of High Renaissance art are nothing more than the translation of this human and social ideal into visual terms. But it is not merely the lack of tension between their spiritual and physical qualities, not merely the equation of physical beauty and spiritual power, that corresponds to the courtly ideal, but, above all, the freedom with which they move, the relaxed carriage and the calm, in fact the care-free, nature of their whole bearing. For Castiglione, the quintessence of refinement is that one should preserve one's composure and self-control under all circumstances, avoid all ostentation and exaggeration, give an impression of unconstraint, not strike an attitude, and behave in company with an unaffected nonchalance and effortless dignity. Now, in the figures of Cinquecento art we rediscover not only this composure of the gestures, this calmness of bearing, this freedom of movement, but the change-over from the previous period also extends to the purely formal elements: the slender, bloodless, Gothic form and the broken, short-winded line of the Quattrocento gain an assured flow, a rhetorical verve, an elegant roundness more perfectly than in any art since the age of classical antiquity. The artists of the High Renaissance no longer find any pleasure in the short, angular, hasty movements, the sprawling and ostentatious elegance, the austere, youthful, unripe beauty of the Quattrocento figures. They extol the abundance of power, the ripeness of age and beauty; they portray life as being, not as a process of

86

becoming; they work for a society of people who have arrived, and want to remain where they are, and, like them, their feelings are conservative. Castiglione desires that the nobleman should strive to avoid the conspicuous, the loud and the motley both in his behaviour and in his dress, and recommends him to wear, like the Spaniards, black or, at any rate, dark clothes.[136] The change of taste which is manifest here goes so deep that even in art the colourfulness and brightness of the Quattrocento are avoided. That is the first victory of that fondness for the monochrome, especially black and white, which dominates modern taste. The colours disappear, first of all, from architecture and sculpture, and, from now on, people obviously find it difficult to imagine the works of Greek architecture and sculpture as coloured. The classical age already bears within itself the essence of the classicistic style.[137]

The High Renaissance was of short duration; it covered no more than twenty years. After the death of Raphael it is hardly possible to speak of classical art as representative of a general stylistic trend. The shortness of its life is typical of the fate of all the periods of classical style in modern times; since the end of feudalism the epochs of stability have been nothing but short episodes. The rigorous formalism of the High Renaissance has certainly remained a constant temptation for later generations, but apart from short, mostly sophisticated and educationally inspired movements, it has never prevailed again. On the other hand, it has proved to be the most important undercurrent in modern art; for even though the strictly formalistic style, based on the typical and the normative, was unable to hold its own against the fundamental naturalism of the modern age, nevertheless, after the Renaissance, a return to the incoherent, cumulative, co-ordinating formal methods of the Middle Ages was no longer possible. Since the Renaissance, we think of a work of painting or sculpture as a concentrated picture of reality, seen from a single and uniform point of view—a formal structure that arises from the tension between the wide world and the undivided subject opposed to the world. This polarity between art and the world was mitigated from time to time, but never again abolished. It represents the real inheritance of the Renaissance.

5. THE CONCEPT OF MANNERISM

Mannerism came so late into the foreground of research on the history of art, that the depreciatory verdict implied in its very name is often still taken to be adequate, and the unprejudiced conception of this style as a purely historical category has been made very difficult. In the case of other names given to historical styles, such as Gothic and Renaissance, baroque and classicism, the original—positive or negative—valuation has already become completely obliterated, but in the case of mannerism, on the other hand, the negative attitude is still so strongly active that one has to fight against a certain inner resistance, before one can summon up the courage to call the great artists and writers of this period 'manneristic'. Not until the concept of the manneristic is completely separated from that of the mannered, do we get a category that can be used in the historical investigation of these phenomena. The purely descriptive concept of the species and the qualitative concept, which have to be distinguished from each other here, coincide over certain stretches, but intrinsically they have almost nothing in common.

The conception of post-classical art as a process of decline, and of the manneristic practice of art as a rigid routine slavishly imitating the great masters, is derived from the seventeenth century and was first developed by Bellori in his biography of Annibale Carracci.[138] Vasari still uses *maniera* to mean artistic individuality, a historically, personally or technically conditioned mode of expression, hence 'style' in the widest sense of the word. He speaks of a *gran' maniera*, and means something thoroughly positive. The term *maniera* has a wholly positive meaning in Borghini, who even regrets the lack of this quality in certain artists,[139] and thereby anticipates the modern distinction between style and lack of style. The classicists of the seventeenth century —Bellori and Malvasia—are the first to connect with the concept of the *maniera* the idea of an affected, hackneyed style of art, reducible to a series of formulae; they are the first to be aware of the breach that mannerism introduces into the development of art, and the first to be conscious of the estrangement from classicism which makes itself felt in art after 1520.

But why does this estrangement really take place so early? Why does the High Renaissance remain a 'narrow ridge'—as Woelfflin says—which is crossed the moment it is reached? A ridge which is even still narrower than Woelfflin would lead one to think. For not only the works of Michelangelo, but even those of Raphael already contain within them the seeds of dissolution. The 'Expulsion of Heliodorus' and the 'Transfiguration' are full of anti-classical tendencies bursting through the framework of the Renaissance in more than one direction. What is the explanation of the shortness of the time in which classical, conservative and rigorously formal principles hold undisturbed sway? Why does classicism, which in antiquity was a style based on composure and permanence, now appear as a 'transitory stage'? Why does it degenerate so quickly this time into a purely external imitation of classical models, on the one hand, and a spiritual aloofness from them, on the other?—Perhaps, because the balance that found its artistic expression in the classicism of the Cinquecento was more an ideal and a fiction than a reality from the very outset, and because the Renaissance remained, as we know, to the very last an essentially dynamic age, which was unable to find complete satisfaction in any one solution of its problems. The attempt which it made to master the shifting nature of the capitalistic mind and the dialectical nature of the scientific outlook was, at any rate, no more successful than the similar attempts made in later periods of modern cultural development. A state of constant social composure has never been reached again since the Middle Ages; therefore, above all, the classicistic movements of modern times are more the result of a programme and the reflection of a hope than the expression of a state of calm assurance. Even the precarious balance which arose around the turn of the Quattrocento, as the creation of the sated, courtier-aping upper middle class and of the capitalistically strong and politically ambitious curia, was of short duration. After the loss of Italy's economic supremacy, the deep shock sustained by the Church in the Reformation, the invasion of the country by the French and the Spaniards and the Sack of Rome, even the fiction of a well-balanced and stable state of affairs can no longer be maintained. The predominant mood in Italy is one of impending doom, and

it soon spreads to the whole of Western Europe, though not merely from Italy as its point of origin.

The tension-free formulae of balance propounded by classical art are no longer adequate; and yet they are still adhered to— sometimes even more faithfully, more anxiously, more desperately than would be the case in a relationship which is taken for granted. The attitude of the young artists to the High Renaissance is remarkably complicated; they cannot simply renounce the artistic achievements of classicism, even though the harmonious philosophy of this art has become completely foreign to them. Their desire to maintain the unbroken continuity of the artistic process, however, could hardly have been fulfilled unless the continuity of social development had supported such efforts. For, in essentials, the artists, as a collective body, and the public are constituted as they were in the age of the Renaissance, although the ground beneath their feet is already beginning to quake. The feeling of insecurity explains the ambivalent nature of their relation to classical art. The art critics of the seventeenth century had already felt this ambivalence, but they did not see that the simultaneous imitation and distortion of classical models was conditioned not by a lack of intelligence, but by the new and utterly unclassical spirit of the mannerists.

It was left to our own age, which stands in just as problematical relationship to its ancestors as mannerism did to classical art, to understand the creative nature of this style and to recognize in the often anxious imitation of classical models an over-compensation for the spiritual distance by which it was separated from them. We are the first to grasp the fact that the stylistic efforts of all the leading artists of mannerism, of Pontormo and Parmigianino as of Bronzino and Beccafumi, of Tintoretto and Greco as of Bruegel and Spranger, were concentrated, above all, on breaking up the all too obvious regularity and harmony of classical art and replacing its superpersonal normativity by more subjective and more suggestive features. At one time, it is the deepening and spiritualizing of religious experience and the vision of a new spiritual content in life; at another, an exaggerated intellectualism, consciously and deliberately deforming reality, with a tinge of the bizarre and the abstruse; sometimes, however,

it is a fastidious and affected epicureanism, translating everything into subtlety and elegance, which leads to the abandonment of classical forms. But the artistic solution is always a derivative, a structure dependent in the final analysis on classicism, and originating in a cultural, not a natural experience, whether it is expressed in the form of a protest against classical art or seeks to preserve the formal achievements of this art. We are dealing here, in other words, with a completely self-conscious style,[140] which bases its forms not so much on the particular object as on the art of the preceding epoch, and to a greater extent than was the case with any previous significant trend of art. The conscious attention of the artist is directed no longer merely to choosing the means best adapted to his artistic purpose, but also to defining the artistic purpose itself—the theoretical programme is no longer concerned merely with methods, but also with aims. From this point of view, mannerism is the first modern style, the first concerned with a cultural problem and which regards the relationship between tradition and innovation as a problem to be solved by rational means. Tradition is here nothing but a bulwark against the all too violently approaching storms of the unfamiliar, an element which is felt to be a principle of life but also of destruction. It is impossible to understand mannerism if one does not grasp the fact that its imitation of classical models is an escape from the threatening chaos, and that the subjective over-straining of its forms is the expression of the fear that form might fail in the struggle with life and art fade into soulless beauty.

The topical interest of mannerism for us, the revision to which the art of Tintoretto, Greco, Bruegel and the late Michelangelo has recently been subjected, is just as symptomatic of the intellectual climate of our day as the revaluation of the Renaissance was for Burckhardt's generation and the vindication of the baroque for that of Riegl and Woelfflin. Burckhardt considered Parmigianino affected and repulsive, and Woelfflin still saw in mannerism something in the nature of a disturbance of the natural, healthy development of art—a superfluous intermezzo between the Renaissance and the baroque. Only an age which had experienced the tension between form and content, between beauty and expression, as its own vital problem, could do justice

to mannerism, and work out the true nature of its individuality, in contrast to both the Renaissance and the baroque. Woelfflin still lacked the genuine and direct experience of post-impressionist art—the experience which enabled Dvořák to assess the importance of the spiritualistic trends in the history of art, and to see in mannerism the victory of such a trend. Dovřák knew quite well that spiritualism does not exhaust the meaning of manneristic art and that it does not represent, as does the transcendentalism of the Middle Ages, a complete renunciation of the world; he did not overlook the fact that beside a Greco there was also a Bruegel and beside a Tasso a Shakespeare and Cervantes.[141] The main problem to concern him seems to have been precisely the mutual relationship, the common denominator and the principle of differentiation between the various—spiritualistic and naturalistic —phenomena within mannerism. The analyses of this scholar, who died far too early, unfortunately do not go far beyond the statement of these two, as he called them, 'deductive and inductive' tendencies, and they make the fact that his life was cut short so early seem all the more regrettable.

The two opposed currents in mannerism—the mystical spiritualism of Greco and the pantheistic naturalism of Bruegel —do not, however, always confront each other as separate stylistic tendencies personified in different artists, but are in fact usually indissolubly intertwined. Pontormo and Rosso, Tintoretto and Parmigianino, Mor and Bruegel, Heemskerck and Callot, are just as decided realists as they are idealists, and the complex and hardly to be differentiated unity of naturalism and spiritualism, formlessness and formalism, concreteness and abstraction, in their art is the basic formula of the whole style which they share. But this heterogeneity of tendencies does not imply a mere subjectivism and a pure arbitrariness in the choice of the degree of reality to be attained in the work of art, as even Dvořák thought,[142] but is rather a sign of the shattering of all the criteria of reality and the result of the often desperate attempt to bring the spirituality of the Middle Ages into harmony with the realism of the Renaissance.

Nothing characterizes the disturbance of the classical harmony better than the disintegration of that unity of space which was

the most pregnant expression of the Renaissance conception of art. The uniformity of scene, the topographical coherence of the composition, the consistent logic of the spatial structure, were for the Renaissance amongst the most important preconditions of the artistic effect of a picture. The whole system of perspective drawing, all the rules of proportion and tectonics, were merely means serving the ultimate end of spatial logic and unity. Mannerism begins by breaking up the Renaissance structure of space and the scene to be represented into separate, not merely externally separate but also inwardly differently organized, parts. It allows different spatial values, different standards, different possibilities of movement to predominate in the different sections of the picture: in one the principle of economy, and in another that of extravagance in the treatment of space. This breaking up of the spatial unity of the picture is expressed most strikingly in the fact that there is no relationship capable of logical formulation between the size and the thematic importance of the figures. Motifs which seem to be of only secondary significance for the real subject of the picture are often overbearingly prominent, whereas what is apparently the leading theme is devalued and suppressed. It is as though the artist were trying to say: It is by no means settled who are the principal actors and who are the mere walkers-on in my play!—The final effect is of real figures moving in an unreal, arbitrarily constructed space, the combination of real details in an imaginary framework, the free manipulation of the spatial coefficients purely according to the purpose of the moment. The nearest analogy to this world of mingled reality is the dream, in which real connections are abolished and things are brought into an abstract relationship to one another, but in which the individual objects themselves are described with the greatest exactitude and the keenest fidelity to nature. It is, at the same time, reminiscent of contemporary art, as expressed in the description of associations in surrealist painting, in Franz Kafka's dream world, in the montage-technique of Joyce's novels and the autocratic treatment of space in the film. Without the experience of these recent trends, mannerism could hardly have acquired its present significance for us.

Even the most general characterization of mannerism contains very varying features, which it is difficult to gather into a uniform concept. A special difficulty lies in the fact that mannerism does not cover a particular, strictly confined historical period. It certainly represents the leading style between the third decade and the end of the century, but it does not dominate the century unopposed, and, particularly at the beginning and end of the period, it is mingled with baroque tendencies. The two lines are already closely intertwined in the later works of Raphael and Michelangelo. In these works there is already a competition between the passionately expressionistic aims of the baroque and the intellectualistic 'surrealist' outlook of mannerism. The two post-classical styles arise almost at the same time out of the intellectual crisis of the opening decades of the century: mannerism as the expression of the antagonism between the spiritualistic and the sensualistic trends of the age, and the baroque as the temporary settlement of the conflict on the basis of spontaneous feeling. After the sack of Rome, the baroque trend in art is gradually repressed, and there follows a period of over sixty years in which mannerism prevails. Some scholars interpret mannerism as a reaction following the early baroque, and the later baroque as the counter movement which then supersedes mannerism.[143] The history of sixteenth-century art would then consist in repeated clashes between mannerism and baroque with the temporary victory of the manneristic and the ultimate victory of the baroque tendency—but such a theory unjustifiably makes the early baroque begin before mannerism and exaggerates the transitory character of mannerism.[144] The conflict between the two styles is, in reality, more sociological than purely historical. Mannerism is the artistic style of an aristocratic, essentially international cultured class, the early baroque the expression of a more popular, more emotional, more nationalistic trend. The mature baroque triumphs over the more refined and exclusive style of mannerism, as the ecclesiastical propaganda of the Counter Reformation spreads and Catholicism again becomes a people's religion. The court art of the seventeenth century adapts the baroque to its specific needs; on the one hand, it works up baroque emotionalism into a magnificent theatricality and, on

the other, it develops its latent classicism into the expression of an austere and clear-headed authoritarianism. But in the sixteenth century mannerism is the court style par excellence. At all the influential courts of Europe it is favoured against every other trend. The court painters of the Medici in Florence, Francis I in Fontainebleau, Philip II in Madrid, Rudolf II in Prague and Albrecht V in Munich are mannerists. With the manners and customs of the Italian courts, princely patronage spreads over the whole of Western Europe and is even intensified at certain courts, for example in Fontainebleau. The court of the Valois is already very big and pretentious and exhibits characteristics reminiscent of the later court of Versailles.[145] The milieu of the smaller courts is less dazzling, less public and, in some respects, more in line with the intimate, intellectualistic nature of mannerism. Bronzino and Vasari in Florence, Adriaen de Vries, Bartholomaeus Spranger, Hans von Aachen and Josef Heinz in Prague, Sustris and Candid in Munich, enjoy, in addition to the generosity of their patrons, the intimacy of a less pretentious environment. There is an affection even in the relationship between Philip II and his artists, which is surprising in view of the gloomy character of this monarch. The Portuguese painter Coelho is one of his closest intimates, a special corridor connects his rooms with the court artists' workshops and he is said to have been a painter himself.[146] When he becomes Emperor, Rudolf II moves into the Hradshin in Prague, shuts himself off from the world there with his astrologers, alchemists and artists, and has pictures painted, the refined eroticism and smart elegance of which suggest the hedonistic atmosphere of a rococo-like environment rather than the lonely and desolate dwelling of a maniac. The two cousins, Philip and Rudolf, always have money to spare for works of art and time for artists or art dealers; a work of art is the most certain means of obtaining an audience with them.[147] There is a jealous, secretive impulse in the art collecting of these rulers; the motives of propaganda and display fade almost completely into the background in contrast to the all-important motive of aesthetic hedonism.

The mannerism of the courts is, especially in its later form, a uniform and universally European movement—the first great

international style since the Gothic. The source of its universal influence is the absolutism which spreads all over Western Europe and the vogue of the intellectually interested and artistically ambitious court households. In the sixteenth century the Italian language and Italian art attain universal influence reminiscent of the authority of Latin in the Middle Ages; mannerism is the particular form in which the artistic achievements of the Italian Renaissance are spread abroad. But this international character is not the only thing that mannerism has in common with the Gothic. The religious revival of the period, the new mysticism, the yearning for the spiritual, the disparagement of the body and the absorption in the experience of the supernatural, lead to a renewal of Gothic values, which only finds outward and often exaggerated expression in the slender forms of the mannerist style. The new spiritualism manifests itself rather in the tension between the spiritual and physical elements than in the complete overcoming of classical kalokagathia. The new formal ideals do not in any way imply a renunciation of the charms of physical beauty, but they portray the body struggling to give expression to the mind, they show it, as it were, turning and twisting, bending and writhing under the pressure of the mind, and hurled aloft by an excitement reminiscent of the ecstasies of Gothic art. By spiritualizing the human figure, the Gothic took the first great step in the development of modern expressionism, and now mannerism takes the second by breaking up the objectivism of the Renaissance, emphasizing the personal attitude of the artist and appealing to the personal experience of the onlooker.

6. THE AGE OF POLITICAL REALISM

Mannerism is the artistic expression of the crisis which convulses the whole of Western Europe in the sixteenth century and which extends to all fields of political, economic and cultural life. The political revolution begins with the invasion of Italy by France and Spain, the first imperialistic great powers of modern times—France the result of the emancipation of the crown from feudalism and the successful conclusion of the Hundred Years War, Spain, in its union with Germany and the Netherlands, the

creation of chance, which gives rise to a political power unparalleled since the reign of Charlemagne. The political structure into which Charles V transforms the lands which fall to him by inheritance has been compared with the incorporation of Germany into the Frankish kingdom and described as the last great attempt to restore the unity of the Church and the Empire.[148] But this idea had had no real foundation since the end of the Middle Ages, and, instead of the desired unity, the political conflict arose which was to dominate European history for over four hundred years.

France and Spain had devastated and subjugated Italy and brought her to the brink of despair. When Charles VIII began his Italian campaign, the memory of the invasions of the German emperors in the Middle Ages had already completely faded. The Italians were always fighting each other, but they no longer knew what it meant to be controlled by a foreign power. They were dazed by the sudden invasion and were never able really to recover from the shock. The French first occupied Naples, then Milan and finally Florence. They were soon driven out of Southern Italy again by the Spaniards, but for whole decades Lombardy remained the scene of conflict between the two great rival powers. The French maintained themselves here until 1525, when Francis I was beaten in the Battle of Pavia and deported to Spain. Charles V now had Italy completely in his hands, and was no longer willing to submit to the intrigues of the Pope. In 1527 twelve thousand mercenaries moved against Rome to punish Clement VII. They joined forces with the Imperial army under the Constable of Bourbon, invaded the Eternal City and eight days later left it in ruins. They plundered the churches and monasteries, killed the priests and monks, raped and ill-treated the nuns, turned S. Peter's into a stable and the Vatican into a barracks. The very foundations of Renaissance culture seemed to be destroyed; the Pope was powerless, the prelates and bankers no longer felt safe in Rome. The members of the school of Raphael, who had dominated the artistic life of Rome, scattered and the city lost its artistic importance in the immediately following period.[149] In 1530 Florence also became the prey of the Spanish-German army. In agreement with the Pope, Charles V

installed Alessandro Medici as a hereditary prince and thereby did away with the last remains of the Republic. The revolutionary disturbances which had broken out in Florence after the sack of Rome and which led to the expulsion of the Medici expedited the Pope's decision to come to an agreement with the Emperor. The head of the Pontifical State now becomes the ally of Spain: a Spanish viceroy resides in Naples and a Spanish governor in Milan; in Florence the Spaniards rule through the Medici, in Ferrara through the Este, in Mantua through the Gonzaga. The Spanish way of life and moral code, Spanish etiquette and Spanish elegance reign supreme in both the artistic centres of Italy, Rome and Florence. On the other hand, the intellectual dominion of the conquerors, whose culture is backward in comparison with the Italian, does not penetrate very deep and the connection of art with the native tradition survives. For even where Italian culture seems to succumb to the Hispanic influence it merely follows an evolutionary trend resulting from the presuppositions of the Cinquecento, which strives to achieve the formalism of court art quite apart from Spanish influence.[150]

Charles V had conquered Italy with the help of German and Italian capital.[151] Even the election of the Emperor was more or less a question of money and this was settled by a syndicate of bankers under the direction of the Fuggers. Electors were not cheap and the Pope asked no less than a hundred thousand ducats as the price for his support. From that moment finance capital dominated the world. The armies with which Charles conquered his enemies and kept his empire together were the creation of this power. It is true that his wars and those of his successors ruined the biggest capitalists of the age, but they secured world-power for capitalism. Maximilian I was not yet in a position to collect regular taxes and maintain a standing army; power still resided in essentials in the territorial armies. His grandson was the first to succeed in organizing the state finances according to purely business considerations, creating a uniform bureaucracy and a great mercenary army, and turning the feudal aristocracy into a court and official aristocracy. To be sure, the bases of the centralized principality were already very old. For, since the time that the landlords had let out their estates, instead of managing

them themselves, their hangers-on had dwindled and the pre-condition for the predominance of the central authority had been created.[152] Progress on the road to absolutism then proved to be a mere question of time—and money. As the income of the crown lay very largely in the taxes received from the non-aristocratic and non-privileged sections of the population, it was in the interest of the state to promote the economic prosperity of these classes.[153] This consideration had, however, to yield in every crisis before the interests of the great capitalists, whose help the kings could by no means renounce, despite their regular revenues.

When Charles V began to establish his rule in Italy, the centre of world trade had already shifted from the Mediterranean to the West as a result of the Turkish menace, the discovery of the new sea-routes and the emergence of the oceanic nations as economic powers. And now that in the organization of world trade the place of the small Italian states is taken by uniformly adminis-tered powers with incomparably greater territories and means at their disposal, the age of early capitalism comes to an end, and modern capitalism begins on a large scale. The introduction of precious metals from America to Spain, important as are its direct results, namely the increase in the supply of money and the rise in prices, is not sufficient to explain the beginning of the new era of capitalism. A much more important factor than the Ameri-can silver, which the attempt is made, not with much success, to treat as mere wealth, that is to say, to immobilize and keep inside the country in accordance with the mercantilist theory—a much more important factor is the alliance between the state and capital, and, as a consequence of this alliance, the private capitalist foundations of Charles V's and Philip II's political enterprises.

From a very early date, it is possible to observe the trend away from the artisan undertaking, working with comparatively small capital resources, to the large-scale industrial undertaking and from the goods trade to the purely financial business. In the course of the fifteenth century this tendency gets the upper hand in the centres of Italian and Netherlandish trade. But it is not until the turn of the century that the small-scale undertaking based on individual craftsmanship is rendered out of date by large-scale industry, and money dealings become entirely separate

from the goods trade. The loosening of all restraints on free competition leads, on the one hand, to the end of the corporative principle, on the other, to the shifting of economic activity to province more and more remote from production. The small works are incorporated into the larger units, but these are directed by capitalists who devote themselves increasingly to pure finance. Most men find it more and more difficult to fathom the decisive factors in economic affairs and are less and less able to exert any influence on them. The demands of the market attain a mysterious, but all the more inexorable reality; they hover suspended over men's heads like a lofty, inescapable power. The lower and middle ranks of society lose their feeling of security along with their influence in the guilds; but the capitalists do not feel secure either. If they intend to assert themselves, there can be no standstill for them; but as they grow, they also penetrate into more and more dangerous spheres. The second half of the century produces an unbroken series of financial crises; in 1557 the French and the Spanish states go bankrupt, and in 1575 the Spanish bankruptcy recurs—catastrophes which not only shake the foundations of the leading business houses, but mean the ruin of innumerable lesser livelihoods.

The most tempting business is transactions in state loans; but, in view of the heavy indebtedness of the princes, it is, at the same time, the most dangerous. Besides the bankers and professional speculators, the middle classes, with their deposits in the banks and their commitments on the only recently created stock exchanges, also had a far-reaching interest in the gamble. As the financial resources of the individual banking houses prove inadequate to meet the capital needs of the monarchs, the stock exchanges in Antwerp and Lyons also begin to be called upon for credits.[154] Partly in connection with these transactions, all possible kinds of stock-exchange speculation develop: dealing in stocks, time-bargaining, arbitrage, insurance business.[155] The whole of Western Europe is seized by the stock-exchange mentality and a fever of speculation, which rises to a climax when the English and Netherlandish overseas trading companies offer the public the chance of sharing in their often fantastic profits. The consequences are catastrophic for the broad masses: unemploy-

100

ment as a result of the transfer of interest from agricultural to industrial production, overcrowding of the cities, rising prices and low wages are experienced everywhere. Social dissatisfaction reaches its climax in the country where, for a time, the greatest accumulation of capital takes place—Germany—and it breaks out in the most neglected class—the peasantry. It comes to a head in direct connection with the religious peasant movement; partly because this movement is itself conditioned by the social dynamism of the age, partly because the opposition forces still find it easiest to meet under the common banner of a religious idea. It is not merely in the Anabaptist movement that the social and religious revolutions form an inseparable unity; contemporary voices, such as the outbursts of an Ulrich von Hutten against protectionism and money economy, against usury and land speculation, in a word, against 'Fuggerei', as he calls it,[156] suggest rather that dissatisfaction is generally still in a chaotic and ill-defined stage of development. It unites the classes who are more interested in the religious than the social revolution, with those who are obviously more or even exclusively interested in the social revolution. But, however these various elements are distributed among themselves, the Middle Ages are still so near that all conceivable ideas are expressed with the greatest ease within the conceptual and emotional patterns of religious faith. That explains the obscure and feverish condition, the universal, vague expectation of redemption, which the religious and social factors combine to produce.

But the decisive fact for the sociology of the Reformation is that the movement started in a wave of indignation against the corruption of the Church, and that the avarice of the clergy, the trading in indulgences and ecclesiastical offices, was the immediate cause by which it was set in motion. The oppressed and exploited classes insisted thereafter that the biblical condemnation of the rich and the promises made to the poor referred not merely to the Kingdom of Heaven. The middle-class elements, however, who co-operated with enthusiasm in the struggle against the feudal privileges of the clergy, not only withdrew immediately their own aims were achieved, but resisted any progress that might have injured their interests, because it favoured those of

the lower classes. Protestantism, which began as a popular movement on the widest possible basis, now rested for the most part on the local sovereigns and on these middle-class elements. With a genuine political flair, Luther seems to have judged the prospects of the revolutionary classes to be so unfavourable that he gradually sided completely with those ranks of society whose interests were bound up with the preservation of law and order. In so doing, he not only simply left the masses in the lurch, but he even stirred up the princes and their followers against the 'murderous and rapacious peasant rabble'. Obviously, he wanted at all cost to prevent the impression of having anything to do with the social revolution.

Luther's betrayal must have had a devastating effect.[157] The explanation of the scarcity of direct evidence on this point is probably that the betrayed classes had no real spokesmen outside the ranks of the Anabaptists. But the gloomy outlook of the age is an indirect expression of the disillusion which must have been felt in wide circles of the population at the way the Reformation was developing. Luther's 'sensible' attitude was a terrifying example of political realism. It was certainly not the first time that religious ideals had entered into a compromise with practical life—the whole history of the Christian Church seems to consist in the striking of a balance between the things that are God's and the things that are Caesar's—but the earlier concessions took place gradually, in scarcely noticeable transitions, and, moreover, in a period in which the background of political events was mostly hidden from the public. The degeneration of Protestantism, on the other hand, proceeded in the full daylight of humanism, in an age of printing, of pamphlets, of universal interest in and competence to judge of political matters. The intellectual leaders of the age may have been totally uninterested in the peasants' cause and have stood for diametrically opposed concerns, but the spectacle of the perversion of a great idea could not leave them unaffected, even if they were hostile to the Reformation. Luther's standpoint in the peasant problem was indeed merely a symptom of the course which any revolutionary idea had inevitably to take in the age of absolutism.[158]

In the first half of the century, that is, in the period before the

wars of religion, the Council of Trent and the uncompromising Counter Reformation, Protestantism presented Western Europe not merely with an ecclesiastical and denominational problem, but—like the Sophistic movement in the classical world, the enlightenment in the eighteenth century and socialism in our day—with a problem of conscience from which no morally responsible person could entirely escape. After the Reformation there not only ceased to be any good Catholics not convinced of the corruption of the Church and the necessity for its purification, but the influence of the ideas originating in Germany went much deeper: people became aware of the inwardness, otherworldliness and uncompromising quality of the Christian faith which had been lost, and they felt an unappeasable longing that these characteristics might be restored. What aroused and inspired good Christians everywhere, and above all the idealists and intellectuals in Italy, was the anti-materialism of the Reformation movement, the doctrine of justification by faith, the idea of direct communion with God and of the priesthood of all believers. But now that Protestantism had become the creed of princes interested merely in politics and of a middle class interested above all in business, and was in the way to becoming a new Church, these idealists and intellectuals, who had flirted with it as a purely spiritual movement, were certainly the most disappointed of all.

The desire for a new spirituality and a deepening of the religious life was nowhere stronger than in Rome, and nowhere was there a greater awareness of the danger with which the unity of the Church was threatened by the German Reformation, even though these feelings and thoughts did not originate in the immediate entourage of the Pope. The leaders of the Catholic reform movement were mostly enlightened humanists, who entertained very progressive ideas about the infirmities of the Church and the severity of the operation needed to cure its ills, but their radicalism stopped short at questioning the absolute authority of the papacy. They all wanted to reform the Church from within. But they certainly wanted to reform it, and they proposed to start by convening a free and universal Church council. Clement VII would not hear of it, however—one could

never tell what would come out of such a council. About the year 1520, there was formed in Rome the 'Oratory of Divine Love', an association which was intended to set an example of piety and to make suggestions for Church reform. Some of the most learned and respected members of the Roman clergy, such as Sadoleto, Giberti, Thiene and Caraffa, belonged to it. The sack of Rome also put an end to this enterprise; the members scattered and it was some time before they were again able to combine their forces. The movement was continued in Venice where Sadoleto, Contarini and Pole were its main supports. Here, as afterwards again in Rome, the target was the reconciliation with Lutheranism and the salvaging of the moral content of the Reformation for the benefit of the Catholic Church, especially the doctrine of justification by faith.

Vittoria Colonna and her friends, of whom Michelangelo was one from 1538 onwards, were closely connected with this humanistically educated circle whose main interest was in religion. In his *Conversations on Painting* (1539), the Portuguese painter Francisco de Hollanda describes the religious enthusiasm of this society to which he was introduced by a friend, and reports, among other things, on their meetings in the church of S. Silvestro on Monte Cavallo, where a famous theologian of the time expounded the letters of St. Paul. Here, in the company of Vittoria Colonna and her friends, Michelangelo probably received the decisive stimuli which led to his spiritual rebirth and the spiritualistic style of his later works. The religious development which he went through was thoroughly typical of the transitional period leading from the Renaissance to the Counter Reformation, but the one extraordinary thing about it was the passionateness of his inward transformation and the depth of expression which it received in his works. Even as a youth Michelangelo seems to have been very responsive to religious stimuli. The personality and the fate of Savonarola made an indelible impression on him; during the whole of his life he remained aloof from the activities of the world, an attitude which must have originated in this experience. As he grew older, his piety became deeper; it became more and more fervent, uncompromising and exclusive, until it completely filled his soul, and not only displaced his Renaissance

ideals but made him doubt the purpose and value of his whole artistic activity. The change did not take place by any means all at once; it proceeded step by step. The signs of a manneristic conception of art, characterized by the disturbance of the sense of harmony, are already evident in the Medici tombs and the corner-spandrels of the ceiling of the Sistine Chapel. In the 'Last Judgement' (1534–41) the new spirit holds unrestricted sway; it is no longer a monument of beauty and perfection, of power and youth, that arises here, but a picture of bewilderment and despair, a cry for redemption from the chaos which suddenly threatens to swallow up the world of the Renaissance. Devotion and the desire to extinguish all earthly, physical and sensual, things within oneself dominates the work. The spatial harmony of Renaissance compositions is gone. The space in which the representation moves is unreal, discontinuous and neither seen uniformly, nor constructed in accordance with a uniform scale of measurement. The conscious, often ostentatious infringement of the old principles of organization, the deformation and disintegration of the Renaissance world-picture, is expressed in every aspect of the work, above all in the waiving of the rules of perspective, one of the most striking signs of which is the lack of foreshortening and, therefore, the exaggeration in the treatment of the upper figures in the composition in relation to the lower.[159] The 'Last Judgement' in the Sistine Chapel is the first important artistic creation of modern times which is *no longer* 'beautiful' and which refers back to those medieval works of art which were *not yet* beautiful but merely expressive. Michelangelo's work is nevertheless very different from them; it represents a protest, achieved with obvious difficulty, against beautiful, perfect, immaculate form, a manifesto in the shapelessness of which there is something aggressive and self-destructive. It is not only a denial of the artistic ideals which the Botticellis and Peruginos sought to realize in the same place, but also of the aims once pursued by Michelangelo himself in the representations on the ceiling of the same Sistine Chapel, and it surrenders those ideals of beauty to which the whole chapel owes its existence and all the building and painting of the Renaissance its origin. And it is not merely a question of the experiment of an irresponsible eccentric, but of

a work which, coming from the hand of the most distinguished artist in the Christian world, was intended to adorn the most important place which Christendom had in its power to offer, the main wall of the Pope's domestic chapel. Here indeed was a world in decline.

The frescoes of the Cappella Paolina, the 'Conversion of St. Paul' and the 'Crucifixion of St. Peter' (1542–9), represent the next phase in Michelangelo's development. There is no longer the slightest trace of the harmonious order of the Renaissance in these pictures. The figures have something unfree, something of dreamy irresolution about them, as if they were labouring under a mysterious, inescapable constraint, under a pressure whose origin is beyond discovery. Empty portions of space alternate with weirdly overfilled space, barren stretches of desert and tightly packed clusters of human beings stand adjacent to each other, as in a bad dream. The optical uniformity and continuity of space is abolished; the spatial depth is not achieved step by step, but, as it were, rent open; the diagonals break through the picture and bore space-engulfing holes into the background. The only purpose served by the spatial coefficients of the composition seems to be to express the bewilderment and homelessness of the figures. There is no longer any coherence between the figures and the stage they occupy, between man and the world. The performers of the action lose all their individual particularity; the marks of age, sex and temperament are blurred, everything strives towards generality, abstraction and schematism. The importance of individual personality fades beside the enormous significance of humanity in general. After the completion of the frescoes of the Cappella Paolina, Michelangelo produced no more large works; the 'Pietà' in Florence Cathedral (1550–5) and the 'Pietà Rondanini' (1556–64) are, together with the drawings of a Crucifixion, the sole artistic productions of the last fifteen years of his life, and even these works merely draw the inevitable conclusions from the decision which he had already made formerly. As Simmel says, there is in the 'Pietà Rondanini', 'no more material against which the soul might be called upon to defend itself, the body has given up the struggle for its independence, the phenomena presented are incorporeal'.[160] This work is hardly

any longer an artistic matter at all, it is rather the transition from a work of art to an ecstatic confession; a unique exposure of that spiritual interregnum, where the aesthetic meets the metaphysical, an act of expression which, hovering between the sensual and the supersensual, seems to be wrested from the mind by force. What is finally produced here is near to blankness—shapeless, toneless and without articulation.

The ultimate failure of Contarini's negotiations at the Diet of Rabisbon in 1541 marks the end of the first 'humanistic' period of the Catholic reform movement. The days of enlightened, philanthropic, tolerant men, like Sadoleto, Contarini and Pole, are numbered. The principle of realism triumphs all along the line. The idealists have proved themselves unable to master reality. Paul III (1534–49) already represents the transition from the lenient Renaissance to the intolerant Counter Reformation. In 1542 the Inquisition is introduced, in 1543 the censorship of printed matter, and in 1545 the Council of Trent is opened. The lack of success in Ratisbon leads to a militant attitude and to the restoration of Catholicism by authority and force. The persecution of the humanists in the ranks of the higher clergy is begun. The new spirit of fanaticism and hostility to the Renaissance is apparent everywhere, most strikingly of all in the new monastic foundations, the new asceticism and in the emergence of new saints, such as Carlo Borromeo, Filippo Neri, John of the Cross and St. Teresa.[161] But nothing is more typical of the change in the general development of affairs than the foundation of the Jesuit order, which was to become a model of dogmatic strictness and ecclesiastical discipline, and which became the first embodiment of the totalitarian idea. With its principle of the end justifying the means, it signifies the supreme triumph of the idea of political realism and gives the sharpest possible expression to the basic intellectual characteristic of the century.

Machiavelli was the first to develop the theory and programme of political realism; in his work is to be found the key to the whole world-outlook of mannerism which wrestles with this idea so desperately. But Machiavelli did not invent 'Machiavellism', that is, the separation of political practice from Christian ideals—every petty Renaissance prince was a ready-made Machiavellian.

It was merely the doctrine of political rationalism which he was the first to formulate, and he was, at the same time, the first clear-headed advocate of the application of conscious, systematic realism to practical affairs. Machiavelli was, however, only an exponent and spokesman of his age. If his doctrine had been nothing more than the extravagant whim of a clever and cruel philosopher, it would not have had the shattering influence which it in fact had, nor would it have moved the conscience of every morally endowed person, as it in fact did. And if it had been only a matter of the political methods of the petty Italian tyrants, his writings would certainly have caused no more excitement than the horrific stories which were spread abroad about the morals of these tyrants. Meanwhile, history produced more striking examples of realism than the crimes of the gang leader and the poisoner whom Machiavelli quotes as his prototype. For what else was Charles V, the patron of the Catholic Church, who threatened the life of the Holy Father and had the capital of Christendom destroyed, if not an unscrupulous realist? And Luther, the founder of the modern people's religion par excellence, who betrayed the common people to the overlords and made the religion of inwardness the creed of the most efficiently practical stratum of society and the one most deeply involved in the interests of the world? And Ignatius Loyola, who would have crucified Christ a second time, if the teachings of the risen Lord had threatened the stability of the Church, as in Dostoevsky's story? And any prince of the age one cares to mention, who sacrificed the welfare of his subjects to the interests of the capitalists? And was not the whole capitalistic economy in the long run simply an illustration of Machiavelli's theory? Did it not show clearly that reality was obedient to its own stern necessity, that all mere ideas were powerless when faced with its relentless logic, and that the only alternative was to submit to or be destroyed by it?

It is scarcely possible to over-estimate the importance of Machiavelli for his contemporaries and the next few generations. The whole century was frightened, intimidated and thoroughly agitated by its encounter with the first master of exposure, the forerunner of Marx, Nietzsche and Freud. One only needs to

recall the English drama of the Elizabethan and Jacobean ages, in which Machiavelli had become a hackneyed stage figure, the quintessence of all fraud and hypocrisy, and the proper name 'Machiavelli' had begun to change into the generic name of *machiavelli*, to realize the extent to which he engaged the human imagination. It was not the violence of the tyrants which caused the general shock and not the panegyrics of their court poets which filled the world with indignation, but the justification of their methods by a man who allowed the gospel of gentleness to stand alongside the philosophy of force, the rights of the noble alongside those of the clever, and the morality of the 'lions' alongside that of the 'foxes'.[162] Ever since there existed rulers and ruled, masters and servants, exploiters and exploited, there also existed two different orders of morality, one for the powerful, the other for the powerless. Machiavelli was merely the first to make men conscious of this moral dualism, and the first to attempt to justify the recognition of different standards of conduct in state affairs from those current in private life, and, above all, the recognition of the fact that the Christian moral principles of fidelity and truthfulness are not absolutely binding on the state and the prince. Machiavellism with its doctrine of *dual morality*[163] had only one analogy in the history of Western man, and that was the doctrine of the 'dual truth' which rent the culture of the Middle Ages in twain and ushered in the age of nominalism and naturalism. There now arose in the moral world a cleft similar to that which had then arisen in the intellectual, only, this time, the shock was greater to the extent that more crucial values were at stake. The break was in fact so profound that a person familiar with any of the more important literary products of the period should be able to establish whether it was written before or after its author's encounter with the ideas of Machiavelli. To become acquainted with them it was, incidentally, not in the least necessary to read Machiavelli's own writings—which were in fact read by very few; the idea of political realism and of 'dual morality' was common property, and was conveyed to people by the most devious routes. Machiavelli found followers in every walk of life, though the devil's disciples were sometimes suspected in places where they did not in fact exist at all; every liar seemed to

speak the language of Machiavelli and all sharp-wittedness was distrusted.

The Council of Trent became the supreme training ground of political realism. With sober matter-of-factness it adopted the measures which seemed best suited to fit the institutions of the Church and the principles of the faith to the conditions and demands of modern life. The intellectual leaders of the Council wanted to draw a sharp line of demarcation between orthodoxy and heresy. If secession could no longer be prevented, at any rate the further spread of the evil should be stopped. It was recognized that it was more sensible in the given circumstances to emphasize the differences than to conceal them, and to raise rather than lessen the demands made on the faithful. The victory of this standpoint meant the end of the unity of Western Christendom.[164] But soon after the conclusion of the Tridentine deliberations, which lasted eighteen years, another change of policy followed, dictated by a sense of profound realism, which substantially mitigated the severity of the period during which the Council was sitting, especially in matters of art. There was no more need to be afraid of misunderstandings in the interpretation of orthodoxy ; the order of the day was now to brighten up the gloom of militant Catholicism, to enlist the senses in the propagation of the faith, to make the forms of divine service more pleasing and to turn the church into a resplendent and attractive centre for the whole community. These were tasks to which the baroque was first able to do justice, however; the stern decrees of the Council of Trent were still regarded as authoritative during the whole period of mannerism—but it was the same principles of systematic, sober realism which suggested in the one case the way of ascetic severity, in the other, adulation of the senses.

The convening of the Council meant the end of liberalism in the Church's relationship to art. Art produced for Church purposes was placed under the supervision of theologians, and, especially in the case of large-scale undertakings, the painters had to keep strictly to the instructions of their spiritual advisers. Giov. Paolo Lomazzo, the greatest authority of the time in matters of art theory, desires explicitly that the painter should seek the advice of theologians in the representation of religious sub-

jects.[165] In Caprarola, Taddeo Zuccari submits to his instructions even on the choice of colours, and Vasari not only raises no objections to the directives he receives from the Dominican art scholar Vincenzo Borghini during his work in the Cappella Paolina, but he even feels uncomfortable when Borghini is not near him.[166] The intellectual content of the manneristic fresco cycles and altar-pieces is mostly so complicated that even in cases where there is no direct evidence of co-operation between the painters and theologians, such co-operation must be posited. Just as medieval theology not only regains its rights at the Council of Trent, but deepens its influence, in that many questions the discussion of which was left unreservedly to scholasticism in the Middle Ages are now decided by authority,[167] so, too, the choice of artistic media is now laid down by those who commission works of art for the Church more strictly in many respects than in the Middle Ages, when in most cases it could simply be left to the artist. Above all, it is now forbidden to provide a place in churches for works of art that are inspired or influenced by false doctrines. Artists have to conform exactly to the canonic form of biblical stories and to the official interpretation of questions of dogma. In Michelangelo's 'Last Judgement', Andrea Gilio criticizes the unbearded Christ, the mythological Charon ferry, the gestures of the saints, who, in his opinion, behave as if they were attending a bullfight, the arrangement of the apocalyptic angels who, contrary to Scripture, are standing next to each other, instead of being assigned to the four corners of the picture, etc. Veronese is summoned to the tribunal of the Inquisition because, in his 'Supper in the House of Levi', he adds all kinds of arbitrarily chosen motifs, such as dwarfs, dogs, a fool with a parrot and other similar things, to the persons named in the Bible narrative. The decrees of the Council forbid the representation of the nude as well as the introduction of suggestive, indecent and profane representations into holy places. All the writings on religious art which appear after the Council of Trent, above all the *Dialogo degli errori dei pittori* by Gilio (1564) and the *Riposo* by Raffaele Borghini (1584), are against all forms of nudity in ecclesiastical art.[168] Gilio desires that, even in cases where a character could be portrayed in the nude in full accordance with the biblical record,

the artist should add at least a loin-cloth. Carlo Borromeo has all pictures which seem indecent to him removed from the sacred places within his sphere of influence. At the end of a successful life, the sculptor Ammanati disowns the entirely harmless nudes of his youth. Nothing is more typical of the intolerant spirit of this epoch than the treatment suffered by Michelangelo's 'Last Judgement'. In 1559, Paul IV commissions Daniele da Volterra to cover up the naked figures in the fresco which appear to be especially provoking. In 1566, Pius V has further offensive portions of the fresco removed. Finally, Clement VIII desires to have the whole fresco destroyed and is restrained from carrying out his plan only by a petition submitted by the Academy of S. Luca. But even more remarkable than the behaviour of the Popes is the fact that Vasari himself—in the second edition of his *Vite*—condemns the nakedness of the figures in the 'Last Judgement' as unsuitable by reason of their ecclesiastical destination.

The period of the Council of Trent has been described as the 'birthday of prudery'.[169] It is well known that cultures based on aristocracy or other-worldly values are adverse to the representation of the nude; but neither the aristocratic society of early classical antiquity nor the Christian society of the Middle Ages was 'prudish'. They avoided the nude, but were not afraid of it. Their attitude to the physical was much too clear-cut for them ever to have wanted both to conceal and to stress the sexual by introducing the 'fig leaf'. The ambivalence of erotic feelings does not arise until the onset of mannerism, and it is bound up with the whole dichotomy of this culture in which the greatest polarities are united: the most spontaneous feeling with the most intolerable affectation, the strictest possible belief in authority with the most arbitrary individualism and the most chaste representations with the lewdest forms of art. Prudishness is here not merely the conscious reaction against the provoking lasciviousness of the art produced independently of the Church, such as is cultivated at most courts, but it is also itself a form of suppressed lasciviousness.

The Council of Trent was antipathetic to every aspect of formalism and sensualism in art. In the true spirit of the Council, Gilio complains that painters are no longer concerned with the

subject-matter but only with the dazzling display of their own artificially developed skill. The same opposition to virtuosity and the same demand for a direct emotional content is expressed in the Council's purgation of church music, particularly in the subordination of musical form to the text and the recognition of Palestrina as the absolute model. But, in spite of its moral rigorism and its anti-formalistic attitude, the Tridentinum was, in contrast to the Reformation, by no means inimical to art. Erasmus's well-known saying—*ubicumque regnat lutheranismus, ibi literarum est interitus*—cannot be applied in any way to the enactments of the Council of Trent. Luther saw in poetry, at the most, a servant of theology and he could not discover anything praiseworthy at all in the fine arts. He condemned the 'idolatry' of the Catholic Church just as he condemned pagan image-worship. And he had in mind not only the devotional images of the Renaissance, which, of course, had only very little to do with religion, but all artistic externalization of religious feelings what-soever—the 'idolatry' which he saw even in the mere adornment of churches with pictures. All the heretical movements of the Middle Ages were fundamentally iconoclastic in outlook. Both the Albigenses and the Waldenses as well as the Lollards and the Hussites condemned the profanation of the faith by the glamour of art.[170] But in the Reformers, particularly in Karlstadt, who has pictures of the saints burnt in Wittenberg in 1521, in Zwingli, who in 1524 persuades the Zürich city council to have works of art removed from the churches and destroyed, in Calvin, who sees no difference between worshipping an image and taking pleasure in a work of art,[171] and, finally, in the Anabaptists, whose hostility to art is part of their hostility to worldly culture, the doubts about art entertained by earlier heretics are worked up into a real iconophobia. Their condemnation of art is not merely much more uncompromising and consistent than Savonarola's attitude, which was, intrinsically, not iconoclastic at all, only purificatory,[172] but it is also even more radical than the icono-clasm of the Byzantines, which was, as we know, directed not so much against pictures in themselves as against those who profited from image-worship.

The Counter Reformation, which allowed art to play the

greatest conceivable part in divine worship, desired not merely to remain true to the Christian tradition of the Middle Ages and the Renaissance, in order thereby to emphasize its antagonism to the Reformation, to be friendly to art, whereas the heretics were hostile, but it desired, above all, to use art as a weapon against the doctrines of heterodoxy. The aesthetic culture of the Renaissance had infinitely enhanced the quality of art as a means of propaganda; it became more supple, more natural, and, therefore, more useful as a means of propaganda, so that the Counter Reformation had at its disposal an instrument for influencing public opinion unknown to the Middle Ages. Opinions are divided as to whether the original and direct artistic expression of the Counter Reformation is to be seen in the mannerism or in the baroque.[173] Mannerism is nearer to the Counter Reformation chronologically, and the austere spiritualistic approach of the Tridentine epoch is expressed more purely in mannerism than in the voluptuous baroque. But the artistic programme of the Counter Reformation, the propagation of Catholicism through the medium of art among the broad masses of the population, is first accomplished by the baroque. It is obvious that what was in the mind of the Council of Trent was not an art which, like mannerism, appealed merely to a thin stratum of intellectuals, but a people's art, such as the baroque in fact became. At the time of the Council, mannerism was the most widespread and the most live form of art, but it in no way represented the particular direction which was best calculated to solve the artistic problems of the Counter Reformation. The fact that it had to yield to the baroque is to be explained, above all, by its inability to master the ecclesiastical tasks committed to art by the Counter Reformation.

The mannerists found no more than a weak support in the doctrines of the Church. The instructions issued by the Council offered the artists no substitute for their previous incorporation in the system of Christian culture and the corporative order of society. For, apart from the fact that these instructions were more of a negative than a positive nature, and that there were no sanctions to support them outside ecclesiastical art, Church people could not help being conscious that, in view of the differentiated

structure of the art of their age, they could, by an all too extreme rigour, easily destroy the effectiveness of the very means of which they wanted to make use. In the circumstances of the time there could be no question of a purely hieratic organization of artistic production comparable to that of the Middle Ages. However good Christians and however deeply religious they were, artists could not simply renounce the secular and pagan elements in the artistic tradition; they had to endure the inner contradiction between the different factors of their means of expression and to accept it as unresolved and apparently irresolvable. Those who were unable to bear the weight of the conflict either escaped into the intoxication of aestheticism or, as Michelangelo did, into the 'arms of Christ'. For Michelangelo's way out of the conflict was also merely an escape. What medieval artist would have felt induced by his experience of God to give up his artistic work, as he did? The deeper the religious feelings of the medieval artist, the deeper was the source from which he was able to draw his artistic inspiration. And not merely because he was completely a believing Christian, but also because he was completely a creative artist. The moment he stopped being artistically productive, he ceased to be anything at all; Michelangelo, on the other hand, remained, even after he had finished his work as an artist, a very interesting person both in the eyes of the world and in his own eyes. In the Middle Ages a conflict of conscience, such as Michelangelo's, would have been quite impossible, not only because an artist could hardly conceive of any other way of serving God except through his art, but also because the rigid social organization of the period offered a man no possibility of making a livelihood outside his own trade and the traditions of his trade. In the sixteenth century, on the other hand, an artist was able to be well-to-do and independent, like Michelangelo, or find extravagant patrons, like Parmigianino, or was also prepared to put up with failure after failure, to lead a questionable life outside ordered society and hold fast to his own ideas, like Pontormo.

The artist of the age of mannerism had lost almost everything that was able to give a foothold to the artist-craftsman of the Middle Ages and, in many respects, even to the Renaissance artist in process of emancipating himself from the thraldom of crafts-

manship: a solid position in society, the protection of the guild, a clear-cut relation to the Church, and an, on the whole, unproblematical relation to tradition. The culture of individualism provided him with innumerable openings that were not available to the medieval artist, but it set him in a vacuum of freedom, in which he was often on the point of losing himself. In the intellectual revolution of the sixteenth century, which impelled artists to undertake a total revision of their world-view, they were unable either completely to entrust themselves to leadership coming from outside or to rely entirely on their own instincts. They were torn by force, on the one hand, and by freedom, on the other, and stood defenceless against the chaos that threatened to destroy the whole order of the intellectual world. In them we encounter for the first time the modern artist with his inward strife, his zest for life and his escapism, his traditionalism and his rebelliousness, his exhibitionistic subjectivism and the reserve with which he tries to hold back the ultimate secret of his personality. From now on the number of cranks, eccentrics and psychopaths among artists increases from day to day. Parmigianino devotes himself to alchemy in his later years, becomes melancholy and entirely neglects his appearance. From his youth upwards, Pontormo suffers from serious fits of depression and becomes more and more timid and reserved as the years pass.[174] Rosso commits suicide. Tasso dies engulfed in mental darkness. Greco sits behind curtained windows in broad daylight,[175] to see things which an artist of the Renaissance would probably not have been able to see at all, but which an artist of the Middle Ages would have been able to see, if at all, even in daylight.

A change corresponding to the general intellectual crisis occurs in the theory of art. In contrast to the naturalism, or, as it would be called in philosophical terminology, the 'naïve dogmatism', of the Renaissance, mannerism is the first movement to raise the epistemological question: for the first time the agreement of art with nature is felt to constitute a problem.[176] For the Renaissance, nature was the source of artistic form; the artist achieved it through an act of synthesis, by gathering and combining the scattered elements of beauty in nature. The patterns

116

of art were, therefore, based on an objective prototype though organized by the subject. Mannerism drops the theory of art as a copying of nature; in accordance with the new doctrine, art creates not merely *from* nature but *like* nature. Both Lomazzo[177] and Federigo Zuccari[178] think that art has a spontaneous origin in the mind of the artist. According to Lomazzo, the artistic genius works in art as the divine genius works in nature, and according to Zuccari, the artistic idea—the *disegno interno*—is the manifestation of the divine in the artist's soul. Zuccari is the first to ask explicitly, whence art derives its inner substance of truth, whence comes the agreement between the forms of the mind and the forms of reality, if the 'idea' of art is not acquired from nature. The answer is that the true forms of things arise in the artist's soul as a result of his direct participation in the divine mind. Here, too, as already in scholasticism and later in Descartes, the inborn ideas imprinted on the human soul by God form the criterion of certainty. God creates an agreement between nature, which produces real things, and man, who brings forth works of art.[179] But Zuccari lays more stress on the spontaneity of the mind than do not only the scholastics but also Descartes. The human mind had already become conscious of its creative nature in the Renaissance, and the derivation of its spontaneity from God merely serves, in the mind of the mannerists, to enhance its justification. The naïve subject-object relationship between the artist and nature, the final result of Renaissance aesthetics, was now undone; the genius feels without a foothold and in need of completion. The doctrine of the individualism and irrationalism of artistic creativity which arose in the Renaissance, above all the thesis that art is unteachable and unlearnable, and that the artist is born, is not stated, however, in its extreme form until the age of mannerism, namely by Giordano Bruno, who speaks not merely of the freedom but even of the unsystematic nature of artistic work. 'Rules are not the source of poetry,' he thinks, 'but poetry is the source of rules,·and there are as many rules as there are real poets.'[180] This is the aesthetic doctrine of an age which attempts to combine the idea of the God-inspired artist with that of the autocratic genius.

The antagonism between conformity to rule and lack of rule,

between discipline and freedom, divine objectivity and human subjectivity, which governs this doctrine, also finds expression in the transformation of the idea of the Academy. The original purpose and spirit of the academies was a liberal one: they served as a means of emancipating the artist from the guild and of raising him above the level of the craftsman. The members of the academies were everywhere relieved sooner or later of the obligation of belonging to a guild and of keeping to the restrictions of the guild system. In Florence the members of the Accademia del Disegno enjoyed these privileges as early as 1571. The purpose of the academies was, however, not merely representative but also educational; they were intended to replace the guilds not only as corporations but also as teaching institutions. As such they turned out to be, after all, nothing but another form of the old strait-laced, anti-progressive institution they were supposed to be replacing. Instruction in the academies was organized even more strictly than in the guilds. The irresistible development was towards the ideal of a canon of education, which, though it was only realized in France in the next period, had its origin here. Counter Reformation, authority, academicism, and mannerism are all different aspects of the same frame of mind, and it is by no means a coincidence that Vasari, the first systematic mannerist, was also the founder of the first regular academy of art. The older academy-like institutions represented mere improvisations; they were started without any systematic curriculum, were mostly limited to a series of unconnected evening courses and were made up of a constantly changing group of teachers and pupils. The academies of the age of mannerism were, on the other hand, organized from top to bottom,[181] and the teacher-pupil relationship was just as clear-cut, though organized on different principles, as the master-apprentice relationship in the guild workshops. In many places artists had already formed, alongside the guilds, religious and charitable institutions organized on more liberal lines, the so-called confraternities. There was one in Florence too, the 'Compagnia di S. Luca', and Vasari linked up his suggestions with this institution, when he induced the Grand Duke Cosimo I to found the 'Accademia del Disegno' in 1561. In contrast to the authoritarian

118

organization of the guilds and in accordance with the elective principles of the fraternities, membership of Vasari's academy was an honour conferred only on independent and creative artists. A solid, many-sided cultural background was one of the indispensable preconditions of admission. The Grand Duke and Michelangelo were 'capi' of the institution, Vincenzo Borghini was elected 'luogo tenente', that is to say, president, and thirty-six artists were chosen to be members. The teachers were to instruct a number of young people, partly in their own studios, partly in the rooms of the academy. Every year three masters were to inspect the work of the 'giovani' in the workshops of the city. Workshop instruction, therefore, did not by any means come to an end, only the theoretical auxiliary subjects, such as geometry, perspective and anatomy, were to be taught in regular academic courses.[182] In 1593, thanks to the initiative of Federigo Zuccari, the Roman academy of St. Luke was raised to the status of an art school with a permanent site and systematic teaching, and as such it served as a model for all later foundations. But this academy also remained, like the one in Florence, an essentially representative body and was not a teaching institution in the modern sense.[183] It is true that Zuccari possessed very concrete ideas about the tasks and proper methods of an art school, which provided a basis for the whole system and organization of academies, but the old craft teaching methods were still so deep-rooted in his generation that he was unable to make headway with his plans. In Rome the educational purpose was probably more in the forefront than in Florence, where the purely political and organizational aspects of art as a professional career played a leading rôle among the aims of the institution,[184] but what was actually achieved here also lagged far behind what had been planned. In his opening speech, which characteristically also contains an exhortation to cultivate virtue and piety, Zuccari stresses the importance of lectures and discussions on questions of art theory. Among the problems treated pride of place is given to the dispute about the order of precedence in the arts, which had become a matter of general interest since the Renaissance, and to the definition of the basic concept and slogan of the whole theory of mannerism, *disegno*, that is, the rough plan, the artistic

idea behind the work. The lectures given by members of the academy were also published later and made generally available to the public; they are the prototype of the famous *conférences* of the Paris Academy, which were to play such an important part in the artistic life of the following two centuries. But the art academies were by no means concerned exclusively with problems of professional organization, art education and discussions on aesthetics; even Vasari's institution already became a centre of consultation upon all kinds of artistic questions; questions were asked about the setting of works of art, it was asked to recommend artists, to give an expert judgement on building plans and to confirm export licences.

For three centuries academicism dominated artistic policy, the public advancement of the arts, art education, the principles according to which prizes and scholarships were awarded, the organization of art exhibitions and, to some extent, art criticism. To its influence must be ascribed, above all, the fact that the tradition of earlier ages, which was based on organic growth, is replaced by the convention of classical models and the eclectic imitation of the masters of the Renaissance. Nineteenth-century naturalism was the first movement to succeed in shaking the reputation of the academies, and to give a new direction to the theory of art, which had been classically inclined ever since their inception. In Italy itself, it is true that the idea of the academy of art never underwent the rigid formalization and contraction to which it was subjected when it was transferred to France; but even in Italy the academies gradually became more and more exclusive. In the beginning membership of these institutes was intended merely to differentiate the artist from the craftsman, but soon academic status became a means of raising some artists, namely the more cultured and materially independent, above the level of the uncultured and poorer elements. The cultural background, which was the precondition of academic recognition, increasingly became a criterion of social distinction. Previously, in the Renaissance, to be sure, individual artists had received unusual honours, but the great majority of artists led a relatively modest albeit assured existence; now every recognized artist is a 'professore del disegno', and a 'cavaliere' is no longer a curiosity

among artists. But that kind of differentiation is not only apt to destroy the social unity of artists as a corporative body and to split them up into different classes completely alien to one another, but it also leads to the highest of these classes identifying itself with the upper class of the public instead of with the rest of the artist fraternity. The fact that amateurs and laymen are also elected to membership of the art academies creates a solidarity between the cultured circles of the general public and the artists which is without precedent in the history of art. The Florentine aristocracy is strongly represented in the Accademia del Disegno and this new rôle leads to quite a different kind of interest in artistic matters from that connected with previous forms of patronage. The same academicism, therefore, which, on the lower level, separates the artists as a body from non-artistic craftsmanship, on the higher level, bridges the gap between the productive working artist and the cultured layman.

This mingling of the various strata of society is also expressed in the fact that the art critics no longer write merely for artists but also for art-lovers. Borghini, the author of the famous *Riposo*, does so quite explicitly; but the fact that he thinks it necessary to justify himself as one who, though not a member of the craft, nevertheless writes about art, is a symptom that there is still a certain amount of opposition among artists to the invasion of the field of art criticism by the layman. In his *L'Aretino* (1557), Lodovico Dolce already discusses in detail the problem as to whether it behoves a non-artist to play the part of judge in questions of art, and he reaches the conclusion that the cultured layman must be allowed an absolute right to do so, except in purely technical matters. In accordance with this view, there is a definite falling off in the treatment of technical questions in the writings of the more modern theorists, in contrast to the art treatises of the Renaissance. But, since art theory is carried on mainly by non-artists, it is natural that those aspects of art which are not dependent on individual techniques, but are common to all the arts, are given more emphasis and discussed with more care than hitherto.[185] An aesthetic doctrine gradually becomes predominant which not only neglects the importance of the manual element, but conceals what is specific in the

individual arts and tends towards a general conception of art. Now, this is the best possible proof of how a sociological phenomenon can influence a decision on purely theoretical questions. The promotion of the artists as a body into higher spheres of society and the participation of the upper classes in artistic life leads, though by a roundabout way, to the abolition of the autonomy of artistic techniques and to the rise of the doctrine of the fundamental homogeneity of art. It is true that, in the persons of Federigo Zuccari and Lomazzo, professional artists come to the forefront again in art literature, but the lay element is well on the way to taking possession of art criticism. Art criticism in the narrower sense of the term, that is to say, the discussion of the artistic merit of individual works, which is more or less independent of the technical and philosophical theory of art, a branch of criticism that only achieves importance, however, during the next period in the history of art, is the domain of non-artists from the very outset.

The first comparatively short phase of Florentine mannerism, which in essentials covers the decade from 1520 to 1530, constitutes a reaction against the academicism of the Renaissance. This tendency is not intensified until the entry of the second phase, which reaches its climax around the middle of the century and of which Bronzino and Vasari are the main representatives. Mannerism begins, therefore, with a protest against the art of the Renaissance, and the people of the time are perfectly well aware of the breach that thereby arises in the development of art. What Vasari says about Pontormo already proves that the new direction is felt as a rupture with the past. Vasari remarks that in his frescoes in the Certosa di Val d'Ema, Pontormo imitates Dürer's style and he describes that as a deviation from the classical ideals, which he and his contemporaries, that is to say, the generation of those born between 1500 and 1510, again hold in the highest respect. But Pontormo's turning away from the masters of the Italian Renaissance to Dürer is in fact not merely a question of taste and form, as Vasari thinks, but the artistic expression of the intellectual affinity which links up Pontormo's generation with the German Reformation. With the influx of the Northern

religious movement, North European art also gains ground in Italy and, above all, the art of that German artist who, of all his fellow-countrymen, comes nearest to Italian taste and, owing to the spread of his engravings, is also the most popular in the South. But it is by no means those aspects of Dürer's style which it shares with Italian art that make it so attractive especially for Pontormo and those who think like him, but rather the spiritual depth and inwardness, in other words, the qualities which they miss most in classical Italian art. The antitheses of 'Gothic' and 'Renaissance', however, which are largely smoothed out in Dürer himself, are still irreconciled and irreconcilable in the outlook of the mannerists.

This antagonism is expressed most strikingly in their treatment of space. Pontormo, Rosso, Beccafumi, exaggerate the spatial effect of their pictures and make the individual groups of figures suddenly press down into and then shoot up out of the depth, but often they nullify space altogether not merely by abolishing its optical uniformity and structural homogeneity, but also by basing the composition on a planimetric pattern and by combining the propensity towards depth with a tendency to keep to the surface. For the Renaissance, as for every stirring, surging, dynamic culture, space is the basic category of the optical view of the world; in mannerism spatiality loses this predominant position without, however, being completely devalued—in contrast to most static and conservative, other-worldly and spiritualistic, periods in the history of art, which usually renounce the representation of space altogether and portray their figures in abstract isolation, without depth and without atmosphere. The painting of realistic, world-affirming and expansive cultures places the figures, to start with, in a coherent spatial context, then gradually makes them the substratum of the space and, finally, dissolves them in space entirely. That is the path leading from Greek classicism through the art of the fourth century B.C. to Hellenism, and from the Renaissance through baroque to naturalism and impressionism. The early Middle Ages are no more interested in space and spatiality than was classical archaism. Spatiality does not become the principle of actual life, the bearer of light and atmosphere, until the end of the Middle

Ages. But as the development of art approaches the Renaissance, this consciousness of space is transformed into a real obsession with space. Spengler has pointed out that the spatial mode of vision and thought of the Renaissance man—of the 'Faustian man', as he calls him[186]—is a basic characteristic of all dynamic cultures. The golden sky and perspective are in fact much more than two different ways of dealing with the background, they are characteristic of two different approaches to reality. The one takes man, the other the world as its starting point; the one stresses the primacy of the figure over the space, the other allows space, as the element of appearance and the substratum of sense experience, to predominate over the substantiality of man and allows the human figure to be absorbed by space. 'Space exists before the body which is brought to a definite place', says Pomponius Gauricus, the best representative of the Renaissance outlook in this particular context.[187] Mannerism is different from these typical approaches in that it tries, on the one hand, to surmount all spatial limitations, but cannot, on the other hand, forgo the expressive effects of spatial depth. The often exaggerated plasticity and the usually excessive mobility of its figures seem to compensate for the unreality of space, which ceases to form a coherent system and becomes a mere sum-total of spatial co-efficients. In works such as Pontormo's 'Joseph in Egypt' or Parmigianino's 'Madonna del collo lungo', this contradictory attitude to the problem of space leads to a phantasmagoria, which can very easily appear to be a mere whim, but which, in fact, has its origin in the weakened sense of reality of the age.

With the consolidation of absolutism, mannerism loses much of its artiness in Florence and takes on a predominantly courtly-academic character; on the one hand, the absolute authority of Michelangelo is recognized and, on the other, the binding nature of firm social conventions. Now, for the first time, the dependence of mannerism on classical art becomes stronger than its opposition to it—above all, probably under the influence of the authoritarian spirit, which dominates courtly Florence and also imposes fixed standards on art. The idea of cool, unapproachable grandezza, which the Duchess brings from her Spanish homeland, is most directly realized in the work of Bronzino, who, with the

crystal-clear correctness of his forms, is the born court painter. But with the ambivalent nature of his relationship to Michelangelo and to the problem of space, above all with the inner contradiction which has been called the spiritual uneasiness behind the armour of a cool bearing,[188] he is, at the same time, the typical mannerist. In the case of Parmigianino, who is dominated by less strict conventions, the 'armour' is thinner and the signs of spiritual unrest more directly apparent. He is more delicate, more nervous, more morbid than Bronzino; he is able to let himself go more than the court painter and courtier in Florence, but he is just as affected and artificial. There now develops throughout Italy a refined court style, a kind of rococo, the subtlety of which is in no way inferior to the French art of the eighteenth century, but which is often richer and more complicated. Now, for the first time, mannerism acquires the universal recognition and international character that the art of the Renaissance never enjoyed. In this style, which now spreads over the whole of Europe, the precious rococo-like virtuosity forms just as important a constituent as the strict canon based on Michelangelo. And however little these two elements have in common intrinsically, the precious element was already present to some extent in Michelangelo himself, especially in such works as the 'Victor' and the Medici tombs.

Michelangelo's real heir is, however, not international, Michelangelesque mannerism, but Tintoretto, who is perhaps not entirely independent of this international style, but is, in essentials, remote from it. Venice has no court of its own and Tintoretto does not work for foreign courts, like Titian; in fact, it is not until towards the end of his life that he is given commissions even by the Republic. In the main, he is employed by the confraternities instead of by the courts and the states. It is difficult to say whether the religious character of his art was conditioned above all by the demands of those from whom he received commissions or whether he looked for his customers from the very outset in circles already closely related to him spiritually; at any rate, he was the only artist in Italy in whom the religious rebirth of the age found just as deep expression as in Michelangelo, though it was of a different kind. He worked for the fraternity

of S. Rocco, of which he had become a member in 1575, on such modest terms that one may assume that, above all, emotional factors determined his undertaking the work. The intellectual and religious direction of his art was, if not conditioned or even produced, in any case, made possible by the circumstance that he was working for people with such a different outlook from those for whom Titian worked, for example. The fraternities, built up on a religious foundation and usually organized according to occupational categories, are particularly characteristic of sixteenth-century Venice; the popularity they enjoy is a symptom of the deepening of religious life, which is more intensive in Contarini's home town than in most other places in Italy. The members are mostly simple folk and that also explains the priority given to the strictly religious element in their artistic pursuits. But the confraternities themselves are well-to-do and can afford to adorn their club-houses with important and ambitious pictures. By working on the decoration of one such club-house, the Scuola S. Rocco, Tintoretto becomes the greatest and most representative painter of the Counter Reformation.[189] His spiritual rebirth takes place about 1560, at the time when the Tridentinum is drawing towards its close and formulating its decrees on artistic matters. The great paintings of the Scuola S. Rocco, which are created in two separate periods, in the years 1565–7 and 1576–87, portray the heroes of the Old Testament, narrate the life of Christ and glorify the sacraments of the Christian religion. In subject-matter they constitute the most comprehensive series of pictures created by Christian art since Giotto's cycle of frescoes in the Cappella dell'Arena, and as far as the spirit inspiring them is concerned, one must go back to the sculptures in Gothic cathedrals to find such an orthodox description of the Christian cosmos. Michelangelo is a pagan wrestling with the mysteries of Christianity, compared with Tintoretto, who is already in sure possession of the secret which his predecessor still had to struggle to unravel. The biblical scenes, the Annunciation, the Visitation, the Last Supper, the Crucifixion, are no longer merely human events for him, as they were for most of the artists of the Renaissance, nor are they mere episodes in the tragedy of the Redeemer, as they are for Michelangelo, but they are rather the

visible manifestation of the mysteries of the Christian faith. In his work, the representations assume a visionary character and although they unite within themselves all the naturalistic achievements of the Renaissance, the main impression is unreal, spiritual, inspired. There seems to be an absolute absence of gap here between the natural and the supernatural, the secular and the sacred. This perfect balance only represents a passing phase, however; the orthodox Christian significance of the works is lost again. The world-picture of Tintoretto's later paintings is often pagan and mythological, at best Old Testament in character, but on no account based on the Christian gospel. What takes place in them is cosmic in its range; it is a primeval drama, in which both the prophets and saints and Christ and God the Father are, as it were, all partners, fellow-actors, not producers of the play. In the painting 'Moses bringing forth water from the rock', the biblical hero not only has to renounce his rôle as the leading character and yield before the miracle of the jet of water, but God himself becomes a moving heavenly body, a whirling wheel of fire in the mechanism of the universe. In the 'Temptation' and the 'Ascension', this macrocosmic drama, which contains far too little historical definition and human reference to be called strictly Christian and biblical, is repeated. In other works, such as the 'Flight into Egypt' and both 'St. Mary Magdalen' and 'St. Mary Aegyptiaca', the scenery is transformed into a visionary mythological landscape, in which the figures disappear almost completely and the background dominates the whole stage.

Greco is Tintoretto's only real successor. Like the art of the great Venetian mannerist, his art also develops in the main independently of the courts. Toledo, where Greco settles after his years of apprenticeship in Italy, is, next to Madrid—the seat of the court—and Sevilla—the main nodal-point of trade and communications—the third most important city in the Spain of the time and the centre of ecclesiastical life.[190] It is no coincidence that the most deeply religious artist since the Middle Ages should choose this city for his home. It is true that he did try to secure an appointment at the court in Madrid,[191] but his failure to do so is a sign that even in Spain an antagonism was beginning to develop between courtly and religious culture, and that for an

artist like Greco the courtly formula of mannerism had become too narrow. His art is in no way a denial of the courtly origin of the style which it employs, but it far outgrows the realm of the courtly. 'The Burial of the Count of Orgaz' is a ceremony in the proper courtly style, but it rises, at the same time, into regions where all purely social and inter-human affairs are left behind. On the one hand, it is a faultless ceremonial picture; on the other, the representation of an earthly-heavenly drama of the deepest, tenderest and most mysterious feeling. This condition of balance is followed in Greco, as in Tintoretto, by a period characterized by deformation, disproportion and exaggeration. In Tintoretto the scene of the pictures broadened out into the infinities of cosmic space, in Greco intellectually inexplicable incongruities arise between the figures which impel us to seek an interpretation beyond the categories of the rational and the natural. In his last works, Greco approaches Michelangelo's dematerialization of reality. In works such as the 'Visitation' and the 'Wedding of Mary', which in his development take the place of the 'Pietà Rondanini', the figures are already wholly dissolved in the light and have become pale, unsubstantial shadows gliding along in an indefinite, unreal, abstract space.

Greco also has no direct successor; he, too, stands alone with his solution of the burning artistic problems of the day. In contrast to the Middle Ages, the uniform style of which comprehended even the most perfect creations of the time, general currency is now obtained only by the average level of achievement. Greco's spiritual style is not even carried on indirectly, as the cosmic world-view of Italian mannerism is in the art of Bruegel. For, in spite of all the differences, the sense of the cosmic is also the predominant element in this artist, although, in complete contrast to Tintoretto, for example, the symbols of totality are often the most trivial things—a mountain, a valley or a wave. In Tintoretto the ordinary vanishes at the breath of the All, whereas in Bruegel the All is immanent in objects of the most everyday experience. What is realized here is a new form of symbolism, one more or less opposed to all previous symbolisms. In medieval art the symbolical significance was all the more forcibly recognized, the more distant the picture was from em-

pirical reality, the more stylized and stereotyped it was; here, on the other hand, the symbolical power of the picture increases with the ephemeral and peripheral nature of the subject-matter. As a result of the abstract and conventional character of their symbolism, medieval works of art were always open to only one interpretation, whereas the great artistic creations since the age of mannerism are capable of innumerable possible explanations. To be understood, the paintings of Bruegel and the writings of Shakespeare or Cervantes must always be approached from a different angle. Their symbolical naturalism, which marks the beginning of modern art, implies, as the absolute reversal of Homeric homogeneity, the fundamental divorce of purpose and existence, essence and life, God and the world. The world is not significant here, simply because it is in *being*, as it is in Homer, and these artistic representations are not true simply because they are different from normal reality, as was the case in the Middle Ages, but through their incompleteness and their inherent incomprehensibility they point to a more perfect, more complete, more significant reality.

At first sight, Bruegel seems to have little in common with most of the mannerists. There are no 'tours de force', no artistic niceties, no convulsions and contortions, no arbitrary proportions and contradictory conceptions of space in his·work. He seems, especially if one concentrates on the peasant pieces of his last period, to be a robust naturalist, who in no way fits into the framework of problematical, intellectually differentiated mannerism. But, in reality, Bruegel's world-view is as divided, his approach to life just as self-conscious and unspontaneous, as that of the rest of the mannerists. Self-conscious not merely in the sense of the reflectiveness common to all post-Renaissance art, but also in the sense that the artist presents not a description of reality in general, but consciously and intentionally presents *his* version, *his* interpretation of reality, and in the sense that all his work could be summed up under the heading 'How I see it'. This is the revolutionary novelty and the eminently modern feature both in the art of Bruegel and in the whole of mannerism. All that is missing in Bruegel is the preciousness of most of the mannerists, but not their piquant individualism, not the

supreme desire for self-expression. No one will ever forget his first encounter with Bruegel. It often needs some practice before the inexperienced observer comes to appreciate the characteristics of the art of other, especially older masters; he usually begins by mixing up the works of the different artists. But Bruegel's individuality is unforgettable and unmistakable, even for the beginner.

Bruegel's painting is also like the rest of manneristic art in that it makes no popular appeal. That has not been recognized any more than the general stylistic character of his painting has been understood, having usually been considered a healthy, ingenuous, integral naturalism. He was dubbed the 'Peasant Bruegel', and people fell into the error of imagining that an art which portrays the life of simple folk is also intended for simple folk, whereas the truth is, in reality, rather the opposite. It is usually only the conservatively thinking and feeling ranks of society that seek in art for an image of their own way of life, the portrayal of their own social environment. Oppressed and upward-striving classes wish to see the representation of conditions of life which they themselves envisage as an ideal to aim at, but not the kind of conditions they are trying to work themselves out of. Only people who are themselves superior to them feel sentimentally about simple conditions of life. That is so today, and it was no different in the sixteenth century. Just as the working class and the petty bourgeoisie of today want to see the milieu of rich people and not the circumstances of their own constricted lives in the cinema, and just as the working-class dramas of the last century achieved their outstanding successes not in the popular theatres, but in the West End of the big cities, so Bruegel's art was not intended for the peasantry, but for the higher, or at any rate, the urban, levels of society. It has been shown that his peasant pictures had their origin in court culture.[192] The first signs of an interest in country life as a subject for art are to be observed at the courts, and in the calendar pictures of the prayer-books of the Duke of Berri we possess courtly portrayals of rural scenes from as early as the beginning of the fifteenth century. Book illuminations of this kind form one source of Bruegel's art; the other has been discerned in those tapestries which were also intended primarily

for the court and court circles, and in which, alongside the ladies and gentlemen concerned with hunting and dancing and social games, working country folk, woodcutters and vine-growers, are also portrayed.[193] The effect of these descriptions of the customs of country and natural life was originally by no means emphatically emotional and romantic—that kind of impression first arose in the eighteenth century—but rather comical and grotesque. The life of the simple country and working-class folk was regarded as a curiosity by those circles for whom the illuminated prayer-books and hangings were intended, as something strange and exotic, but in no way humanly touching and moving. The master class found the same kind of pleasure in these representations of the daily life of simple folk as they did in the fabliaux in earlier centuries, the only difference being that, from the outset, these also provided entertainment for the lower classes, whereas the enjoyment of the precious miniatures and tapestries was restricted to the highest circles of society. Those interested in Bruegel's pictures will also have belonged to the most well-to-do and the most cultivated classes. After a sojourn in Antwerp, the artist settles in courtly, aristocratic Brussels somewhere around 1562/3. This move coincides with the stylistic change which is an all-important influence on his final manner and with his turning to the subject-matter of the peasant pictures which established his fame.[194]

7. THE SECOND DEFEAT OF CHIVALRY

The renaissance of chivalric romanticism, with the new blaze of enthusiasm for the heroic life and the new vogue of the novels of chivalry, a phenomenon which first appears in Italy and Flanders towards the end of the fifteenth century and which reaches its climax in France and Spain in the next century, is essentially a symptom of the incipient predominance of authoritarian forms of government, of the degeneration of middle-class democracy and the gradual assimilation of Western culture to the standards of the courts. Chivalrous ideals and conceptions of

virtue are the sublimated form in which the new aristocracy, rising from the lower classes, and the princes, tending towards absolutism, disguise their ideology. The Emperor Maximilian is regarded as the 'last knight', but he has many successors who still lay claim to this title, and even Ignatius Loyola calls himself the 'knight of Christ' and organizes his order according to the principles of the moral code of chivalry—though, at the same time, also in the spirit of the new philosophy of political realism. The ideals of knighthood themselves are no longer capable of supporting the new social structure; their incompatibility with the rationalistic pattern of economic and social reality, their out-of-dateness in the world of 'windmills', is all too obvious. After a century of enthusiasm for the knight-errant and of luxuriating in the adventures of the novels of chivalry, chivalry suffers its second defeat. The great poets and dramatists of the century, Shakespeare and Cervantes, are the mouthpiece of their age—they merely proclaim what is everywhere apparent, that chivalry has outlived its day and that its creative force has become a fiction.

Nowhere did the new cult of chivalry reach the same pitch of intensity as in Spain, where in the seven-hundred-year-long struggle against the Arabs the maxims of faith and honour, the interests and prestige of the ruling class, had become fused into an indissoluble unity, and where the wars of conquest against Italy, the victories over France and the exploitation of the treasures of America offered themselves, as it were, automatically as so many pretexts for the heroizing of the military class. But in this country, where the newly revived spirit of chivalry shone most brilliantly, the disillusion, when the dominance of the ideals of knighthood was shown to be fictitious, was also the greatest. In spite of its conquests and its treasures, victorious Spain had to yield before the economic supremacy of the Dutch traders and English pirates; it was not in a position to supply its war-tried heroes; the proud hidalgo became a starveling, if not a rogue and a vagabond: the novels of chivalry proved to be the least suitable preparation imaginable for the tasks which a soldier who had served his time had to tackle in establishing himself in civilian society.

SECOND DEFEAT OF CHIVALRY

The biography of Cervantes provides an extremely typical example of what could befall a man living during the transition from romantic chivalry to realism. Without knowing this story it is impossible to appreciate *Don Quixote* sociologically. The author comes from a destitute family belonging to the knightly aristocracy; because of his poverty, he is forced to serve as a common soldier in Philip II's army from his youth up, and to suffer all the hardships of the Italian campaigns. He takes part in the Battle of Lepanto, in which he is severely wounded. On the return home from Italy, he falls into the hands of Algerian pirates, spends five bitter years as a prisoner, until he is released in 1580 after several unsuccessful attempts to escape. At home, he finds his family poverty-stricken and up to the ears in debt. But there is also no suitable employment for himself, the deserving soldier, the hero of Lepanto, the knight taken prisoner by the heathen; he has to be satisfied with the subordinate position of a paltry tax-collector, he has material worries, is imprisoned innocently or for some trivial offence, and has, finally, to experience the collapse of Spain's military power and her defeat at the hands of the English. The tragedy of the individual knight is repeated on a wider scale in the fate of the chivalrous nation par excellence. It becomes more and more clear to him that the blame for both the individual and the national failure lies in the historical anachronism of chivalry, in the untimeliness of irrational romanticism in this thoroughly un-romantic age. If Don Quixote attributes the incompatibility of the world and his ideals to the bewitching of reality, and cannot understand the discrepancy between the subjective and objective order of things, that only means that he has slept through the world-historical transformation, and that his world of dreams, therefore, seems to him to be the only real world, whereas reality appears to be a magic world full of evil demons. Cervantes recognizes the absolute lack of tension and polarity in this attitude and, therefore, its complete incurability; he sees its idealism is just as unanswerable from the point of view of reality as external reality must inevitably remain unaffected by it, and that, given this lack of relationship between the hero and his environment, all action is condemned to miss the mark.

It may well be that Cervantes was not aware of the deeper significance of his idea at the very beginning, and was merely thinking in the first place of writing a parody of the novels of chivalry. But he must soon have recognized that it was not simply the reading-matter of his contemporaries which was to be questioned. The parodying of chivalry was no new thing in his lifetime: Pulci had already made fun of the stories of chivalry and in Bojardo and Ariosto we find the same ridiculing attitude to its charms. In Italy, where knighthood was represented to some extent by middle-class elements, the new chivalry did not take itself quite seriously. It was doubtless here that Cervantes was prepared for his sceptical attitude, here, in the home of liberalism and humanism, and it was to Italian literature that he probably owed the first suggestion for his epoch-making joke. His work was not intended, however, merely to take a rise out of the artificial and mechanical novels of fashion, nor to become merely a criticism of out-of-date chivalry, but also to be an indictment of the world of diseachanted, matter-of-fact reality, in which there was nothing left for an idealist but to dig himself in behind his *idée fixe*. The novelty in Cervantes' work was, therefore, not the ironic treatment of the chivalrous attitude to life, but the relativizing of the two worlds of romantic idealism and realistic rationalism. What was new was the indissoluble dualism of his world-view, the idea of the impossibility of realizing the idea in the world of reality and of reducing reality to the idea.

In his relationship to the problem of chivalry, Cervantes is entirely determined by the ambivalence of the manneristic approach to life. He wavers between the justification of unworldly idealism and of worldly-wise common sense. From that arises his own conflicting attitude to his hero, which ushers in a new age in the history of literature. Before Cervantes there had only been good and bad characters, deliverers and traitors, saints and blasphemers, in literature; here the hero is saint and fool in one and the same person. If a sense of humour is the ability to see two opposite sides of a thing at the same time, then the discovery of this double-sidedness of a character signifies the discovery of humour in the world of literature—of the kind of humour

that was unknown before the age of mannerism. We possess no analysis of mannerism in literature going beyond the usual exposition of marinism, gongorism and related tendencies; but if one wished to carry out that kind of analysis, one would have to start with Cervantes.[195] Apart from the wavering sense of reality, the effacement of the frontiers between the real and the unreal, one could also best study in his work the other basic features of mannerism: comedy shining through the darkness of tragedy, the presence of the tragic in the comic, as well as the hero's dual nature, making him seem ridiculous in one moment and sublime in the next. The phenomenon of 'conscious self-deception' is also a leading feature of this style: the various allusions made by the author to the fact that the world of his narrative is a fictitious one, the constant transgression of the frontiers dividing the reality immanent in the work and the reality outside the work, the unconcern with which the characters of the novel step out of their proper sphere and walk over into the reader's world, the 'romantic irony' with which reference is made in the second part to the fame of the main characters established by the first part—how, for example, they reach the ducal court, thanks to their literary fame, and the way Sancho Panza says of himself, that he is Don Quixote's 'squire, who is, or should be in the book, Sancho Panza by name, if he was not changed in his cradle, that is, in the press'. The *idée fixe* by which the hero is obsessed is also manneristic, the compulsion which governs his movements, and the marionette-like character which the whole action acquires as a consequence. The grotesque and capricious style of the presentation, the arbitrary, formless and extravagant nature of the structure, is manneristic; the insatiable delight the narrator takes in introducing more and more new episodes, commentaries and excursions; the cinematic jumps in the story, the digressions and 'dissolves'. The mixture of the realistic and imaginative elements in the style, of the naturalism of the details and the unreality of the total conception, the uniting of the characteristics of the idealistic novel of chivalry and the vulgar picaresque novel, the combination of dialogue based on everyday conversation, which Cervantes is the first novelist to use,[196] with the artificial rhythms and affected figures of speech of *conceptism*—all this is

manneristic. The fact that the world is presented, as it were, in a process of formation and growth, that the story changes its direction, that the author alters the characters in the course of the narrative, that such an important and apparently indispensable figure as Sancho Panza is altogether an afterthought, that the person of Don Quixote gradually becomes so much deeper and so sublimated that Cervantes—as has been asserted[197]—ends by not even understanding his hero himself—all this is very typically manneristic. Finally, the lack of uniformity in the execution, the mixture of virtuosity and delicacy with the negligence and crudity, on account of which *Don Quixote* has been called the most careless of all the great literary creations[198]— though the assertion is only half true, since there are works by Shakespeare equally deserving this description.

Cervantes and Shakespeare were almost the same age; they died in the same year, though not in the same year of their lives. The points of contact between the world-view and the artistic intentions of the two writers are innumerable, but the agreement between them is nowhere so significant as in reference to chivalry, which they both consider out of date and decadent. Despite this fundamental unanimity, their feelings in regard to the ideals of chivalry are very different, as is only to be expected with such a complex phenomenon. Shakespeare the dramatist takes up a more positive attitude to the idea of chivalry than the novelist Cervantes, but being the citizen of an England which is in a more progressive stage of social development, he rejects knighthood as a class more sharply than does the Spaniard, who, because of his own knightly descent and military career, is not quite so impartial. If only for stylistic reasons, the dramatist does not wish to renounce the social advancement of his heroes: they must be princes, generals and great lords, in order to stand out against their fellow creatures on the stage, and they must fall from a sufficient height, to make a correspondingly deep impression with their sudden change of fortune.

Under the Tudors, kingship had developed into despotism. The nobility had been almost completely destroyed at the end of the Wars of the Roses, but the gentry, the yeomanry and the urban middle class wanted peace and order above all things—

they did not mind what government they had so long as it was strong enough to prevent the return of anarchy. Immediately before Elizabeth's accession to the throne the country was again afflicted with the horrors of civil war; religious antagonisms seemed to have become more irreconcilable than ever before, the national budget was in a hopeless state, foreign affairs were confused and by no means without danger. The very fact that the Queen succeeded in partly removing, partly evading these dangers assured her of a certain measure of popularity in many sections of the population. For the privileged and possessing classes her reign meant, above all, that they were protected against the threatening danger of revolutionary movements rising from below. All the fears entertained by the middle classes about the increase in the powers of the sovereign were silenced by the support they had in the monarchy in waging the class war. Elizabeth promoted the capitalist economy in every way; like most of the rulers of her age, she was constantly finding herself in financial difficulties, and she even took a direct part in the undertakings of Drake and Raleigh. Private enterprise had the benefit of hitherto unheard-of protection; not only the government but legislation, too, was concentrated on looking after its interests.[199] The acquisitive economy rose uninterruptedly and the spirit of profit-making connected with it embraced the whole nation. Everybody who was economically mobile indulged in speculation. The rich bourgeoisie and the landowning or industrially active nobility formed the new ruling class. The stabilization of society is expressed in the alliance between the Crown and this new class. One must not over-estimate, however, the political and intellectual influence of these social strata. The court, at which the old aristocracy still sets the fashion, forms the centre of public life and the Crown favours the court nobility as against the middle class and the gentry, wherever it can do so without harm and danger. On the other hand, the court is already made up partly of people first raised to the peerage under the Tudors and enabled by their wealth to rise in society. The very few descendants of the old nobility and the members of the squirearchy are quite willing to marry into and co-operate economically with the rich and conservative section of the middle

class. The social levelling ensues here, as in almost the whole of Europe, partly through the children of middle-class people marrying into the aristocracy, partly through the placing of the younger sons of the nobility in bourgeois professions. In England, however, where the second case is the rule, what takes place is essentially the levelling down of the nobility to the middle class; in contrast, above all, to France, where the rise of the middle class into the nobility is the characteristic phenomenon. In England, the fact that the monarchy had restored order after century-long feuds and was now ready to guarantee the security of the propertied classes remained the decisive factor governing the relationship of the upper middle class and the squirearchy to the Crown. The principle of order, the idea of authority and security, becomes the basis of the middle-class outlook on life, since the acquisitive classes become more and more conscious of the fact that there is nothing so dangerous for them as a weak government and the undermining of the social hierarchy. 'When degree is shaked . . . the enterprise is sick' (*Troilus and Cressida*, I. 3)—that is the quintessence of their social philosophy. Their fear of chaos explains Shakespeare's royalism as well as that of his contemporaries. The thought of anarchy pursues them everywhere; the order of the universe, and the dissolution with which this order seems to them to be menaced, is a leading theme of their thinking and writing.[200] They invest the picture of social disorder with the dimensions of the troubled harmony of the universe, and they interpret the music of the spheres as the song of victory of the angels of peace in their triumph over the elements of revolt.

Shakespeare sees the world through the eyes of a well-to-do, on the whole liberally-minded, sceptical and in some respects disillusioned townsman. He expresses political views which are rooted in the idea of human rights—as we should call it today— he condemns the encroachments of power and the oppression of the common people, but he also condemns what he calls the arrogance and prepotence of the mob, and, in his bourgeois uneasiness and fear of anarchy, he sets the principle of 'order' above all humanitarian considerations. Conservative critics usually agree that Shakespeare despises the common people and hates the

'rabble' of the streets, whereas some socialists, who would like to claim him as one of their own, think that there can be no question of hatred and contempt in him in this connection, and that one is not entitled to expect of a poet of the sixteenth century that he should have taken his stand on the side of the proletariat as we understand it today, all the less as that kind of proletariat was non-existent at the time.[201] The arguments of Tolstoy and Shaw, who identify Shakespeare's political views with those of his aristocratic heroes, above all with the views of Coriolanus, are not particularly convincing, even though it is remarkable with how much obvious delight Shakespeare allows the common people to be insulted—in saying which one must not forget, however, with how much gusto insults were bandied about for their own sake on the Elizabethan stage. Shakespeare certainly does not approve of Coriolanus' prejudices, but the regrettable delusions of the aristocrat do not spoil his delight in the sight of the 'fine fellow'. He looks down on the broad masses of the people with a feeling of superiority in which—as Coleridge already remarked—there is a mixture of disdain and patient benevolence. On the whole, his approach corresponds to the attitude of the humanists, whose catchwords referring to the 'uncultured', 'politically immature', 'fickle' crowd he guilelessly repeats. But as soon as one remembers that the English aristocracy, which is more closely connected with humanism, approaches the common people with more understanding and goodwill than the middle class, which is more directly menaced by the economic aspirations of the proletariat, and that, for example, Beaumont and Fletcher, who stand closer to the aristocracy than any of Shakespeare's professional colleagues, show the common people in a more favourable light than most of the dramatists of the period,[202] it will immediately become obvious that these reservations are not merely cultural in origin. But however high or low Shakespeare assessed the intellectual and moral qualities of the masses, however much or little personal sympathy he showed for the 'evil-smelling' and 'honest' common people, it would be an all too far-reaching simplification of the facts to represent him simply as a tool in the hands of reaction. Marx and Engels diagnosed the decisive factor here just as

correctly as in the case of Balzac. Both writers were, despite their fundamentally conservative approach, pioneers of progress, for both had recognized the critical and indefensible nature of the situation in which most of their contemporaries were content to acquiesce. Whatever Shakespeare thought about the monarchy, the middle class and the common people, the mere fact that he expressed a tragic view of life and the deepest pessimism, in an age of national ascent and economic prosperity from which he himself profited so much, is evidence of his sense of social responsibility and his conviction that not everything in this demi-Paradise was for the best. He was certainly no revolutionary and no fighter by nature, but he was on the same side as those who prevented the revival of the feudal nobility by their healthy rationalism, just as Balzac involuntarily and unconsciously became one of the forerunners of modern socialism through his unmasking of middle-class psychology.

Shakespeare's historical dramas make it sufficiently clear that in the struggle between the Crown, the middle class and the gentry, on the one side, and the feudal aristocracy, on the other, the dramatist by no means stood on the side of the cruel and arrogant rebels. His interests and inclinations bound him to the social strata which embraced the middle class and the liberally-minded aristocracy that had adopted the middle-class outlook, and which formed a progressive group, at any rate, in contrast to the old feudal nobility. Antonio and Timon, the rich, cultured, generous merchants with cultivated manners and seignorial bearing, probably came nearest to his ideal. In spite of his sympathies for the ruling-class attitude to life, Shakespeare always stood on the side of healthy common sense, justice and spontaneous feeling, wherever these middle-class virtues came into conflict with the obscure motives of an irrational knightly romanticism, of superstition and a turbid mysticism. Cordelia is the purest embodiment of these virtues in the midst of her feudal milieu.[203] For however highly Shakespeare the dramatist places the decorative value of chivalry, he cannot reconcile himself to the unrestrained hedonism, the thoughtless hero-cult, the wild, unruly individualism of this class. Sir John Falstaff, Sir Toby Belch, Sir Andrew Aguecheek are shameless parasites; Achilles,

Ajax, Hotspur, idle, swaggering bullies; the Percys, Glendowers, Mortimers, ruthless egoists—and Lear is a feudal despot in a state where heroic-knightly moral principles reign supreme and where nothing gentle, affectionate and unassuming has a chance of survival.

It has been thought possible completely to reconstruct Shakespeare's conception of chivalry from the portrayal of Falstaff's character. But Falstaff represents only one type of Shakespearian knight, namely the knight who has been uprooted by economic developments and corrupted by his adoption of the middle-class outlook, who has become an opportunist and a cynic and would still like to appear as a selfless and heroic idealist. He combines within himself features from the character of Don Quixote with some of Sancho Panza's qualities, but, in contrast to Cervantes' hero, is only a caricature. Characters like Brutus, Hamlet, Timon and, above all, Troilus represent the Don Quixote type more purely.[204] Their other-worldly idealism, their naïvety and credulity are all qualities which they have in common with Don Quixote; the only peculiar characteristic of the Shakespearian vision is their terrible awakening from delusion and the untold misery which follows from their belated recognition of the truth.

Shakespeare's attitude to chivalry is very involved and not entirely consistent either. He transforms the decline of knighthood, which he still describes with complete satisfaction in his historical plays, into the tragedy of idealism—not because he had come any nearer the ideal of chivalry, but because he had also become estranged from 'unchivalrous' reality and its Machiavellism. It had now become apparent where the rule of this doctrine had led! Marlowe was still fascinated by Machiavelli, and the young Shakespeare, the author of the chronicle of *Richard III*, was obviously also more enthusiastic about him than the later Shakespeare, for whom, as for his contemporaries, Machiavellism had become a nightmare. It is impossible to describe Shakespeare's attitude to the social and political problems of his age uniformly, regardless of the various stages in his development. Especially around the turn of the century, at the time of his full maturity and at the height of his success, his philosophy underwent a change, which fundamentally altered

his whole judgement of the social situation and his feelings towards the different sections of society. His earlier contentment with existing conditions and his optimism regarding the future were undermined and even though he held fast to the principle of order, the appreciation of social stability and the rejection of the heroic ideal of feudal chivalry, he seems to have lost his confidence in Machiavellian absolutism and a ruthlessly acquisitive economy. Shakespeare's turning to pessimism has been connected with the tragedy of the Earl of Essex, in which the poet's patron, Southampton, was also involved, and reference has also been made to other unpleasant events in the history of the time, such as the enmity between Elizabeth and Mary Stuart, the persecution of the Puritans, the gradual transformation of England into a police state, the end of the comparatively liberal government of Elizabeth and the new feudalistic tendency under James I, the climax in the conflict between the monarchy and the puritanically-minded middle class, as possible causes of this change.[205] However that may be, the crisis through which he passes undermines his whole balance and produces a moral philosophy of which nothing is so characteristic as the fact that, from now on, the poet feels more sympathy for people who are failures in public life than for those who have good fortune and success. He has a particularly warm spot in his heart for Brutus, the political bungler and unlucky fellow.[206] Such a revaluation can hardly be explained by a mere change of mood, by some completely private experience or purely intellectual rectification of previous views. Shakespeare's pessimism has a superindividual significance and bears the marks of a historical tragedy.

Shakespeare's relation to the theatre public of his age corresponds to his social outlook in general; but the changes in his sympathies can be followed better in this concrete context than in general abstractions. We can divide his literary career into several easily distinguishable phases, according to the social strata to which he devotes special attention and the concessions which he makes to them. The author of the poems 'Venus and Adonis' and 'Lucrece' is still a poet who conforms to fashionable humanistic taste and writes for aristocratic court circles, who chooses the

epic form to establish his fame, obviously because, in accordance with the courtly conception, he sees in the drama a genre of the second rank. The lyric and the epic are now the favourite literary forms in cultured court circles, beside which the drama, with its wider public appeal, is regarded as a comparatively plebeian form of expression. After the end of the Wars of the Roses, when the English aristocracy follow the example of their Italian and French compeers and begin to take an interest in literature, the court becomes, as in other countries, the centre of literary life. English Renaissance literature is courtly and dilettante, in contrast to medieval literature, which was only partly courtly and was carried on in the main by professional writers. Wyatt, Surrey and Sidney are cultured amateurs, but most of the professional authors of the age are also subject to the influence of the cultivated aristocrats. As for the origin of these littérateurs, we know that Marlowe was the son of a shoemaker, Peele of a silversmith and Dekker of a tailor, and that Ben Jonson first takes up his father's occupation and becomes a mason; but only a relatively small proportion of the writers come from the lower strata of society, the majority spring from the gentry, the official and the rich merchant class.[207] No literature could possibly be more class-determined in its origins and direction than the Elizabethan, the chief aim of which consists in the training of real noblemen, and which appeals, above all, to the circles directly interested in the achievement of this aim. It has been thought curious that at a time when the old aristocracy had very largely died out and the new had, until very recently, still been part of the middle class, so much importance should have been attached to noble descent and bearing;[208] but it is well known that it is precisely the fact that the members of an aristocracy are upstarts that often explains their snobbishness and the exaggerated claims which they make on their own compeers. Literary culture is one of the most important acquirements expected of a man of gentle birth in the Elizabethan age. Literature is now the great vogue and it is good form to talk about poetry and discuss literary problems. The affected style of the fashionable poetry is transferred to ordinary conversation; even the Queen speaks in this artificial style, and not to speak in it is

considered just as much a mark of ill-breeding as the inability to speak French.[209] Literature becomes a party game. In polite society epic and, above all, lyric poems, countless sonnets and songs by cultured dilettanti pass from hand to hand in manuscript; they are not printed, in order to stress the fact that the author is not a professional writer offering his works for sale and that he wishes to restrict their circulation from the very outset.

In these circles of society, even among professional writers, a lyric or epic poet is esteemed more highly than a dramatist; he finds a patron more easily and can count upon more generous support. And yet the material existence of a dramatist, writing for the public theatres which are so popular with all classes of society, is more secure than that of the writers dependent on a private patron. It is true that the plays are badly paid for in themselves—Shakespeare acquires his fortune not as a dramatist but as a theatre shareholder—the constant demand guarantees, nevertheless, a regular income. Thus almost all the writers of the age work for the stage at least for a time; they all try their luck in the theatre, though often with a bad conscience—which is all the more remarkable as the Elizabethan theatre originates partly in the courtly or quasi-courtly life of the great houses. The actors who travel around the country and those resident in London derive directly from the clowns and jesters hitherto employed in these houses. At the end of the Middle Ages, the great seignorial households had their own actors—either in permanent or occasional employ—just as they had their own minstrels; originally they were probably identical. On festive occasions, above all at Christmas and at family festivities, especially weddings, they performed plays usually written for the occasion. They wore livery and the badge of their masters just like the other attendants and servants. The outward form of this service relationship was maintained even when the minstrels and house mimes had formed themselves into independent companies of actors. The patronage of their former masters offered them protection against the animosity of the city authorities and guaranteed them an additional income. Their protector paid them a small annual fee and an extra sum for their services whenever he wanted to arrange a theatrical performance for a family occasion.[210] These

domestic and court players, therefore, form the direct link between the minstrels and mimes of the Middle Ages and the professional actors of the modern age. The old families gradually die out, the great households are broken up—the players have to stand on their own feet; but it is the rapid development of London and the centralization of court and cultural life under the Tudors which supplies the decisive incentive for the formation of regular theatrical companies.[211]

In the Elizabethan age a wild chase after patrons already begins. The dedication of a book and the payment for the honour becomes an occasional deal in which not the slightest attachment between author and patron or any real esteem is assumed. Authors outbid each other in the thickly laid on flattery of the dedications, which they address often to complete strangers; meanwhile the patrons themselves become more and more niggardly and unreliable with their gifts. The old patriarchal relationship between patron and protégé is in process of dissolution.[212] Shakespeare also seizes the opportunity of transferring his talents to the theatre. It is difficult to say whether he does so first of all because of the greater security it offers, or because the respect in which the theatre is held has grown meanwhile, and because his interests and sympathies had shifted from the narrow circle of aristocrats to the broader masses—probably all these factors combined in making up his mind . This change to the theatre marks the beginning of the second phase in Shakespeare's artistic development. The works which he now writes no longer have the classicizing and affectedly idyllic note of his first productions, but they still conform to the taste of the upper classes. They are partly proud chronicles, great historical and political plays, in which the idea of monarchy is extolled, partly light-hearted, exuberantly romantic comedies, which move, full of optimism and joy of life, unconcerned about the cares of every day, in a completely fictitious world. Around the turn of the century the third and tragic period in Shakespeare's development begins. The poet has now left the euphuism and playful romanticism of the upper strata of society far behind; but he also seems to have become estranged from the middle classes. He writes his tragedies for the great mixed public of the London theatres without regard

to a particular class. There is no longer a trace of the old light-heartedness; even the so-called comedies of this period are full of melancholy. Then follows the last phase in the poet's development: a time of resignation and soothing calm—with tragi-comedies which stray once more into the romantic mood. Shakespeare leaves the middle class, which becomes more short-sighted and narrow-minded in its puritanism from day to day, further and further behind him. The attacks of the civic and ecclesiastical authorities on the theatre increase in violence; the actors and dramatists have once again their patrons and protectors in the circles of the court and the nobility and adapt themselves more to their taste. The tendency represented by Beaumont and Fletcher is victorious; Shakespeare himself also follows it to some extent. He again writes plays in which the romantic-fabulous elements are predominant and which are, in many respects, reminiscent of the shows and masques of the court. Five years before his death, at the height of his development, Shakespeare retires from the theatre and stops writing plays altogether. Was the most sublime dramatic work that it was granted to a poet to create the gift of destiny to a man who wanted, first of all, to supply his theatrical undertaking with saleable goods, and who ceased to produce when he had secured a carefree livelihood for himself and his family, or was it rather the creation of a poet who gave up writing when he felt there was no longer any public left for whom it was worth his while to write?

No matter how one answers this question, and whether one thinks of Shakespeare as leaving the theatre saturated or disgusted, so much is certain, that during most of his theatrical career he stood in a very positive relationship to his public, even though he favoured different sections of it in the various phases of his development and finished by not being able to identify himself completely with any particular one. In any case, Shakespeare was the first, if not the only great poet in the history of the theatre, to appeal to and meet with the full approval of a broad and mixed public embracing almost all levels of society. Greek tragedy was too complex a phenomenon, public interest in it was made up of too many different factors, for us to be able to assess its intrinsic aesthetic influence; religious and political

motives played a part of no less importance in its public reception than artistic motives; owing to the fact that admission was restricted to full citizens, its public was more homogeneous than that of the Elizabethan theatre; moreover, its performances took place in the form of comparatively rare festivals, so that its power of attracting the broad masses was never really put to the test. Again, the medieval drama, the performance of which took place under external conditions similar to the Elizabethan, had no really important works to show; its popularity with the masses, therefore, does not represent a problem of the sociology of art in the way that the Shakespearian drama does. In the case of Shakespeare, however, the real problem does not consist in the fact that he, the greatest writer of his age, was also its most popular dramatist, and that the plays which we like most were also the most successful with his contemporaries,[213] but that, this time, the judgement of the broad masses of the public was more correct than that of the cultured classes and the connoisseurs. Shakespeare's literary fame reached its height about 1598 and diminished precisely from the moment when he reached his full maturity; but the theatre public remained loyal to him and strengthened the unrivalled position which he had already achieved in earlier days.

In contradiction of the assumption that Shakespeare's theatre was a mass theatre in the modern sense, reference has been made to the relatively small capacity of the playhouses of the time.[214] But the smallness of the theatres, which was made up for by daily performances, does not alter the fact that their audiences consisted of the most varied strata of the London population. Those who frequented the pit were by no means the absolute masters of the theatre, but they were there and could not be overlooked under any circumstances. In addition, they were there in comparatively large numbers. Although the upper classes were represented more generously than was appropriate to their numerical share in the total population, the working classes, who formed the overwhelming majority of the inhabitants of the city, made up the majority of the audience, despite the fact that proportionately they were less well represented. The prices of admission, which conformed chiefly to the financial capacity of

these people, also allow us to form that conclusion.[215] The audience which confronted Shakespeare was, at any rate, a motley one, both economically and also from a class and educational point of view; it brought together the tavern public, representatives of the cultured upper class and members of the middle classes who were neither particularly cultured not absolutely uncivilized. And even if it was by no means any longer the public of the travelling miming stages, which filled the playhouses of Elizabethan London, it was still the public of a people's theatre in the comprehensive sense in which the term was understood by the romantics. Was the coincidence of quality and popularity in the Shakespearian drama based on a pregnant inner relationship or a mere misunderstanding? In Shakespeare's plays the public seems, at any rate, to have found pleasure not merely in the violent stage effects, the wild bloody action, the coarse jokes and loud tirades, but also the more tender and deeper poetic details, otherwise these passages would not have been allowed to occupy as much space as they do. It is possible, of course, that the pit only took in the mere sound and general mood of such passages, as may well happen with a simple public that loves the theatre. But these are idle, insoluble problems. There is not much more point in the question whether Shakespeare made use of the effects, which he apparently only employed to please the less exacting section of his public, with a good artistic conscience or against his will. The cultural differences between the various strata of the public will not have been anything like so great as to make it admissible for us to assume a preference for fisticuffs and smutty jokes only in the less educated part of the audience. Shakespeare's outbursts against the pit are misleading; there was no doubt some affectation mixed up with them, and the desire to flatter the more refined section of the audience may also have played a part.[216] The difference between the 'public' and the 'private' theatres also does not seem to have been so great as has been assumed hitherto; *Hamlet* was equally successful in both, and the audience of both types was absolutely indifferent to the rules of classical drama.[217] But even in Shakespeare himself one must not make such a sharp distinction between what we understand by artistic conscience and the preconditions of his theatre,

as has often happened in earlier Shakespeare criticism.[218] Shakespeare does not write his plays because he wants to hold fast an experience or solve a problem; he does not find a theme first and then look for a suitable form and possibility of performing it in public, but first comes the demand and then he tries to meet it. He writes his plays because his theatre needs them. But in spite of Shakespeare's deep connection with the living theatre, one must not exaggerate the doctrine of the value of his plays as 'good theatre'. It is quite true that his plays were intended, first of all, for a folk theatre, but he was writing in an age of humanism in which a great deal was also read. It has been remarked that, with the usual playing time of two and a half hours, most of Shakespeare's plays were much too long to be performed without cuts. (Were the poetically most valuable passages cut in the theatrical performances?) The obvious explanation of the length of these plays is that when he was writing them the poet was not thinking merely of the stage but also of their publication in book form.[219] Both conceptions, the one that attributes Shakespeare's whole greatness to the fact that the plays were written by a craftsman for immediate stage requirements and to the fact that his art has a popular basis, as well as the other conception according to which everything common, in bad taste and careless in his plays is a concession to the broad masses of the public, are equally romantic.

Shakespeare's greatness can no more be explained sociologically than can artistic quality in general. But the fact that in Shakespeare's time there was in existence a folk theatre, which embraced the most varied sections of society, and which united them in the enjoyment of the same works, must be capable of explanation. Like most of the dramatists of his time, Shakespeare is absolutely indifferent to religious problems. There can be no question of his public having been possessed of a sense of social community. The consciousness of national unity was only just beginning to arise and was not yet having any effect on cultural life. The uniting of the various strata of society in the theatre was made possible only by the dynamic quality of social life, which keeps the boundaries between the classes in a state of flux, and which, even though it by no means obliterates the objective

differences, allows the subject to move from one category into another. The individual social categories are less sharply divided from one another in Elizabethan England than anywhere else in Western Europe; above all, cultural differences are smaller here than, for example, in the Italy of the Renaissance, where humanism drew more decisive lines of demarcation between the various sections of society than in the England of the Elizabethan age, which had a similar economic and social structure, but was a 'younger' country. In Italy, therefore, no cultural institution with a universality comparable to that of the English theatre could possibly hope to thrive. This theatre is the result of a levelling of minds, unheard of outside England. And in this connection the often exaggerated analogy between the Elizabethan stage and the cinema is really instructive. People go to the cinema to see a film; educated or uneducated, they all know what to expect. With a stage play, on the other hand, this is by no means the case today. But in the Elizabethan age people went to the theatre as we go to the cinema, and agreed in the main in their expectations concerning the performance, however different their intellectual needs were in other respects. The common criterion of the entertaining and the moving, which was current in the various strata of society, made Shakespeare's art possible, though it in no sense created it, and it conditioned its particularity though not its quality.

Not only the content and tendency, but also the form of Shakespearian drama is determined by the political and social structure of the period. It springs from the basic experience of political realism, namely the experience that the pure, unadulterated, uncompromising idea cannot be realized here on earth, and that either the purity of the idea must be sacrificed to reality or reality must remain unaffected by the idea. This was, of course, not the first time the dualism of the world of ideas and the world of phenomena had been discovered, since it was known both to the Middle Ages and to classical antiquity. This antagonism is, however, quite foreign to the Homeric epic, and even Greek tragedy does not yet really deal with the conflict of these two worlds. It rather describes the situation in which mortals are plunged through the interference of the divine powers. The

tragic complication does not arise here, because the hero feels a yearning for a truer life, and it does not, by any means, lead to his approaching the world of ideas, to his being more deeply penetrated by the idea. Even in Plato, who not only knows of the antagonism between idea and reality but makes it the basic principle of his system, the two spheres did not come into contact with each other. The aristocratically-minded idealist persists in a passively contemplative attitude to reality and moves the idea into an unapproachable, immeasurable remoteness. The Middle Ages felt the contrast between this world and the next, between physical and spiritual life, and between the unfulfilment and the perfection of being more deeply than any previous or later age, but the awareness of this contrast does not produce a tragic conflict in medieval man. The saint renounces the world; he does not seek to realize the divine in the earthly, but to prepare himself for a life in God. According to the doctrine of the Church, it is not the world's task to rise to transcendent reality, but to be the footstool under the feet of God. For the Middle Ages only different distances from God are possible, but not conflict with Him. A moral standpoint, which would attempt to justify antagonism to the divine idea and create recognition for the voice of the world against the voice of heaven, would be perfectly nonsensical from the point of view of medieval philosophy. These factors explain why the Middle Ages has no tragedy and why Greek tragedy is fundamentally different from what we understand by a drama with a tragic solution. The form of tragic drama corresponding to our conception is first discovered by the age of political realism, which shifts the dramatic conflict from the action itself to the soul of the hero; for only an age which is able to understand the problems involved in action based on direct reality can ascribe a moral value to an attitude, which takes into account the exigencies of the world though it is inimical to ideas.

The late medieval moralities form the transition from the non-tragic and non-dramatic mysteries of the Middle Ages to the tragedies of the modern age. They are the first expression of the spiritual conflict which is worked up in the Elizabethan drama into a tragic conflict of conscience.[220] The motifs which Shakespeare and his contemporaries add to the description of this

spiritual struggle consist in the inevitability of the conflict, its ultimate insolubility and the moral victory of the hero in the midst of disaster. This victory is first made possible by the modern conception of destiny, which differs from the classical idea, above all, in the fact that the tragic hero affirms his fate and accepts it as intrinsically significant. A fate becomes tragic in the modern sense only through being accepted. The intellectual affinity of this idea of tragedy with the Protestant idea of predestination is unmistakable; and even if there is perhaps no direct dependence, at any rate, it is a case of parallelism in the history of ideas, which invests with real significance the simultaneity of the Reformation and the origins of modern tragedy.

In the age of the Renaissance and mannerism, there are three more or less independent forms of the theatre in the civilized nations of Europe: (1) the religious play, which comes to an end everywhere except in Spain; (2) the learned drama, which spreads everywhere with humanism but nowhere becomes popular; and (3) the folk theatre, which creates a number of different forms, moving between the *commedia dell'arte* and the Shakespearian drama with varying degrees of approximation to literature, but never entirely losing its connection with the medieval theatre. The humanist drama introduced three important innovations: it transformed the medieval play, which consisted in the main in pageantry and pantomime, into a work of literary art, it isolated the stage from the auditorium in order to increase the effect of illusion, and, finally, it concentrated the action spatially and temporally; in other words, it replaced the epic extravagance of the Middle Ages by the dramatic concentration of the Renaissance.[221] Of these innovations Shakespeare adopts only the first, but, to a certain extent, he preserves both the medieval lack of division between the stage and the auditorium and also the epic breadth of the religious drama as well as the mobility of the action. In this respect he is less progressive than the authors of the humanist drama, and for that reason also he has no real successors in modern dramatic literature. Both the *tragédie classique*, the bourgeois drama of the eighteenth century and the drama of German classicism, as well as the naturalistic theatre of the nineteenth century from Scribe and Dumas *fils* to Ibsen and

Shaw, are, from a formal point of view, at any rate, closer to the humanist drama than to the Shakespearian type of loosely constructed play with its comparatively modest scenic illusionism. Shakespearian form is not really adopted again until the advent of the film. Here too, of course, only a part of the principles of this form is retained; above all the cumulative style of composition, the discontinuity of the action, the abrupt changes of scene, the free and highly varied treatment of space and time—but in the film there can be no more or even less question than in the modern drama of a waiving of scenic illusionism. The popular medieval tradition in the theatre, which was still alive in Shakespeare and his contemporaries, was destroyed by humanism, mannerism and the baroque—in later dramatists it survives at best as a mere memory; there is obviously no intellectual continuity between Shakespeare and the aspects of the film which are reminiscent of this tradition. They are due to the possibilities offered by a technique that is in a position to solve the difficulties which were naïvely and crudely disregarded by the Shakespearian theatre.

From the stylistic point of view, the most peculiar characteristic of Shakespeare's theatre is the combination of the popular tradition with an avoidance of the tendency which leads to the 'domestic drama'. In contrast to most of his contemporaries, he does not use middle-class figures from everyday life as leading characters, nor does he introduce their peculiar sentimentality and inclination to moralize. Even in Marlowe we meet main characters, like Barnabas the usurer and Faustus the doctor, who could have been, at the most, subsidiary characters in the humanist drama. Shakespeare, whose heroes, even when they belong to the middle class, display an aristocratic attitude, marks a certain retrogression sociologically, even compared with Marlowe. But amongst Shakespeare's younger contemporaries there are already dramatists, such as Thomas Heywood and Thomas Dekker, who often give their plays an entirely middle-class setting and express the outlook of the middle class. They choose merchants and craftsmen as their heroes, portray family life and family manners, seek after melodramatic effects and the extraction of a moral, love sensational themes and grossly realistic milieus, such as

madhouses, brothels, etc. The classical example of the 'bourgeois' treatment of a love tragedy of this period is Heywood's *A Woman Killed with Kindness*, a play of which the hero is a nobleman, but one who reacts to the ruin of his marriage in an extremely unheroic and unchivalrous manner. It is a problem play, which revolves around the apparently burning issue of adultery, just as Ford's *'Tis a Pity She's a Whore* revolves around the popular theme of incest or Middleton's *The Changeling* around the psychology of sin. In all these plays, to which the anonymous sensational drama *Arden of Feversham* must also be added, the 'middle-class' element is the interest in crime, which, to the bourgeois who clings to the principle of order and discipline, means sheer chaos. In Shakespeare violence and sin never have this criminal touch; his evil-doers are natural phenomena, who would find it impossible to breathe in the indoors atmosphere of the middle-class dramas of Heywood, Dekker, Middleton and Ford. And yet the basic character of Shakespeare's art is thoroughly naturalistic. Not only in the sense that he neglects the unities, the economy and order of classical art, but also that he labours at the constant expansion and elaboration of his material. Above all, his character-drawing is naturalistic, the differentiated psychology of his figures and the human lifelikeness of his heroes, who are a bundle of contradictions and full of weaknesses. One need only think of Lear, who is a stupid old man; of Othello, a big childish boy; Coriolanus, an obstinate, ambitious schoolboy; Hamlet, a weakling, short-winded and fat; Caesar, epileptic, deaf in one ear, superstitious, vain, inconsistent, easily influenced and, nevertheless, possessed of a greatness from whose impact it is impossible to escape. Shakespeare intensifies the naturalism of his character-drawing by his 'petits faits vrais', as when Prince Henry asks for beer after his fight, or Coriolanus wipes the sweat from his brow, or Troilus warns Cressida of the cold morning air after the first night of love: 'You will catch cold and curse me.'

But the limitations of Shakespeare's naturalism are only too evident. He is always mixing up individual with conventional characteristics, the complex with the simple and naïve, the most subtle with the primitive and the crude. He deliberately and systematically takes over some of the methods which he finds

ready to hand, but more often than not quite uncritically and thoughtlessly. The worst error of the older Shakespeare criticism consisted in regarding all the poet's means of expression as well-considered, carefully pondered, artistically conditioned solutions and, above all, in trying to explain all the qualities of his characters on the basis of inner psychological motives, whereas, in reality, they have remained very much as Shakespeare found them in his sources, or were chosen only because they represented the most simple, convenient and quickest solution of a difficulty, to which the dramatist did not find it worth his while to devote any further trouble.[222] The most striking expression of Shakespeare's conventionalism is to be found in the repeated use of stock types from older plays. It is not merely the early comedies which retain the stereotyped figures of classical comedy and mime, even such an apparently original and complicated character as Hamlet is a regular type, namely the 'melancholist', who was the fashion in Shakespeare's day, and whom we meet all over the place in contemporary literature. But Shakespeare's psychological naturalism is also limited in other directions. The lack of uniformity and consistency in the character-drawing, the un-motivated changes and contradictions in the development of his characters, their self-descriptions and self-explanations in monologues and asides, the lack of perspective in their statements about themselves and their opponents, their comments, which have always to be taken literally, the great amount of irrelevant talking which has no connection with the character of the speaker, the inattentiveness of the poet, who sometimes forgets who is really speaking, whether it is Gloster or Lear, indeed whether it is Timon or Lear, who often makes his characters speak lines which have a purely lyrical, atmospherical and musical function, and who often speaks through the mouth of his characters—all these are offences against the rules of that psychology of which Shakespeare is, in fact, the first great master. His psychological wisdom and depth remain unaffected, however, by the careless-ness which is allowed to creep in. His characters have—and this is a quality which he shares again with Balzac—such irresistible inner truth, such inexhaustible substantiality, that they do not cease to live and breathe, however much they are violated and

155

however badly they are drawn. But there is hardly any transgression against psychological truth committed by the other Elizabethan dramatists from which Shakespeare can be absolved; he is incomparably greater, yet of the selfsame stock. His greatness also has nothing of the 'perfection', nothing of the 'flawlessness' of the classics. He lacks their absolute authority, but he also lacks their simplicity, their monotony. The particularity of Shakespeare as a phenomenon and the antagonism of his dramatic style to classical and normative forms has been felt and emphasized at all times. Voltaire and even Jonson recognized that a wild, natural force was at work here, which was neither concerned about the 'rules' nor capable of being controlled by them, and which found expression in a dramatic form utterly different from that of classical tragedy. Anyone with a sense of stylistic variations could see that it was a question of two different types of the same genre; but it was not always recognized that the difference was historical and sociological. The sociological difference only becomes apparent when one tries to explain why the one type succeeds in England, the other in France, and what the constitution of the public may have had to do with the victory of the Shakespearian form of drama here and that of the *tragédie classique* there.

The appreciation of Shakespeare's individuality was made more difficult especially by the fact that people persisted in regarding him as the supreme poet of the English Renaissance. Certain Renaissance-like—individualistic and humanistic—characteristics are doubtless present in his art, and since it was the ambition of every national literary historian in Western Europe in the last century to prove that his country had a Renaissance movement of its own, what more worthy representative of such a movement in England could be established than Shakespeare, whose tremendous vitality was, in any case, most in accord with the current conception of the Renaissance? On the other hand, the wilfulness, extravagance and exuberance of Shakespeare's style were left unexplained. To the problem of this unexplained residue is to be ascribed the fact that about a generation ago, when the concept of the baroque was subjected to revision and the revaluation of the creations of baroque art produced

something in the nature of a vogue, the idea of the baroque character of Shakespearian drama attracted much support.[223] If one regards passion, pathos, impetuosity, exaggeration as specially characteristic of the baroque, it is, of course, easy to make a baroque poet out of Shakespeare. But it is impossible to establish a concrete parallel between the methods of construction of the great baroque artists like Bernini, Rubens and Rembrandt and those of Shakespeare. The transfer of Woelfflin's categories of the baroque—pictorialness, spatial depth, lack of clarity and unity—to Shakespeare means either indulging in meaningless generalities or basing oneself on mere equivocations. Naturally, Shakespeare's art contains baroque elements, just as Michelangelo's does; but the creator of Othello is no more a baroque artist than the creator of the Medici tombs. Each of them is a special case in which elements of the Renaissance, of mannerism and the baroque are intermingled in a particular way; only in Michelangelo Renaissance characteristics, in Shakespeare the manneristic tendencies, predominate. The indissoluble union of naturalism and conventionalism suggests that the best approach to an explanation of Shakespearian form is from the side of mannerism. The continuous mixture of tragic and comic motifs, the mixed nature of the tropes, the gross contrast between the concrete and abstract, the sensual and intellectual elements of the language, the often forced ornamental pattern of the composition, as for example the repetition of the motif of childish ingratitude in *Lear*, the emphasis on the a-logical, the unfathomable and contradictory in life, the idea of the theatrical and the dream-like quality, the compulsions and restraints of human life—all these are arguments for taking mannerism as the starting point of the analysis. The artificiality, affectation and mania for originality in Shakespeare's language are also manneristic and to be explained only by the manneristic taste of the age. His euphuism, his often overladen and confused metaphors, his piling up of antitheses, assonances and puns, his fondness for the complicated, intricate and enigmatic style, are all manneristic, as are also the extravagant, bizarre and paradoxical elements from which no work of Shakespeare's is completely free; the erotic trifling with the masculine disguise of girls played by boys in the comedies, the

lover with the ass's head in *A Midsummer Night's Dream*, the negro as the hero in *Othello*, the crinkled figure of Malvolio in *Twelfth Night*, the witches in *Macbeth*, the moving forest in *Richard III*, the mad scenes in *Lear* and *Hamlet*, the gruesome Last Judgement atmosphere in *Timon of Athens*, the speaking picture in *A Winter's Tale*, the mechanism of the world of magic in the *Tempest*, etc. etc. All this is part of Shakespeare's style even though they do not exhaust the resources of his art.

8. THE CONCEPT OF THE BAROQUE

As an artistic style, mannerism conformed to a divided outlook on life which was, nevertheless, spread uniformly all over Western Europe; the baroque is the expression of an intrinsically more homogeneous world-view, but one which assumes a variety of shapes in the different European countries. Mannerism, like Gothic, was a universal European phenomenon, even if it was restricted to much narrower circles than the Christian art of the Middle Ages; the baroque, on the other hand, embraces so many ramifications of artistic endeavour, appears in so many different forms in the individual countries and spheres of cultures, that it seems doubtful at first sight whether it is possible to reduce them all to a common denominator. The baroque of courtly and Catholic circles is not only wholly different from that of middle-class and Protestant communities, the art of a Bernini and a Rubens not only depicts a different inner and outer world from that of a Rembrandt and a van Goyen, but even within these two great tendencies of style further decisive differentiations make themselves felt. The most important of these secondary sub-divisions is that of courtly-Catholic baroque into a sensualistic, monumental-decorative tendency, in the traditional meaning of 'baroque', and into a stricter, formally more rigorous 'classicistic' style. It is true that the classicistic current is present in the baroque from the very outset and ascertainable as an under-current in all the special national forms of baroque art, but it does not become predominant until about 1660, under the particular social and political conditions prevailing at this time in

France. Beside these two basic forms of ecclesiastical and courtly baroque, there is in the Catholic countries a naturalistic tendency which comes forward independently at the beginning of the period, and which has its own particular supporters in Caravaggio, Louis Le Nain and Ribera, but is subsequently immanent in the art of all the important masters. Like classicism in France, it finally prevails in Holland, and in these two tendencies the social factors which determine the baroque make their separate impact.

Since the Gothic period, the structure of art styles had become more and more complicated; the tension between the particular spiritual contents became ever greater and the different elements of art correspondingly more heterogeneous. Before the baroque it was, however, still possible to say whether the artistic approach of an age was fundamentally naturalistic or anti-naturalistic, making for unity or differentiation, classicistic or anti-classicistic —but now art no longer has a uniform stylistic character in this strict sense, it is naturalistic and classicistic, analytical and synthetic at the same time. We are the witnesses of the simultaneous blossoming of absolutely opposite tendencies, and we see contemporaries, like Caravaggio and Poussin, Rubens and Hals, Rembrandt and van Dyck, standing in completely different camps.

It is only recently that the art of the seventeenth century, as a whole, has been classified under the name of baroque. When it first emerged in the eighteenth century, the concept was still applied exclusively to those phenomena of art which were felt, in accordance with the prevailing classicistic aesthetic, to be extravagant, confused and bizarre.[224] Classicism itself was excluded from this concept, which remained predominant almost until the end of the nineteenth century. Not only the attitude of Winckelmann, Lessing and Goethe, but also that of Burckhardt is still guided fundamentally by the point of view of classicistic theory; they all reject the baroque on account of its 'irregularity' and 'capriciousness', and they do so in the name of an aesthetic which reckons the unmistakable baroque artist Poussin among its models of perfection. Burckhardt and the later purists, such as Croce, for example, who are incapable of liberating themselves from the often narrow-minded rationalism of the eighteenth

century, perceive in the baroque merely the tokens of illogicality and lack of structure, see only the columns and pilasters with nothing to support, the architraves and walls bent and warped, as if they were made of pasteboard, the figures illuminated artificially and conducting themselves unnaturally, as on a stage, the sculptures with their search for the illusionistic surface effects, which belong by rights to painting and which, as the critics have emphasized, should remain its preserve. One would think that the experience of the art of a Rodin, for example, would have been sufficient in itself to make these epigones of classicism realize the meaning and value of such sculpture. But their stipulations against the baroque are also stipulations against impressionism, and when Croce deplores the 'bad taste' of baroque art,[225] he represents, at the same time, academic conventions hostile to modern art.

The reinterpretation and revaluation of the baroque, in the sense in which the term is understood today, an achievement carried out in the main by Woelfflin and Riegl, would have been unthinkable without the previous assimilation of impressionism. Woelfflin's categories of the baroque are, in fact, nothing but the application of the concepts of impressionism to the art of the seventeenth century—that is to say, to a part of this art, for the clarity of the concept of the baroque is obtained even by him at the price of mostly neglecting to consider the classicism of the seventeenth century. The light which is shed on non-classicistic baroque as a result of this one-sidedness is all the more piercing. It is also the reason why the art of the seventeenth century here appears almost exclusively as the dialectical opposite of the art of the sixteenth century and not as its continuation. Woelfflin under-estimates the importance of subjectivism in the Renaissance and over-estimates it in the baroque. He notes in the seventeenth century the beginnings of the impressionistic tendency, which he calls 'the most important reorientation in the history of art',[226] but he fails to recognize that the subjectivization of the artistic world-view, the transformation of the 'tactile' into the 'visual', of substance into mere appearance, conceiving the world as impression and experience, regarding the subjective aspect as primary and emphasizing the transitory character inherent in

every optical impression—he fails to recognize that all this is consummated in the baroque, but is prepared for to a far-reaching extent by the Renaissance and mannerism. Woefflin, who is not interested in the extra-artistic preconditions of this dynamic world-view, and who conceives of the whole course of the history of art as a self-contained, quasi-logical function, overlooks the real origin of the change of style by ignoring its sociological presuppositions. For even if it is perfectly right that the discovery, for example, that the rolling wheel loses its spokes when experienced subjectively, implies a new world-view for the seventeenth century, one must not forget that the development which leads to this and similar discoveries begins with the dissolution of the symbolical painting of ideas and its replacement by the increasingly independent optical view of reality in the Gothic period, and that it is directly connected with the victory of nominalistic over 'realistic' thought.

Woefflin develops his system on the basis of five pairs of concepts, in each of which a characteristic of the Renaissance is opposed to a quality of the baroque, and which, with the exception of one of these antinomies, show the same development away from a stricter towards a freer conception of art. The categories are as follows: (1) Linear and painterly; (2) plane and recession; (3) closed and open form; (4) clearness and unclearness; (5) multiplicity and unity. The striving after the 'painterly'—that is to say, the dissolution of firm, plastic and linear form into something moving, hovering and incapable of being grasped; the obliteration of frontiers and contours, to arouse the impression of the unlimited, the immeasurable and the infinite; the transformation of static, rigid, objective being into a becoming, a function, an interdependence between the subject and the object —constitutes the basis of Woelfflin's conception of the baroque. The tendency away from the plane to the depth gives expression to the same dynamic outlook, the same opposition to everything stable, laid down once and for all, to everything with immovable frontiers, to a world-view in which space is understood as something in process of formation, as a function. The favourite method employed by the baroque to illustrate spatial depth is the use of oversized foregrounds, of *repoussoir* figures brought quite near to

the beholder and of the sudden reduction in size of background motifs. In this way, space acquires not only an intrinsic mobility, but as a result of the extremely close at hand viewpoint the observer feels the element of space as a form of existence which belongs to him, is dependent on him and, as it were, created by him. The baroque tendency to replace the absolute by the relative, greater strictness by greater freedom, is expressed most powerfully, however, in its fondness for the 'open', a-tectonic form. In a closed, 'classical' composition what is represented is a self-contained phenomenon, all the elements of which are inter-related and interdependent; nothing seems to be superfluous or missing in this coherent whole, whereas the a-tectonic compositions of baroque art always give the impression of being more or less incomplete and disconnected; they seem to point beyond themselves, to be capable of continuation. Everything solid and settled in them begins to waver; the stability expressed by the horizontals and verticals, the idea of balance and symmetry, the principles of filling in the surface and adjusting the picture to the line of the frame, are depreciated; one side of the composition is always emphasized more than the other; again and again the beholder is shown the apparently accidental, improvised and ephemeral instead of the 'pure' aspects of the face and the profile. 'In the final analysis,' says Woelfflin, 'the tendency is to make a picture seem not a self-contained piece of reality, but a passing show in which the beholder has the good luck to participate just for a moment . . . The whole intention is to make the totality of the picture seem unintentional.'[227] The artistic outlook of the baroque is, in a word, cinematic; the incidents represented seem to have been overheard and spied out; every indication that might betray consideration for the beholder is blotted out, everything is presented in apparent accordance with pure chance. The comparative lack of clarity in the presentation is also related to this quality of improvisation. The frequent and often violent overlappings, the excessive differences in the size of objects seen in perspective, the neglect of the directional lines given by the frame of the picture, the incompleteness of the material and the unequal treatment of the motifs are all used intentionally to make it difficult to see the picture as a lucid whole. The normal

progress of historical evolution itself plays a certain part in the growing distaste for the all too clear and the all too obvious, in the process which moves within a particular, continuously developing culture from the simple to the involved, from the plain to the less plain, from the obvious to the hidden and the veiled. The more cultured, fastidious and intelligently interested in art a public is, the more it demands this intensification of artistic stimuli. But apart from the attraction of the new, the difficult and the complicated, this is once again an attempt to arouse in the beholder the feeling of the inexhaustibility, incomprehensibility and infinity of the representation—a tendency which dominates the whole of baroque art.

All these characteristics are the expression of the same anti-classical impulse towards the unrestrained and the arbitrary; only one of the stylistic criteria discussed by Woelfflin, namely the striving for unity, is the expression of the increased desire for synthesis, and, therefore, for a stricter principle of composition. If, as Woelfflin assumes, the natural process were to proceed in accordance with pure logic, then a tendency to variety, to thematic accumulation and agglomeration, would inevitably be connected with the fondness for the pictorial and for spatial differentiation, for the a-tectonic and the obscure, but in fact the baroque displays in almost all its creations a desire for concentration and subordination. In this respect it is—a point which Woelfflin omits to emphasize—the continuation of the classical art of the Renaissance, not its opposite. Even in the early Renaissance there was already a noticeable striving for unity and subordination, in contrast to the cumulative method of composition of the Middle Ages; the rationalism of the period found its artistic expression in the indivisibility of the conception and the consistency of the approach. The prevalent opinion was that an illusion could arise only if the beholder did not have to alter his point of view and, especially, his standard of fidelity to nature during the assimilation of the work. But the homogeneity of Renaissance art was merely a kind of logical consistency, and the totality in its works nothing but an aggregate and sum total of the details, in which the different components were still clearly recognizable. This comparative independence of the parts comes to an end in baroque

art. In a composition of Leonardo or Raphael the single elements can still be enjoyed in isolation from one another, whereas in a painting of Rubens or Rembrandt the individual detail no longer has any significance in itself. It is true that the compositions of the baroque masters are richer and more complicated than those of the Renaissance painters, but they are, at the same time, more homogeneous, filled with a greater, deeper, more continuous breath. The unity is no longer merely the result, but the *a priori* of the artistic creation; the artist approaches his subject with a unified vision, and in this vision everything isolated and particular finally perishes. Even Burckhardt recognized that one of the characteristics of the baroque consisted in this destruction of the independent significance of the detailed forms, and Riegl repeatedly emphasizes the insignificance and 'ugliness', that is to say, the lack of proportion of the details in the works of baroque art. Just as in architecture the baroque favours colossal orders and, where the Renaissance divides the separate stories by a horizontal articulation, brings them into a unity by running columns and pilasters up the whole façade, so, in general, it attempts to subordinate the details to a leading motif and to concentrate on one main effect. In this way, the pictorial composition is often dominated by a single diagonal or by a patch of colour, the plastic form by a single curve, and the piece of music by one predominating solo voice.

According to Woelfflin, the development from strictness to freedom, from the simple to the complicated, from closed to open form, represents a typical, consistently recurring process in the history of art. He regards the development of style in the Roman Empire, in the late Gothic, in the seventeenth century and impressionism as parallel phenomena. He believes that in all these cases the objectivity and the formal rigorism of a classical period is followed by a kind of baroque, that is to say, by a subjective sensualism and a more or less radical dissolution of form. He even goes so far as to consider the polarity of these styles the basic formula in the history of art. He believes that if a universal law of periodicity exists anywhere then it must be here. And from this recurrence of the typical styles in art he derives his thesis that the history of art is ruled by an inner logic, by an immanent necessity

of its own. Woelfflin's unsociological method here leads to an unhistorical dogmatism and to a wholly arbitrary interpretation of history. The Hellenistic, the late medieval, the impressionistic and the real 'baroque' share only so many characteristics as there are similar factors in their sociological background. But even if the succession of classicism and baroque were also evidence of a general law, it would never be possible to explain on immanent, that is to say, on purely formal, grounds, why there is an advance at a particular point in time from strictness to freedom and not from strictness to greater strictness. There is no 'climax' in the development; a summit is reached and a change takes place, when the general historical, that is, social, economic and political, conditions carry their development in a particular direction to an end and change their course. A change of style can only be conditioned from outside—it does not become due for purely internal reasons.

Most of Woelfflin's categories cannot be applied to the classical art of the baroque period. Poussin and Claude Lorrain are neither 'painterly' or 'unclear', nor is the structure of their art a-tectonic. Even the homogeneity of their works is different from the exaggerated, overtense, violent striving for unity of a Rubens. But is it still possible to speak in that case of a stylistic unity of the baroque?—One ought, really, never to speak of a uniform 'style of the time' dominating a whole period, since there are at any given moment as many different styles as there are artistically productive social groups. Even in epochs in which the most influential work is founded on a single class, and from which only the art of this class has come down to us, it ought to be asked whether the artistic products of other groups may have been buried or lost. We know, for example, that in classical antiquity a popular art of mime existed alongside of high tragedy, the importance of which was certainly greater than the fragments that have been preserved would suggest. And in the Middle Ages, the creations of secular and popular art must have been, at any rate, more significant in relation to ecclesiastical art than the works that have survived would lead one to suspect. If, therefore, the production of art was not entirely uniform even in these ages of undivided class rule, how much less will it have been in a

century like the seventeenth, when there were already several cultured strata, each with its own absolutely individual outlook on social, economic, political and religious matters, and each confronting art with often quite different problems. The artistic aims of the curia in Rome were fundamentally different from those of the royal court in Versailles, and what they had in common, could certainly not be reconciled with the artistic purpose of Calvinist, bourgeois Holland. Nevertheless, it is possible to establish certain common characteristics. For, apart from the fact that the development which promotes intellectual differentiation always helps to integrate, at the same time, by facilitating the spread of cultural products and exchanges between the different cultural regions, one of the most important cultural achievements of the age of the baroque, the new natural science and the new philosophy based on natural science, was international from the outset; but the universal outlook, which found expression here, also dominated the whole art production of the age with all its ramifications.

The new scientific world-view proceeded from Copernicus' discovery. The theory that the earth moves round the sun, instead of the universe moving round the earth, as had previously been maintained, changed the old place in the universe assigned to man by Providence for good and all. For the moment, the earth could no longer be regarded as the centre of the universe, man himself could no longer be regarded as the aim and purpose of creation. But the Copernican theory not only meant that the world ceased to revolve around the earth and man, but also that it no longer had any centre at all and consisted merely in a number of homogeneous and equivalent parts, the unity of which was manifested exclusively in the universal validity of natural law. The universe was, according to this theory, infinite and yet uniform, a co-operative and continuous system organized on a single principle, a coherent and vital whole, an ordered, efficient mechanism—a perfect clockwork, to use the language of the period. Along with the conception of the natural law that allows for no exceptions, there arose the concept of a new kind of necessity, absolutely different from theological foreordination. That meant, however, the undermining not only of the idea of divine

arbitrariness, but also of the idea of man's prerogative of divine grace and of his participation in the supramundane existence of God. Man became a tiny, insignificant factor in the new disenchanted world. But the most remarkable thing was that, out of this changed position, he developed a new feeling of self-respect and pride. The consciousness of understanding the great, overwhelmingly powerful universe, of which he himself was a mere part, became the source of an unprecedented and boundless self-confidence.

In the homogeneous and continuous world into which the old dualistic Christian reality had become transformed, the place of the earlier anthropocentric world-view was taken by an awareness of the cosmos, that is, by the conception of an infinite continuity of interrelationships embracing man and containing the ultimate ground of his existence. The conception of the universe as an unbroken systematic whole was incompatible with the medieval concept of God, of a personal God standing outside the cosmic system; the world-view of divine immanence, by which medieval transcendentalism was superseded, only recognized a divine power working from within. Certainly, as a fully developed theory all this was new, but the pantheism, which constituted the quintessence of the new doctrine, originated, like most of the progressive elements in the thinking of the Renaissance and the baroque, in the beginnings of the money economy, of the late medieval city, of the new middle class and in the victory of nominalism. 'The rise of modern European pantheism is, Dilthey thinks, the work . . . of the intellectual revolution which follows the great thirteenth century and fills nearly three centuries.'[228] At the end of this development the fear of the judge of the universe is superseded by the 'frisson métaphysique', by Pascal's anguish in face of the 'silence éternel des espaces infinis', by the wonder at the long unbroken breath which pervades the cosmos.

The whole of the art of the baroque is full of this shudder, full of the echo of the infinite spaces and the interrelatedness of all being. The work of art in its totality becomes the symbol of the universe, as a uniform organism alive in all its parts. Each of these parts points, like the heavenly bodies, to an infinite, unbroken continuity; each part contains the law governing the

whole, in each the same power, the same spirit is at work. The impetuous diagonals, the sudden foreshortenings, the exaggerated light and shade effects, everything is the expression of an overwhelming, unquenchable yearning for infinity. Every line leads the eyes into the distance, every form instinct with movement seems to be trying to surpass itself, every motif is in a state of tension and exertion, as if the artist were never quite certain of real success in expressing the infinite. Even behind the calm of the Dutch painters of daily life one feels the impelling force of infinity, the constantly imperilled harmony of the finite. That is doubtless a common characteristic—but is it sufficient to enable us to speak of a homogeneous baroque style? Is it not just as futile to define the baroque as a striving for the infinite as to derive the Gothic merely from the spirituality of the Middle Ages?

9. THE BAROQUE OF THE CATHOLIC COURTS

Towards the end of the sixteenth century a striking change takes place in the history of Italian art; cool, complicated, intellectualistic mannerism yields to a sensual, emotional, universally comprehensible style—the baroque. This is the reaction of a conception of art which is partly intrinsically popular, partly held by the ruling cultural class but with consideration for the masses against the intellectual exclusiveness of the preceding period. The naturalism of Caravaggio and the emotionalism of the Carracci represent the two directions. In both camps the high level of culture attained by the mannerists declines. For even in the studio of the Carracci the things which are copied from the great masters of the Renaissance are comparatively simple and the thoughts and feelings to be expressed uncomplicated. Of the three Carracci, only Agostino can really be called 'cultured', and Caravaggio is plainly the typical bohemian, hostile to culture and a stranger to all speculation and theorizing.

The historical importance of the Carracci is extraordinary; the history of the whole of modern 'church art' begins with them. They transform the difficult, involved symbolism of the mannerists into that simple and solid allegorical style which is the

origin of the whole development of the modern devotional image with its hackneyed symbols and formulae, the cross, the halo, the lily, the skull, the affectedly pious look, the ecstasies of love and suffering. For the first time, religious art becomes absolutely distinct from profane art. In the Renaissance and the Middle Ages there were still innumerable transitional forms between works of art serving purely ecclesiastical and those serving secular purposes, but with the development of the style of the Carracci a fundamental severance takes place.[229] The iconography of Catholic Church art is fixed and schematized; the Annunciation, the Birth of Christ, the Baptism, the Ascension, the Carrying of the Cross, the Woman of Samaria, Christ as the Gardener and many other biblical scenes attain the form which still holds good today as the standard model for the devotional image. Church art assumes an official character and loses its spontaneous, subjective characteristics; it becomes more conditioned by worship and less by immediate faith. The Church knows only too well the danger with which it is threatened by the subjectivism of the Reformation spirit; it desires that works of art should express the meaning of orthodoxy just as independently of all arbitrary interpretation as the writings of the theologians. Compared with the dangers of artistic freedom, the stereotypy of the works seems the lesser of two evils.

Caravaggio also had great successes to begin with; his influence on the artists of the century went even deeper than that of the Carracci. But, in the long run, his bold, unvarnished, sturdy naturalism was unable to satisfy the taste of his high ecclesiastical patrons; they missed in his work that 'sublimity' and 'nobility' which they considered essential to a religious picture. They objected to his paintings, which were unsurpassed for quality in the Italy of the time, and repeatedly turned them down, as they saw in them merely the unconventional form, and were incapable of understanding the deep piety of the master's genuinely popular language. Caravaggio's failure is sociologically all the more remarkable as he is probably the first great artist, at any rate since the Middle Ages, to be rejected on account of his artistic individuality, and to arouse the repugnance of his contemporaries for precisely the same reasons as were the basis of his

later fame. But if Caravaggio really is the first master of the modern age to be slighted by reason of his artistic worth, then the baroque signifies an important turning point in the relationship between art and the public, namely the end of the 'aesthetic culture' which begins with the Renaissance and the beginning of that more rigid distinction between content and form in which formal perfection no longer serves as an excuse for any ideological lapse.

In spite of the desire to influence as wide a public as possible, the aristocratic spirit of the Church finds expression everywhere. The curia would like to create a 'folk art' for the propagation of the Catholic faith, but to limit the popular element to simplicity of ideas and forms; it wishes to avoid plebeian directness of expression. The sacred persons portrayed are to speak to the faithful as insistently as possible, but under no circumstance to climb down to them. Works of art are to make propaganda, to persuade, to overwhelm, but must do so in a choice and elevated language. In pursuit of the given propagandistic goal, a certain democratization, and even plebeianization of art cannot be avoided; the effect made by a work is often all the more uncouth the more genuine and the deeper the religious feeling is from which it springs. But the Church is concerned not so much with the deepening as with the dissemination of the faith. To the extent that it secularizes its aims, the religious feeling of the faithful becomes weaker. It is true that the influence of religion loses nothing of its amplitude, on the contrary, piety takes up more space in daily life than before, but it becomes an external routine, and loses its strictly supramundane character.[230] We know that Rubens attended mass every morning, and that Bernini not only communicated twice a week, but, following the counsel of Ignatius, withdrew once a year into the solitude of a monastery, to devote himself to spiritual exercises. But who would assert that these artists were really more religiously-minded than their predecessors?

The affirmative attitude to life, which, with the coming of the baroque, displaces the tendency to escape from the world, is above all a symptom of the tiredness felt after the long wars of religion, and of the readiness to compromise which follows the

denominational intransigence of the Tridentine period. The Church abandons the fight against the demands of historical reality and strives to adapt itself to them as far as possible. It becomes more and more tolerant towards the faithful, even though it continues to persecute the 'heretics' as mercilessly as ever. But in its own camp it grants all possible freedom; it not only tolerates but promotes interest in the affairs of the world around and sanctions a delight in the interests and joys of secular life. Almost everywhere it becomes a national Church and an instrument of political government, with which is connected *a priori* a far-reaching subordination of spiritual ideals to the interests of the state. Even in Rome, religious considerations have to recede in favour of political exigencies. Sixtus V already makes concessions to unreliable France in order to set a limit to the predominance of orthodox Spain, and under the later baroque Popes the secular trend of the policy of the curia becomes even more obvious.

It now devolves upon Rome to function in full splendour not only as the papal residence but also as the capital of Catholic Christianity. The grandiose, pompous character of court art now comes to predominate in Church art too. Mannerism had to be stern, ascetic, other-worldly, but the baroque is allowed to follow a more liberal, more sensual course. The competitive struggle against Protestantism has come to an end; the Catholic Church has renounced the lost territories and recovered its sense of security in those preserved for the faith. A period of the richest, most luxurious and extravagant art production now begins in Rome. It produces a vaster quantity of churches and chapels, ceiling paintings and altar-pieces, statues of saints and tomb monuments, reliquaries and votive offerings, than any previous age. And it is by no means merely the ecclesiastical branches of art which owe a new wave of prosperity to the revival of Catholicism. The Popes erect not only magnificent churches, but also build magnificent palaces, villas and gardens for themselves. And the cardinal-nepots, who more and more assume the style of royal princes in their way of life, display just as much luxurious extravagance in their buildings. The Catholicism represented by the Pope and the higher clergy becomes more and more official

and courtly, in contrast to Protestantism, which becomes more and more middle class.[231] The bees of the Barberini are to be seen all over baroque Rome, just as the Napoleonic eagle is seen in the Paris of the Empire. But the Barberini are in no sense exceptional among the papal families; apart from them, and the equally famous Farnese and Borghese, the Ludovisi, Pamfili, Chigi and Rospigliosi are among the most zealous friends of art of the age.

Under Urban VIII, the Barberini Pope, Rome became the baroque city as we know it. At least in the first half of his pontificate, Rome still dominates the whole artistic life of Italy and is the artistic centre of the whole of Western Europe. Roman baroque art is international, just as the French Gothic had been; it assimilates all the available forces, and combines all the vital artistic endeavours of the age into the one style which is considered up to date throughout Europe. By about 1620 the baroque had finally made its way in Rome. The mannerists, above all Federigo Zuccari and the Cavaliere d'Arpino, continue to paint, but their trend is out of date and even Caravaggio and the Carracci are already antiquated by historical developments. Pietro da Cortona, Bernini and Rubens are the names that matter now. They form the transition to a development which has its centre no longer in Italy but in Western and Northern Europe. The art of Cortona, the leading master of high baroque fresco painting in Rome, is continued outside Italy in the ebullient and luxuriant style of decoration of the French interiors. In France, where he is received like a prince, Bernini comes up against nationalist opposition and this prevents the execution of his plan for the Louvre. The Duke of Bouillon calls Paris the capital of the world around the middle of the century,[232] and, in fact, France now becomes not only the leading power in Europe politically, but also takes the lead in all matters of culture and taste. With the decline of the influence of the curia and the impoverishment of Rome, the centre of the world of art shifts from Italy to the country where the most progressive political structure of the age, absolute monarchy, is developed and where art production has the most important resources at its disposal.

The victory of absolutism was to a certain extent a con-

sequence of the wars of religion. At the end of the sixteenth century, France was so weakened by the endless slaughter, the eternal famines and epidemics that the people wanted peace and quiet at any price and longed for a strong regime to take over, or were at least prepared to put up with one. The new policy operated most harshly against the old nobility, which was always on the point of conspiring against the crown and whose opposition had to be broken if the government was to rule undisturbed. The bourgeoisie, on the other hand, which always prospers best when there is internal peace and which is always ready to back up the 'policy of the strong hand', gave absolutism its enthusiastic support, and this was highly appreciated by the king and the government. The ennoblement of members of the middle class, which had been under way again for a long time, was now carried on more indiscriminately than ever before. The appointment of commoners to the nobility had at all times been the prize with which the princes had rewarded special services; but since the sixteenth century, the number of ennoblements had increased by leaps and bounds after a limit had already been set to the spread of this practice in the Middle Ages. Francis I honours with the title of nobility not only military but also civil services and even does business in patents of nobility. In the course of time the right to ennoblement is connected with the tenure of certain offices, and in the seventeenth century there are already four thousand office-holders in the law, in the treasury and the administration who belong to the hereditary nobility.[233] In this way, more and more members of the middle class find admission into the nobility and they already outnumber the birthright aristocracy in the seventeenth century. The old aristocratic families are partly wiped out in the uninterrupted .succession of campaigns, civil wars and risings, and partly ruined economically and left unfit to earn a living. For many, accommodation at the court, where they could obtain benefices and pensions by begging, was the only means of existence. Of course, many of the old landowning nobility continued to live on the land; but most of them led a very frugal life there. The impoverished aristocrats had no longer any ways and means of enriching themselves again and the king would not even grant them a function of their own in

the state.[234] As the standing army developed, their military importance diminished; offices were usually filled with middle-class elements and the nobility did not regard it as in keeping with their rank to work, that is, to take an active part in industry and commerce.

But the relationship between the king and the absolute state, on the one hand, and the nobility, on the other, is not at all straightforward. Only the rebellious nobility, by no means the nobility as such, are persecuted; on the contrary, the nobility are still considered the backbone of the nation. Their privileges, with the exception of the purely political, continue; their seigniorial rights in relation to the peasants are left as they were, and they retain their full immunity from taxation. Absolutism by no means abolished the old class order of society; it certainly modified the relation of the estates to the king, but it left their relation to one another unaltered.[235] The king still feels that he belongs to the nobility and likes to call himself the first 'gentilhomme' of the country. He compensates the aristocracy for the loss of prestige which they suffer as a result of the new ennoblements, by spreading the legend of their supreme moral and intellectual excellence by all the available means of official art and literature. The distance between the aristocracy and the 'roture', on the one side, and the birthright nobility and the patent nobility, on the other, is artificially enlarged and felt more strongly than hitherto. All this leads to a new aristocratization of society and a fresh renaissance of the old chivalrous-romantic concepts of morality. The real nobleman is now the 'honnête homme', who belongs to the birthright nobility and acknowledges the ideals of chivalry. Heroism and fidelity, moderation and self-control, generosity and politeness, are the virtues of which he must be master. They are all part of the semblance of the beautiful, harmonious world, clothed in which the king and his entourage present themselves to the public. They pretend that these virtues really do matter and, deceiving even themselves at times, they pretend they are the knights of a new Round Table. Hence the unreality of court life, which is nothing but a party game, a brilliantly staged theatrical show. Loyalty and heroism are the names given to slavish subjection by literary propaganda, when

it is a question of interests of state and the will of the monarch. Politeness usually means 'making the best of a bad bargain', and generosity the attitude that allows the master class to forget that they have become beggars. Moderation and self-control are the only genuine virtues demanded by the aristocratic and courtly life. The spiritually sound man of gentle birth does not wear his heart on his sleeve; he adapts himself to the standards of his class, does not wish to move and persuade others, but to represent his class and to impress. He is impersonal, reserved, cool and strong; he regards all exhibitionism as plebeian, all passions as diseased, incalculable and turbid. One does not let oneself go in the presence of another, least of all in the presence of the king— that is the basic rule of court morality. One does not unbosom oneself, one strives to be pleasant and to represent one's kind as perfectly as possible. Court etiquette is guided by the same principles of good form and keeps to the same style as that in which the king's palaces are built and his gardens trimmed.

But like all the outward forms of the French baroque, court life also passes from a state of comparative freedom to one of strict regimentation. The familiarity in the intercourse between the king and his entourage, which was still so characteristic of the court of Louis XIII, disappears under his successor.[236] The impetuous, exuberant nobleman of earlier days becomes the tame, well-bred courtier. The motley, ever-changing picture of the preceding period yields to a universal monotony. The differences between the individual categories of the court nobility are obliterated; at the court all alike are courtiers now, in relation to the king all are equally unimportant. 'Les grands mêmes y sont petits'—says La Bruyère. Baroque culture becomes more and more an authoritarian court culture. The meaning attributed to 'beautiful', 'good', 'intelligent', 'refined', 'elegant' now depends on what the court considers these qualities to imply. The *salons* also lose their original importance; the court becomes the authoritative forum in all questions of taste. It is the court which gives the great, commanding style of art its guiding principles; here is formed that 'grande manière' which invests reality with an ideal, resplendent, festive and solemn character, and which sets the standard for the style of official art in the whole of Europe. To be

sure, the French court attains the international recognition of its manners, fashion and art at the expense of the national character of French culture. The French, like the ancient Romans, look upon themselves as citizens of the world, and nothing is more typical of their cosmopolitan outlook than the fact that in all the tragedies of Racine, as has been noted, not a single Frenchman appears.

It is absolutely wrong to see in the classicism of this court culture the French 'national style'. Classicism has just as long and almost as unbroken a tradition in Italy as in France. In the seventeenth century, there is hardly anywhere to be found a purely and exclusively sensualistic baroque based entirely on wealth and direct effect of motifs; wherever baroque endeavours are found, we also discover a more or less developed classicism. But it is no more accurate to speak of the French 'grand siècle' as a historically clear-cut epoch pursuing consistent artistic aims, than it is to talk about the uniformity of the baroque. In reality, a deep cleft breaks the century into two exactly distinguishable phases of style with the beginning of the personal government of Louis XIV as the dividing line.[237] Before 1661, that is, under Richelieu and Mazarin, a comparatively liberal tendency still predominates in artistic life; artists are not yet under state tutelage, there is still no government-organized art production, there is still no general acceptance of rules sanctioned by the state. The 'great century' is by no means identical with the age of Louis XIV as was still thought long after Voltaire. The life-work of Corneille, Descartes and Pascal was completed before the death of Mazarin; Louis XIV never met Poussin and Le Sueur; Louis Le Nain died in 1648, Vouet in 1649. Of the important authors of the century, only Molière, Racine, La Fontaine, Boileau, Bossuet and La Rochefoucauld can be regarded as the representatives of the age of Louis XIV. But when the King takes the government into his own hands, even La Rochefoucauld is already 48, La Fontaine 40, Molière 39 and Bossuet 34 years old; only Racine and Boileau are young enough for their intellectual development to be influenced from outside. In spite of its important writers, the second half of the century is nothing like so creative as the first. The general type rather than the particular artistic personality

prevails everywhere and even more exclusively in the fine arts than in poetry and literature. The individual works of art lose their autonomy, and amalgamate into the total ensemble of an interior, a house or a palace; they are more or less all merely the parts of a monumental decoration. From 1661 onwards political imperialism is paralleled by an intellectual imperialism. No department of public life is spared from the intervention of the state: law, administration, trade, religion, literature and art, everything is regulated from outside. For the arts Le Brun and Boileau are the legislators, the academies are the courts of law, and the protectors are the King and Colbert. Art and literature lose their relationship with real life, with the traditions of the Middle Ages and the mind of the broader masses of the people. Naturalism is tabooed, because the desire is to see everywhere in art the picture of an arbitrarily constructed and forcibly conserved world instead of reality itself, and form enjoys a preference over content, because, as Retz says, the veil is never lifted from certain things.[238] Molière is the only writer to maintain the connection with the folk poetry of the Middle Ages, and even he speaks contemptuously of the

> . . . fade goût des monuments gothiques,
> Ces monstres odieux des siècles ignorants.[239]

The provinces and the regional centres of culture lose their importance, 'la Cour et la Ville', Versailles and Paris, are the stage on which the whole of French intellectual life takes place. All this leads to the complete belittling of individuality, personal style and initiative. The subjectivism that was still predominant in the period of the high baroque, roughly in the second third of the century, yields to a uniformly regulated culture of authority.

Like all the forms of life and culture of the age, first of all the mercantilist economic system, the aesthetic of classicism is guided by the principles of absolutism—the absolute primacy of the political conception over all the other expressions of cultural life. The special characteristic of the new social and economic forms is the anti-individualistic tendency derived from the idea of the absolute state. Mercantilism is also, in contrast to the older form

177

of profit economy, based on state-centralism, not on individual units, and it attempts to eliminate the regional centres of trade and commerce, the municipalities and the corporations, that is to say, to put state-autonomy in the place of separate autarchies. And just as the mercantilists try to destroy all economic liberalism and particularism, so, too, the representatives of official classicism want to put an end to all artistic freedom, to every effort to achieve a personal taste, to all subjectivism in the choice of theme and form. They demand that art should be universally valid, that is to say, a formal language, with nothing arbitrary, bizarre, peculiar about it, and which corresponds to the ideals of classicism as the regular, lucid, rational style par excellence. They have not the slightest awareness of how restricted their idea of 'universality' is and of how few they are thinking when they talk about 'everybody' and 'anybody'. Their universalism is a fellowship of the élite—of the élite as formed by absolutism. There is hardly a rule or a requirement of classicistic aesthetics which is not based on the ideas of this absolutism. The desire is that art should have a uniform character, like the state, should produce the effect of formal perfection, like the movement of a corps, that it should be clear and precise, like a decree, and be governed by absolute rules, like the life of every subject in the state. The artist should be no more left to his own devices than any other citizen; he should rather be guided by the law, by regulations, so as not to go astray in the wilderness of his own imagination.

The quintessence of classical form is discipline, limitation, the principle of concentration and integration. This principle is expressed nowhere so characteristically as in the dramatic 'unities' which had come so much to be taken for granted in French classicism that, after 1660, they are never questioned, but at most formulated differently.[240] For the Greeks, the spatial and temporal restrictions of the drama resulted from the technical presuppositions of their stage; they were, therefore, able to treat them as elastically as actual theatrical possibilities allowed. But for the French, the doctrine of the unities was also directed against the extravagant, uneconomical method of composition of the Middle Ages, which had led to an endless accumulation of episodes. They were not only acknowledging their indebtedness

178

to classical antiquity but, at the same time, they were taking leave of 'barbarism'. In this respect, too, the baroque signified the final dissolution of the medieval cultural tradition. Now, after the failure of mannerism's last attempt to restore it, the medieval age really comes to an end. The feudal nobility have lost all their importance in the state as a military class; the political communities have become transformed into absolute, that is, modern national, states; unified Christianity has disintegrated into Churches and sects; philosophy has made itself independent of religiously directed metaphysics and turned itself into the 'natural system of the sciences'; art has overcome medieval objectivism and become the expression of subjective experience. The unnatural, coercive, and often forced quality, which distinguishes modern from classical and Renaissance classicism, is due precisely to the fact that the striving for the typical, the impersonal, the universally valid now has to make its way against the artist's subjectivity. All the laws and regulations of classicistic aesthetics are reminiscent of the paragraphs of the penal code; the whole constabulary of the academies is needed to secure their universal observance. The compulsion to which artistic life is subject in France is expressed most directly in these academies. The concentration of all utilizable forces, the suppression of all individual effort, the supreme glorification of the idea of the state as personified in the king, these are the tasks which the academies are called upon to deal with. The government wishes to dissolve the personal relationship between the artist and the public and to make them directly dependent on the state. It wants to bring to an end both private patronage and the promotion of private interests and aspiration by artists and writers. From now on they are to serve only the state,[241] and the academies are to educate them for and hold them to this subservient position.

The 'Académie Royale de Peinture et de Sculpture', which begins its activities in the year 1648 as a free society of members all entitled to the same rights and granted admission in unlimited numbers, is transformed into a state institution with a bureaucratic administration and a strictly authoritarian board of directors, after receiving a royal subvention since 1655, but especially after 1664, when Colbert becomes the 'surintendant des bâti-

179

ments', that is to say, something like a Minister of Fine Arts, and Le Brun becomes the 'premier peintre du roi' and the perpetual director of the Academy. For Colbert, who, in this way, makes the Academy directly dependent on the King, art is nothing but an instrument of state government with the special function of raising the prestige of the monarch, on the one hand, by developing a new myth of kingship, and, on the other, by intensifying the splendour of the court as the framework of the royal dominion. Neither the King nor Colbert has a real understanding or a genuine love of art. The King is incapable of thinking of art except in connection with his own person. 'I entrust to you the most precious thing on earth—' he once said in an address to the leading members of his Academy 'my fame.' He makes Racine, his historian, Le Brun and van Meulen, his history and war painters, visit the scenes of his campaigns, and shows them round the camp himself, explaining technical military details to them and seeing to their personal safety. But he has not the slightest idea of the artistic significance of his favourites. When Boileau once remarked that Molière was the greatest writer of the century, he replied in astonishment: 'But I never knew that.'

The Academy has at its disposal all the benefices that an artist can ever hope to receive, and all the instruments of power calculated to intimidate him. It makes state appointments, bestows public commissions and confers titles; it has a monopoly in art education and is able to supervise the development of an artist from his first beginnings until his ultimate employment; it awards prizes, above all the Rome prize, and pensions; permission to exhibit and to take part in competitions has to be obtained from it; the views on art which it represents are regarded with special respect by the public and assure a favoured position from the outset for the artist who conforms to them. From its very foundation, the Academy of Fine Arts devoted itself to art education, but it is only after its reform by Colbert that it enjoys the prerogative of art instruction; from then onwards no artist outside the Academy is allowed to give public instruction and to let his pupils draw from life. In 1666, Colbert founds the 'Académie de Rome', and ten years later he affiliates it to the Paris Academy, by making Le Brun the head of the Rome

Academy as well. From now on artists are purely the creatures of the state educational system; they can no longer escape from the influence of Le Brun. They stand under his supervision in the Paris Academy, they have to conform to his directives in Rome, and if they stand the test there, the best they can hope for is to be employed by the state under Le Brun as their chief.

Besides the monopoly of art education, the state organization of art production is also part of the system which secures absolute predominance for the court style and its rules. Colbert makes the King the only important patron of art in the country and turns the aristocracy and high finance out of the art market. The royal building activity in Versailles, at the Louvre, on the Invalides, on the church of Val-de-Grâce, absorbs nearly all the available artistic labour. The emergence of patrons, like Richelieu or Fouquet, would now have been impossible on technical grounds alone. In the same way as he made the Academy the centre of art education, in 1662 Colbert also organizes the tapestry manufactory acquired from the Gobelin family and makes it the framework for all art production in the country. Thus he brings together in a common task architects and ornamental draughtsmen, painters and sculptors, tapestry-weavers and cabinet-makers, silk and cloth weavers, bronze-founders and goldsmiths, ceramists and glassblowers. Under Le Brun, who also takes over the management here, the *Manufacture des Gobelins* develops an enormous activity. All the works of art and decoration for the royal palaces and gardens are produced in its workshops. Here, too, the King has the works of art made which he gives as presents to foreign courts and important personalities abroad. At the same time, everything that comes out of the royal manufactory is marked by impeccable taste and technical perfection. The union of the late medieval tradition of craftsmanship with what had been learnt from the Italians produces achievements in the decorative arts which have never been surpassed and which, even if they are lacking in individual excellence, have an all the more uniform level of quality. To be sure, works of painting and sculpture now also acquire an industrial character. Painters and sculptors produce sets, repeat and vary fixed patterns, and treat the decorative framework with the same care as the works of art

themselves—if they feel the dividing line between the work of art and the framework at all. The mechanized, factory-like method of manufacture leads to a standardization of production both in the applied and the fine arts.[242] The new technique of manufacture makes it possible to discover aesthetic values in the stereotyped article and to under-estimate the value of uniqueness, of unrepeatable individual form. But the fact that this tendency by no means keeps abreast with technical development, and that later ages return to the earlier Renaissance conception of art in their appreciation of individuality, indicates that the impersonal character of the 'Louis XIV style' depends not only on the technical presuppositions of production, that is to say, on manufacturing, but that other factors are also operative. Mechanical production is, incidentally, older than the mechanistic philosophy of the seventeenth century and the impersonal art philosophy that went with it.[243]

Almost everything produced in the 'Gobelins' originates under the personal supervision of Le Brun. He himself draws many of the plans; others are prepared according to his instructions and executed under his immediate surveillance. The 'art of Versailles' takes its shape here and is in essentials the creation of Le Brun. Colbert knew perfectly well whom he was making his confidant: Le Brun directed the institutions in his charge according to strictly doctrinaire and totalitarian principles, wholly in the spirit of his master. He was a dogmatist and a friend of absolute authority, and, at the same time, a man of the greatest experience and trustworthiness in all technical matters of art. For twenty years he remained the art dictator of France, and as such he became the real creator of the 'academicism' to which French art owed its world fame. Colbert and Le Brun were pedantic natures who desired to see theories not merely obeyed, but laid down in black and white. In 1664 the famous *conférences* were introduced at the Academy and continued for ten years. These Academy lectures always began with the analysis of a picture or a piece of sculpture, and the lecturer summed up his opinion of the work under review in a dogmatic proposition. This was followed by a discussion, which it was intended should achieve the formulation of a generally valid rule; often this was realized only

by taking a vote or by the decision of a referee. Colbert desired that the results of these lectures and discussions, which he called 'préceptes positifs', should be 'registered', like the decisions of a committee, in order, in this way, to obtain for perpetual reference a solid fund of authoritative aesthetic principles. There was, in fact, formed a canon of artistic values, which had never before been formulated with so much clarity, absoluteness and precision. In Italy, on the other hand, academic theory preserved a certain liberality in its approach; it was nothing like so uncompromising as in France. This difference has been explained by the fact that in Italy aesthetics had resulted from the native and on the whole homogeneous practice of art, whereas it came to France along with Italian art as an import, intended for the upper classes, and as such found itself from the outset opposed to both the medieval and the popular art tradition of the country.[244] But even here it was still much more liberal around the middle of the century than later on. Félibien, the friend of Poussin and the author of the *Entretiens sur la vie et les ouvrages des plus excellents peintres* (1666), still acknowledges the importance of artists like Rubens and Rembrandt, still emphasizes that there is nothing in nature that is not beautiful and cannot be given artistic shape, and still attacks the slavish imitation of the great masters. The most important elements of academic aesthetics are, however, already present in his work, above all the thesis of the correction of nature by art and the primacy of drawing over colour.[245] But the real classicistic doctrine is not developed until the sixties by Le Brun and his followers; it is then that the academic canon of beauty is first constituted, with its models of classical antiquity, Raphael, the masters of Bologna and Poussin, all of which are above criticism, and from then onwards unconditional consideration for the fame of the King and the reputation of the court becomes all important in the portrayal of historical and biblical subjects. The opposition to this academic doctrine and the corresponding practice of art very soon makes itself felt, however, in spite of the premiums that are put on the observance of the academic rule. Even in Le Brun's time a certain tension arises between the official art, which is the product of a cautious cultural programme, and spontaneous artistic activity both inside and out-

side the academic circle. Beside Le Brun himself, there was never really any artist with an absolutely orthodox style; but from 1680 the general taste in art already turns quite openly against the dictates of Le Brun.

The tension between the outlook of official, whether ecclesiastical or courtly, circles and the taste of the artists and friends of art, who are, on the whole, not interested in what these circles think, is not peculiar to French artistic life, but is typical of the whole of baroque. Only in France the antagonism which had already found expression in the attitude of the various sections of the public for and against Caravaggio, for example, was intensified. For, although it may well have happened even in earlier times that a gifted artist or artistic trend was not to the liking of some ecclesiastical or secular patron or other, nevertheless, before the age of the baroque no fundamental distinction could be made between an official art and an art appealing to the general public. Now it happens for the first time that the progressive tendencies have to fight not merely against the inertia of the natural process of development, but also against the conventions which are supported by the all-powerful authority of the state and the Church. The typically modern conflict, so familiar to us, between the conservative and the progressive factors in artistic life, which results not merely from a difference of taste, but is waged, above all, as a struggle for power, and as one in which all the privileges and opportunities are on the side of the conservatives and all the disadvantages and dangers on the side of the progressives, is unknown before the baroque. Of course, even in earlier days there were, as well as the people who understood art, also those who neither understood nor were interested in it, but now two parties arise within the art public itself, one hostile to progress and innovation, and the other liberal and interested in new developments from the very start. The antagonism between these two parties, between an academic-official and a non-official, free art, the quarrel between an abstract, programmatically drawn-up aesthetic and a dynamic one developing in conjunction with everyday practice, invests the baroque and the following period with its special, modern character. The fight between the Poussinistes and the Rubénistes, the opposition between the

classicistic-linear and the sensualistic-pictorial tendency which ends with the final victory of the colourists over Le Brun and his supporters, was merely a symptom of the general tension. The choice between drawing and colour was more than a technical question; the decision for colouring implied a stand against the spirit of absolutism, rigid authority and the rational regimentation of life—it was the sign of a new sensualism and finally led to phenomena such as Watteau and Chardin.

The opposition in the seventies to the academicism of Le Brun prepared the way for a new development in art in more than one respect.[246] A circle of people interested in art was then being formed for the first time consisting not only of specialists, that is to say, artists, patrons and collectors, but also of such laymen as presumed to express an opinion of their own on works of art. Hitherto the Academy had granted the exclusive right to express an opinion on artistic questions, and it granted that right only to professionals. Now, all at once, its authority to do so was disputed. Roger de Piles, the theorist of the generation following Félibien, championed the rights of the lay public, arguing that unprejudiced, simple taste was also entitled to have its say, and that common sense and the natural, impartial eye may well be in the right as opposed to rules and regulations and expert opinion. The first victory of the lay public is to be explained partly by the fact that the payments which Louis XIV caused to be made to artists became more and more trifling towards the end of his reign, and that the Academy was more or less forced to appeal to the wider public, in order to recoup itself for the loss of its government subsidy.[247] It was, however, only the following century which drew the logical conclusion from the propositions of de Piles; Du Bos was the first to stress the point that the purpose of art is not to 'teach' but to 'move', and that the only adequate attitude to take up to it is not one of reason but of 'feeling'. It was not until the eighteenth century that anyone dared to emphasize the superiority of the layman to the specialist and to express the idea that the feelings of people who are constantly dealing with the same thing necessarily become blunt, whereas those of the amateur and the layman remain natural and fresh.

The constitution of the art public did not change from one day to the next; even the simple, unprofessional appreciation, in fact the mere interest in works of art, was dependent on certain educational conditions, which only comparatively few people were in a position to fulfil in seventeenth-century France. But the art public grew in size from day to day, embraced increasingly diverse elements of the population and at the end of the century already formed a social group that was by no means so homogeneous and so malleable as the court public of the Le Brun period, which is not by any means to say that the public of classicistic art was absolutely uniform and restricted entirely to court circles. The archaic severity, the impersonal stereotyped quality, the die-hard conventionalism of that art were certainly characteristics in accordance with the aristocratic outlook on life —since for a class which bases its privileges on antiquity, blood and general bearing, the past is more real than the present, the group more substantial than the individual, moderation and self-discipline more praiseworthy than temperament and feeling— but the rationalism of classicistic art was just as typical an expression of the middle-class philosophy as of that of the nobility. This rationalism was, in fact, rooted in the bourgeois way of thinking more deeply than in that of the nobility, which had merely taken over the rationalistic conception of life from the bourgeoisie. In any case, the efficient, profit-making burgher had begun to conform to a rationalistic scheme of living earlier than the aristocrat merely interested in his privileges. And the middle-class public found pleasure in the clarity, simplicity and terseness of classicistic art more quickly than the nobility, who were still under the influence of the romanesque, bombastic, capriciously extravagant taste of the Spaniards at a time when the middle class was already showing enthusiasm for the lucidity and regularity of Poussin's art. At any rate, the works of this master, almost all of which arose in the age of Richelieu and Mazarin, were bought for the most part by members of the bourgeoisie, by civil servants, merchants and financiers.[248] As is known, Poussin did not accept any orders for big decorative paintings; throughout his life, he kept to smaller sizes and a more unassuming style. He also only rarely accepted ecclesiastical commissions;

he did not feel there was any kind of connection between the classicistic style and the purely ceremonial purposes of art.[249]

The court gradually changed over from the sensualistic to the classicistic baroque, just as the aristocracy adopted the economic rationalism of the middle class, in spite of its dislike of anything to do with figures. Both classicism and rationalism were in keeping with the progressive trend of development; sooner or later they were accepted by all classes of society. By following classicism, court circles were adopting an originally middle-class tendency, but they transmuted its simplicity into solemnity, its economic use of resources into reserve and self-control, its clarity and regularity into a rigorous and uncompromising attitude. Naturally, it was only the upper strata of the middle class who found pleasure in classicistic art, and even these were not exclusively devoted to it. To be sure, the rational organization of classicism was in accordance with their objective way of thinking, but, owing to their practical and realistic outlook on life, they were more responsive to naturalistic impressions. In spite of Poussin's rationalism, the naturalist Louis Le Nain is the middle-class painter par excellence.[250] But naturalism remained by no means the exclusive property of the middle class. Like rationalism, it became for all classes of society an indispensable intellectual weapon in the struggle for existence. Not only business success, but also success at court and in the salons presupposed psychological acumen and a subtle knowledge of men. And even though the rise of the middle class and the beginnings of modern capitalism had given the first impetus to the formation of that anthropology with which the history of modern psychology begins, nevertheless, the real origin of our art of psychological dissection is to be found at the courts and in the salons of the seventeenth century. The psychology of the Renaissance, the basis of which was, to begin with, purely scientific, acquires a practical, ethical character in the autobiographical writings of Cellini, Cardano and Montaigne, and above all in the historical characterizations and analyses of Machiavelli. Machiavelli's psychology of exposure already contains the principle of the whole of subsequent psychological literature; his conception of egoism and hypocrisy serves the whole century as a key to the under-

standing of the hidden motives of human passions and actions. Naturally, the Machiavellian method had to go through a long development at the court and in the *salons* of Paris before it could become the instrument of a La Rochefoucauld. The observations and formulations of the 'Maximes' are unthinkable without the social arts and culture of this court and these *salons*. The mutual observation of the members of these circles in their daily intercourse, the critical spirit which everybody cultivates at the other's expense, the cult of *bon mots* and *médisance* which is their pastime, the intellectual competition which develops amongst them, their endeavour to express an idea in the most surprising, the cleverest and most pointed way, the self-analysis of a society which becomes its own problem and the theme of constant reflection, the analysis of feelings and passions, which is carried on as a kind of party game—all these factors are the background of the characteristic questions and typical answers of La Rochefoucauld. In this milieu he found not merely the first suggestion for his ideas but it was also here that they will have first proved their effectiveness.

Together with the courtly *savoir-vivre* and social culture of the *salons*, the pessimism of the disillusioned nobility, deprived of the very content of its life, is one of the most important sources of the new psychology. Mme de Sévigné says somewhere that she often had such sad conversations with Mme de Lafayette and La Rochefoucauld that probably the best thing they could have done would be to have had themselves buried. All three belong to that exhausted aristocracy which, forced out of active life, holds on to its social prejudices despite their lack of success. Like Retz and Saint-Simon, they are aristocratic amateurs, for whom social quality, the direct expression of class and rank, is much more real than for the middle-class writers, who feel themselves to be supremely individuals. It is by no means an engaging picture of man that they draw, and yet it is correct, as has been said, that, seen through their eyes, there is no longer anything sinister and terrible about the individual; he is no longer a 'horrible secret', a 'monstre incompréhensible', as he still is in Pascal and even in Corneille, but, 'stripped of all extraordinary qualities, he attains an average, handy, easily manageable size'.[251]

There is no longer any mention here of his sins, of his transgressions against God, against himself and against his neighbour as his brother, as blood of his blood; all spiritual impulses and qualities of character, all virtues and vices, are now measured merely by the criterion of sociability.

The *salons* had their heyday in the first half of the century, at a time when the court was not yet the cultural centre of the country, and it was still a question of creating a real public for art and a forum of sound judgement, which, in the absence of professional critics, was intended to pass sentence on the quality of works of art. In this way, the *salons* became small, unofficial academies at which literary fame and literary fashions were created and which, because of their freer communication with the outside world and their internal freedom, were calculated to establish a much more direct connection between the producers and the consumers of art than the court and the real academies in later years. It is impossible to overrate the educational and cultural importance of the *salons*, but the literary output directly initiated by them is not very significant. Not one single great talent emerged even from the Hôtel de Rambouillet, the first and most important of all the *salons*;[252] the *Guirlande de Julie*, which was compiled for a daughter of the Marquise, the prototype of all albums for young girls, is the most representative literary product of this circle. Even the precious style can only be called the creation of the *salons* in a limited sense; it is, in fact, only the French variant and continuation of marinism, gongorism, euphuism and all the other manneristic arts of make-believe. What we have here is simply the typical mode of expression and communication of people who often meet each other and who create their own jargon—a secret language of which they understand the slightest hints and intimations, but which remains unpalatable, nay, unintelligible to others and of which it is the favourite occupation of the initiated to intensify the strangeness and secrecy. Without going back to the Alexandrines, the 'dark rhyming' of the troubadours already had affinities with this artificial and sectarian language in that it was also, above all, a means of avoiding social levelling and always on the outlook for unusual, unnatural and difficult words and formulations as tokens

of social distinction. But it has been rightly emphasized that preciosity was by no means merely the passing folly of a small circle; the precious style was spoken not only by a few dozen cultured and high-spirited ladies, and a few untalented or only moderately talented poets; the whole of the French intellectual élite of the seventeenth century was more or less precious—even the austere Corneille and the middle-class Molière. Even when they were at the highest pitch of excitement, the heroes and heroines on the stage did not forget their good breeding and still addressed each other as Monsieur and Madame. They remained polite and chivalrous in all circumstances; but this gallantry was only a formality, from which it is impossible to draw conclusions as to the sincerity of their feelings—like every form and every language, it used the same words to express authentic and unauthentic sentiments.[253]

The *salons* also contributed to the development of an art public by bringing together in their circle connoisseurs and people interested in art from widely differing classes of society. It was here that members of the hereditary nobility, who were, of course, in a majority, met representatives of the official nobility and the bourgeoisie—especially the financiers—who were already playing a part in the world of art and literature.[254] The nobility still provided the country with the army officers, the provincial governors, the diplomats, the court functionaries and the high ecclesiastical dignitaries, whereas the bourgeoisie not only occupied the important posts in the law courts and in the treasury, but was also beginning to compete with the nobility in cultural life. In France business men never enjoyed the esteem which was shown to them in Italy and England or Germany; they could acquire a more elevated social position only by dint of a higher education and an elevated mode of life. Hence their children were nowhere so eager to give up business life and become highbrow *rentiers* as in France. The French writers who, at the time of the Renaissance, are still mostly descended from the nobility, already belong very largely to the middle class in the seventeenth century. Alongside the relatively few aristocrats and Church leaders who now play a part in French literature, such as the Duc de la Rochefoucauld, the Marquise de

Sévigné and Cardinal Retz—Racine, Molière, La Fontaine and Boileau, to mention only the most important names, are ordinary members of the bourgeoisie and professional writers. The social position of Molière and his relation to the different classes of society is particularly characteristic of the conditions of the age. By descent, intellectual attitude and the character of his art, he is a thoroughgoing bourgeois. He owes his first decisive successes and his understanding of the needs of the theatre to his contact with the broad masses of the public. All his life, he remains critical and often plebeianly disrespectful in his outlook, seeing the ridiculous and the vulgar in the sly peasant, the petty merchant, the vain bourgeois, the coarse squire and the stupid count with the same penetration and representing it with the same candour. But he is careful not to attack the institution of monarchy, the authority of the Church, the privileges of the nobility, the idea of social hierarchy, or even a single duke or marquis. To this wariness he owes the favour of the King, who again and again protects him from the attacks of the court. If it was not so difficult to distinguish a conservative from a revolutionary in the realm of art, one might, therefore, be inclined to call Molière a writer who never disowns his social origins, but is essentially a conservative who for opportunist reasons became the upholder of the prevailing social order. In any case, Molière can certainly not be included in the same category as Aristophanes, although, in some respects, he was more servile. He must be reckoned rather as one of the writers who, in spite of all their subjective conservatism, have become the pioneers of progress by their unmasking of social reality or at least a part of this reality. From this point of view, to be sure, Beaumarchais's Figaro will no longer figure as the first harbinger of the revolution, but merely as the successor of Molière's servants and chambermaids.

10. THE BAROQUE OF
THE PROTESTANT BOURGEOISIE

The Spanish rule in Flanders and its acceptance by the upper classes produced conditions very similar to those prevailing in the

France of the same period. Here too the aristocracy was made absolutely dependent on the power of the state and transformed into a docile court nobility; here too the ennoblement of the bourgeoisie and its inclination to turn its back on business life as soon as possible was a predominant characteristic of social development;[255] here too an almost monopolistic position was granted to the Church, though it had, as in France, to pay the price of becoming an instrument of government; here too the culture of the ruling classes took on an entirely courtly character and gradually lost all connection not only with popular traditions but also with the still more or less middle-class inspired outlook of the Burgundian court. In particular, art also had on the whole an official stamp, only, in contrast to the French baroque, it had a religious tendency at the same time—which is to be explained, above all, by the Spanish influence. Another difference was that there was no state-organized production of art and no complete absorption of all works of art by the court, not only because the archducal court was incapable of financing such production, but also because that kind of regimentation would have been incompatible with the conciliatory manner in which the Habsburgs desired to rule in Flanders. Even the Church, far and away the most important institution interested in art, merely prescribed a general, Catholic line, but did not impose any particular obligation on art, either in relation to the basic mood or the thematic details of the representation. Restored Catholicism allowed the artist more freedom here than elsewhere, and it is owing to this liberal attitude that Flemish art was less formalistic and more spontaneous than court art in France, and also more natural and cheerful in its general mood than Church art in Rome. Even if all the circumstances do not explain the artistic genius of a Rubens, they make it clear that it was in the courtly and ecclesiastical milieu of Flanders that he found the form peculiar to his art.

Nowhere outside the South German countries was the restored Catholic Church so successful as in Flanders,[256] and never was the alliance between Church and state so intimate as under Albert and Isabella, that is, in the golden age of Flemish art. The Catholic idea related itself to the idea of monarchy just as

naturally here as Protestantism identified itself with the Republic in the North. Catholicism derived the sovereignty of the ruler from God, in accordance with the principle of the representation of the faithful by the spiritual estate; Protestantism, on the other hand, with its belief that all men are the children of God, was essentially hostile to authority. But the choice of denomination was often adapted to political standpoint. Immediately after the Revolt, the Catholics in the North were still almost as numerous as the Protestants; it was only later that they went over to the enemies of Rome. The religious antagonism between the southern and the northern states was, therefore, by no means the real reason for the cultural opposition between the two territories; but this opposition can neither be derived from the racial character of the population—it has economic and sociological causes, which also explain the fundamental stylistic difference within Netherlandish art. In no period of the history of art is the sociological analysis of developments more rewarding than here, when two such basically different trends as Flemish and Dutch baroque arise almost simultaneously, in close geographical proximity, under quite similar external conditions. This subdivision of styles, the analysis of which allows us, therefore, to exclude all non-sociological factors, can be regarded as a supreme test case for the sociology of art.

Philip II, in whose reign the bifurcation of Netherlandish culture takes place, was a progressive sovereign who wanted to introduce into the Netherlands the achievements of absolutism, the system of the centralized state and the rationalism of a planned budget.[257] The whole country rose in revolt against this programme: the North successfully, the South unsuccessfully. The 'Catholic' southern provinces rebelled just as bitterly against the new financial sacrifices which the centralized government demanded from the middle class as the 'Protestant' North. The cultural opposition between the two regions did not appear before the conflict with Spain; it only developed as a consequence of the different fortunes which attended the struggle, as the reflection of the social differences which had resulted from the outcome of the revolt in the South and North. The middle-class attitude to Spain was the same everywhere, to begin with; and it was this

class, with its guild background and its preference for decentralization, that thought and felt conservatively, not the monarch, who had been brought up in the ideological atmosphere of political rationalism and mercantilism. The bourgeoisie wanted, above all, to preserve its autonomy in the towns and the privileges connected therewith, and it was agreed on this throughout the country. The story of the Protestant and republican Dutchmen who revolted against the Catholic despot, with the merciless Inquisition and the infamous rabble of soldiers in the background, is no more than a pretty legend. The Dutch did not rise against Spain because they were Protestants, although the individualism of the Protestant faith may have intensified the impetuosity of their rebellion.[258] Catholicism was, intrinsically, no more reactionary than Protestantism was revolutionary,[259] except perhaps that a Calvinist revolted against his king with a better conscience than a Catholic. However that may be, the rising in the Netherlands was a revolution of conservatives.[260] The victorious northern provinces were defending medieval concepts of freedom and an out-of-date system of regional self-government. The fact that they were able to assert themselves for a time shows, as has been said, that absolutism was not the only political system in harmony with the requirements of the age, but the short duration of their success did prove that, in the long run, an urban-federal form of government was untenable in an age of centralized communities.

The northern states formed a union of cities in quite a different sense from the southern provinces, which possessed just as many and just as great cities as the North but in which the function of the townships underwent a fundamental change with the loss of local self-government. After the defeat of the Revolt, the most influential social element was no longer the urban middle class, as in Holland, but the aristocratic or pseudo-aristocratic upper class dependent on the court. In the South foreign rule led to the victory of court culture over urban middle-class culture, whilst in the North the achievement of national independence meant the preservation of bourgeois culture. It was not, however, the freedom-loving virtues which played the greatest part in the new wave of economic prosperity in Holland, but

good luck and sheer accident. The favourable maritime situation, which foreordained that this country should play a predominant part in the organization of trade between Northern and Southern Europe, the wars that forced Spain to purchase goods from the enemy, the insolvency of Philip II in 1596, which led to the ruin of the Italian and German bankers and caused Amsterdam to become the centre of the European money market—all these were so many possibilities of enrichment which Holland had only to exploit, not to create. All it owed to its old-fashioned economic system was the fact that the new wealth benefited not the state and a dynasty, but the urban middle class, which was dismembered, as in medieval days, and still thinking along the lines of economic isolation and autonomy. But this class of merchants and industrial employers thereby became the ruling class. And, as happened wherever this class attained influence and power, it oppressed not only the wage-earning class, but also the petty bourgeoisie consisting of independent but destitute craftsmen and small tradesmen. This bourgeoisie, whose social position in Holland was based on wealth and money-making even more exclusively than elsewhere, allowed its economic and political interests to be represented by a special class recruited from its own ranks, the so-called regents. The town councils with their mayors, aldermen and councillors were made up of these regents, and they it was who really exercised the power of the ruling class. As their office was usually inherited from father to son, they possessed more authority from the very outset and enjoyed greater respect than the normal official class. The regents were, to begin with, mostly former merchants living on private means and exercising their office as a hobby, but their sons already studied at the universities of Leiden and Utrecht and prepared themselves, above all by the study of law, for the government posts which they were to take over from their fathers.

The nobles were not completely without influence, especially in the provinces of Gelderland and Overysel, but they were few in number and only a few families kept themselves isolated from urban patrician society. Most of them mixed with the rich bourgeoisie either by marrying into middle-class families or by participation in their business enterprises. The upper middle class itself

developed into a merchant aristocracy, and the regent families began to adopt a way of life which alienated them more and more from the wider circles of the middle class. They formed the transition from the middle classes to the nobility, and established a continuity in the social hierarchy almost unknown elsewhere. The tension between the military-minded monarchists assembled round the stadtholder, on the one side, and the peace party of the middle class and the antimonarchist aristocracy, on the other, was much greater than any differences between the middle classes and the nobility.[261] But the real power lay in the hands of the bourgeoisie and was not open to serious threat from any side.

In spite of the constant philandering of the possessing classes with aristocratic tendencies in matters of taste, the middle-class spirit also remained predominant in the world of art and imposed an essentially bourgeois stamp on Dutch painting in the midst of a general European court culture. At the moment when Holland attains its cultural prime, middle-class culture is already on the decline elsewhere;[262] in the rest of Europe the middle class does not develop another culture reminiscent of the Dutch until the eighteenth century. Dutch art owes its middle-class character, above all, to the fact that it ceases to be tied to the Church. The works of the Dutch painters are to be seen everywhere except in churches; and the devotional picture is nonexistent in the Protestant milieu. Bible stories retain only a relatively modest place alongside secular subjects and are usually treated as genre pictures. Representations of real everyday life are the most popular of all: the picture of manners, the portrait, the landscape, the still life, interiors and architectural views. Whilst the biblical and secular narrative picture remains the predominant form of art in the Catholic countries and in those ruled by absolute monarchs, in Holland subjects that had hitherto been treated as non-essential adjuncts now become absolutely independent. Motifs of everyday life, of landscape and still life form not merely the accessories of biblical, historical and mythological compositions, but acquire an autonomous value of their own; the artist no longer needs an excuse to portray them. And the more direct, obvious and commonplace a motif is, the greater

is its value for this art. The attitude to the world which is expressed here is without aloofness and based on everyday experience—it regards reality as something that has been conquered and is, therefore, familiar. It is as if this reality were being discovered, taken possession of and settled down in for the first time. What art is most interested in is the possessions of the individual, the family, the community and the nation: rooms and courtyards, the town and its environs, the local landscape and the liberated, regained countryside. But even more typical of Dutch art than the choice of subject-matter is the peculiar naturalism by which it is differentiated not only from the general European baroque, with its heroic attitudes, its austere and often rigid solemnity and its impetuous, exuberant sensualism, but also from all earlier styles based on fidelity to nature. For it is not merely the simple, pious, reverent objectivity of the representation, not merely the endeavour to depict life in its immediacy, in the familiar forms, which everyone can confirm for himself, but the personal experience implicit in its outlook, which gives this painting its special quality of truth. The new middle-class naturalism is a style which attempts not only to make spiritual things visible, but all visible things a spiritual experience. The intimate easel painting, in which this conception of art is embodied, became the characteristic form of the whole of modern middle-class art—no other is such an adequate expression of the bourgeois spirit with its untiring psychological inquisitiveness and its limitations at the same time. It is the result of restrictions connected with the small-scale size, on the one hand, and of the highest possible concentration of spiritual content, on the other. The middle class has no use for big decorations; court standards are out of the question as far as its private needs are concerned; official assignments are relatively rare and insignificant, compared with the exacting requirements of the great courts. The stadtholder residence, based on French models, never develops into a real cultural centre and is also much too small and poor to exert an influence on the development of art. Thus in Holland, painting, the most unassuming of the fine arts, and more especially the cabinet picture, its least pretentious form, becomes the predominant genre.

The fate of art in Holland is, therefore, decided not by the

Church, not by a monarch, not by a court society, but by a middle class which attains importance more by reason of the great number of its well-to-do members, than by the outstanding wealth of individuals. The private taste of the middle class has never before, not even in the Florence of the early Renaissance, let alone the Athens of the classical period, kept itself so free from all official and public influences, and replaced public by private commissions, so much as here. But even in Holland the demand is not wholly uniform, for beside private customers, official and semi-official employers, the communes, the corporations and civic associations, the orphanages, hospitals and almshouses, play a certain part, even though their artistic influence is comparatively unimportant. The style of the works intended for these buyers proves to be somewhat different from that of the ordinary middle-class painting, if only as a result of the more imposing size of the works commissioned. And although there is no use in Holland for art in the grand style, such as was sought after in France and Italy, even for official purposes, nevertheless, classical-humanistic taste, the tradition of which had never died out completely amongst certain circles in the land of Erasmus, has more influence in official art, in the architecture of the big public buildings, the pictures decorating the council chambers and banqueting-halls, the monuments which the Republic has erected to its deserving heroes, than in the art intended for private people. But even the private middle-class taste in art is by no means entirely uniform; the middle class belongs to different cultural strata of the population and makes different demands on art. The well-educated members of the class brought up on classical literature, who continue the tradition of humanism, favour Italianizing tendencies and develop close contacts with mannerism. In opposition to popular taste, they prefer representations of classical history and mythology, allegories and pastoral pieces, pleasant illustrations of biblical stories and elegant interiors, such as were produced by Cornelis van Poelenburgh, Nicolas Berchem, Samuel van Hoogstraten and Adriaen van der Werff. But not even the taste of the non-intellectual bourgeoisie is perfectly homogeneous. Terborch, Metsu and Netscher obviously work for the most distinguished and richest strata of the bourgeoisie, Pieter de Hooch and

Vermeer van Delft for a somewhat more unassuming circle, whereas Jan Steen and Nicolas Maes probably have customers in all classes of society.

The unpretentious naturalistic and the classical-humanistic taste are in a state of tension throughout the golden age of Dutch painting. The naturalistic tendency is incomparably more important as regards both the quality and the quantity of the works produced, but the classicistic tendency is preferred by the well-to-do and well-educated circles, and that alone secures greater esteem and a better income. The opposition in Holland between the middle sections of the bourgeoisie, with its more simple way of life and its religious outlook, and the more secular-minded circles, with their classical-humanistic approach, corresponds, as has been noted, to the antagonism between the Puritans and the Cavaliers in England;[263] in both countries the representatives of a simple, serious, practical way of life stand on one side and those of a refined epicureanism, often disguised as idealism, on the other. It must not be forgotten, however, that the Dutch culture of the seventeenth century, unlike the English culture of the Restoration, never entirely renounces its bourgeois character. Nevertheless, even in Holland a gradual approximation of middle-class taste to the more fastidious conception of art is to be observed; the process is in harmony with the whole tendency towards a more aristocratic mode of life which makes itself felt everywhere in the second half of the century. The fact that Rembrandt is passed over, when the decoration for the Town Hall in Amsterdam is commissioned, is symptomatic; there is a turning away not merely from Rembrandt but from naturalism as well,[264] and classicistic academicism with its professors and epigones is now triumphant even in Holland. The new un-democratic spirit is also expressed, for example, in the fact that, as Riegl has noted, the big group portraits representing complete Civil Guard groups come to an end, and portraits are made only of the officers of these groups.[265]

The question as to how far the different cultural strata in Holland were able to judge the value of their painters is one of the most difficult problems in the history of art. The feeling for artistic quality was certainly not always in accordance with the

general level of education, otherwise Vondel, the greatest Dutch poet, would hardly have placed a Flinck higher than a Rembrandt. Even at that time there were, of course, people who knew exactly how great a painter Rembrandt was, but they are no more to be identified with the humanistically educated literati than they are to be sought in the broad ranks of the middle class; they were probably, like Rembrandt's own friends, preachers, rabbis, doctors, artists, high officials, in a word, men from the most diverse circles of the cultured middle class, and, also like Rembrandt's friends, not very numerous. The taste of the middle and petty bourgeoisie, who formed the majority of the public interested in art, was by no means very developed, and recognized hardly any criterion of artistic quality other than resemblance. Incidentally, one must not assume that these people always bought pictures in accordance with their own taste; usually they were, no doubt, guided by what was popular in the higher circles of society, just as these circles again allowed themselves to be influenced by the artistic outlook of the intellectual élite with its classical-humanistic education. The demand from a naïve, unpretentious public was a great advantage for the artist, to start with, although later on it became just as great a danger. It allowed them to work freely, according to their own ideas, without having to take the wishes of individual customers into consideration; later on, however, this freedom led to disastrous over-production as a result of anarchic conditions on the market.

In the seventeenth century many people in Holland came into money that could not always be invested advantageously, owing to the over-abundance of capital, and was often not enough to enable them to make very substantial purchases. The buying of articles of furniture and decoration, especially pictures, became a popular form of investment in which even comparatively poor people could participate. They bought pictures, above all, because there was nothing else to buy, but also because other people, including better-placed people, bought pictures, because pictures looked well in the home and gave an impression of respectability and, finally, because it was possible to sell them again. Certainly, the least decisive reason why they bought them was to satisfy their thirst for beauty. It may well have often happened that

they kept the pictures, if they did not need the money invested, and that their children then had a genuine joy in the beauty of these pictures. Thus it probably followed that what was originally a modest property developed in the second and third generation into real art-collections, such as were to be found throughout the country and even in relatively unpretentious circles. In view of the increasing affluence of the population, there was perhaps in fact no single middle-class house without its paintings; but when it is said that in Holland everybody 'from the richest patrician to the poorest peasant' owned pictures, the reference to the 'poorest peasant' can hardly be accurate, and even if the richer peasant did buy pictures, he did so for a different purpose and he looked at the pictures with different eyes than did the 'richest patrician'.

John Evelyn, the art patron and diarist, reports in his memoirs on the lively trade in pictures, and even in good pictures, which he observed at the Rotterdam fair in 1641. There were, as he remarks, very many pictures and they were mostly very cheap. The buyers were largely petty bourgeois and peasants, and amongst the latter there are said to have been some who owned pictures worth two to three thousand pounds; though they sold their pictures again and at a good profit.[266] Under the influence of the boom, which was the result of the general wave of speculation on the art market, such a vast quantity of pictures came into existence in Holland after 1620 that, in spite of the great demand, there was a state of over-production which led to a very serious situation for the artists.[267] At the outset, however, painting must have guaranteed a good income, otherwise there is no explanation for the inundation of the profession. We know that, as early as the sixteenth century, the production was very great in Antwerp, which exported pictures on a considerable scale. There are said to have been three hundred masters busy with painting and the graphic arts around 1560, when the city had only 169 bakers and 78 butchers.[268] Mass production, therefore, does not begin for the first time in the seventeenth century, nor in the northern provinces; the only new feature here is that production is based in the main on the home market, and that a serious crisis arises in artistic life when the public is no longer able to accept the goods. At any rate, it happens for the first time

in the history of Western art that we are able to establish the existence of a surplus of artists and of a proletariat in the art world.[269] The dissolution of the guilds and the fact that artistic production ceases to be regulated by a court or by the state allow the boom on the art market to degenerate into a state of fierce competition, to which the most individual and most original talents fall victim. There were artists living in cramped circumstances in earlier times, but there were none in actual want. The financial troubles of the Rembrandts and the Hals are a concomitant of that economic freedom and anarchy in the realm of art, which now comes on the scene for the first time and still controls the art market today. Here are the beginnings, too, of the social uprooting of the artist and the uncertainty of his existence, which now seems to be superfluous in view of the unnecessary profusion of what he produces. The Dutch painters lived mostly in such miserable circumstances that many of the greatest of them were forced to turn to another source of income outside the artistic profession. Thus van Goyen traded in tulips, Hobbema was employed as a tax-collector, van de Velde was the proprietor of a linen business, Jan Steen and Aert van der Velde were innkeepers. The poverty of the painters seems indeed to have been the greater the more important they were. Rembrandt still had at least some days of prosperity, but Hals was never particularly popular and never realized the prices which were paid, for example, for the portraits of a van der Helst. Not only Rembrandt and Hals, but also Vermeer, the third leading painter in Holland, had to fight against material worries. And the other two greatest painters of the country, Pieter de Hooch and Jacob van Ruisdael, were also not very highly esteemed by their contemporaries and by no means among the artists leading a comfortable life.[270] This epic of Dutch painting is not complete unless one adds that Hobbema had to give up painting in the best years of his life.

The beginnings of the Dutch fine art trade go back to the fifteenth century, and are connected with the export of Dutch miniatures, Flemish gobelins and devotional pictures from Antwerp, Bruges, Ghent and Brussels to Paris.[271] But the fine art trade in the fifteenth and sixteeth centuries is still mostly in the hands of the artists themselves, who trade not only in their own

but also in works from extraneous sources. The booksellers and the publishers of engravings already trade in paintings from a very early date; they are soon joined by the dealers in second-hand goods and by jewellers as well as frame-makers and inn-keepers.[272] The restrictions which are imposed on the fine art trade by the painters' guilds in the fifteenth and sixteenth centuries show that the art market already has to contend with a surplus of goods and that there are too many 'art dealers'. Individual towns protect themselves against the import trade and unruly street hawking and only allow persons belonging to a painters' guild to sell pictures. But this measure does not differentiate between a painter and a dealer, and is not intended to limit the pursuit of the art trade to artists; it is merely directed to protecting the home market.[273] A painter spends many years as an apprentice; during this time he cannot earn money from his own work, since everything he paints belongs, according to guild regulations, to his master. Under these circumstances nothing is more obvious than to keep one's head above water by becoming an art dealer. To begin with, the artist buys and sells principally engravings, copies, work done by students, hence cheap goods. But the painters who become art dealers are not by any means all young and unable to earn their own living; of the older ones David Teniers the Younger and Cornelis de Vos are only the most celebrated. Engravers are often to be found as art dealers —Jeroome de Cock, Jan Hermensz de Muller, Geeraard de Jode are the best known names—the decidedly commercial nature of their products induces them instinctively to go in for the picture trade in addition to their own engravings. The development of the art trade into an independent business has a far-reaching influence on modern art life. It leads, above all, to the specialization of painters according to definite genres, since the art dealers ask them again and again for the kind of work that proves to be the most saleable. Thus an almost mechanical division of labour comes about in which one painter restricts himself to the representation of animals, another to the reproduction of landscape backgrounds. The fine art trade standardizes and stabilizes the market; it not only ties down art production to permanent types, but also regulates the otherwise chaotic trade. On the one hand,

it creates a regular demand, by often stepping into the breach when the private customer fails, and, on the other hand, it informs the artist about the wishes of the public in a much more comprehensive and speedy fashion than he would ever be in a position to do himself. It must be admitted, however, that this mediation of the fine art trade between production and consumption also leads to the artist becoming estranged from the public. People get used to buying what they find in stock at the art dealer's and begin to regard the work of art as just as impersonal a commodity as any other. For his part, the artist again becomes accustomed to working for unknown, imperso al customers, of whom he knows nothing except that they are on the lookout for historical pictures today, whereas yesterday they were still buying genre pictures. The fine art trade also involves the estrangement of the public from contemporary art. The dealers prefer to advertise the art of previous ages, for the simple reason that, as has been rightly said, the products of this art cannot multiply and, therefore, cannot depreciate—they are the object of the least risky speculation.[274] The art trade has a disastrous effect on production by the systematic whittling down of prices. The artist becomes more and more dependent on the art dealer for his daily bread, and the dealer finds it increasingly easy to dictate prices to him, the more the public accustoms itself to buying from the dealer rather than ordering direct from the artist. Finally, the art trade floods out the market with copies and forgeries and thereby reduces the value of the originals.

Prices on the art market in Holland were, generally speaking, very low; one could buy a painting for a mere two or three guilders. A good portrait cost sixty guilders, for example, when the price of an ox was ninety.[275] Jan Steen once painted three portraits for twenty-seven guilders.[276] At the height of his fame, Rembrandt received no more than 1,600 guilders for the 'Night Watch', and van Goyen obtained 600 guilders, the highest price of his life, for his view of the Hague. The case of Isaak van Ostade, who, in 1641, supplied an art dealer with thirteen pictures for twenty-seven guilders, shows the kind of starvation wages with which famous painters had to content themselves.[277] In relation to the often exaggeratedly high prices which were paid

for the works of artists who had visited Italy and worked in the Italianizing manner, pictures painted in the native naturalistic style were always very cheap. Frans Hals, van Goyen, Jacob van Ruisdael, Hobbema, Cuyp, Isaak van Ostade, de Hooch, never received high prices.[278] In countries with a courtly-aristocratic culture artists were better paid. In neighbouring Flanders, Rubens received much higher payments for his pictures than the most popular Dutch painters. He reckoned on a hundred guilders for a day's work in his best period,[279] and he obtained 14,000 francs for his 'Acteon', the highest price ever paid for a picture before the age of Louis XIV.[280] Under Louis XIV and Louis XV, the income, above all, of the court painters became stabilized and remained on a comparatively high level; thus Hyacinthe Rigaud, for example, earned on an average 30,000 francs per annum between 1690 and 1730—for the portrait of Louis XIV alone he received 40,000.[281] On the other hand, Rigaud was an exception even in France, where, incidentally, artists were never so prosperous as writers, who were often really pampered. It is a well-known fact that Boileau led the life of a grand seigneur in his house at Auteuil, and left a fortune in cash of 286,000 francs. As royal historiographer, Racine received a salary of 145,000 francs over a period of ten years; in the course of fifteen years, Molière earned 336,000 francs as theatrical director and actor, and a further 200,000 francs as a writer.[282] The difference between the income of a writer and that of an artist is still an expression of the old prejudice against manual labour and the higher valuation of people who have nothing to do with manual crafts. In France even court painters only held the rank of inferior court officials right up to the eighteenth century.[283] Cochin reports that the Duc d'Antin, the successor of Mansart as superintendent, was in the habit of treating the members of the Academy very arrogantly and calling them 'tu'.[284] A Le Brun was dealt with differently, of course, and, in any case, the treatment of artists varied very widely from one individual to another.

The relatively small respect that was paid to artists meant that both in France and the Netherlands the profession was taken up exclusively by members of the middle and lower sections of the middle class. Rubens was also an exception in this respect;

he was the son of a high state official, received the best schooling and ended his social education in the service of the court. Even before he had become the court painter of Archduke Albert, he was in the service of Vincenzo Gonzaga in Mantua, and he remained in close contact with court life and court diplomacy throughout his life. In addition to his brilliant social position, he acquired a princely fortune and ruled over the whole artistic life of his country like a monarch. His organizing abilities played just as great a part in all this as his artistic talent. Without such abilities, it would have been impossible for him to carry out the commissions which poured in on him, and which he always fulfilled to the last detail. He was able to cope with them only by applying the methods of industrial manufacture to the organization of artistic work, by the careful choice of expert collaborators and the rational employment of their time and talents. Compared with his manufacture-like routine, in which the work was strictly subdivided, the Dutch artists' workshops—even Rembrandt's workshop—seem quite patriarchal. It has rightly been pointed out that Rubens' method of working was first made possible by the classical interpretation of the process of artistic creation. The rational organization of artistic work, which is consistently applied for the first time in Raphael's studio, and which makes a fundamental distinction between the conception of the artistic idea and its execution, is based on the notion that the artistic value of a picture is already entirely contained in the cartoon, and that the transcription of the pictorial idea into the ultimate form is only of secondary importance.[285] This idealistic conception of art was still absolutely current in the theory and practice of the courtly and classicistic baroque, but it was so no longer in the naturalism of Dutch painting. Here such importance is attached to the manual execution, the pictorial handwriting, the stroke of the brush and every contact of the master's hand with the canvas, that the wish to maintain all this in its original purity imposes limitations on the division of labour from the very outset. Rubens adopts the classicistic conception of artistic creation in that period of his life in which he has the most demands to meet and has to leave the execution of his works mostly to his assistants. It does not find expression until

after the 'Elevation of the Cross' in Antwerp,[286] and disappears again in the last phase of his activity, from which once again more of his own personal work has come down to us.

Rembrandt reaches a stage of development corresponding to the style of Rubens' old age directly after his first period as a portrait painter. From that time onward painting is for him a form of direct personal communication—the ever renewed form of an 'impressionism' which makes reality the creation of the all-conquering, all-possessing eye. Riegl divides the history of art into two great periods: in the first, the primitive period, everything is object; in the second, the present, everything subject. According to this theory, the development between the age of classical antiquity and the baroque is nothing but the gradual transition from the first to the second period, with the Dutch painting of the seventeenth century as the most important turning point on the way to the present situation, in which all objects appear as mere impressions and experiences of the subjective consciousness.[287] The artistic radicalism which Rubens achieves at the end of his life did not prejudice his public reputation, whereas the same radicalism cost Rembrandt everything he had to lose. The decline begins after the completion of the 'Night Watch' in 1642, although the picture itself was not an absolute failure.[288] Between 1642 and 1656 Rembrandt is not yet out of work, but his connections with the rich bourgeoisie are beginning to loosen and break up. There is no noticeable decline in the number of his commissions until the fifties and it is only then that he becomes involved in serious financial difficulties.[289] Rembrandt was by no means merely the victim of his own unpractical nature and of the neglected state of his private affairs; his failure was rather the result of the gradual turning of the public to classicism,[290] and of his own withdrawal from the solemnities of the baroque, to which he had been by no means averse in his younger days.[291] The rejection of his 'Claudius Civilis', painted for the Amsterdam Town Hall, is the first sign of the modern crisis in art. Rembrandt was its first great victim. No earlier age could have moulded him into what he became, but no other would have allowed him to go under in this way. In a conservative courtly culture an artist of his kind would perhaps never

have made a name for himself at all, but once recognized, he would probably have been able to hold his own better than in liberal middle-class Holland where he was allowed to develop in freedom, but which broke him when he refused to submit any longer. The spiritual existence of the artist is always in danger; neither an authoritarian nor a liberal order of society is entirely free from peril for him; the one gives him less freedom, the other less security. There are artists who only feel safe when they are free, but there are also such as can breathe freely only when they are secure. The seventeenth century was, at any rate, one of the periods farthest removed from the ideal of a synthesis of freedom and security.

NOTES

RENAISSANCE, MANNERISM, BAROQUE

1. Cf. J. HUIZINGA: 'Das Problem der Renaissance'. In *Wege der Kulturgeschichte*, 1930, pp. 134 ff.—G. M. TREVELYAN: *English Social History*, 1944, p. 97.

2. JULES MICHELET: *Histoirè de la France*, VII, 1855, p. 6.

3. Cf. ADOLF PHILIPPI: *Der Begriff der Renaissance*, 1912, p. 111.

4. ERNST TROELTSCH: 'Renaissance und Reformation'. *Hist. Zeitschrift*, 1913, vol. 110, p. 530.

5. ERNST WALSER: 'Studien zur Weltanschauung der Renaissance'. In *Gesammelte Studien zur Geistesgeschichte der Renaissance*, 1932, p. 102.

6. Cf. KARL BORINSKI: 'Der Streit um die Renaissance und die Entstehungsgeschichte der hist. Beziehungsbegriffe Renaissance und Mittelalter', *Sitzungsberichte der Bayr. Akad. d. Wiss.*, 1919, pp. 1 ff.

7. KARL BRANDI: 'Die Renaissance'. In *Propylaeen-Weltgeschichte*, IV, 1932, p. 160.

8. WERNER KAEGI: 'Ueber die Renaissanceforschung Ernst Walsers'. In ERNST WALSER'S *Gesammelte Studien*, 1932, p. xxviii.

9. Thus, for example, in GEORGES RENARD: *Histoire du travail à Florence*, II, 1914, p. 219.

10 E. WALSER, op. cit., p. 118.

11. On Nietzsche's relationship to Heinse vide WALTER BRECHT: *Heinse und der aesthetische Immoralismus*, 1911, p. 62.

12. W. KAEGI, loc. cit., p. xli.

13. J. HUIZINGA: *The Waning of the Middlé Ages*, 1924, p. 298.

14. DAGOBERT FREY: *Gotik und Renaissance*, 1929, p. 38.

15. Cf. for the following D. FREY, op. cit., p. 194.

16. J. C. SCALIGER: *Poetices libri septem.*, 1591, VI, 21.

17. DAGOBERT FREY, who characterizes the difference between the medieval and the Renaissance conception of art by the distinction between the successive and the simultaneous interpretation of the pictorial space, obviously relies on ERWIN PANOFSKY's differentiation of an 'aggregate' and a 'systematic' space (*Die Perspektive als 'symbolische Form'*, 1927). Panofsky's thesis again assumes WICKHOFF's theory of the 'continuous' and the 'distinguishing' mode of representation, in which Wickhoff himself may have been stimulated by LESSING's idea of the 'pregnant moment'.

18. SCALIGER, loc. cit.

NOTES

19. JAKOB STRIEDER: 'Werden und Wachsen des europ. Fruehkapitalismus'. In *Propylaeen-Weltgeschichte*, IV, 1932, p. 8.

20. JAKOB STRIEDER: *Jacob Fugger*, 1926, pp. 7–8.

21. WERNER WEISBACH: 'Renaissance als Stilbegriff', *Hist. Zeitschrift*, 1919, vol. 120, p. 262.

22. HENRY THODE: *Franz von Assisi und die Anfaenge der Kunst der Renaissance*, 1885.—The same, 'Die Renaissance', *Bayreuther Blaetter*, 1899.—ÉMILE GEBHARDT: *Origines de la Renaissance en Italie*, 1879.—The same, *Italie mystique*, 1890.—PAUL SABATIER: *Vie de Saint François d'Assise*, 1893.

23. KONRAD BURDACH: *Reformation Renaissance Humanismus*, 1918, p. 138.

24. CARL NEUMANN: 'Byzantinische Kultur und Renaissancekultur', *Hist. Zeitschr.*, 1903, vol. 91, pp. 228, 231, 215.

25. LOUIS COURAJOD: *Leçons professées à l'École du Louvre*, 1901, II, p. 142.

26. JAKOB STRIEDER: *Studien zur Gesch. der kapit. Organisationsformen*, 1914, p. 57.

27. JULIEN LUCHAIRE: *Les Sociétés italiennes du XIIIᵉ au XVᵉ siècle*, 1933, p. 92.

28. MAX WEBER: *Wirtschaft und Gesellschaft*, 1922, p. 573.

29. ROBERT DAVIDSOHN: *Forschungen zur Gesch. von Florenz*, IV, 1908, p. 268.

30. MAX WEBER, op. cit., p. 562.

31. Ibid., p. 565.

32. ALFRED DOREN: *Italienische Wirtschaftsgeschichte*, I, 1934, p. 358.—Cf. R. DAVIDSOHN: *Gesch. von Florenz*, IV, 2, 1925, pp. 1–2.

33. ALFRED DOREN: *Studien zu der Florentiner Wirtschaftsgesch. I. Die Florent. Wollentuchindustrie*, 1901, p. 399.

34. ALFRED DOREN: *Studien zu der Florentiner Wirtschaftsgesch. II. Das Florent. Zunftwesen*, 1908, p. 752.

35. ALFRED DOREN: *Die Florent. Wollentuchindustrie*, p. 458.

36. R. DAVIDSOHN: *Gesch. von Florenz*, IV, 2, p. 5.

37. Cf. GEORGES RENARD, op. cit., II, pp. 132–3.

38. A. DOREN: *Das Florent. Zunftwesen*, p. 726.

39. R. DAVIDSOHN: *Gesch. von Florenz*, IV, 2, pp. 6–7.

40. FERDINAND SCHEVILL: *History of Florence*, p. 362.

41. A. DOREN: *Die Florent. Wollentuchindustrie*, p. 413.

42. WERNER SOMBART: *Der moderne Kapitalismus*, I, 1902, pp. 174 ff.—GEORG VON BELOW: 'Die Entstehung des mod. Kapitalismus', *Hist. Zeitschr.*, 1903, vol. 91, pp. 453–4.

43. WERNER SOMBART: *Der Bourgeois*, 1913.

44. Cf. JAKOB BURCKHARDT: *Die Kultur der Renaissance*, 1908, 10th edit., I, pp. 26, 51.

44a. MAX DVOŘÁK: 'Die Illuminatoren des Johann Neumarkt', *Jahrb.*

d. Kunsthist. Samml. d. Allerhoechsten Kaiserhauses, 1901, XXII, pp. 115 ff.

45. Cf. for the following: GEORG GOMBOSI: *Spinello Aretino*, 1926, pp. 7–11.

46. Ibid., pp. 12–14.

47. BERNARD BERENSON: *The Italian Painters of the Renaissance*, 1930, p. 76.—Cf. ROBERTO SALVINI: 'Zur florent. Malerei des Trecento', *Kritische Berichte zur kunstgeschichtl. Literatur*, VI, 1937.

48. ADOLFO GASPARY: *Storia della letteratura ital.*, I, 1887, p. 97.

49. WERNER WEISBACH: *Francesco Pesellino und die Romantik der Renaissance*, 1901, p. 13.

50. JULIUS V. SCHLOSSER: 'Ein veronesisches Bilderbuch und die hoefische Kunst des XIV. Jahrhunderts', *Jahrb. d. Kunsthist. Samml. d. Allerh. Kaiserhauses*, 1895, vol. XVI, pp. 173 ff.

51. A. GASPARY, op. cit., I, pp. 108–9.

52. WILHELM PINDER: *Das Problem der Generation*, 1926, p. 12 and passim.

53. WILHELM V. BODE: *Die Kunst der Fruehrenaissance in Italien*, 1923, p. 80.

54. RICHARD HAMANN: *Die Fruehrenaissance der ital. Mal.*, 1909, pp. 2–3, 16–17.—The same, *Geschichte der Kunst*, 1932, p. 417.

55. FRIEDRICH ANTAL: 'Studien zur Gotik im Quattrocento', *Jahrb. d. Preuss. Kunstsamml.*, 1925, vol. 46, pp. 18 ff.

56. Cf. HENRI PIRENNE: 'Les périodes de l'histoire sociale du capitalisme', *Bulletins de l'Académie Royale de Belgique*, 1914, pp. 259–60, 290 and passim.

57. A. DOREN: *Die Florent. Wollentuchind*, p. 438.

58. Ibid., p. 428.

59. Cf. MARTIN WACKERNAGEL: *Der Lebensraum des Kuenstlers in der florent. Renaissance*, 1938, p. 214.

60. A. DOREN: *Ital. Wirtschaftsgesch.*, I, pp. 561–2.

61. A. DOREN: *Das Florent. Zunftwesen*, p. 706.

62. Ibid., pp. 709–10.

63. Cf. for the following: M. WACKERNAG EL, 'op. cit., p. 234

64. Cf. ibid., pp. 9–10.

65. Ibid., p. 291.

66. Ibid., pp. 289–90.

67. ROBERT SAITSCHICK: *Menschen und Kunst der ital. Renaiss.*, 1903, p. 188.

68. Quoted from ALFRED V. REUMONT: *Lorenzo de' Medici*, 1883, II, p. 121.

69. ERNST CASSIRER: *Individualismus und Kosmos in der Philos. der Renaiss.*, 1927, pp. 177–8.

70. RICHARD HOENIGSWALD: *Denker der ital. Renaiss.*, 1938, p. 25.

71. Cf. ANTHONY BLUNT: *Artistic Theory in Italy*, 1940, p. 21.

72. WILHELM V. BODE: *Bertoldo und Lorenzo di Medici*, 1925, p. 14.

NOTES

73. Wilhelm v. Bode: *Die Kunst der Fruehrenaiss.*, p. 81.

74. Jakob Burckhardt: *Beitraege zur Kunstgesch. Italiens*, 1911, 2nd edit., p. 397.

75. Lothar Brieger: *Die grossen Kunstsammler*, 1931, p. 62.

76. J. v. Schlosser, op. cit., p. 194.

77. Georg Voigt: *Die Wiederbelebung des classischen Altertums*, 1893, 3rd edit., I, p. 445.

78. J. Burckhardt: *Die Kultur der Renaiss.*, I, p. 53.

79. M. Wackernagel, op. cit., p. 307.

80. Ibid., p. 306.

81. Ibid., p. 307.

82. M. Wackernagel: 'Aus dem florent. Kunstleben der Renaissance-zeit'. In *Vier Aufsaetze ueber geschichtl. u. gegenwaertige Faktoren des Kunstlebens*, 1936, p. 13.

83. M. Wackernagel: 'Das ital. Kunstleben u. die Kuenstlerwerkstatt im Zeitalter der Renaissance'. In *Wissen und Leben.*, 1918, No. 14, p. 39.

84. Thieme-Becker: *Allg. Lexikon der bild. Kuenstler*, III, 1909.

85. Giov. Batt. Armenini: *De' veri precetti della pittura*, 1586.

86. Cf. Albert Dresdner: *Die Entstehung der Kunstkritik*, 1915, pp. 86-7.

87. Kenneth Clark: *Leonardo da Vinci*, 1939, pp. 11-12.

88. Cf. for the following: M. Wackernagel: *Der Lebensraum des Kuenstlers*, pp. 316 ff.

89. A. Dresdner, op. cit., p. 94.

90. Gaye: *Carteggio inedito d'artisti dei sec. XIV–XVI*, 1839–40, I, p. 115.

91. M. J. Jerrold: *Italy in the Renaissance*, 1927, p. 35.

92. H. Lerner-Lehmkuhl: *Zur Struktur u. Gesch. des florent. Kunstmarktes im XV. Jahrhundert*, 1936, pp. 28-9.

93. Ibid., pp. 38-9.

94. Ibid., p. 50.

95. M. Wackernagel: *Der Lebensraum des Kuenstlers*, p. 355.

96. R. Saitschick, op. cit., p. 199.

97. Paul Drey: *Die wirtschaftlichen Grundlagen der Malkunst*, 1910, p. 46.

98. Ibid., pp. 20-1.

99. H. Lerner-Lehmkuhl, op. cit., p. 34.

100. R. Saitschick, op. cit., p. 197.

101. H. Lerner-Lehmkuhl, op. cit., p. 54.

102. A. Dresdner, op. cit., pp. 77-9.

103. Ibid., p. 95.

104. Joseph Meder: *Die Handzeichnung. Ihre Technik und Entwicklung*, 1919, p. 214.

105. Leonardo Olschki: *Gesch. der neusprachlichen wiss. Lit.*, I, 1919, pp. 107-8.

NOTES

106. A DRESDNER, op. cit., p. 72.

107. J. P. RICHTER: *The Literary Work of Leonardo da Vinci*, 1883, I, No. 653.

108. R. SAITSCHICK, op. cit., pp. 185–6.

109. Cf. Bandello's description of Leonardo's discontinuous method of working on 'The Last Supper'; quoted by KENNETH CLARK, op. cit., pp. 92–3.

110. EDGAR ZILSEL: *Die Entstehung des Geniebegriffes*, 1926, p. 109.

111. Cf. DIETRICH SCHAEFER: *Weltgesch. der Neuzeit*, 1920, 9th edit., pp. 13–14.—J. HUIZINGA: *Wege der Kulturgeschichte*, 1930, p. 130.

112. JULIUS SCHLOSSER: *Die Kunstliteratur*, 1924, p. 139.

113. JOSEPH MEDER, op. cit., pp. 169–70.

114. KARL BORINSKI, op. cit., p. 21.

115. ERNST WALSER: *Ges. Schriften*, pp. 104–5.

116. K. BORINSKI, op. cit., pp. 32–3.

117. PHILIPPE MONNIER: *Le Quattrocento*, 1901, II, p. 229.

118. WILHELM DILTHEY: *Weltanschauung u. Analyse des Menschen seit Renaiss. u. Reformation. Ges. Schriften*, II, 1914, pp. 343 ff.

119. ADOLF HILDEBRAND: *Das Problem der Form i.d.bild. Kunst*, 1893. —B. BERENSON, op. cit.

120. Cf. for the following: ERWIN PANOFSKY: *Die Perspektive als 'symbolische Form'*, Vortraege der Bibl. Warburg, 1927, p. 270.

121. Ibid., p. 260.

122. Cf. JACQUES MESNIL: *Die Kunstlehre der Fruehrenaissance im Werke Masaccios*, Vortraege der Bibl. Warburg, 1928, p. 127.

123. The speed of the execution is also praised in ARETINO'S letters to Tintoretto (1545–6).

124. E. ZILSEL, op. cit., pp. 112–13.

125. E. WALSER, op. cit., p. 105.

126. Cf. J. HUIZINGA: *Erasmus*, 1924, p. 123.—KARL BUECHER: 'Die Anfaenge des Zeitungswesens'. In *Die Entstehung der Volkswirtschaft*, 1919, 12th edit., I, p. 233.

127. HANS BARON: 'Franciscan Poverty and Civic Wealth as Factors in the Rise of Humanistic Thought', *Speculum*, XIII, 1938, pp. 12, 18 ff. Quoted by CH. E. TRINKAUS: *Adversity's Noblemen*, 1940, pp. 16–17.

128. ALFRED V. MARTIN: *Sociology of the Renaissance*, 1944, pp. 53 ff.

129. JULIEN BENDA: *La Trahison des clercs*, 1927.

130. PH. MONNIER, op. cit., I, p. 334.

131. Cf. for the following: CASIMIR V. CHLEDOWSKI: *Rom. Die Menschen der Renaissance*, 1922, pp. 350–2.

132. HERMANN DOLLMAYR: 'Raffaels Werkstaette', *Jahrb. d. Kunsthist. Samml. d. Allerh. Kaiserhauses*, 1895, XVI, p. 233.

133. L. B. ALBERTI: *De re aedificatoria*, 1485, VI, 2.

134. ED. MUELLER: *Gesch. der Theorie der Kunst bei den Alten*, I, 1834, p. 100.

135. L. B. ALBERTI: *Della pittura*, II.

213

NOTES

136. BALDASSARE CASTIGLIONE: *Il Cortegiano*, II, 23–8.
137. Cf. HEINRICH WOELFFLIN: *Die klassische Kunst*, 1904, 3rd edit., pp. 223–4.
138. BELLORI: *Vita dei pittori*, etc., 1672.—Cf. WERNER WEISBACH: 'Der Manierismus', *Zeitschr. f. bild. Kunst*, 1918–19, vol. 54, pp. 162–3.
139. R. BORGHINI: *Il Riposo*, 1584.—Cf. A. BLUNT, op. cit., p. 154.
140. WILHELM PINDER: 'Zur Physiognomik des Manierismus'. In *Die Wissenschaft am Scheidewege*, Ludwig-Klages-Festschrift, 1932, p. 149.
141. MAX DVOŘÁK: 'Ueber Greco und den Manierismus'. In *Kunstgeschichte als Geistesgeschichte*, 1924, p. 271.
142. MAX DVOŘÁK: 'Pieter Bruegel der Aeltere', ibid., p. 222.
143. W. PINDER: *Das Problem der Generation*, p. 140.—The same, *Die deutsche Plastik vom ausgehenden Mittelalter bis zum Ende der Renaissance*, 1928, II, p. 252.
144. This occurs, above all, in W. WEISBACH: 'Der Manierismus', p. 162, and MARGARETE HOERNER: 'Der Manierismus als kuenstlerische Anschauungsform', *Zeitschr.f.Aesth.u.allg.Kunstwiss.*, vol. 22, 1926, p. 200.
145. ERNEST LAVISSE: *Histoire de France*, V, 1, 1903, p. 208.
146. LUDWIG PFANDL: *Spanische Kultur und Sitte des XVI. u. XVII. Jahrhunderts*, 1924, p. 5.
147. L. BRIEGER, op. cit., pp. 109–10.
148. H. A. L. FISHER: *A History of Europe*, 1936, p. 525.
149. H. DOLLMAYR, loc. cit., p. 363.
150. Cf. BENEDETTO CROCE: *La Spagna nella vita ital. del Rinascimento*, 1917, p. 241.
151. RICHARD EHRENBERG: *Das Zeitalter der Fugger*, 1896, I, p. 415.
152. FRANZ OPPENHEIMER: *The State*, 1923, pp. 244–5.
153. Cf. W. CUNNINGHAM: *Western Civilization in its Economic Aspects. Med. and Mod. Times*, 1900, p. 174.
154. R. EHRENBERG, op. cit., II, p. 320.
155. HENRI SÉE: *Les Origines du capitalisme moderne*, 1926, pp. 38–9.
156. F. v. BEZOLD: 'Staat u. Gesellschaft des Reformationszeitalters'. In *Staat u. Gesellschaft der neuern Zeit. Die Kultur der Gegenwart*, II, 5/1, 1908, p. 91.
157. E. BELFORT BAX: *The Social Side of the German Reformation, II. The Peasant War in Germany 1525–6*, 1899, pp. 275 ff.
158. FRIEDRICH ENGELS: *Der deutsche Bauernkrieg*, passim.
159. WALTER FRIEDLAENDER: 'Die Entstehung des antiklassischen Stils in der ital. Mal. um 1520', *Repertorium f. Kunstwiss.*, vol. 46, 1925, p. 58.
160. GEORG SIMMEL: 'Michelangelo'. In *Philosophische Kultur*, 1919, 2nd edit., p. 159.
161. Cf. NIKOLAUS PEVSNER: 'Gegenreformation und Manierismus'. *Repertorium f. Kunstwiss.*, vol. 46, 1925, p. 248.
162. MACHIAVELLI: *Il Principe*, cap. XVIII.
163. Cf. PASQUALE VILLARI: *Machiavelli e i suoi tempi*, III, 1914, p. 374.

164. ALBERT EHRHARD: 'Kathol. Christentum u. Kirche Westeuropas in der Neuzeit'. In *Geschichte der christl. Relig.* Kultur der Gegenwart, 1909, 2nd edit., p. 313.

165. GIOV. PAOLO LOMAZZO: *Idea del tempio della pittura*, 1590, cap. VIII.

166. CHARLES DEJOB: *De l'influence du Concile de Trente*, 1884, p. 263.

167. R. V. LAURENCE: 'The Church and the Reformation', *Cambridge Mod. Hist.*, II, 1903, p. 685.

168. ÉMILE MÂLE: *L'Art relig. après le Concile de Trente*, 1932, p. 2.

169. JULIUS SCHLOSSER: *Die Kunstliteratur*, p. 383.

170. EUGÈNE MUENTZ: 'Le Protestantisme et l'art', *Revue des Revues*, 1900, March 1, pp. 481–2.

171. Ibid., p. 486.

172. GUSTAVE GRUYER: *Les Illustrations des écrits de Jérôme Savonarola publiés en Italie au XV^e et au XVI^e siècles et les paroles du Savonarola sur l'art*, 1879.—JOSEF SCHNITZER: *Savonarola*, 1924, II, pp. 809 ff.

173. WERNER WEISBACH: *Der Barock als Kunst der Gegenreformation*, 1921.—N. PEVSNER, loc. cit.

174. FRITZ GOLDSCHMIDT: *Pontormo, Rosso und Bronzino*, 1911, p. 13.

175. According to a letter of the painter Giulio Clovio. Cf. H. KEHRER in *Kunstchronik*, vol. 34, 1923, p. 784.

176. E. PANOFSKY: *Idea*, 1924, p. 45.

177. GIOV. PAOLO LOMAZZO: *Trattato dell'arte della pittura, scultura et architettura*, 1584.—*Idea del tempio della pitt*, 1590.

178. FEDERIGO ZUCCARI: *L'Idea de' pittori scultori e architetti*, 1607.

179. E. PANOFSKY: *Idea*, p. 49.

180. GIORDANO BRUNO: *Eroici furori. I. Opere italiane*, edited by Paolo de Lagarde, 1888, p. 625.

181. NIKOLAUS PEVSNER: *Academies of Art*, 1940, p. 13.

182. Ibid., pp. 47–8.

183. Cf. A. DRESDNER, op. cit., p. 96.

184. N. PEVSNER: *Academies of Art*, p. 66.

185. J. SCHLOSSER: *Die Kunstliteratur*, p. 338.—A. DRESDNER, op. cit., p. 98.

186. OSWALD SPENGLER: *Der Untergang des Abendlandes*, I, 1918, pp. 262–3.

187. POMPONIUS GAURICUS: *De scultura*, 1504. Quoted by PANOFSKY: *Die Perspektive*, etc., p. 280.

188. W. PINDER: 'Zur Physiognòmik des Manierismus'.

189. Cf. E. v. BERCKEN-A. L. MAYER: *Tintoretto*, 1923, I, p. 7.

190. L. PFANDL, op. cit., p. 137.

191. O. GRAUTOFF: 'Spanien'. In *Barockmalerei i. d. roman. Laendern.* Handbuch der Kunstwiss., 1928, p. 223.

192. GUSTAV GLUECK: 'Bruegel und der Ursprung seiner Kunst'. In *Aus drei Jahrhunderten europaeischer Malerei*, 1933, p. 154.

193. Ibid., p. 163.

194. Cf. CH. DE TOLNAI: *P. Bruegel l'Ancien*, 1935, p. 42.

195. MAX DVOŘÁK and WILHELM PINDER have referred to the manneristic character of the works of Shakespeare and Cervantes without entering into an analysis, however.

196. J. F. KELLY: *Cervantes and Shakespeare*, 1916, p. 20.

197. MIGUEL DE UNAMUNO: *Vida de Don Quijote y Sancho*, 1914.

198. W. P. KER: *Collected Essays*, 1925, II, p. 38.

199. W. CUNNINGHAM: *The Growth of English Industry and Commerce in Modern Times: The Mercantile System*, 1921, p. 98.

200. E. M. W. TILLYARD: *The Elizabethan World Picture*, 1943, p. 12.

201. T. A. JACKSON: 'Marx and Shakespeare', *International Literature*, 1936, No. 2, p. 91.

202. Cf. A. A. SMIRNOV: *Shakespeare. A Marxist Interpretation*. Critics Group Series, 1937, pp. 59–60.

203. SERGEI DINAMOV: 'King Lear'. *International Literature*, 1935, No. 6, p. 61.

204. Cf. WYNDHAM LEWIS: *The Lion and the Fox*, 1927, p. 237.

205. MAX J. WOLFF: *Shakespeare*, 1908, II, pp. 56–8.

206. Cf. JOHN PALMER: *Political Characters of Shakespeare*, 1945, p. viii.

207. PHOEBE SHEAVYN: *The Literary Profession in the Elizabethan Age*, 1909, p. 160.

208. DAVID DAICHES: *Literature and Society*, 1938, p. 90.

209. JOHN RICHARD GREEN: *A Short History of the English People*, 1936, p. 400.

210. E. K. CHAMBERS: *The Elizabethan Stage*, 1923.

211. C. J. SISSON: 'The Theatres and Companies'. In *A Companion to Shakespeare Studies*, edited by H. Granville-Barker and G. B. Harrison, 1944, p. 11.

212. PH. SHEAVYN, op. cit., pp. 10–12, 21–2, 29.

213. ALFRED HARBAGE: *Shakespeare's Audience*, 1941, p. 136.

214. J. DOVER WILSON: *The Essential Shakespeare*, 1943, p. 30.

215. A. HARBAGE, op. cit., p. 90.

216. C. J. SISSON, loc. cit., p. 39.

217. H. J. C. GRIERSON: *Cross Currents in English Lit. of the 17th Cent.*, 1929, p. 173.—A. C. BRADLEY: *Shakespeare's Theatre and Audience*, 1909, p. 364.

218. Cf. ROBERT BRIDGES: 'On the Influence of the Audience'. In *The Works of Shakespeare*. Shakespeare Head Press, vol. X, 1907.

219. L. L. SCHUECKING: *Die Charakterprobleme bei Shakespeare*, 1932, 3rd edit., p. 13.

220. Cf. ALLARDYCE NICOLL: *British Drama*, 1945, 3rd edit., p. 42.

221. Cf. HENNIG BRINKMANN: *Anfaenge des modernen Dramas in Deutschland*, 1933, p. 24.

222. Cf. L. L. SCHUECKING, op. cit., passim.—E. E. STOLL: *Art and Artifice in Shakespeare*, 1934.

NOTES

223. OSKAR WALZEL: 'Shakespeares dramatische Baukunst', *Jahrbuch der Deutschen Shakespeare-Gesellschaft*, vol. 52, 1916.—L. L. SCHUECKING: *The Baroque Character of the Elizabethan Hero.* The Annual Shakespeare Lecture, 1938.—WILHELM MICHELS: 'Barockstil in Shakespeare und Calderon', *Revue Hispanique*, 1929, LXXV, pp. 370–458.

224. Cf. FRANCESCO MILIZIA: *Dizionario delle belle arti del disegno*, 1797.

225. BENEDETTO CROCE: *Storia della età barocca in Italia*, 1929, p. 23.

226. HEINRICH WOELFFLIN: *Kunstgeschichtliche Grunbegriffe*, 1929, 7th edit., pp. 23–4.

227. Ibid., p. 136.

228. W. DILTHEY: *Gcs. Schriften.*, II, 1914, p. 320.

229. E. MÂLE, op. cit., p. 6.

230. ALBERT ÉHRHARD, op. cit., p. 356.

231. EBERHARD GOTHEIN: 'Staat u. Gesellschaft des Zeitalters der Gegenreformation', *Kultur der Gegenwart*, II, 5/1, 1908, p. 200.

232. REINHOLD KOSER: 'Staat u. Gesellschaft zur Hoehezeit des Absolutismus', *Kultur der Gegenwart*, II, 5/1, 1908, p. 255.

233. Ibid., p. 242.

234. E. LAVISSE, op. cit., VII, 1, 1905, p. 379.

235. WALTER PLATZHOFF: 'Das Zeitalter Ludwigs XIV', *Propylaeen-Weltgesch.*, VI, 1931, p. 8.

236. F. FUNCK-BRENTANO: *La Cour du Roi Soleil*, 1937, pp. 142–3.

237. Cf. for the following: HENRY LEMMONIER: *L'Art franç. au temps de Richelieu at Mazarin*, 1893, passim, especially p. 28.

238. Ibid., p. 38.

239. *La Gloire de Val-de-Grâce*, V, 85–6.

240. RENÉ BRAY: *La Formation de la doctrine classique en France*, 1927, p. 285.

241. E. LAVISSE, op. cit., VII, 2, p. 82.

242. Cf. HANS ROSE: *Spaetbarock*, 1922, p. 11.

243. Cf. HENRYK GROSSMANN: 'Mechanistische Philosophie und Manufaktur', *Zeitschr. f. Sozialforschung*, 1935, IV, 2, passim, especially pp. 191–2.

244. A. DRESDNER, op. cit., pp. 104–5.

245. ANDRÉ FONTAINE: *Les Doctrines d'art en France*, 1909, p. 56.

246. A. DRESDNER, op. cit., pp. 121 ff.

247. E. LAVISSE, op. cit., VIII, 1, 1908, p. 422.

248. JOSEPH AYNARD: *La Bourgeoisie française*, 1934, p. 255.

249. WERNER WEISBACH: *Franzoesische Malerei des XVII. Jahrhunderts im Rahmen von Kultur und Gesellschaft*, 1932, p. 140.

250. H. LEMONNIER, op. cit., p. 104.—W. WEISBACH: *Franz. Mal.*, p. 95.

251. KARL VOSSLER: *Frankreichs Kultur im Spiegel seiner Sprachentwicklung*, 1921, p. 366.

252. BÉDIER-HAZARD: *Hist. de la litt. franç.*, I, 1923, p. 232.

253. VIKTOR KLEMPERER: 'Zur franzoesischen Klassik', *Oskar Walzel-Festschrift*, 1924, p. 129.

254. ROGER PICARD: *Les Salons littéraires et la société française*, 1943, p. 32.

255. HENRI PIRENNE: *Histoire de Belgique*, IV, 1911, pp. 437–8.

256. P. J. BLOK: *Geschichte der Niederlande*, IV, 1910, p. 7.

257. Cf. for the following: J. HUIZINGA: *Hollaendische Kultur des XVII. Jahrhunderts*, 1933, pp. 11–14.—G. J. RENIER: *The Dutch Nation*, 1941, pp. 11 ff.

258. G. J. RENIER, op. cit., p. 32.

259. Cf. FRANZ MEHRING: *Zur Literaturgeschichte von Calderon bis Heine*, 1929, p. 111.

260. J. HUIZINGA: *Hollaendische Kultur*, p. 13.

261. KURT KASER: *Gesch. Europas im Zeitalter des Absolutismus*. L. M. Hartmann-Weltgesch, VI, 2, 1923, pp. 59, 61.

262. F. v. BEZOLD: *Staat u. Ges. d. Ref.*, p. 92.

263. J. HUIZINGA: *Hollaendische Kultur*, pp. 28–9.

264. E. SCHMIDT-DEGENER: 'Rembrandt und der holl. Barock', *Studien der Bibliothek Warburg*, 1928, IX, pp. 35–6.

265. ALOIS RIEGL: 'Das hollaendische Gruppenportraet', *Jahrb. d. Kunsthist. Samml. d. Allerh. Kaiserhauses*, 1902, vol. 23, p. 234.

266. JOHN EVELYN: *Memoirs*, 1818, p. 13.

267. W. MARTIN: 'The Life of a Dutch Artist. How the Painter sold his Work', *The Burlington Magazine*, 1907, XI, p. 369.

268. HANNS FLOERKE: *Studien zur niederlaendischen Kunst- u. Kulturgesch.*, 1905, p. 154.

269. Cf. N. PEVSNER: *Academies of Art*, p. 135.

270. W. v. BODE: *Die Meister der holl. u. vlaem. Malerschulen*, 1919, pp. 80, 174.

271. H. FLOERKE, op. cit., pp. 74–5.

272. Ibid., pp. 92–4.

273. Cf. for the following: H. FLOERKE, op. cit., pp. 89–90.

274. Ibid., p. 120.

275. N. S. TRIVAS: *Frans Hals*, 1941, p. 7.

276. W. MARTIN, loc. cit., p. 369.

277. ADOLF ROSENBERG: *Adriaen und Isack van Ostade*, 1900, p. 100.

278. H. FLOERKE, op. cit., p. 180.

279. Ibid., p. 54.

280. G. D'AVENEL: *Les Revenus d'un intellectuel de 1200 à 1913*, 1922, p. 231.

281. Ibid., p. 237.

282. Ibid., pp. 293, 300, 341.

283. PAUL DREY: *Die wirtsch. Grundlagen der Malkunst*, 1900, p. 50.

284. A. DRESDNER, op. cit., p. 309.

NOTES

285. RUDOLF OLDENBOURG: *P. P. Rubens*, 1922, p. 116.
286. Ibid., p. 118.
287. ALOIS RIEGL, op. cit., p. 277.
288. CARL NEUMANN: *Rembrandt*, 1902, p. 426.
289. MAX J. FRIEDLAENDER: *Die niederlaend. Mal. des XVII. Jahrhunderts*, 1923, p. 32.
290. WILLI DROST: *Barockmalerei in den german. Laendern.* Handbuch der Kunstwiss., 1926, p. 171.
291. F. SCHMIDT-DEGENER, op. cit., p. 27.

INDEX

Aachen, Hans von, 95
Absolute monarchy, 173
 and the social classes, 174
Absolutism, 99
 and classicism, 177
Academicism, 120 f., 182 f.
Académie de Rome, 180
Académie Royale de Peinture et de
 Sculpture, 179 f.
Academies of art, 39, 118 ff., 179–83,
 185
Accademia del Disegno, 118, 121
Accademia di San Luca, 119
Aestheticism, 5, 67, 74 f., 170
Albert, Archduke, 192, 206
Alberti, Leon Battista, 18, 56 f., 68,
 69, 80, 82, 203
Albertinelli, Mariotto, 48
Albizzi family, 18
Albrecht, V., 95
Amateurs, 36
Amsterdam, 199, 207
Anabaptism, 102
Angelico, Fra Giovanni, 28, 38, 49,
 50, 77
Antal, Frederick, 211
Antonio da Sangallo, 70
Antwerp, 100, 131, 201, 202, 207
Arazzi (Raphael), 81
Architecture as a profession, 70 f.
Aretino, Pietro, 72, 213
Ariosto, 134
Aristocratic moral concepts, 174 f.
Aristotle, 80
Armenini, Giovanni Battista, 44, 212
Arpino, Cavaliere d', 172
Art, collectors, 35 f.

Art, criticism, 121 f.
 as an educator, 75
 instruction, 118 ff.
 market, 35
 public, 185, 204
 progressive and conservative,
 184 f.
 and science, 56 f., 67 f.
'Art of Versailles', 184
Artist, freedom and security of, 208
 and the work of art, 54, 61, 63 f.
Artists,
 and art dealers, 203 f.
 and posterity, 63 f.
 workshop organization of, 205
'Artistic intention' (Kunstwollen), 210
Arts,
 order of precedence in, 57, 119
 unity of, 122
Athens, 16, 19
Aucassin et Nicolette, 2
Autonomy of art, 65 ff.
Avignon, 24, 76
Aynard, Joseph, 217

Baglioni family, 14
Balzac, 140
Baron, Hans, 209
Baroque,
 a-tectonic structure of, 162
 basic concepts of, 161–4
 of the Catholic Church, 159, 170ff.
 Church art, 169, 172
 cinematic features of, 162
 classicism of, 158 f., 176–9, 187
 and the Middle Ages, 177, 179
 concept of, 158–68

Baroque,
concept of the Universe, 166 f.
cosmic world-view of, 166 f.
of the courts, 158, 165–73
democratization of Church art, 170
devotional image, 169
dynamic quality of, 161 f.
and impressionism, 160
and mannerism, 158, 168, 171, 172
naturalism of, 159
official and non-official trend of, 184
papal art patronage, 171
painterly quality of, 161
piety, 170
ramifications of, 158 f., 166
and Renaissance, 163 f., 167
revaluation of, 159 f.
sociological presuppositions of, 161
space, 161 f.
striving for the infinite, 163, 167f.
striving for unity, 163
Bartolommeo, Fra, 46, 48, 79
Bax, E. Belfort, 214
Bayle, Pierre, 3
Beaumarchais, 191
Beaumont, Francis, 139, 146
Beccafumi, 90, 123
Bédier, Joseph, 217
Bellini, Giovanni, 47
Bellori, 90, 214
Below, Georg von, 210
Benda, Julien, 213
Benedetto da Majano, 38, 53, 70
Bentivogli family, 14
Berclem, Nicolas, 198
Bercken, E. von, 215
Berenson, Bernard, 24, 68, 211, 213
Bernini, Lorenzo, 158, 170, 172
Berri, Duc de, 130
Bertoldo di Giovanni, 39 f.
Bezold, Fr. von, 214, 218
Bicci, Neri di, 44, 49
Bisticci, Vespasiano, 38

Blok, P. J., 218
Blunt, (Sir) Anthony, 211, 214
Boccaccio, 1, 16, 21, 57, 71
Bohemianism, 74 f.
Boileau, 176, 177, 191, 205
Bojardo, 40, 134
Bologna, 14, 58
Borghese family, 172
Borghini, Raffaele, 111, 121, 214
Borghini, Vincenzo, 88, 111, 119
Borgia, Cesare, 59
Borgia, Lucrezia, 41
Borinski, Karl, 209, 213
Borromeo, Carlo, 107
Bossuet, 176
Botticelli, 29, 32, 38, 46, 49, 50, 105
Bouillon, Duke of, 172
Bozzetti, 63
Bracciolini, Poggio, 4
Bradley, A. C., 216
Bramante, 70, 77
Brancacci family, 37
Bray, René, 217
Brecht, Walter, 209
Bridges, Robert, 216
Brieger, Lothar, 212, 214
Brinkmann, Hennig, 216
Bronzino, 49, 90, 95, 122, 124 f.
Bruegel, Pieter, 90, 91, 92, 128–31
Brunelleschi, 3, 19, 34, 37, 38, 46, 58, 70
Bruni, Leonardo, 4
Bruno, Giordano, 117, 215
Brussels, 131, 202
Buecher, Karl, 213
Burckhardt, Jakob, 2, 3, 4, 61, 91, 159, 164, 210, 212
Burdach, Konrad, 11, 210

Callot, Jacques, 92
Calvin, 3, 113
Campin, Robert, 12
Candid (Pieter de Witte), 95
Cangrande, 26
Capitalism, 19 ff., 31, 98 ff., 137

Cappella Paolina, 106, 111
Capponi family, 18
Caraffa, Cardinal Carlo, 104
Caravaggio, 159, 168 ff., 172, 184
Cardano, Girolamo, 70, 187
Carracci family, 166 f., 170
Carracci, Agostino, 166
Carracci, Annibale, 88
Carrara family, 26
Cassirer, Ernst, 211
Cassoni, 36, 49, 53
Castagno, Andrea del, 7, 28, 35, 46
Castiglione, Baldassare, 41, 59, 86 f., 213
Cavalcanti, Guido, 57, 71
Cellini, Benvenuto, 187
Cennini, Cennino, 55
Central perspective, 8 f., 12, 68 ff.
Cervantes, 3, 92, 129, 132, 133–6
Cézanne, 68
Chambers, E. K., 216
Change of style, 165
Chardin, Jean-Siméon, 185
Charlemagne, 97
Charles V, 59, 60, 97, 98 f., 108
Charles VIII, 97
Chigi family, 172
Chigi, Agostino, 59, 78
Chivalry, 131–4, 136, 140 f.
 novels of, 131, 134
 parody of, 134 f.
Chledowski, Casimir de, 213
Cimabue, 47, 57
Cino da Pistoja, 71
Cinquecento, 59, 67, 77, 79–87, 89
 anti-emotionalism of, 82
 authoritarian principles of, 83
 classicism of, 79–83
 formalism of, 82 f., 87
Ciompi revolt, 17, 23, 27
Cione, Nardo di, 24
Clans, in Greece, 56
Clark, (Sir) Kenneth, 212, 213
Classicism, 79–87, 89 f., 178 f.
 and the aristocracy, 186 f.

Classicism, and the bourgeoisie, 186 f.
 and naturalism, 187
 and rationalism, 186 f.
Claude Lorrain, 165
Clement VII, 97, 103
Clement VIII, 112
Clovio, Giulio, 215
Cochin, Ch.-N., 205
Cock, Jeroome de, 205
Coelho, Claudio, 95
Colbert, 177, 179–83
Coleridge, 139
Colonna, Vittoria, 104
Columbus, 3
Commedia dell' arte, 152
Commercialism, 19
Common people and art, 130 f.
Conférences of the Paris Academy, 120, 182 f.
Connoisseurs, 36, 45
 and laymen, 185
 'conscious self-deception', 135
Constant factors of evolution, 6
Contarini, Gaspare, 104, 107
'Continuous' representation, 8
Copernican world-view, 166 f.
Copernicus, 1, 166
Corneille, 176, 188, 189
Cortegiano, Il, 41
Cortona, Pietro da, *see* Pietro
Cosimo I, de' Medici, 118
Cosimo, Piero di, *see* Piero
Cossa, Francesco, 40 f.
Council of Trent, 103, 107, 110–14
Counter-Reformation, 76, 94, 103, 107, 110–14
 and art, 110 f.
 and baroque, 114
 and mannerism, 114
Country folk in art, 130
Courajod, Louis, 11, 210
Croce, Benedetto, 159 f., 214, 217
Cruse, Amy, 214, 216
Cuyp, Aelbert, 205

INDEX

Daddi, Bernardo, 24
Daiches, David, 216
Daniele da Volterra, 112
Dante, 1, 10, 11
D'Avenel, G., 218
Davidsohn, Robert 210
Decamerone, 41
Dejob, Charles, 215
Dekker, Thomas, 143, 153, 154
Descartes, 117, 176
Desiderio da Settignano, 32, 35
Dilettantism, 71
Dilthey, Wilhelm, 67, 167, 213, 217, 218
Dinamov, Sergei, 216
Dischi di parto, 36
Disegno, 119
Dolce, Lodovico, 121
Dolmayr, Hermann, 213, 214
Dominicans, 24
Donatello, 7, 28, 30, 38, 46, 48, 49, 50, 77
Don Quixote, 133–6, 141
Doren, Alfred, 210, 211
Dostoevsky, 108
Drake, Sir Francis, 137
Dramatic unities, 178 f.
Drawings, 63
 in the Middle Ages, 64
 in the Renaissance, 64
Dresdner, Albert, 212, 213, 215, 217, 218
Drey, Paul, 212, 218
Drost, Willi, 219
Dual morality, 109
Du Bos, Abbé, 185
Dumas, *fils*, 152
Dürer, 122 f.
Dutch
 art market, 198, 200–5
 patronage, 198
 production, 201 f.
 public, 198–202, 204
 stratification of, 198 ff.
 artists' workshop, 206

Dutch
 bourgeoisie, 194 f.
 capitalism, 195
 economic prosperity, 194 f.
 fine art trade, 202–5
 liberalism, 194
 middle-class art, 197
 middle-class culture, 196, 199
 nobility, 195 f.
 painters, economic situation of, 202, 204–7, 209
 painting, 168
 classical-humanistic tendencies in, 198 f.
 genres of, 196 f.
 middle-class character of, 196 ff.
 naturalism of, 197, 199
 specialization in, 203 f.
 Protestantism, 193 f.
 and art, 196
Dvořák, Max, 92, 210, 214, 216
Dyck, Anthony van, 159

Economic rationalism, 9, 19 ff., 132
Ehrenberg, Richard, 214
Ehrhard, Albert, 215, 217
Eicken, Heinrich von, 220, 222
Elizabeth I, Queen of England, 137, 142, 143
Elizabethan
 courtly literature, 143 f.
 drama, 153 f., 155
 England, 150
 patronage of literature, 145
 professional writers, 144 f.
 theatre, 144–50
Emotionalism, 82, 185
Engels, Friedrich, 139, 214
English
 aristocracy, and bourgeoisie, 135
 gentry, 136 f.
 middle class, 136 ff.
 nobility, 136 ff., 140, 143
 Renaissance literature, 143 f.
Enlightenment, 1

223

INDEX

Erasmus, 113, 198
Essex, Earl of, 142
Este family, 14, 98
Evelyn, John, 201, 218
Eyck, Jan van, 1, 6

Fabriano, Gentile da, 1, 26, 50, 58, 77
Fa-presto technique, 71
Farnese family, 14, 172
Félibien, 183
Ferrara, 14, 40, 42
Ficino, Marsilio, 39
Filarete, 58, 63
Film, 93
Fine art trade, 37, 202–5
Fisher, H. A. L., 214
Flanders
 and France, 192
 organization of art production in,
 205
 Spanish rule in, 191 ff.
Flaubert, 70, 184, 199
Flemish aristocracy, 192 ff.
 art, 192
 Catholicism, 192 ff.
 and Dutch baroque, 193
 society, 192
Fletcher, John, 139, 146
Flinck, Govert, 200
Floerke, Hanns, 218
Florence, 13, 14, 15–19, 23 ff.,
 26–32, 40, 43 f., 50, 53, 57,
 75 f., 78, 95, 97 f., 118 f., 124 f.
 Baptistry, 20, 34, 52, 71
 Campanile, 22, 34
 Cathedral, 22, 42
 San Lorenzo, 35, 38
 Santa Croce, 22, 35, 37
 Santa Maria Novella, 22, 24, 53,
 58
 Spanish Chapel, 24
Florentine art, 22, 24, 26–9
 mannerism, 122–5
Folk theatre, 149
Fontaine, André, 217

Fontainebleau, 95
Formalistic conception of art, 66, 76
Fouquet, Jean, 1
Francesca, Piero della, 7, 28, 29, 42,
 68
Francia, Francesco, 46, 47, 58
Franciabigio, 48
Francis I, 95, 97, 173
Franciscan movement, 11
Franco-Burgundian art, 7
Franco-Flemish Gothic, 11
Frederick II, Emperor, 15
'Free arts', 57
French
 absolutism, 173 f.
 and art, 177
 academic art theory, 183 f.
 academies, 179–83, 185
 aristocracy, 173
 moral code of, 174 f.
 art market, in the seventeenth
 century, 205
 artists and writers, economic situ-
 ation of, in the seventeenth
 century, 205
 baroque classicism, 176–9, 183,
 186 f.
 bourgeoisie, 173
 and literature, 190
 classical art education, 179 ff.
 classical drama, 178 f.
 court art
 and literature, 175 ff., 181 f.
 society, 174 f.
 salons, 175, 187–90
 and the court, 189
 and literature, 189 f.
 and modern psychology, 188 f.
 state patronage, 179 ff.
Freud, 108
Frey, Dagobert, 209
Friedlaender, Max J., 219
Friedlaender, Walter, 214
Fugger family, 98
Funck-Brentano, F., 217

Gaddi, Taddeo, 24
Galileo, 67
Gaspary, Adolfo, 211
Gauricus, Pomponius, 124, 215
Gaye, 212
Gebhardt, Emile, 210
Genius, 60, 61–5, 71
Ghiberti, 19, 34, 38, 46, 48, 50, 58,
 71
Ghirlandajo, Demenico, 29, 32, 37,
 41, 46, 47, 48, 49, 51, 53, 58,
 70, 71
Giberti, Giammatteo, 104
Gilio, Andrea, 111
Giotto, 1, 7, 11, 21 ff., 27, 47, 57,
 70, 126
Giovanni da Udine, 78
Giuliano da Sangallo, 38
Glück, Gustav, 215
Gobelin family, 181
Goethe, 159
Goldschmidt, Fritz, 215
Gombosi, Georg, 211
Gongorism, 135, 189
Gonzaga family, 98
Gonzaga, Ludovico, 41, 42
Gonzaga, Vincenzo, 206
Gethein, Eberhard, 217
Gothic, 1 ff.
 accumulative composition, 7 ff.
 naturalism, 2, 25
Goyen, Jan van, 158, 202, 204, 205
Gozzoli, Benozzo, 28, 29, 38, 49, 50,
 77
Grande maniera, 79, 88
Grande manière, 175
Grand siècle, 176
Grautoff, O., 215
Greco, El, 90, 91, 92, 96, 107 ff.
Greek theatre, 178
Green, J. R., 216
Grierson, H. J. C., 216
Grossmann, Henryk, 217
Gruyer, Gustave, 215
Guild Priors, 15, 17, 18

Guinicelli, Guido, 57
Guirlande de Julie, 189

Habsburg, House of, 192
Hals, Frans, 159, 202, 205
Hamann, Richard, 211
Harbage, Alfred, 216
Hazard, Paul, 217
Heenskerck, Marten van, 92
Heinse, 5, 209
Heinz, Josef, 95
Helst, Bartholomaeus van der, 202
Henry III, 59
Heretical movements and icono-
 clasm, 113
Heywood, Thomas, 153, 154
High Renaissance, 7, 9, 77, 79–87,
 89 f.
Hildebrand, Adolf, 68, 213
Hobbema, 202, 205
Hoenigswald, Richard, 211
Hoerner, Margarete, 214
Hollanda, Francisco de, 65, 104
Honnête homme, 174
Hooch, Pieter de, 198, 202, 205
Hoogstraten, Samuel van, 198
Hôtel de Rambouillet, 189
Huizinga, J., 209, 213, 218
Humanists, 45, 54, 57, 71–5
 social origins of, 71 f.
 and artists, 54 f., 65, 74 f.
 political views of, 139
Humanist drama, 152 f.
Humour, 134 f.
Hutten, Ulrich von, 101

Ibsen, 152
Iconoclasm, 113
Immanence of the history of art, 81,
 164 f.
Individualism, and the concept of
 the Renaissance, 4, 6
Intelligentsia, 73 ff.
 alienation of, 74 f.
 and the propertied classes, 74

Isabella, Archduchess, 192
Isabella d'Este, 41

Jackson, T. A., 216
James I, 142
Jerrold, M. J., 212
Jesuit Order, 107
Jode, Geeraard de, 203
John of the Cross, 107
Jonson, Ben, 143, 156
Julius II, 77, 78

Kaegi, Werner, 209
Kafka, Franz, 93
Kalokagathia, 84 ff., 96
Karlstadt, 113
Kaser, Kurt, 218
Kehrer, H., 215
Kelly, J. F., 216
Kepler, 67
Ker, W. P., 216
Klemperer, Viktor, 218
Koser, R., 217

La Bruyère, 175
Lafayette, Mme de, 188
La Rochefoucauld, 176, 188, 190
'L'art pour l'art', 36
Last Judgement (Michelangelo),105, 106 f.
Late medieval courtly art, 24 f.
Latini, Brunetto, 71
Laurence, R. V., 215
Lavisse, Ernest, 214, 217
Le Brun, 177, 180–5, 205
Lemonnier, Henry, 217
Le Nain, Louis, 159, 176, 187
Leo X, 77
Leonardo da Vinci, 38, 43, 47, 48, 51, 53, 55, 56, 59, 60, 76, 79, 81, 85, 164
Lerner-Lehmkuhl, H., 212
Lessing, 57, 209
Le Sueur, 176
Lewis, Wyndham, 216

Liberalism, and the concept of the Renaissance, 3, 6
Linearism, and colorism, 180
Lippi, Filippino, 37, 38, 49, 51, 53
Lippi, Filippo, 38, 46, 50, 58
Lomazzo, Giovanni Paolo, 110, 117, 122, 215
Lorenzetti, Ambrogio, 23, 24, 69
Lorenzo Monaco, 28
Louis XIII, 175
Louis XIV, 176, 180 ff., 185, 191, 205
Louis XV, 205
Loyola, Ignatius, 108, 132, 170
Louvre, 172, 181
Luchaire, Julien, 210
Ludovisi family, 172
Luther, 3, 101 f., 108, 113

Machiavelli, 107 ff., 187, 214
Machiavellism, 108 f., 141
Maes, Nicolas, 199
Majano, Benedetto da, see Benedetto
Malatesta, Sigismondo, 42
Mâle, Emile, 215, 217
Malvasia, 88
Maniera, 88
Maniera grande, 79, 88
Mannerism, 9, 63, 90 ff., 96, 122–130, 135 f.
 and academicism, 118–21
 anti-classicism of, 89
 and art education, 118 ff.
 art theory of, 116 f.
 and baroque, 94, 114
 classicism of, 90
 concept of, 88–96
 in conception of space, 93, 105 f., 123 f.
 and Counter-Reformation, 114, 126
 as a court style, 95, 124
 eroticism of, 112
 and Gothic, 96
 intellectualism of, 90, 94

INDEX

Mannerism, internationalism of, 94, 95
and knightly romanticism, 131–4, 140 f.
and the Middle Ages, 92, 115
and modern art, 91, 93
naturalism of, 92
pantheism of, 92
and Reformation, 123
and Renaissance, 92 f., 105 f., 122, 124
and rococo, 125
and Roman Catholic Church, 114 ff.
spiritualism of, 90, 92, 96
manneristic and mannered, 88
Mantegna, 40 f., 42, 77
Mantua, 40, 42, 206
Manufacture des Gobelins, 181 f.
Marinism, 135, 189
Marlowe, 141, 143, 153
Martelli, Roberto, 38, 49
Martin, Alfred, von, 213
Martin, W., 218
Martini, Simone, 23, 57
Marx, 108, 139
Masaccio, 7, 27, 28, 29, 30, 37, 50, 56, 77
Maximilian I., 98, 132
Mayer, A. L., 215
Mazarin, 176, 186
Meder, Joseph, 212, 213
Medici family, 14, 18, 32, 37, 95, 98
Medici, Alessandro, 98
Medici, Cosimo, 18 f., 30, 32, 35, 37, 38
Medici, Lorenzo, 4, 30 f., 35, 38 ff., 42, 75
Medici, Piero, 35
Medici tombs, 105
Medieval drama, 147, 153
Mehring, Franz, 218
Melozzo da Forlí, 77
Mercantilism, 99, 177 f.
Mesnil, Jacques, 213

Metsu, 198
Meulen, van, 180
Michelangelo, 48, 50, 51, 52, 53, 59 f., 70, 71, 77, 78, 79, 80, 85, 89, 91, 94, 104–7, 115, 119, 125, 126, 127, 157
Michelet, Jules, 3, 209
Michelozzo, 38, 48, 58
Michels, Wilhelm, 217
Middleton, Thomas, 154
Middle Ages,
class struggles in, 13
cultural unity of, 62
universalism of, 6
Middle-class
morality, 21
virtues, 20 f.
Milan, 13, 14, 25, 26, 33, 38, 48
Milizia, Francesco, 217
Modern Church art, 168 f.
Molière, 1, 176, 177, 180, 189, 191, 205
Monnier, Philippe, 213
Montaigne, 3, 187
Mor, Anthony, 92
Moro, Ludevico, 51, 59
Mueller, Eduard, 213
Muentz, Eugène, 215
Muller, Jan Hermensz de, 203

Naturalism, 1
Neoplatonism, 30, 38, 39, 66
Neri, Filippo, 107
Netherlandish
bourgeoisie, 193 f.
Catholicism and Protestantism, 193 f.
culture, bifurcation of, 193
monarchism and republicanism, 193
Revolt, 193 f.
Netscher, Caspar, 198
Neumann, Carl, 11, 210, 219
Nicoll, Allardyce, 216
Nietzsche, 5, 108, 209

Night Watch, 204, 207
Nominalism, 1
Novel, picaresque, 135

Oceanic nations, 99
Oldenbourg, Rudolf, 219
Olschki, Leonardo, 212
Olympia, sculptures, 79
Oppenheimer, Franz, 214
Orcagna, Andrea, 24, 70
'Original genius', 63
Originality, 61 ff.
Ostade, Isaak van, 204, 205

Padua, 25, 26
Palestrina, 113
Palla, Giovanni Battista della, 37
Palmer, John, 216
Pamfili family, 172
Panofsky, Erwin, 59, 209, 213, 215
Pantheism, 167
Papal courts, 53, 76 ff.
Paradiso degli Alberti, 41
Parallelisms in the history of art, 164 f.
Paris, 172, 177
Parmigianino, 90, 91, 92, 115, 116, 124 f.
Parthenon, 79, 81
Pascal, 167, 176, 188
Patronage, 60 f., 73
Paul III, 107
Paul IV, 112
Pavia,
 Battle of, 97
 Certosa di, 33
Pazzi family, 37
Peele, George, 143
Penni, Francesco, 78
Periodicity in the history of art, 164 f.
Perurgia, 14, 58
Perugino, 7, 38, 46, 53, 58, 59, 76, 81, 105
Peruzzi family, 16, 22

Peruzzi, Baldassare, 71, 78
Pesellino, 28, 32, 41
Petrarch, 1, 9, 67, 71
Pevsner, Nikolaus, 214, 215, 218
Pfandl, Ludwig, 214, 215
Philip II, 95, 99, 133, 193 ff.
Philippi, Adolf, 209
Picard, Roger, 218
Picaresque novel, 135
Piero di Cosimo, 32, 49
Pietà Rondanini, 106
Pietro da Cortona, 172
Piles, Roger de, 185
Pinder, Wilhelm, 211, 214, 215, 216
Piombo, Sebastiano del, 52, 78
Pirenne, Henri, 211, 218
Pisa, 13, 33
Pisanello, 1, 6, 26, 70
Pius V, 112
Plato, 55, 74, 151
Platzhoff, Walter, 217
Plotinus, 66
Podestà, 14 f.
Poelenburgh, Cornelis van, 198
Poggi, Giovanni Battista, 50
Pole, Reginald, 104, 107
Political realism, 102, 107–10, 132
Politicization of the spirit, 75
Pollajuolo, brothers, 46
Pollajuolo, Antonio del, 29, 35, 38, 46, 47, 48, 49, 70
Pontormo, 49, 90, 92, 115, 116, 122 ff.
Pontifical state, 76
Popular art, 130
Poussin, 159, 165, 176, 183, 186 f.
Poussinistes and Rubénistes, 184
Prague, 95
Preciosity, 189 f.
Predis, Evangelista da, 48
Protestantism
 and the common people, 102
 and the middle class, 102, 103
 and the peasantry, 101 ff.
 and the princes, 102, 103

Proto-Renaissance, 2
Psychology
 of exposure, 187 f.
Pulci, Luigi, 4, 40, 134
Puritanism, 142, 146

Quaratesi family, 34
Quaratesi, Castello, 37
Quattrocento, 7, 27–32, 36 f., 49, 51,
 58, 67, 77, 80 f., 82, 83 f., 87
Quercia, Jacopo della, 34

Rabelais, 3
Racine, 176, 180, 191, 205
Rajna, Pio, 213
Raleigh, Sir Walter, 137
Raphael, 7, 47, 53, 59, 70, 71, 75 f.,
 77, 78, 79, 81, 85, 87, 89, 94,
 97, 164, 183, 206
Rappresentazioni sacre, 43
Rationalism,
 and the aristocracy, 186 f.
 and the bourgeoisie, 186 f.
Ravenna, 25
Reformation, 101–4
 and art, 113 f.
Rembrandt, 157, 158, 159, 164, 183,
 199, 200, 202, 204, 207 f.
Renaissance, 89 f., 91 f., 93, 105,
 107
aristocracy, 14–17, 21, 78, 83–7
art academies, 30, 39, 56
art appreciation, 42 ff.
art and craftsmanship, 36 f., 46,
 49, 55, 60
art education, 47, 55 f.
art market, 35 f., 50 f., 53 f.
art public, 13, 42–5, 79
artistic
 competitions, 33
 co-operation, 47
artists,
 anecdotes about, 57
 apprenticeship of, 47, 55
 biographies of, 57

Renaissance, artists,
 and courts, 52
 economic situation of, 50–3
 and guilds, 46, 50, 52–5
 legend of, 61
 social status of, 46, 54, 58, 59 ff.
 veneration of, 59 ff.
 versatility of, 70
 virtuosity of, 71
 workshop of, 43, 47, 48, 49
capitalism, 9, 10 f., 14, 19 ff.
chivalric-romantic tendencies of,
 13, 25, 31, 32, 40
class struggles of, 14, 16
and classical antiquity, 10 f.
classicism of, 7, 9, 22, 79–87
collectors, 35
communes, artistic activity of,
 32 f.
concept of, 1–12
concept of space, 209
conservatism of, 80, 82, 87
court society, 21, 27
courtly culture, 40 ff.
 salons, 41 f.
 tendencies, 13, 25, 26, 27, 31,
 76, 86 f.
courts, 13, 25 f., 38 ff., 72, 76
cultural élite, 44 f.
democracy, 17, 18
'discovery of world and man', 2
fine art trade, 37
formalism, 66, 76
Gothic-Spiritualistic features of,
 21, 28, 30 f.
guilds, 14–17, 54 f.
 artistic activity of, 32 ff.
individualism of, 61 f.
and liberalism, 3 f.
literary professionalism in, 71 ff.
literary public of, 72 f.
masters
 and assistants, 47
 and pupils, 47, 49, 55 f.
and the Middle Ages, 1 ff., 6–12

Renaissance, middle class, 13, 15 ff., 20 ff., 27, 28, 29, 31, 40, 72 f.
 art, 22, 27 ff., 40 f.
 artistic activity of, 34
 national and racial criterion of, 6 f.
 naturalism of, 2 f., 12, 22, 23, 24, 26–9, 32
 novelle, 57
 origins of, 10 f.
 patronage of art, 37–40, 42, 73, 78
 popular art, 43
 princes, 41
 patronage of, 42
 principle of uniformity, 7 ff., 12
 rationalism of, 9, 10 f., 13, 19 ff., 40
 and religion, 3 f.
 rentiers, 17, 21, 30, 72 f.
 representation of space, 8, 23
 secularization, 26
 simultaneity of vision, 9
 specialization, 70
 universalism, 70
 working-class, 16 f.
 workshop community, 47, 48
 workshop organization, 48
 writers, social origins of, 71
Renard, Georges, 209, 210
Renier, G. J., 218
Repoussoir figures, 161
Retz, Cardinal de, 177, 188, 191.
Reumont, Alfred von, 211
Riario family, 14
Ribera, 159
Richelieu, Cardinal, 176, 186
Richter, J. P., 213
Riegl, Alois, 91, 160, 164, 199, 207, 218, 219
Robbia, Luca della, 38, 48, 49, 71
Rodin, 160
Roman Catholic
 art, 169, 171 f.
 reform movement, 103
Romano, Giulio, 68

Rome, 33, 76–7, 97, 103, 118 f., 171 f.
Rose, Hans, 217
Rosenberg, Adolf, 218
Rospigliosi family, 172
Rosselli, Cosimo, 49
Rosso, Fiorentino, 92, 116, 123
Rubens, 157, 158, 159, 164, 170, 172, 183, 192, 205 ff.
Rucellai family, 37
Rucellai, Giovanni, 34 f.
Rudolf II, 95
Ruisdael, Jacob van, 202, 205

Sabatier, Paul, 210
Sacchetti, Franco, 57, 71
Sack of Rome, 94
Sadoleto, Jacopo, 104, 107
Saint-Simon, Duc de, 188
Saitschick, Robert, 211, 212, 213
Salutati, Coluccio, 4
Salvini, Roberto, 211
Sancho Panza, 135 f., 141
Sangallo, Antonio da, 70
Sangallo, Giuliano da, 38
Sarto, Andrea del, 46, 48, 49, 80
Sassetti family, 37
Savonarola, 104, 113
Scaliger, J. C., 9, 209
Schaefer, Dietrich, 213
Schewill, Ferdinand, 210
Schmidt-Degener, F., 218, 219
Schnitzer, Josef, 215
Schuecking, L. L., 216, 217
Scribe, 152
Sée, Henri, 214, 215
Sercambi, 71
Sévigné, Mme de, 188, 191
Sforza, Francesco, 14, 33
Shakespeare, 1, 3, 92, 129, 136–58
Shakespeare's
 audience, 142, 146–50
 baroque style, 157
 concept of chivalry, 132, 136, 140 f.
 dramatic form, 150–3

INDEX

Shakespeare's
 liberalism, 138, 140
 mannerism, 157 f.
 naturalism, 154 f.
 political views, 138 ff.
 psychology, 154 f.
 social sympathies, 142
 theatre, 146, 149
Shaw, G. B., 139, 153
Sheavyn, Phoebe, 216
Sidney, Sir Philip, 143
Siena, 23, 24
Sienese painting, 283
Signorelli, 7, 59
Signoria, 14
Simmel, Georg, 105, 214
Simonides, 57
Sisson, C. J., 216
Sixtus IV, 77
Sixtus V, 171
Smirnov, A. A., 216
Social levelling, 138
Soderini, Pietro, 75
Sodoma, 78
Sombart, Werner, 210
Sophistic movement, 103
Sophists, 73
Southampton, Earl of, 142
Space
 and dynamic cultures, 123 f.
 representation of, 92 f., 105 f., 123 f.
Spain, 97, 132 ff.
Spengler, Oswald, 124, 215
Spinello Aretino, 24
Spranger, B., 90, 95
Squarcione, Francesco, 47, 49
Steen, Jan, 199, 202, 204
Stoll, E. E., 216
Strieder, Jakob, 210
Strozzi family, 34, 37
Stuart, Mary, 142
'Style Louis XIV', 176, 182
Subjectivism, 61 ff.
Surrealism, 93
Surrey, Earl of, 143

Sustris, 95
Symbolism, 128 f.

'Tactile values', 24
Tasso, 92, 116
Technicism, in art theory, 210
Teniers, David, the younger, 203
Terborch, Gerard, 198
Teresa, St., 107
Thiene, Count Gaetano da, 104
Thode, Henry, 11, 240
Tillyard, E. M. W., 216
Tintoretto, 90, 91, 92, 125–8
Titian, 53, 59, 60, 80, 125, 126
Toledo, 127
Tolnai, Charles de, 216
Tolstoy, 139
Tornabuoni family, 37
Tornabuoni, Giovanni, 53
Tragédie classique, 152 f.
Tragedy,
 idea of, and the Middle Ages, 151
 and political realism, 151
 and Protestantism, 152
'Trahison des clercs', 75
Trecento, 10, 22 ff., 26, 27
Trinkaus, C. E., 213
Trivas, N. S., 218
Troelsch, Ernst, 261
Tudor, House of, 136 f.
'Typical styles', 164 f.

Uccello, Paolo, 28, 35, 46, 50, 56, 64
Udine, Giovanni da, 78
Unamuno, Miguel de, 216
Uomo universale, 70
Urban VIII, 172
Urbino, 40
Uzzano family, 18

Valla, Lorenzo, 4
Valois, House of, 95
Vasari, 21, 50, 54, 59, 64, 71, 88,
 95, 111, 112, 118, 120, 122
Velde, Aert van der, 202

231

INDEX

Veneziano, Domenico, 26, 28, 35
Venice, 13, 14, 19, 24, 48, 49, 104, 125 f.
 Scuola San Rocco, 126
Vermeer van Delft, 199, 202
Verona, 13, 25, 26
Veronese, 111
Verrocchio, Andrea del, 29, 32, 35, 38, 46, 47, 48, 49
Versailles, 95, 166, 177, 181
Villani, Giovanni, 16, 21, 57, 71
Villari, Pasquale, 214
Virtuosity, 71
Visconti family, 14, 33
Vitruvius, 80
Voigt, Georg, 212
Voltaire, 3, 38, 156, 176
Volterra, Daniele da, 112
Vondel, Joost van der, 200
Vos, Cornelis van, 203
Vossler, Karl, 217
Vouet, Simon, 176
Vries, Adriaen de, 95

Wackernagel, Martin, 211, 213
Waldenses, 113

Walser, Ernst, 4, 209, 213
Walzel, Oskar, 217
Wandering scholar, 2
Wars of Religion, 170, 173
Wars of Roses, 136, 143
Watteau, 185
Weber, Max, 210
Weisbach, Werner, 210, 211, 214, 215, 217
Werff, Adriaen van der, 198
Wickhoff, Franz, 209
Wilson, J. Dover, 216
Winckelmann, 159
Woelfflin, Heinrich, 89, 91, 157, 160–65, 214, 217
Wolff, Max J., 216
Women, and artistic life, 41 f.
Workshop instruction and academies, 119
Wyatt, Sir Thomas, 143

Zilsel, Edgar, 213
Zuccari, Federigo, 117, 119, 122, 172, 215
Zuccari, Taddeo, 111
Zwingli, 113